HERITAGE MATTERS

SAFEGUARDING INTANGIBLE CULTURAL HERITAGE

Heritage Matters

ISSN 1756–4832

Series Editors
Peter G. Stone
Peter Davis
Chris Whitehead

Heritage Matters is a series of edited and single-authored volumes which addresses the whole range of issues that confront the cultural heritage sector as we face the global challenges of the twenty-first century. The series follows the ethos of the International Centre for Cultural and Heritage Studies (ICCHS) at Newcastle University, where these issues are seen as part of an integrated whole, including both cultural and natural agendas, and thus encompasses challenges faced by all types of museums, art galleries, heritage sites and the organisations and individuals that work with, and are affected by them.

Previously published titles are listed at the back of this book

Safeguarding Intangible Cultural Heritage

Edited by

MICHELLE L. STEFANO, PETER DAVIS
AND GERARD CORSANE

THE BOYDELL PRESS

First published 2012
The Boydell Press, Woodbridge
Paperback edition 2014

ISBN 978 1 84383 710 7 hardback
ISBN 978 1 84383 974 3 paperback

The Boydell Press is an imprint of Boydell & Brewer Ltd
PO Box 9, Woodbridge, Suffolk IP12 3DF, UK
and of Boydell & Brewer Inc.
668 Mt Hope Avenue, Rochester, NY 14620–2731, USA
website: www.boydellandbrewer.com

The publisher has no responsibility for the continued existence or accuracy
of URLs for external or third-party internet websites referred to in this book,
and does not guarantee that any content on such websites is,
or will remain, accurate or appropriate.

A CIP record for this book is available
from the British Library

This publication is printed on acid-free paper

Contents

Illustrations

TABLES

The authors and publisher are grateful to all the institutions and individuals listed for permission to reproduce the materials in which they hold copyright. Every effort has been made to trace the copyright holders; apologies are offered for any omission, and the publishers will be pleased to add any necessary acknowledgment in subsequent editions.

Acknowledgments

First and foremost, we would like to thank Catherine Dauncey, who was not only invaluable in the planning, organisation and publication of *Safeguarding Intangible Cultural Heritage*, but kept us on track and made the process as smooth as possible. Of course, none of this could have happened without the patience and hard work of the contributors, whose chapters were specifically written for this book. They were each invited to participate based on the extensive knowledge and expertise they bring to issues concerning the protection and management of cultural heritage throughout the world. Moreover, their passions for honouring the voices and perspectives of communities, groups and individuals with respect to cultural expressions and beliefs constitute the book's main strengths and significance. Thanks also need to go to the communities, groups and individuals who provided information for the chapters. It is important to recognise that, without them, safeguarding intangible cultural heritage effectively would be impossible.

Michelle Stefano, Peter Davis and Gerard Corsane
New York and Newcastle-upon-Tyne
June 2011

Touching the Intangible: An Introduction

Michelle L Stefano, Peter Davis and Gerard Corsane

The need to promote, protect and revitalise cultural expressions and practices of communities, groups and individuals from throughout the world is gaining an increasing amount of recognition and, thus, importance at international and national levels. Indeed, the contribution of culture to strengthening the livelihoods of people, as well as their agency within broader social, economic, political and environmental contexts, is an area that deserves greater attention. Viewed as the nuanced components of our cultural diversity, a great number of cultural expressions, or 'intangible cultural heritage', are considered to be threatened with extinction as a result of the homogenising forces of globalisation, or the rise of one, mass culture. For instance, changes in local economies, which may lead to higher unemployment, the creation of new industries and migration, can affect the vitality of certain cultural practices and identity expressions. In response, transnational initiatives are in the process of being implemented to counteract their potential degradation and disappearance.

Usage of the term 'intangible cultural heritage' has grown in the past several decades on an international scale. Without presenting its official definition (or definitions), it can be deduced that the term relates to forms of cultural heritage that lack physical manifestation. It also evokes that which is untouchable, such as knowledge, memories and feelings. In this light, it can also be suggested that intangible cultural heritage represents everything: the immaterial elements that influence and surround all human activity. Moreover, since human activity of the past exists only as tangible evidence, intangible cultural heritage must be tied, in whatever form it takes, to the present.

Evidently, the term is vague. What it means can be subject to unlimited interpretation, depending on the interpreter. Nonetheless, within the current international heritage sector, it is a term that carries with it a UNESCO-specific definition, which is stated as follows:

> The 'intangible cultural heritage' means the practices, representations, expressions, knowledge, skills – as well as the instruments, objects, artefacts and cultural spaces associated therewith – that communities, groups and, in some cases, individuals recognize as part of their cultural heritage. This intangible cultural heritage, transmitted from generation to generation, is constantly recreated by communities and groups in response to their environment, their interaction with nature and their history, and provides them with a sense of identity and continuity, thus promoting respect for cultural diversity and human creativity. For the purposes of this Convention, consideration will be given solely to such intangible cultural heritage as is compatible with existing international human rights instruments, as well as with the requirements of mutual respect among communities, groups and individuals, and of sustainable development.
>
> (UNESCO 2003, Article 2)

Introduced in 2003, this definition is found within the *Convention for the Safeguarding of the*

Intangible Cultural Heritage (hereafter 2003 Convention) of the United Nations Educational, Scientific and Cultural Organization (UNESCO). It can be stated that when 'intangible cultural heritage' (hereafter ICH) is referenced at the international level, the above description is implied. Additionally, UNESCO (2003, Article 2) has also categorised ICH to include:

a) oral traditions and expressions, including language as a vehicle of the intangible cultural heritage;
b) performing arts;
c) social practices, rituals and festive events;
d) knowledge and practices concerning nature and the universe; and
e) traditional craftsmanship.

In essence, ICH is more comprehensible when it is thought of as a language or a dance. The abstract nature of the term becomes anchored through a set of 'shapes' that it can take.

It is also understood that people play a crucial role in keeping ICH alive. As noted in the above definition, it is through communities, groups and individuals that it is passed on, as well as 'recreated' (UNESCO 2003, Article 2). Here, an essential dimension of ICH is uncovered: people are responsible for its transformations over time and thus its vitality. Using the example of language, it is apparent that the fluctuating use of certain words, including the creation of new ones, constitutes one aspect of its evolving nature. In some cases, these changes are a result of larger societal forces, such as the introduction of new digital technologies. However, it is important to stress that it is through people that these changes are made, as well as spread. Thus, sustaining the connection between ICH and its communities, groups and individuals can be argued to be central to its survival.

While there are currently 142 States Parties to the 2003 Convention (UNESCO 2012), its implementation remains in its infancy. Understandably, there exists a significant gap in the literature in terms of actual efforts, problems and plans owing to activities still being at an early stage. A large amount of the relevant literature is dedicated to the strengths and weakness of UNESCO's prescribed approaches, including important historiographies of UNESCO and related organisations' initiatives (see, for example, Kirshenblatt-Gimblett 2004; 2006; Blake 2006; Smith 2006; Kurin 2007; Hafstein 2009). However, an understanding of what is currently unfolding at local, regional and national levels is still very much needed in the ICH discourse.

In response, the present volume seeks to fill this gap in the literature and stimulate the ICH discourse with critical reflections and new ideas. Owing to the fact that the importance of ICH is growing globally, it was felt that questions concerning the current state of affairs of ICH promotion and protection at local, regional and national levels should be explored from a wide array of geographical locations. Indeed, one of the key strengths of this volume is its international scope, thanks to the contributions of heritage scholars and professionals who bring knowledge and experience in safeguarding ICH from Africa, Asia, Australasia, Europe, North and South America and the Middle East. Most importantly, this international scope serves to underscore the notion that not only is ICH manifested in a whole range of diverse forms but so too are the social, economic, political, cultural and environmental contexts within which it is expressed and developed.

Similarly, the volume also asks if it is time to 'move beyond the convention' and engage with other safeguarding paradigms that lie 'outside' of its increasingly dominant framework. Supporting this idea are several chapters that critically engage with the 2003 Convention and

the ideologies that structure its approach. In addition, the volume offers a series of 'dispatches' on the implementation of the 2003 Convention from a variety of places. These discussions, which follow a conversation-like style and are interspersed throughout the volume, also focus on conceptualisations of 'ICH', responses to the 2003 Convention and pre-existing mechanisms for safeguarding ICH within each of the contributors' respective countries. In particular, the 'conversations' are with Harriet Deacon (South Africa), Ewa Bergdahl (Sweden), Maurizio Maggi (Italy), Susan Keitumetse (Botswana) and Vasant Hari Bedekar (India).

In addition to the interspersed Conversation Pieces, the following chapters are grouped under three themes, or sections: 'Negotiating and Valuing the Intangible', 'Applying the Intangible Cultural Heritage Concept', and 'On the Ground: Safeguarding the Intangible'. The first section of chapters can be considered to highlight the dichotomous nature of the ICH concept and how it is negotiated and valued from a variety of perspectives, depending on geographical scale and location. On one hand, the ICH concept operates at the international and national levels as a direct result of its conceptualisation and categorisation by UNESCO. In this sense, it is imbued with non-local values that render ICH as universal in nature. On the other hand, however, ICH is specific and nuanced when thought of in terms of the multitude of languages, dialects, cultural knowledge and meanings, craft skills and religious festivals, as examined throughout this volume, that live at the local level in connection to those who embody, practice and transmit them.

In addition, ICH can also be re-appropriated and revived, reflecting the changing identities and circumstances of those who value it at the local level. As examined by Alivizatou in the first chapter, ICH-related activities at the National Museum of New Zealand Te Papa Tongarewa and the National Museum of the American Indian focus on cultural practices that reflect contemporary identities of the communities with which they engage. Additionally, Cummins demonstrates how central issues of ownership are to the ICH discourse through her exploration of the negotiations involved in representing historically neglected ICH of Caribbean communities within the museum context. Similarly, Hennessy discusses the 'virtual repatriation' of digital records and ethnographic information about a First Nations community in North Eastern Canada.

Expanding upon the ICH concept, as it is defined by UNESCO, Abungu discusses the values and meanings that are attributed by local communities to a wide array of natural and cultural sites across the African continent, including two examples from the island of Mauritius. Furthermore, in the Jordanian context, Abu-Khafajah and Rababeh explore the memories and meanings attributed to archaeological sites by local communities within the ever-evolving city of Amman.

The second section, 'Applying the Intangible Cultural Heritage Concept', focuses more on the use of the ICH concept as defined in the 2003 Convention. Accordingly, Hottin and Grenet present an overview of the challenges in implementing the 2003 Convention and safeguarding ICH expressions at a national scale in France. Leader-Elliot and Trimboli examine Australia's non-ratification of the 2003 Convention, the lack of relevant public discussions on the matter, and the implications for safeguarding Australian ICH. In addition, several authors explore the ICH concept within particular regional contexts and, thereby, remind readers of the specificity of locally expressed cultural diversity and associated stakeholder groups. In particular, Meijer-van Mensch and van Mensch examine two distinct heritage expressions, a Christmas-time festival and the commemorations of the abolition of slavery, through the lens of the ICH discourse in the Netherlands. Within the context of Wales, Dixey examines the differences between highly publicised ICH, such as the Eisteddfod cultural gatherings, and other expressions that are 'unofficial' and, thus, less promoted. Furthermore, MacKinnon examines intangible cultural expressions

from the Nova Scotia region of Canada and relevant efforts in their safeguarding, even though Canada has yet to ratify the 2003 Convention.

It should be noted that UNESCO's widespread promotion of the importance of ICH has given us its concept to deconstruct, debate and, indeed, discuss from differing international perspectives. Most evidently, this volume could not have been conceived without the work of UNESCO in setting the parameters of the ICH concept these past several decades. During this time, awareness of the concept has grown along with a rise in international ICH-themed conferences, workshops and other educational meetings where ideas are exchanged and developed. In this light, the final section, 'On the Ground: Safeguarding the Intangible', begins with a chapter by Denes, who presents the efforts of the ICH and Museums Field School in Lamphun, Thailand. This two-week programme brings together participants from throughout the Greater Mekong sub-region to learn skills in documenting and promoting local intangible cultural expressions of surrounding communities and groups. At the time of writing, the Field School is entering its third year.

This section is also devoted to an exploration of alternative approaches to safeguarding the cultural expressions, beliefs and values of communities, groups and individuals. Kreps examines a community-based project in Indonesian Borneo that aims to revitalise a local weaving tradition. Assunção dos Santos and Müller discuss the potential for 'grass-roots' safeguarding efforts within the Brazilian state of Pernambuco. Similarly, Bowers and Corsane examine the potential for increasing both economic and cultural capital through sustainable tourism practices that can benefit the safeguarding of indigenous ICH expressions in the Rupununi region of Guyana. Furthermore, Stefano suggests that using the philosophy of ecomuseology can provide a more holistic and integrated way forward for safeguarding intangibles based on an investigation of the significance and values of three folk traditions from North East England. Corsane and Mazel finish the section and volume by providing an overview of the multinational *en-compass* project, a significant part of which deals with the safeguarding of ICH and cultural expressions in four different parts of the world. The project represents one type of model which could be used by others to promote ICH and cultural expressions in different contexts.

BIBLIOGRAPHY AND REFERENCES

Blake, J, 2006 *Commentary on the UNESCO 2003 Convention on the Safeguarding of the Intangible Cultural Heritage*, Institute of Art and Law, Leicester

Hafstein, V, 2009 Intangible Heritage as a List: From Masterpieces to Representation. 2008, in *Intangible Heritage* (eds L Smith and N Akagawa), Routledge, London and New York, 93–111

Kirshenblatt-Gimblett, B, 2004 Intangible Heritage as Metacultural Production, *Museum International* 56 (1–2), 52–65

—— 2006 World Heritage and Cultural Economics, in *Museum Frictions: Public Cultures/Global Transformations* (eds I Karp, C A Kratz, L Szwaja and T Ybarra-Frausto), Duke University Press, 161–202

Kurin, R, 2007 Safeguarding Intangible Cultural Heritage: Key Factors in Implementing the 2003 Convention, *International Journal of Intangible Heritage* 1, 10–20

Smith, L, 2006 *The Uses of Heritage*, Routledge, London and New York

UNESCO, 2003 *Convention for the Safeguarding of the Intangible Cultural Heritage*, UNESCO, Paris, available from: http://unesdoc.unesco.org/images/0013/001325/132540e.pdf [29 January 2012]

—— 2012 *The States Parties to the Convention for the Safeguarding of the Intangible Cultural Heritage (2003)* [online], available from: http://www.unesco.org/culture/ich/index.php?pg=00024 [29 January 2012]

Negotiating and Valuing the Intangible

The Paradoxes of Intangible Heritage

Marilena Alivizatou

There is little doubt that had it not been for the United Nations Education Scientific and Cultural Organisation (UNESCO) and its work in the field, the concept of intangible cultural heritage would not feature as prominently in the international heritage scene as it does today. Plans and programmes aimed at safeguarding and documenting the intangible heritage of local communities have been drawn from the South Pacific island nations of Tonga and Vanuatu to Cambodia, Siberia, Scotland and the Indigenous communities of Peru and Ecuador, to mention just a few (for more details, see www.unesco.org/culture/ich, accessed December 2009). This observation points, in my view, to two interesting phenomena: on the one hand, it reveals the global reach of the international organisation and its power to affect the lives of people living even in the most remote settings; on the other, it universalises and turns into practice a key anthropological idea: the belief that peoples around the world, despite of their cultural, religious and racial differences, share a common humanity expressed in embodied practices of intergenerational cultural transmission (see Levi-Strauss 1961; Ingold 1992).

UNESCO historiography suggests different paths through which intangible heritage came into being. Since the adoption of the World Heritage Convention in 1972, cultural heritage has been primarily conceptualised as monumental constructions, ruins, fenced-off archaeological sites and pristine landscapes. Such understandings pertain primarily to a European and North American preservationist ethos (Cleere 2001) and express Western-derived archaeological, art historical and naturalist narratives. The imbalance of world heritage sites' representativeness, which clearly prioritised Europe before every other continent, was an impetus for the international organisation and its member states to seek alternative conceptualisations of cultural heritage: one was the concept of 'cultural landscapes' (Cleere 1995; Titchen 1996) and another was intangible heritage, a heritage that is not embedded in material relics as traces of the past, but that is living and taking shape through embodied skills and performance.

Such understandings of cultural heritage on an institutional level were not, however, new. From as early as the 1950s and 1960s, Japan and Korea had adopted laws for the protection of traditional practices and ceremonies thought to be under threat by processes of post-World War II modernisation and globalisation (Yim 2004; Saito 2005). The rationale was that efforts to bring the state and its people in line with economic trends in the West would lead to the abandonment of traditional ways of life and ceremonies and disrupt the local sense of continuity and identity. The aim was therefore to create mechanisms and institutions that would record, sustain and perpetuate those practices. By the end of the 20th century, Japan and Korea were at the forefront of state-sponsored intangible heritage preservation through programmes such as the Living National Treasures. And it is for many the success of these Asian models, along with the influence of Mr Kōichirō Matsuura, UNESCO Director General from 1999 until 2009, that led to the establishment of the Intangible Heritage Section in the UNESCO Secretariat and

the subsequent panegyric adoption of the 2003 *International Convention for the Safeguarding of Intangible Cultural Heritage*.

Although the Asian influence was pivotal in the above, the topic of state-driven cultural preservation had already been on the UNESCO agenda for several decades. Since the 1970s and following proposals by South American representatives (Sherkin 2001), the topic of the preservation of 'folklore' and 'traditional practices' came to the fore of international diplomatic negotiations via the 1989 *Recommendation on the Safeguarding of Traditional Culture and Folklore*. This, however, was an unsuccessful tool. For example, Hafstein (2004) has pointed out the archival focus of the 1989 Recommendation as opposed to the Asian preservation models, a reason that has been acknowledged as a key factor in its failure to engage member states (Aikawa 2004). In a way, the Asian models breathed new life into and provided a different framework for thinking about and dealing with traditional cultural expressions as intangible heritage.

The above constitutes an interesting backdrop for exploring the paradoxes of intangible heritage. These operate in both spatial and temporal dimensions and will constitute a central space for the development of my argument. A first theme emerging is the paradoxical relationship between locality and the global, expressed in the aim of the international organisation to set up standard-setting criteria and guidelines and adopt measures that can be implemented in diverse local cultural settings around the world. As critics have underlined (Nas 2002), UNESCO safeguarding measures seem to be global measures aimed at counteracting globalisation. How is it possible then for local, site-specific and community-related expressions to be asked to meet the same global and vague criteria in the name of cultural diversity and anti-standardisation? Drawing on the above, a second paradoxical situation emerges in the contemplation of the relationship between past, present and future as conceptualised in the UNESCO standard-setting instruments. Inherent in notions of safeguarding and preserving intangible heritage is the idea of making permanent the impermanent and therefore capturing and freezing that which is meant to appear, disappear and reappear. Does a living past that is appropriated and renegotiated in the present need to be safeguarded (Kirshenblatt-Gimblett 2004)?

These paradoxes further raise the question of the role of modern technologies of heritage preservation in processes of cultural transmission and the impact that these may have on the performance of traditional practices by local communities (see De Jong 2007; Churchill 2006); central issues that are further explored in the next section of this chapter. In trying therefore to unpack these paradoxical situations, the aim of this chapter is to provide an alternative framework for rethinking intangible heritage through the politics of erasure and the creative interplay of heritage destruction and transformation (Bharucha 2000). In so doing, I bring into discussion theoretical models and parallels derived from anthropological and performance theory and further explore contemporary negotiations of intangible heritage in a multi-sited ethnography of heritage and museological practice.

MULTI-SITED ETHNOGRAPHY

The idea of conducting multi-sited ethnography in order to trace parallel negotiations of intangible heritage has been inspired by the paradoxical situations described above and the desire to explore other frameworks beyond the contours of the official global narrative. Moreover, taking forward findings from heritage and museum ethnographies that highlighted alternative ways for thinking about the practice of cultural heritage and museology (see, for example, Butler 2007

and Kreps 2003), I wanted to examine the operations of dominant models of heritage and museum practice from below and recast the intellectual and operational distance between the centre (embodied in the Headquarters of UNESCO in Paris) and the periphery. For the purposes of my doctoral research, the latter would be comprised of five museums and heritage spaces that offer critical vantage points for reviewing understandings of intangible heritage in actual heritage and museum work. These are the National Museum of New Zealand Te Papa Tongarewa in Wellington, the Vanuatu Cultural Centre in Port Villa, the National Museum of the American Indian in Washington and New York, the Horniman Museum in London and the Musée du Quai Branly in Paris (Alivizatou 2009). For the purposes of this chapter, however, I will focus here on two of these spaces: the National Museum of the American Indian in Washington and the National Museum of New Zealand Te Papa Tongarewa in Wellington.

Despite their geopolitical differences, these institutions share some common characteristics. Most importantly, they are part of modern technologies of heritage preservation in the sense that they are charged with the mission to safeguard the items in their possession. In so doing, they ascribe to the same preservationist ethos that, as I will argue shortly, has been central to the conceptualisation of UNESCO as the guardian of world heritage. Furthermore, a key characteristic of these institutions is the association between their collections and the communities from which they originate. Interestingly, the institutions that I chose to examine speak to contemporary issues of cultural diversity and intercultural exchange and dialogue, a key factor that makes their relevance to the intangible heritage debate particularly interesting. By employing ethnographic methodologies, doing participant observation in the museum spaces and interviewing members of staff I wanted to trace parallel negotiations of intangible heritage emerging in institutions that work with communities whose cultural practices are threatened by globalisation and therefore 'come within the remit' of UNESCO programmes.

The idea of 'multi-sited' ethnography developed by George Marcus (1995) has offered an insightful methodology for exploring negotiations and permutations of intangible heritage in different settings and according to different museological narratives. Starting from the official narrative of UNESCO, its operational and regional networks and multiple programmes and activities, this chapter aims to explore parallel understandings and conceptualisations of intangible heritage developing on the ground, in actual heritage practice. Before that, however, I return to the official discourse of UNESCO in order to further examine intangible heritage within the preservationist remit of the international organisation.

Reviewing the Paradoxes

Since the Intangible Heritage Section of UNESCO was set up in 1993, the international organisation has adopted different measures, instruments and programmes to help promote the cause of intangible heritage. The three most significant have been the *Living Human Treasures* initiative in 1993, the *Proclamation of Masterpieces of the Oral and Intangible Heritage of Humanity* from 1997 to 2005 and the *Convention for the Safeguarding of Intangible Heritage* in 2003. Although operating on different levels and through different mechanisms, the three projects have been taking shape along similar lines and are much informed by relevant programmes developed in the past decades in Japan and Korea. The main idea is that intangible heritage is threatened with disappearance for reasons related to, amongst other things, rapid processes of industrialisation, the movement of peoples from rural to urban settings and the abandonment of traditional

employments and practices. In a world where traditions are being lost as a result of technological developments and changing socio-political dynamics, state-sponsored measures emerge as a key tool for safeguarding those practices and in so doing preserving the world's cultural diversity. Underlying the above is the fear of cultural homogenisation that since the end of World War II has been much related to the cultural dominance of the USA.

It is largely against this backdrop that the Preamble of the 2003 Convention recognises that 'the processes of globalization and social transformation, alongside the conditions they create for renewed dialogue among communities, also give rise, as does the phenomenon of intolerance, to grave threats of deterioration, disappearance and destruction of the intangible cultural heritage, in particular owing to a lack of resources for safeguarding such heritage' (UNESCO 2003). Along similar lines, on the website of the Living Human Treasures we can read that, 'One of the biggest threats to the viability of intangible cultural heritage (ICH) is posed by declining numbers of practitioners of traditional craftsmanship, music, dance or theatre, and of those who are in position to learn from them.' (www.unesco.org/culture/ich, accessed December 2009), whilst one of the criteria for the selection of cultural expressions for the *Proclamation of Master-pieces* was that 'the form of cultural expression or cultural space will need to demonstrate … the risk of disappearing, due … to processes of rapid change, or to urbanisation or to acculturation' (UNESCO 2004).

Bound up in the threats of disappearance and loss of intangible heritage are contemporary initiatives by governments and state-sponsored organisations to protect and revitalise those endangered practices through the supply of adequate measures and resources. Set up in 1993, the international guidelines for the *Living Human Treasures* programme aimed to sensitise governments and the public to the need to support the transmission of knowledge and craft-skills from one generation to the next. Several countries, including Japan, Korea, Senegal, Nigeria and France, have endorsed this initiative and appropriated it according to the local context.

For example, in 2004 the Nigerian government, following the guidelines of UNESCO, set up its *Living Human Treasures* programme, whereby selected Nigerians 'over 50 years of age [and] possessing skills in danger of disappearing' (www.unesco.org/culture/ich, accessed December 2009) would be recognised and supported financially by the state in order to perpetuate their skills and pass them on to the younger generation. On the website of the *Living Human Treasures* in Nigeria (www.livinghumantreasures.org.ng, accessed December 2009) the profiles of artists, sculptors, traditional performers and musicians that are supported by the scheme are presented, along with plans for exhibitions, educational workshops and other revival projects. The idea here is to support the artists whose skills are endangered and in so doing perpetuate the traditional practices.

Similarly, in France the Art Crafts Council (*Conseil des Métiers d'Art*) has, every two years since 1994, awarded the title of Master of Arts (*Maître d'Art*) to specific individuals who are 'skilled professional[s]' who 'master exceptional or rare know-how'. These individuals are 'recognised by [their] peers for [their] experience and pedagogical competencies' and 'must be capable of transmitting [their] knowledge and skills to an apprentice in order to keep them alive for future generations' (www.unesco.org/culture/ich, accessed December 2009). Masters of Art are active in areas such as instrument-making, book-binding, jewellery-making, theatre, music and dance, and textile and costume fabrication (www.maitres-art.com, accessed December 2009). Interestingly, no special mention is made of the need for the practice to be threatened with disappearance. Although the programme was inspired by the Japanese *National Living Human Treasures*,

which is generally viewed as a system that prioritises the transmission of a specific practice with as little change as possible, the French Masters of Art are presented as skilled individuals who 'are devoted to the evolution of their crafts and display a spirit of innovation' (www.unesco. org/culture/ich, accessed December 2009). This last point is strikingly different from the Japanese system, in that the individual and his/her contribution to the craft are prioritised over the continuation of an unchanging practice, craft technique or ceremony.

The different ways in which member states have approached the *Living Human Treasures* guidelines point to the difficulties of applying international guidelines to different localities around the world. This was possible because *Living Human Treasures* are not recognised or proclaimed by UNESCO, but by member states which are in charge of setting criteria and providing awards and grants. Unlike the *Living Human Treasures*, the *Proclamation of Masterpieces* was a programme administered on an international level by UNESCO and it is in the context of this programme that specific international criteria had to be met and detailed action plans predicted.

As mentioned earlier, Japan has been a key player in setting up programmes for the protection of intangible heritage, much in line with the 1950 *Law for the Protection of Cultural Properties*. The 'westernisation' of Japan that had been gradually expanding since the late 19th century led post-World War II governments to take measures for the protection of 'intangible cultural properties', 'intangible folk-cultural properties' and 'conservation techniques for cultural properties' (Saito 2005). The acknowledgement therefore of particular practices and ceremonies, such as, for example, the Nogaku, Bunraku and Kabuki performing arts practices as national cultural properties, acted as a forerunner to UNESCO's *Proclamation of Masterpieces*.

Set up in 1997, the latter was not aimed at protecting and supporting individual artists or artisans, but rather at safeguarding communally created and sustained expressions, practices and traditions. By 2005, when it officially ended, the Proclamation had served its purpose. With 90 cultural expressions proclaimed as Masterpieces, it had managed to raise significant international awareness as to the need to safeguard intangible heritage and in so doing promoted and facilitated the adoption in 2003 and subsequent entry into force in 2006 of the *Convention for the Safeguarding of the Intangible Cultural Heritage*.

This Convention is today the most salient instrument defining intangible heritage and stressing the need for its preservation. In Article 2, it provides the definition of intangible heritage, according to which:

> The 'intangible cultural heritage' means the practices, representations, expressions, knowledge, skills – as well as the instruments, objects, artefacts and cultural spaces associated therewith – that communities, groups and, in some cases, individuals recognise as part of their cultural heritage. This intangible cultural heritage, transmitted from generation to generation, is constantly recreated by communities and groups in response to their environment, their interaction with nature and their history, and provides them with a sense of identity and continuity, thus promoting respect for cultural diversity and human creativity … It is manifested inter alia in the following domains:
> (a) oral traditions and expressions, including language as a vehicle of the intangible cultural heritage;
> (b) performing arts;
> (c) social practices, rituals and festive events;

(d) knowledge and practices concerning nature and the universe;
(e) traditional craftsmanship.

<div align="right">(UNESCO 2003 article 2 §1,2)</div>

It also defines 'safeguarding' as:

> measures aimed at ensuring the viability of the intangible cultural heritage, including the identification, documentation, research, preservation, protection, promotion, enhancement, transmission, particularly through formal and non-formal education, as well as the revitalization of the various aspects of such heritage. (UNESCO 2003 article 2 §3)

This is expressed in the creation of national and international inventories of intangible heritage such as the international *Representative List of the Intangible Heritage of Humanity* and the *List of Intangible Heritage in Need of Urgent Safeguarding* (UNESCO 2003 article 12, 16, 17) and the adoption of financial, legal and administrative measures such as, for example, the international fund to support safeguarding activities (UNESCO 2003 article 25). Interestingly, ideas of an endangered heritage that is threatened with loss, destruction and disappearance, as well as the establishment of international lists and inventories, are not new. As Blake (2006) has explained, the 2003 Convention is strikingly similar to 1972 World Heritage Convention, both in terms of rationale and operational measures.

For example, in the Preamble of the World Heritage Convention it is stated that 'the cultural heritage and the natural heritage are increasingly threatened with destruction not only by the traditional causes of decay, but also by changing social and economic conditions which aggravate the situation with even more formidable phenomena of damage or destruction' (UNESCO 1972) and that 'deterioration or disappearance of any item of the cultural or natural heritage constitutes a harmful impoverishment of the heritage of all the nations of the world' (ibid). To this end, the Convention further predicts the establishment of a World Heritage List (UNESCO 1972 article 11 §2) with heritage sites of 'outstanding universal value' submitted by member states and a List of World Heritage in Danger (UNESCO 1972 article 11 §4).

What emerges from the above is that the rise of heritage within the context of UNESCO conventions and programmes is very much embedded in a modern preservationist ethos. Pierre Nora's analysis of the 'sites of memory' (1989), for instance, relates the emergence of modern technologies of heritage and of the 'veneration of the trace' (Nora 1989, 13), such as archives, museums and commemorative ceremonies, to a break between the past and present: a break that took shape via processes of 19th-century industrialisation, urbanisation and new types of knowledge bound up in scientific developments and the historiographical consciousness. Such major changes not only resulted in a rupture between the past and the present but also led, according to David Lowenthal, to 'an acute sense of loss' that in turn was expressed in a modern 'rage to preserve' (1985, xxiv). Along similar lines, charting the rise of the 'authorised heritage discourse', Laurajane Smith (2006) traces the emergence of the modern heritage ethos in the UK in the work of John Ruskin and William Morris and the late 19th-century 'preserve-as-found' conservationist agenda. The aim was to establish mechanisms, tools and techniques for preserving the material vestiges of the past at a time when the rapid pace of development and industrialisation threatened them with destruction and disappearance.

This late 19th- and early 20th-century salvage ethos was further expressed in the preser-

vationist work of the first folklorists, anthropologists and ethnomusicologists, concerned with recording and documenting the languages, music and oral traditions of folk, rural or 'exotic' peoples. The salvage mission of the first field anthropologists to save and document the traditions of the Indigenous peoples of the Americas or Oceania, for instance, was a key characteristic of the work of Franz Boas in North America (Stocking 1974) and the Cambridge Anthropological Expedition in Melanesia (Herle and Rouse 1998). In the UK, Cecil Sharp's collection and documentation of English folksongs and dances (Dorson 1968) is acknowledged as a major source of cultural revival and a precursor to UNESCO's safeguarding initiatives (Boylan 2006). Similarly, Bela Bartok's documentation of Hungarian folksongs in the early 20th century at the time of the collapse of the Austrian Empire is not only a key moment in the history of ethnomusicology but also underlines a modern anxiety to return to the roots and search for a sense of collective identity and continuity in the past (Trumpener 2000).

In a sense, UNESCO's late 20th-century agendas of cultural heritage preservation are a continuation – although obviously on a more institutional and international level – of the modern 'rage to preserve' the past, tangible and intangible, and in so doing formalise the knowledge and practice of heritage preservation through science and bureaucracy. This further intensifies the paradoxical aspects of the intangible heritage discourse expressed in the wish to capture and document that which is meant to be alive and therefore constantly changing.

THE POLITICS OF ERASURE

The acknowledgement of the paradoxes inherent in the official negotiations of intangible heritage by UNESCO, the 2003 Convention and its state parties, both in terms of 'globalising the local' and 'preserving the living', underlines the need to seek alternative understandings beyond a predominantly European and North American-derived modern preservationist ethos. Moreover, two further aspects of the UNESCO discourse need more contemplation and rethinking: on the one hand, the conceptualisation of intangible heritage as endangered 'folkloric' and 'marginalised' expressions threatened with disappearance (Brown 2005, 247); and on the other, the need to set up safeguarding programmes, adopt legislative measures and compose action plans for its preservation. In what follows I examine intangible heritage beyond the 19th-century inherited salvage paradigm discussed so far. In so doing I look at the politics of erasure (Bharucha 2000) and engage with ideas of heritage destruction and transformation in order to respond to issues of contemporary changing identities, 'global melange' (Pieterse 2004) and hybrid heritage. I ultimately raise the question of whether safeguarding is the most suitable and useful backdrop against which intangible heritage should be discussed.

In the last decade the interdisciplinary field of heritage studies has offered a significant space for debating representations and appropriations of the past in the present (Fairclough *et al* 2008; Smith 2006; Butler 2006). Of particular relevance to the critical examination of intangible heritage is the ongoing dialogue about the dynamics between destruction and creation for problematising the modern preservationist ethos. A significant part of this discussion has taken place in the context of the conservation of archaeological sites and monuments. For example, the archaeologist Cornelius Holtorf has criticised the scientific canon of treating the past as a 'non-renewable resource' (2006) by arguing that 'every attempt at preserving heritage will necessarily deny the legitimacy of certain uses and engagements with that heritage' (2006, 105). For him, processes of preservation have an important impact on heritage sites and as such 'preservation is

not categorically different from destruction, as both processes transform the site in fundamental ways. A certain degree of heritage destruction and loss is not only unavoidable, but can indeed be desirable in order to accommodate fairly as many claims to that heritage as possible' (2006, 106). In a radical way he further argues that 'destruction and loss are not the opposite of heritage, but ... part of its very substance', further explaining that 'even preservation implies loss. Even destruction implies creation' (2006, 108).

Holtorf is not alone in alluding to the case of the Ise Jingu Shrine in Japan as an example of heritage transmission via destruction. Built by the Japanese imperial family to honour the sun goddess in the 6th century, the temple has been dismantled and rebuilt since AD 690 in order to allow for the wooden structure to be renewed and also for the perpetuation of the knowledge of its construction. This 'act of sacrifice' (Reynolds 2001, 317) of the temple further stresses that the preservation of the original wooden structure is not a key concern; what counts is the transmission of the knowledge of its construction. Therefore, European notions of preserving 'as found' the material remnants of the past are significantly contested and rethought.

Taking these debates forward and focusing on the 'new Asian Museum', performance theorist and practitioner Rustom Bharucha introduces the idea of the 'politics of erasure' (Bharucha 2000). Arguing that Western museological practices of preservation and archiving are not relevant in settings where 'the past is alive' (2000, 15), he envisions the 'new Asian museum' as dismantling a 'factitious past by exploring new imaginaries' (2000, 15) and drawing on 'ecological principles of erasure, renewal and impermanence' (2000, 16). For him, powerful traditional practices and ceremonies transmitted from the past and reinterpreted in the present offer an alternative framework of cultural transmission that is not embedded in documentation and preservation, but in cyclical and performative processes of creation, destruction and renewal. As an example, he refers to the annual Hindu ceremony of the Pujas in Calcutta, where clay models of Durga, Kali and Lakshmi, having been carefully crafted and worshipped for the duration of the celebrations, are then 'unceremoniously tossed into the muddy waters of the Hooghly River' (2000, 16). The destruction of the clay deities emerges as a symbol of the continuation of the ceremonies. This further suggests that modern measures of heritage preservation are not necessary for the cultural transmission of practices that are alive, perpetuated and revived through the body.

Building on the above, in what follows I take forward the examination of intangible heritage in the context of my fieldwork in the National Museum of New Zealand Te Papa Tongarewa (Te Papa) and the National Museum of the American Indian (NMAI) in order to investigate how intangible heritage is negotiated locally in contemporary heritage and museum practice. Interestingly, both of these organisations are national institutions very much concerned with both the preservation of material culture and the cultural revival and continuity of their national Indigenous heritages.

Te Papa opened in 1998 on the Wellington Waterfront and is celebrated today as the embodiment of the country's bicultural partnership between Indigenous Maori and settler Pakeha.[1] Within this framework it is run according to both Maori and Pakeha ideas and principles which become particularly evident in the bicultural management of the organisation and the bicultural interpretation of exhibitions. Here, I discovered that intangible heritage is negotiated quite

1　This is a Maori word for New Zealanders of European descent.

differently from the preservationist narrative of UNESCO. For example, a member of the Maori curatorial team acknowledged that:

> the tangible is about what you see and touch, but intangible heritage is a culture's spirituality, values, philosophy, cosmology ... and it is this part that I enjoy most in my work; dealing with that aspect; helping people discover who they are by showing to them things that they can connect to and their history ... it is all about creating and reclaiming knowledge.
>
> (Te Papa 2007)

Intangible heritage was further related in my interviews to late 20th- and 21st-century Maori cultural revival as a response to European colonisation and early assimilationist policies (Durie 1998; Tuhiwai-Smith 1999). As the same curator acknowledged, Maori traditions were 'sleeping' for the largest part of the 20th century, but over the last three decades they have been 'waking up' and are being reappropriated by contemporary generations (Te Papa 2007). In this sense, the erasure of Maori culture further expressed in early 20th-century beliefs of the Maori 'dying race' (Thomas 1999) eventually resulted in a powerful regeneration and re-appropriation of tradition. This becomes particularly evident in the ceremonial space of the Te Papa *marae* (customary meeting space) with its contemporary carvings and bicultural references. Criticised as a 'customary non-space' (Williams 2005, 85) that defies traditional Maori protocols and is used not only for Maori ceremonies but also for educational activities, singing practices and Pakeha music performances, the *marae* represents the changing face of traditions and repositions notions of cultural authenticity embedded in the official intangible heritage discourse.

In preparation since 1989, the NMAI is celebrated today as a 'living memorial' to the Native American cultures of the Western hemisphere (USA Congress 1989); communities that throughout the European colonisation of the Americas had been fought, persecuted and often violently destroyed (West 2000). Being conceived of as a 'Native Place', the NMAI on the Mall in Washington has been built in accordance with customary beliefs and knowledge systems, while the majority of the exhibitions have been planned in partnership with community elders and chosen representatives. The idea of founding a living museum meant looking beyond 19th- and early 20th-century American Indian collections and instead engaging with the contemporary reality of changing Native identity, celebrating not only the survival of Indigenous people but also the flourishing of contemporary cultures. This is clearly expressed in the interpretation of the old 'ethnographic' collections/curiosities of New York collector George Gustav Heye by contemporary Native community curators (see Blue Spruce 2004) as well as in the performances of changing identities that take place in the museum. As was acknowledged by a member of the Cultural Arts Team:

> in the East Coast, for example, there are communities that have lost their language. Because of the intensity of the contact between Europeans and Indians, they lost a lot of their cultural heritage ... They find new ways to connect to their past through contemporary creation and to reclaim their Indian heritage that was suppressed for so long. (NMAI 2007d)

The diversity of contemporary performances by Native communities emerges as a way for reconnecting with tradition and a bottom-up strategy of identity work (National Museum of the American Indian 2006a; 2006b; 2007a; 2007b; 2007c; www.nmai.si.edu). Cultural events,

workshops, programmes and performances presented at the NMAI reveal contemporary ways for engaging with Native heritage. 'Part of the mission of NMAI is to break down stereotypes that people have about what Native culture is. This is why we show things that are both traditional and more contemporary', acknowledged the same person (NMAI 2007d). As such, among the performances presented in the 2006–7 season was Shakespeare's *Macbeth*, partly performed in Tlingit by Tlingit. Tradition and modernity thus emerge as central dimensions for reclaiming and enacting Native identity at the NMAI.

It is in this context that, as was stressed in another interview, 'intangible heritage is expressed in the foundation of what this museum is. This museum is about living people … The NMAI said that we are going to let American Indians tell their own stories. We are not going to ask an anthropologist to interpret it or to filter it' (NMAI 2007e). The empowerment of Native Americans to become the tellers of their stories and to enact identity at the heart of the US government puts forward understandings of intangible heritage not as endangered and forgotten traditions but instead as practices that are renewed and reinvented by contemporary generations.

CONCLUSIONS

Research at Te Papa and the NMAI has therefore revealed an alternative framework for thinking about intangible heritage. An emerging theme is that intangible heritage is negotiated not within the discourse of preservation and endangered traditions that characterises the often paradoxical heritage plans and safeguarding programmes of state-parties to the 2003 Convention but rather as a past that is revived and reappropriated by contemporary generations. Interestingly, my interviewees, museum professionals and heritage activists working with Indigenous groups and communities, negotiate intangible heritage beyond ideas of preservation, inventories and other safeguarding measures. What seems to be of importance is the creative engagement with the past in a present; a past that is manifested in cultural practices and revived traditions that reflect contemporary identities.

Against this backdrop, the politics of erasure and transformation offer a critical framework for rethinking intangible heritage outside the salvage paradigm of institutional measures. The loss of Indigenous languages, traditional beliefs and life systems tied up with the colonisation of North America and New Zealand by Europeans is negotiated today as a factor that has led to the contemporary revival of traditional practices. Rather than defining intangible heritage as pre-colonial traditions that need to be archived and documented, contemporary heritage-work offers more fluid and nuanced understandings as practices that are inherited from the past, but significantly reworked and renewed in the present. This then suggests that alternative processes of cultural transmission bound up in ecological principles of erasure, impermanence and renewal enable a closer interaction between past and present (see Brown 2005). Intangible heritage emerges therefore not as the subject of archives that needs to be written down and preserved for an indefinite future but rather as cultural practices that are renegotiated by practising communities. Although, as mentioned earlier, the 2003 Convention recognises that intangible heritage is 'constantly recreated' (UNESCO 2003 article 2), the strong emphasis on safeguarding through inventory identification and national and international list-making places it in the context of cultural preservation that leaves little room for change and adaptation. The challenge for UNESCO will be to engage in new ways of thinking and working around intan-

gible heritage as a living process that is not comprised of forgotten or abandoned practices but reflective of contemporary complex and changing identities.

ACKNOWLEDGMENTS

My thanks go to the Scholarships Foundation of Greece for funding my doctoral studies at University College London and to the University of London Central Research Fund, the Graduate School of University College London and the Institute of Archaeology for funding my fieldwork in Wellington and Washington.

BIBLIOGRAPHY AND REFERENCES

Aikawa, N, 2004 An Historical Overview of the Preparation of the UNESCO International Convention for the Safeguarding of the Intangible Cultural Heritage, *Museum International* 56, 137–49

Alivizatou, M, 2007 The UNESCO Programme for the Proclamation of Masterpieces of the Oral and Intangible Heritage of Humanity: A Critical Examination, *Journal of Museum Ethnography* 19, 34–42

—— 2008 Contextualising Intangible Cultural Heritage in Heritage Studies and Museology, *International Journal of Intangible Heritage* 3, 42–54

—— 2009 Preservation, Erasure and Representation: Rethinking Intangible Heritage in a Comparative Museum Ethnography, unpublished PhD thesis, University College London

Bharucha, R, 2000 Beyond the Box: Problematising The 'New Asian Museum', *Third Text* 52, 11–19

Blue Spruce, D (ed), 2004 *Spirit of a Native Place: Building the National Museum of the American Indian*, National Museum of the American Indian, Smithsonian Institution; National Geographic, Washington, DC

Boylan, P, 2006 The Intangible Heritage: A Challenge for Museums and Museum Professional Training, *International Journal of Intangible Heritage* 1, 54–65

Brown, M F, 2005 Heritage Trouble: Recent Work on the Protection of Intangible Cultural Property, *International Journal of Cultural Property* 12 (1), 40–61

Butler, B, 2006 Heritage and the Present Past, in *Handbook of Material Culture* (eds C Tilley, W Keane, S Kuechler-Fogden, M Rowlands and P Spyer), Sage Publications, London, 463–79

—— 2007 *Return to Alexandria: An Ethnography of Cultural Heritage Revivalism and Museum Memory*, Left Coast Press, Walnut Creek, CA

Churchill, N, 2006 Dignifying Carnival: The Politics of Heritage Recognition in Puebla, Mexico, *International Journal of Cultural Property* 13, 1–24

Cleere, H, 1995 Cultural Landscapes as World Heritage, *Conservation and Management of Archaeological Sites* 1, 63–8

—— 2001 Uneasy Bedfellows: Universality and Cultural Heritage, in *Destruction and Conservation of Cultural Property* (eds R Layton, P Stone and J Thomas), Routledge, London, 22–9

Conseil des Métiers d'Art, Maitres d'Art, n.d. available from: www.maitres-art.com [December 2009]

De Jong, F, 2007 A Masterpiece of Masquerading: Contradictions of Conservation in Intangible Heritage, in *Reclaiming Heritage: Alternative Imaginaries of Memory in West Africa* (eds F De Jong and M Rowlands), Left Coast Press, Walnut Creek, CA, 161–84

Dorson, R M, 1968 *The British Folklorists: A History*, University of Chicago Press, Chicago

Durie, M, 1998 *Te Mana Te Kawanatanga: The Politics of Maori Self-Determination*, Oxford University Press, Auckland and Oxford

Fairclough, G J, Harrison, R, Schofield, J, and Jameson, J H (eds), 2008 *The Heritage Reader*, Routledge, London

Hafstein, V, 2004 The Making of Intangible Cultural Heritage: Tradition and Authenticity, Community and Humanity, unpublished PhD thesis, University of California, Berkeley

Herle, A, and Rouse, A (eds), 1998 *Cambridge and the Torres Strait: Centenary Essays on the 1898 Anthropological Expedition*, Cambridge University Press, Cambridge

Holtorf, C, 2006 Can Less Be More? Heritage in the Age of Terrorism, *Public Archaeology* 5 (2), 101–10

Ingold, T (ed), 1996 *Key Debates in Anthropology* (Debate: Is the Past a Foreign Country?), Routledge, London, 201–48

Kirshenblatt-Gimblett, B, 2004 Intangible Heritage as a Metacultural Production, *Museum International* 56, 52–65

Kreps, C, 2003 *Liberating Culture: Cross-Cultural Perspectives on Museums, Curation and Heritage Preservation*, Routledge, London and New York

Levi-Strauss, C, 1961 *Race et Histoire*, UNESCO, Paris

Living Human Treasures in Nigeria, n.d. available from: www.livinghumantreasures.org.ng [December 2009]

Lowenthal, D, 1985 *The Past is a Foreign Country*, Cambridge University Press, Cambridge

Marcus, G E, 1995 Ethnography In/Of the World System: The Emergence of Multi-Sited Ethnography, *Annual Review of Anthropology* 24, 95–117

Nas, P, 2002 Masterpieces of Oral and Intangible Culture: Reflections on the UNESCO World Heritage List, *Current Anthropology* 43 (1), 139–43

National Museum of the American Indian, 2006a *Summer Calendar: June, July and August 2007 Museum Programs*

—— 2006b *Fall Calendar: September, October and November 2007 Museum Programs*

—— 2007a *Winter Calendar: December 2006, January and February 2007 Museum Programs*

—— 2007b *Spring Calendar: March, April and May 2007 Museum Programs*

—— 2007c *Fall Calendar: September, October, November 2007 Museum Programs*

—— 2007d Personal communication (interview conducted by the author), 15 May, National Museum of the American Indian, Washington

—— 2007e Personal communication (interview conducted by the author), 16 May, National Museum of the American Indian, Washington

—— n.d. available from: www.nmai.si.edu [December 2009]

Nora, P, 1989 Between Memory and History: Les Lieux de Memoire, *Representations* (Special Issue: *Memory and Counter-Memory*) 26, 7–24

Pieterse, J N, 2004 *Globalization and Culture: Global Melange*, Rowman & Littlefield Publishers, Maryland

Reynolds, J M, 2001 Ise Shrine and a Modernist Construction of Japanese Tradition, *The Art Bulletin* 83 (2), 316–41

Saito, H, 2005 Protection of Intangible Cultural Heritage in Japan, in *Sub-regional Experts Meeting in*

Asia on Intangible Cultural Heritage: Safeguarding and Inventory Making Methodologies, Bangkok, Thailand, December 13–15, 1–14

Sherkin, S, 2001 A Historical Study on the Preparation of the 1989 Recommendation on the Safeguarding of Traditional Culture and Folklore, in *Safeguarding Traditional Culture: A Global Assessment* (ed P Seitel), UNESCO/Center for Folklife and Cultural Heritage, Smithsonian Institution, Washington, 42–56

Smith, L, 2006 *Uses of Heritage*, Routledge, London and New York

Stocking, G W (ed), 1974 *The Shaping of American Anthropology 1883–1911: A Franz Boas Reader*, Basic Books, New York

Te Papa, 2007 Personal communication (interview conducted by the author), 12 April, National Museum of New Zealand Te Papa Tongarewa, Wellington

Thomas, N, 1999 *Possessions: Indigenous Art/Colonial Culture*, Thames and Hudson, London

Trumpener, K, 2000 Bela Bartok and the Rise of Comparative Ethnomusicology: Nationalism, Race Purity and the Legacy of the Austro-Hungarian Empire, in *Music and the Racial Imagination* (eds M R Radano and P V Bohlman), University of Chicago Press, Chicago, 459–82

Tuhiwai Smith, L, 1999 *Decolonizing Methodologies: Research and Indigenous Peoples*, Zed Books, London and New York; University of Otago Press, Dunedin

UNESCO, 1972 *Convention Concerning the Protection of the World Cultural and Natural Heritage*, available from: http://whc.unesco.org/en/conventiontext/ [12 October 2010]

—— 2003 *Convention for the Safeguarding of the Intangible Cultural Heritage*, available from: http://portal.unesco.org/en/ev.php-URL_ID=17716&URL_DO=DO_TOPIC&URL_SECTION=201.html [12 October 2010]

—— 2004 *Second Proclamation of Masterpieces of the Oral and Intangible Heritage of Humanity*, UNESCO, Paris

—— n.d. UNESCO Intangible Heritage, available from: www.unesco.org/culture/ich [December 2009]

USA Congress, 1989 *National Museum of the American Indian Act*

West, R (ed), 2000 *The Changing Presentation of the American Indian: Museums and Native Cultures*, National Museum of the American Indian; University of Washington Press, Washington, DC and London

Williams, P, 2005 A Breach on the Beach: Te Papa and the Fraying of Biculturalism, *Museum and Society* 3 (2), 81–97

Yim, D, 2004 Living Human Treasures and the Protection of Intangible Cultural Heritage: Experiences and Challenges, *ICOM News* 57 (4), 10–12

Memory, Museums and the Making of Meaning: A Caribbean Perspective

ALISSANDRA CUMMINS

The Caribbean historian Dr Philip Sherlock posited that 'There is no country called the West Indies ... History and geography have combined in the Caribbean to make an island the symbol of national identity, a country whose frontiers were clearly marked out by the shoreline' (Sherlock 1966, 7). The eponymous 1959 Federation Day Exhibition on Aspects of the History of the West Indies, designed by Dr Elsa Goveia, a young advocate/historian based at the department of history on the Mona campus of the University of the West Indies, was therefore expressly concerned to demonstrate the valid historical basis upon which a 'Caribbean' community and identity could be constructed out of the shared experience of historical dislocation, deculturation and disempowerment. She consciously sought opportunities to address public knowledge about issues of community and identity and, in her extensive Introduction to the 1959 exhibit, Goveia initiated the first consciously Anglophone Caribbean attempt at historical reconstruction as a form of identity-creation. In a seminal reinterpretation and restatement of the history of the British West Indies, Goveia recognised the opportunity this process provided to address the disenfranchisement which she saw had compromised the identity of generations within the region which they inhabited. She proposed that in order to achieve a greater degree of control after centuries of subordination to Great Britain:

> It is therefore important to ask what this nation is. If it includes all the people of the Federation, the national government is the government of the Federation ... Changes of government will be meaningless until we have settled the fundamental problem of our national identity. In the earlier struggle for our political rights, it was perhaps enough to be anti-British. Now that we face Independence and the immense problems which it will bring, it has become absolutely essential that we should know whether we are West Indians. (Goveia 1959, 40)

At a moment when the Caribbean region was embarking on a modern evolution of an independence movement, its museums were assessed and found lacking. In Barbados, a 1953 letter to the Director/Curator Mr Neville Connell from its patron Lady Gilbert Carter sheds some light on the phenomenon. In referring to her arrangements for the disposition of her collections after her death, she noted that:

> Sir Alfred Savage wrote that Nigeria was starting a new museum & they would like to have Sir Gilbert's [African] Collection (in the front hall of Ilaro). Now in my will I left it to the Barbados Museum, but I feel sure the Historical Society will waive this & let it go to Nigeria as it came from there, ... I sort of thought that Mr Shilstone [President of the Society] was not anxious

to have it – he rightly stressed the idea that the Arawaks were the only *heathens* which should interest the coloured people in Barbados & that they should be encouraged to <u>forget</u> that they were brought over from there against their will. [my italics]

(Lady Gilbert Carter, 15 January 1953)[1]

In Jamaica, the American human rights activist William Patterson's article in the *Sunday Gleaner* of April 1957 indicated that the Barbados Museum was not alone in the distinct disregard for depicting significant aspects of the community's historical experience. The writer posited that:

If you ask the average passer-by where to find authentic stories of those historical events which blazed the path to the ending of slavery in Jamaica he or she will invariably answer 'Go to the Institute. It is our cultural centre and fills the cultural needs of Jamaicans'. But ... the cultural needs of such a variegated community must be regarded with great objectivity. The question arises ... whose culture and for whom? Distortions of the cultural background of a people can have grave psychological effects upon its youth, a degrading and dehumanising effect.

(Patterson 1957)

The writer then goes on to analyse the Institute's exhibits against this criterion:

The Institute may be for the white Jamaican, for the Englishman and the American, all that it is said to be – a cultural centre satisfying to their needs ... The black man has a place in the Institute of Jamaica as a slave, as a freed man who is a faithful servant for the economic rulers, as a subordinate to his technical advisers, as a backward and subservient figure. His culture is presented to him in terms of what those who rule think best for themselves ... An institute that is a cultural centre for Jamaica should blazen the walls with the struggles of men who valued freedom more than life. Freedom and Culture are inseparable. Here lie the roots of Jamaican culture. In this respect the Institute is a complete failure. (Patterson 1957)

While the museum at the time generally validated the 'absence of meaning' in terms of the human experience of generations of West Indians, Elsa Goveia essentially employed the same tools/the mechanism of an exhibit and informed interpretation to reveal or reconstruct hidden or forgotten aspects of West Indian identity, and referenced historical evidence as the means by which to recover identity.

This sense, this knowledge, depends upon the evidence we have of what the past looked like ... to judge the accuracy of evidence from the past, it must be compared with other evidence ... if this evidence is lost ... our knowledge of the past is likely to be incomplete and inaccurate Without evidence ... there is no history. Through history, we can know the past, and know ourselves by knowing how we have come to be what we are. (Goveia 1959, 41–2)

In effect Goveia was addressing one of the most critical elements of the museum concept, the

1 Lady Gilbert Carter, the former Governor's wife - personal correspondence to Director Neville Connell, Jan 15, 1953, Collection Archives, Barbados Museum and Historical Society.

intangible heritage of the colonial museum model as an *institution of globalisation* when transferred onto West Indian soil, probably the most successful European export in cultural globalisation prior to the 20th century. The postcolonialist Walter Mignolo has argued that:

> we must remember that at the same time that Europe accumulated money through the extraction of gold and silver in the sixteenth century, and through the exploitation of the Caribbean plantations and the massive slave trade in the seventeenth century, Europe also accumulated meaning. Museums and universities were and continue to be two crucial institutions for the accumulation of meaning and the reproduction of the coloniality of knowledge and of beings…. That is what I mean by the colonization of being. Slavery in the sixteenth century was another form of colonizing beings… (Mignolo 2005, 1)

He argues that given 'the parallels and complicities between the accumulation of money and the accumulation of meaning in the modern/colonial world', 'One of the tasks before us is to engage in de-colonial projects, learning to unlearn the principles that justified Museums and Universities, and to formulate a new horizon of understanding … [so that] de-colonization of the Museum shall take place both in scholarship and in Museum exhibits and performances' (Mignolo 2005, 1–2). Goveia's exercise in explicit reinterpreting of West Indian history through the Federation Day exhibition was a significant initiative in the decolonial enterprise but it took another fifteen years before such a process of counter-curatorship was ever engaged and then only in, arguably, the peripheral areas of Jamaican heritage outside the scope of mainstream museum endeavour.

Benedict Anderson has identified the museum as one of the three institutions of power that changed their form and function as the colonised zones and 'profoundly shaped the way in which the colonial state imagined its dominion – the nature of the human beings it ruled, the geography of its domain, and the legitimacy of its ancestry' (Anderson 1983, 163–4). Anderson stressed that 'museums and the museumizing imagination … are both profoundly political' (Anderson 1983, 178) at such a deep level that where 'colonial regimes began attaching themselves to antiquity as much as conquest' they engineered or engendered a process which essentially declared contemporary natives 'incapable of either greatness or self-rule', allowing the creation of what Anderson calls 'alternate legitimacies' (Anderson 1983, 181) which 'owed much to the colonial state's peculiar imagining of history and power' (Anderson 1983, 185). The question for me is to what extent has the intangible heritage of these 'alternate legitimacies', which invested most of the national museums established before independence and for some decades after, really been fully recognised, examined, comprehended and communicated, enabling 21st-century Caribbean communities to reconstruct (or deconstruct) such a ruptured past, such a fragmented history, on their own terms? Anderson has argued that:

> nationality, or, as one might prefer to put it in view of that word's multiple signfications, nation-ness, as well as nationalism, are cultural artifacts of a particular kind. To understand them properly we need to consider carefully how they have come into historical being, in what ways their meanings have changed over time, and why, today, they command such profound emotional legitimacy. (Anderson 1983, 4)

If, as Sharon Macdonald has suggested, the act of 'just having a museum' was itself a 'performative

utterance of having an identity' (Macdonald 2003, 3) then the 'memory' of the museum itself as a legitimising entity is a critical factor in the engagement between coloniality and community, nationality and identity, recognition and repudiation which has consumed both the political and cultural discourse of the region and the role which museums have or have not played, or can or cannot play within and throughout the evolving challenge of the post-colonial discourse. National identity forms an essential part of both a subconscious and, much later, conscious debate on the core mission and role of museums.

The heritage of the Caribbean is not so much valued therefore for the tangible remains and artefacts which litter the galleries, corridors and basements of so many European museums, but rather is a shared, lived, defining (intangible) experience of Indigenous extirpation, slavery, migration, indenture, plantations and colonial control stretching over a period of some 500 years. It is this shared human heritage of our historical experience which so invests the Caribbean memory and inhabits the Caribbean consciousness as to define who we are as a people. The concept of a unified region, society or community is an artificial construct particularised around the administrative boundaries that the colonial powers designed for the convenience of governing; indeed, the Caribbean contains the oldest European colonies. Even as a geographical expression, the Caribbean is a very imprecise place that is difficult to define.[2]

Caribbean peoples are largely new arrivals who have had to reconstruct their identities, having lost (or been deliberately separated from) most of what they owned in the transmigration from the Old World. In essence it is a region where (virtually) everyone came from (virtually) everywhere else, whether voluntarily or by force. As the Caribbean Nobel Laureate Derek Walcott has suggested:

> That is the basis of the Antillean experience, this shipwreck of fragments, these echoes, these shards of a huge tribal vocabulary, these partially remembered customs. They survived the Middle Passage ... separated from their Old World roots even though cultural residues persist in one form or the other. (Walcott 1993, 5)

Identity had to be established. Homeland had to be reinvented. Homeland requires territory to start with before it is transformed into a moral architecture of the mind and memory. Into these new insular spaces, narratives and myths would be infused with memories constructed out of the recent painful past and attached to the land rendering it sacred and historical. Walcott again:

> This gathering of broken pieces is the care and pain of the Antilles, and if the pieces are disparate, ill-fitting, they contain more pain than their original sculpture, those icons and sacred vessels taken for granted in their ancestral places. Antillean art is this restoration of our shattered histories, our shards of vocabulary, our archipelago becoming a synonym for pieces broken off from the original continent. (Walcott 1993, 90)

2 For a more detailed analysis of the various and multifaceted issues surrounding the construction of Caribbean identity the following sources are particularly invaluable: Michel-Rolph Trouillot, 1992 'The Caribbean Region: An Open Frontier in Anthropological Theory', *Annual Review of Anthropology* 21; David Lowenthal, 1972 *West Indian Societies*, Oxford University Press, Oxford; and Benedict Anderson, 1983 (2006 revised edition) *Imagined Communities*, Verso Publications, London.

In this cultural construction of a common Caribbean consciousness, a shared memory of slavery, indenture, plantations and colonial oppression is assigned a distinctive role in the evolution of the contemporary Caribbean self.

The cultural theorist Stuart Hall has posited that 'what the nation "means" is an on-going project, under constant reconstruction' and that 'we come to know its meaning partly through the objects and artefacts which have been made to stand for and symbolize its essential values' (Hall 2000, 5). But objects or tangible heritage, I want to emphasise, only partly address that equation. It is the 'intangible' heritage of human experience as well as the 'memory' of the institution's core values which need to be given equal weight. In looking at the question of museums, memory and the making of meaning then it is necessary to know and understand the ideas, motives and attitudes behind what was and was not collected and exhibited in Caribbean museums from their inception, and what was validated as parts of nationally constructed identities, providing a succinct distillation of collectively authorised memory. I want to suggest that embracing the importance and value of intangible heritage as something which individuals and communities bear within them both consciously and subconsciously correlates with Hall's thesis that 'the Heritage' is:

> a discursive practice … one of the ways in which the nation slowly constructs for itself a sort of collective social memory. Just as individuals and families construct their identities in part by 'storying' the various random incidents and contingent turning points of their lives into a single, coherent, narrative so nations construct identities by selectively binding their chosen high points and memorable achievements into an unfolding 'national story'. (Hall 2000, 5)

Caribbean nations as 'constructed' communities largely made up of 'an imported people in an imported environment' remained vulnerable to the fragmented nature of their national identity (Parry and Sherlock 1963, 10). Where the majority signifiers of Caribbean identity, whether cultural or national, cannot be reflected through the material culture or physical heritage alone, the foundation and bias of most museums, but is perhaps most strongly expressed in the intangible – essentially the orality, transience, rhythm and vibrancy which overlays Caribbean cultures.

Such negotiation of space, time and context must be handled carefully, and in so doing it must be ensured that there is no romanticisation of the past or the contemporary, but instead a conscious discourse on the context that has formed these nation states and their contingent identities. Confronted with issues of interpretation, relevance to the communities they serve and the 'democracy' inherent in the creation of the exhibits, the cultural historian Jeanne Cannizzo states that museums are 'negotiated realities' reflecting the fears and aspirations of those that create them (Cannizzo 1987). Museums and galleries in the Caribbean as elsewhere have relied largely on their collections to frame the interpretation of the exhibits which the viewer will experience. However, within this current discourse around museums, memory and the making of meaning, it is necessary to know and understand the ideas, motives and attitudes behind what was and was not collected and exhibited in Caribbean museums and galleries from their inception, and perhaps most importantly, why. I am concerned with the way that understandings of the 'past' are both produced and authenticated through regional museums, and with the types of historical narratives that are constructed in this process. I am also interested in the distillation and dissemination of the presence and meanings of the 'past' in the Caribbean and elsewhere; in 'breaking the silence', as it were.

In his discussion on how the current global westernised hegemony treats specific historical events, events chosen for their relevance to the text of Western dominance, the Haitian anthropologist Michel-Rolph Trouillot has directly addressed these silences, which he indicates are 'inherent in the creation of sources, the first moment of historical production' (Trouillot 1995, 51). People and places that are designated 'Third World' find their history 'disappeared', as the West (Europe and North America) chooses which historical events fit into its worldview of righteous dominance. He references complex historiographical occurrences of this process of historical production: for example, the accidental 'discovery' of America and its attendant sordid details went unheralded in its own time. Yet, the story of the conquest of the New World demanded a date, so 12 October 1492 became a historical beacon. On the other hand, the only successful revolt against enslavement in history, which led to Haitian independence in 1804, has hardly registered in the Western consciousness. In its time, this cataclysmic event was recognised as a serious threat to the institution of slavery in the New World. Haiti has paid the price for its self-liberation ever since, in ostracism as a Black and poor society, in a sense 'disappeared'. After all, wasn't it the beneficent whites who eventually freed the slaves? Trouillot has posited that 'Slavery here is a ghost, both the past and a living presence; and the problem of historical representation is how to represent that ghost, something that is and yet is not ... Fragments of historical narratives point to gaps yet to be filled' (Trouillot 1995, 147).

The promotion of the 2003 *Convention on the Safeguarding of the Intangible Cultural Heritage*, therefore, has the potential to encourage understanding about other non-object-oriented means of conveying histories and interpreting cultures, and crucially acknowledging finally the indelible link between human rights and human heritage 'as a foundation of identity, a vector for development and a tool for dialogue, reconciliation and social cohesion' (UNESCO 2008, 140). UNESCO's recognition of the role of museums as 'sites for the production of, access to and dissemination of knowledge and culture, and as vectors of social cohesion and human and economic development' establishes the critical conjunction of both public knowledge and professional intent (UNESCO 2008, 141). Museums and communities must together seek to reconstruct/make visible that earlier world without borders, telling a story that often remains unseen/unspoken (and thus sharing in the conspiracy of silence which often surrounds it) but which has essentially constructed our view not only of each other but of ourselves. It is necessary to confront if we are together to reclaim a shared identity, and in so doing help to constitute a world without borders. In my view, given the essentially fragmentary nature of Caribbean culture/identity, the intangible heritage perhaps best elides with our notions of valid expressions of Caribbean history, identity and culture. Contemporary Caribbean curatorship requires that museums contend directly with how to represent the silences, absences and dislocations which so frequently prescribe the historical and modern day experience.

'*White Skin, Black Kin: Speaking the Unspeakable*', an interactive multimedia intervention by the artist Joscelyn Gardner, installed in 2004 in four of the Barbados Museum's galleries, explored areas of conflict and confluence in the lives of Creole women, and their shared experiences within the patriarchal plantation society of Barbados. It was the first of its kind in Barbados, inviting the audience to 'participate' in a unique three-way 'conversation' between/amongst Barbadian art, heritage and identity. As Gabrielle Hezekiah writes:

> Joscelyn Gardner's *White Skin, Black Kin* is an exploration of identity, relation, sameness and difference in colonial and postcolonial Barbados. It is an attempt to 'get at' the lived experiences

of connection and overlap, violence and creation which underlie relations in this creolized space. *White Skin, Black Kin* is also an exploration of the gaps and silences in narratives of race and nation. It restores and recuperates these gaps … (Hezekiah 2004, 15)

When such opportunities do not exist, however, given the distance of time between the end of slavery and the beginning of independence, how can this absence of experience be addressed? The parallels between the role of the artist in 'storying individual memory' and that of the museum in 'constructing collective identity' become clear. As the 'museumist artist' Fred Wilson has stated, traditional 'Ethnographic displays create a distance between cultures that doesn't need to be there. This difference cuts off any connections and flattens out the complexity of our relationship in favour of exoticism' (Wilson quoted in Garfield 1993, 48).

Both the context of the installation (multiple spaces, multiple layers, multiple levels) and the multimedia nature of the exhibition require that the viewer pay attention simultaneously to a multiplicity and layering of sounds and images. The insertion and juxtaposition of objects and images allude to, as well as re-invent, a complex national identity, embedded in a deliberate insistence on the invisibility and the absence of the 'other'. Barbadian national culture ('here' and 'there') has primarily defined itself not only by what it is, but – even more importantly – by what it is not. This perception extends from the colonial convention of identifying as 'creole' any individual – African or English – born on the island. But the shared identity implied by the name did not extend simply to a shared, but rather a mirrored, experience: Black/White; Rich/Poor; Present/Absent. The artist has sought to reveal this denial and unveil a past which has remained voiceless, invisible in a national, political, cultural, gendered, sexualised and racialised context.

The use of sound and new technologies as a medium for heritage interpretation was similarly used in 2007 in another project in which Barbadians investigated, interrogated and interpreted life (both historic and current) in the city of Bridgetown. The installation of <Bridgetown> *whisperpost* into the streets of the city (and the later transmission of these works to digital storage and website) heralded the 'recovery' of disappearing intangible heritage. Sound archives are critical as a means of constructing/reconstructing Caribbean identity, because for a dispossessed and disinherited diasporic people it is often only through sound, oratory and music that we can weave our memories and truly celebrate our culture.

Inspired by various location-specific new media projects that have sprung up in cities such as Los Angeles, New York, Toronto and Vancouver, as well as by map-based sound projects that are currently appearing on the web, no such project had been undertaken in the Caribbean, where layers of history lie buried in the silt and sands of coastal seaports, the rubble of colonial invasion and, more recently, in the concrete and marble of neo-colonial expansion. One of the objectives of this project has also been to explore both the factual and fictive layers of the city of Bridgetown and to fold the past and present into a montage of creative soundscapes which loosely 'narrate' a (hi)story of place and space and help establish the collective history of a city's inhabitants; <Bridgetown> *whisperpost* compresses history into a semantically dense iconic simultaneity with the past pressed up against the present in such a way that history is conflated. This juxtaposition of fragments of the past and present alongside the day-to-day flurry of city life collapses space and time and helps to unravel place as a site of remembrance for the people who live or work there.

In a similar genre, the Barbados Museum hosted artist-in-residence Ingrid Persaud for almost six months, a period which culminated in her May/June 2008 exhibition '*You go down the ladder, I'll Shine the Torch*'. This provided another opportunity in which a contemporary artist

collaborated with the Museum to interrogate traditional museological practice. As Persaud has explained, 'the themes of loss, memory and death that pervade archives are not allowed to over-whelm the space with sadness. Indeed much of the rest of the work use the devices of humour and play to explore these difficult issues …' (Persaud 2008, 108). These constructed identities need to be recognised in museums acting as authorising agents of authentic histories. The manner in which these relationships shaped notions which entered 19th- and 20th-century philosophy, and created an effect which was by no means gratuitous or accidental, therefore needs to be deconstructed and decoded just as deliberately.

More recently, in August 2008, Sonia Boyce's two-screen video installation entitled 'Crop-Over', accompanied by photographs by William Cummins, temporarily replaced the Museum's permanent art exhibition in the Cunard Gallery. As the art historian Allison Thompson has written, 'It samples a wide range of related performances, some real and some staged by the artist. The result is a pseudo-documentary, pseudo-pantomime collage of events that subtly reveals the multiple dimensions of this creolized spectacle' (Thompson 2009, 148). She further observes that 'Boyce's video interjects the scholarly commentary of cultural historians into scenes of popular and traditional culture, deliberately building up layers of interpretation and presentation that seek to identify and historicize these cultural icons but also to problematize them' (ibid). In fact, the quasi-total absence of Carnival within contemporary Caribbean museum exhibitions is matched by its near oblivion from historical and critical art discourses. The Kingston-based art critic Annie Paul has written as part of her closing remarks in a recent essay:

> Caribbean visual art cannot model itself on narrow modernist concepts and tropes without risking extinction. The region's *vernacular moderns* are self-representing subjects who demand engagement on their own terms, cultural citizens combining oral tradition with technological dexterity … Visual art has much to learn from this vibrant region where *sound* sculpts new, unimagined communities from people once treated as property. [my italics] (Paul 2007, 32)

In fact, given the importance of 'the many musical genres of the region – salsa, reggae, soca, dancehall, reggaeton, and others', which, according to Paul 'have shown the way, creating alter-native universal registers unforeseen by traditional modernism', the curating of Carnival or the festival arts should be at the core of the museum exhibition's discourse and display, but remains instead largely artificial and anthropological practice (Paul 2007, 32). Such a silence and absence of the 'performative' dimension of Caribbean heritage in many museums does not recognise the carnival state as a truly Caribbean lifestyle, language and lexicography. In fact playing 'mas', masquerade or carnival is functionally the real 'alternate legitimacy', both in the region's historical past and in its modernity, a fact which clearly reveals the fault lines in curatorial practice, with its focus on traditional media, when paradoxically the format of the exhibition space might lend itself to an expansion of this aspect of regional intangible heritage but instead often inher-ently sublimates the aspiration of Caribbean people to the assumed legitimacy of professional practice. Indeed, it is comprehension of the 'Carnival' state as peculiar to the religiosity of being 'in the spirit', as central to identity and existence, which has the potential for experimentation and re-affirmation of a former footnote to the exhibition's grand narrative. The Museum thus becomes an active site for contestation and communication of histories, memories and identities. 'Spectatorship' actually requires that we actively participate and take a position about what we are seeing. As the humanist art critic John Berger has suggested, seeing is not a passive activity.

'We never look at just one thing; we are always looking at the relation between things and ourselves' (Berger 1990, 9). From my perspective curatorship requires our appreciation of the 'space' between things and ourselves to be recognised. 'Heritage', as David Lowenthal insists, fabricates or 'reshapes the past ... it attests our identity and affirms our worth' (Lowenthal 1998, 4). In so saying he asserts that heritage is essentially a performative act and the tools we use in this process of authentication or validation must respond to the 'need to own our own heritage' (ibid).

BIBLIOGRAPHY AND REFERENCES

Anderson, B, 1983 (2006) *Imagined Communities: Reflections on the Origin and Spread of Nationalism*, Verso Publications, London

Berger, J, 1990 *Ways of Seeing*, Penguin, Harmondsworth

Cannizzo, J, 1987 How Sweet It Is: Cultural Politics in Barbados, in *MUSE* Ottawa IV (4), Winter/January 1987, 22–32

Garfield, D, 1993 Making the Museum Mine: an Interview with Fred Wilson, *Museum News*, May/June, 47–9, 90

Goveia, E, 1959 An Introduction to the Federation Day Exhibition on Aspects of British West Indian History, unpublished document

Hall, S, 2000 Whose Heritage? Un-settling 'The Heritage', Re-imagining the Post-Nation, keynote address given at the national conference *Whose Heritage? The impact of Cultural Diversity on Britain's Living Heritage*, 1 November 1999, Manchester, England, *Third Text* 49, Winter 1999–2000

Hezekiah, G, 2004 'Of Whispers and Traces', in Joscelyn Gardner's White Skin, Black Kin: 'Speaking the Unspeakable', *The Barbados Museum and Historical Society*, February, 15–17

Lowenthal, D, 1998 Fabricating History, *History & Memory* 10 (1)

Macdonald, S, 2003 Museums, national, postnational and transcultural identities, *Museum and Society* 1 (1), 1–16

Mignolo, W D, 2005 *Museums in the Colonial Horizon of Modernity*, in *Proceedings of the Annual CIMAM Conference 2005 (International Association of Museums of Modern Art)* (ed Board of CIMAM), in CD-ROM, vol CD-ROM (2006), Museum of Modern Art, Barcelona (last updated on 26 December 2006)

Parry, J H, and Sherlock, P M, 1963 Introduction, in *A Short History of the West Indies*, Macmillan, London

Patterson, W L, 1957 The Role of the Institute as ... Jamaica's Cultural Centre, *The Sunday Gleaner*, 21 April, n.p.

Paul, A, 2007 Visualizing Art in the Caribbean, in *Infinite Island: Contemporary Caribbean Art*, Brooklyn Museum of Art

Persaud, I, 2008 webblog, available from: http://ingridpersaudexhibit.blogspot.com [25 November 2008], quoted in Alissandra Cummins, What kind of Mirror Image? The Growth and Development of the Fine art Collection, *Journal of the Barbados Museum and Historical Society* LIV

Sherlock, P, 1966 *West Indies*, Thames and Hudson, London

Thompson, A, 2009 Sonia Boyce and Cropover, in *Small Axe* 29, July, 148–63

Trouillot, M-R, 1995 *Silencing the Past: Power and the Production of History*, Beacon Press, Boston

UNESCO, 2008 *Part II A Major Programme IV Culture in Approved Programme and Budget 2008–2009 (34C/5 Approved)*, Paris

Walcott, D, 1993 *The Antilles: Fragments of Epic Memory*, Farrar, Straus, and Giroux, New York

From Intangible Expression to Digital Cultural Heritage

KATE HENNESSY

INTRODUCTION

In an article titled *Oral Tradition and Material Culture: Multiplying Meanings of 'Words' and 'Things'* (1992), anthropologist Julie Cruikshank explored a series of parallel issues of cultural representation in anthropology and museums. In a departure from established disciplinary approaches that had treated the analysis of oral tradition and material culture as separate fields of study, Cruikshank detailed some historical parallels between the collection, interpretation and exhibition of words and things: 'both were originally treated as *objects* to be collected; then attention shifted to viewing words and things in *context*; recently they have been discussed as aspects of cultural *performance*, just as now they are often referred to as cultural *symbols* or as cultural *property*' (ibid, 5). Yet she also drew attention to the ambiguous boundary between words and things, pointing out that, while words are ephemeral, they become things when transcribed on paper or recorded onto tape, and while diverse audiences can interpret objects in museums in very different ways, words are used to give meaning to objects. Significantly, 'this blurred distinction underscores the parallel ways in which verbal utterances and material objects are used both to symbolize the past and to stake out positions in discussions about cultural representation, copyright of oral narratives and ownership of cultural property' (ibid, 6).

In this article I extend consideration of the entangled nature of words and things to a more recent concern in anthropology and museums – that of the creation, preservation and circulation of digital surrogates of tangible and intangible cultural objects – media increasingly being referred to as digital cultural heritage. I draw on fieldwork carried out with the Doig River First Nation, a Dane-ẕaa community in north-eastern British Columbia, Canada, where oral narrative and intangible heritage has been the focus of ethnographic collecting. Recent digitisation and community remediation of ethnographic archives that were created by anthropologist Robin Ridington and his colleagues in the last 40 years has illuminated tensions in the transformation of intangible expression into digital cultural heritage, where 'discussions about cultural representation, copyright of oral narratives and ownership of cultural property' (ibid, 6) are amplified by digital circulation and are central to local heritage and cultural revitalisation discourse. This fieldwork demands critical reflection on two significant heritage policies – the 2003 UNESCO *Convention for the Safeguarding of the Intangible Cultural Heritage* (UNESCO 2003b), which provides signatory nations with prescriptive guidelines for the identification, inventory, documentation and preservation of endangered intangible forms of cultural expression, and the UNESCO *Charter on the Preservation of Digital Heritage* (UNESCO 2003a), which embeds digital media in a broader heritage complex (Cameron 2008). These international policy statements have been

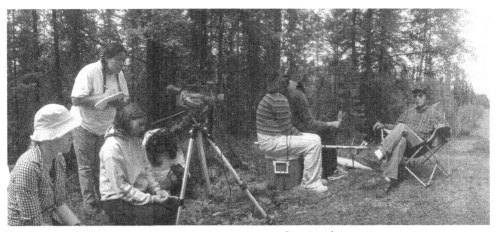

FIG 3.1. DANE WAJICH PROJECT TEAM MEMBERS RECORDING SAM ACKO'S NARRATIVE OF SURVIVAL AT
MADÁTS'ATL'QJE (SNARE HILL), 2005

largely treated as separate heritage issues, yet in the era of the 'born digital' (UNESCO 2003a)
ethnographic object, they have become as infinitely entangled as words and things.

HISTORIES (AND TECHNOLOGIES) OF COLLECTING DANE-ZAA EPHEMERA

Julie Cruikshank's ethnographic collaborations in the Yukon territory have brought anthropological
attention to the symbiotic relationship between oral narrative and material culture, memory, and
place (Cruikshank 1987; 1998). The anthropologist Robin Ridington, working with Dane-zaa
communities further south in British Columbia, similarly followed the lead of storytellers with
whom he worked to demonstrate the complex ecology of oral tradition in northern hunting
societies (Ridington 1988; 1990). In the process, both accumulated significant archives of
Athapaskan oral traditions. Their work as ethnographers has contributed to an idea of culture
expressed not only as objects, which have been the focus of museum collection practices across
North America, Europe and the Pacific, but as intangible heritage, which is defined in the 2003
UNESCO Charter as:

> the practices, representations, expressions, knowledge, skills – as well as the instruments,
> objects, artifacts and cultural spaces associated therewith – that communities, groups and,
> in some cases, individuals recognize as part of their cultural heritage. This intangible cultural
> heritage, transmitted from generation to generation, is constantly recreated by communities
> and groups in response to their environment, their interaction with nature and their history,
> and provides them with a sense of identity and continuity, thus promoting respect for cultural
> diversity and human creativity. (UNESCO 2003b, 2)

While the Indigenous cultures of the north-west coast have been represented in museums around
the world by their monumental sculpture and expressive carving traditions, subarctic Athapaskan
peoples have become known for their equally complex, yet much less visible, intellectual culture

and intangible forms of cultural expression. Because survival in the subarctic required mobility, possessions were kept to a minimum and knowledge of how to procure what was needed, when it was needed, was prioritised over the accumulation of material objects (Cruikshank 1992). According to Julie Cruikshank, 'Oral tradition is a complex and intricate art form in the Yukon, critical for passing on essential information. It weighs nothing and can accompany a traveler anywhere, but it rarely appears in museums' (ibid, 8). Robin Ridington also noted that culture was something carried in the head, rather than on one's back (Ridington 1982 in Cruikshank 1992). Collecting in Dane-ẕaa communities has therefore focused on intangible forms of cultural expression rather than material culture, making the eventual digitisation of the Ridington collection an informative case study of the opportunities and tensions associated with the transformation of intangible expression into digital cultural heritage.

THE CREATION OF THE RIDINGTON/DANE-ẕAA DIGITAL ARCHIVE

Unlike tangible objects, intangible cultural expression cannot be carried away by the ethnographer except as inscribed as ethnographic documents in field notes, recordings, film, or drawings (Kirshenblatt-Gimblett 1991). The act of creation of the ethnographic document and the act of creation of the ethnographic archive to order and preserve documentation of the intangible is far from neutral; indeed, 'what constitutes the archive, what form it takes, and what systems of classification signal at specific times are the very substance of colonial politics' (Stoler 2002, 92). The digital ethnographic archive, much more than a mechanical accumulation of information, is a nexus of debate over representation of culture and ownership of cultural documentation.

Robin Ridington began his fieldwork with Dane-ẕaa communities at Prophet River, Halfway River and members of the Fort St John band, who later became the Doig River and Blueberry River First Nations, in 1968. He was privileged to develop a relationship with Charlie Yahey, an elder who came to be the last known *nááchę* (translated as dreamer, or prophet) in the Peace River region. *Nááchę* are known to have travelled to heaven and received songs (*nááchę yiné?*) and prophecies that provided moral and spiritual guidance to people. Dane-ẕaa oral tradition asserts that *nááchę* dreamed ahead to locate the trails of game animals, predicted the coming of white settlers to the Peace River region and the industrialisation of the oil-rich landscape (Brody 1988; Ridington 1988). *Nááchę yiné?* received in dreams were publicly performed by dreamers and today by groups of drummers at world-renewal ceremonies called the Tea Dance, in which Dane-ẕaa bands gather to dance around a fire to ensure the passing of seasons and helping the spirits of the departed find their way along the trail to heaven (Ridington 1988). In his early fieldwork, Ridington and his colleague Antonia Mills recorded many hours of audiotape of Charlie Yahey's oratory and dreamers' songs, Tea Dances, and public expression of the *nááchę*'s sacred knowledge of heaven. He also photographed some of the drawings made by *nááchę* of their visions of heaven that were shown to him by elders. In the years following his initial fieldwork, some of these images were published in books. For example, in his ethnographic overview of the 'Beaver Indians' in the *Handbook of North American Indians,* Ridington includes an image that he took in 1966 of Augustine Jumbie kneeling in a tipi on the Halfway River Reserve, displaying a drawing by a *nááchę* named *Dakwatlah*. The image's caption indicates that the drawing had been created around 1900 and kept as a ceremonial object (Ridington 1981, 356). *Trail to Heaven* (1988) includes photographs of Charlie Yahey, in two of which he is displaying a double-sided painted moose-hide drum to the camera (Ridington 1988, 112 and 114). This drum was made

by the *nááchę Gaayęą* who died and was buried on the band's former reserve at Montney in 1923. The painting on one side of the drum, interpreted by Ridington as a representation of the Beaver cosmos and the dreamer's flight to heaven, was rendered by Ridington as a line-drawing, published in several works (Ridington 1978; 1981; Ridington and Ridington 1970) and reprinted elsewhere (Burley *et al* 1996, 16).

When Robin Ridington began documenting Tea Dances, *nááchę yiné?* and oral narratives, he used a 35-mm camera and an Uher reel-to-reel tape recorder. There were limitations attached to these particular documentary tools; because he had a limited supply of film, tape and batteries, he turned the recorder off when he thought that 'nothing was happening' (Ridington and Ridington 2003; 2006). The constraints of available technologies influenced his ideas about what was important to record; the narratives of Dane-ȥaa elders and the oratory of the *nááchę* Charlie Yahey were clearly extraordinarily and inevitably took precedence over the documentation of everyday conversations and soundscapes (Ridington and Ridington 2006).

In 1999, Robin Ridington and his partner Jillian Ridington made a transition in documentary technique. Digital technologies, in the form of audio mini-disk, gave them the ability to record sound virtually endlessly. Mini-disks were inexpensive and long-playing. Battery life had also drastically improved, making remote recording lightweight and easy. In 2001, they also changed their approach to visual documentation, transitioning from still photography to digital photography and video and experimenting with non-linear digital video editing (Ridington and Ridington 2006).

In 2003, responding to community demand for greater access to their collection, Robin, Jillian and the folklorist Amber Ridington worked with the Doig River First Nation to procure a grant from the British Columbia Museums Association to digitise the Ridingtons' photographic, audio and video collection of Dane-ȥaa intangible cultural heritage. The entire archive, which by 2003 consisted of approximately 600 hours of audio recordings, 5000 photographs and 60 hours of digital videotape, was to be made available as digital copies on a hard drive and be accessible in the Doig River First Nation's band hall (Ridington and Ridington 2003). The archive was named the *Ridington/Dane-ȥaa Digital Archive* and a selection of images from the archive, including series documenting the dreamer Charlie Yahey and a full catalogue of images, text and audio and video recordings, would be accessible through a password-protected online database called the *Dane-ȥaa Archive Catalogue (2004–2010)*. For the Ridington family, this represented a leap in their ability to 'share ethnographic authority with Dane-zaa First Nations' (Ridington and Ridington 2003).

The digitisation of the Ridington ethnographic archive also represented the transformation of formerly analogue media – circulation of which was moderately controlled by ethnographers and community members with the technology to duplicate it – into media that can be classified as digital cultural heritage. As defined in the UNESCO *Charter on the Preservation of the Digital Heritage*:

> The digital heritage consists of unique resources of human knowledge and expression. It embraces cultural, scientific and administrative resources, as well as technical, legal, medical and others kinds of information created digitally, or converted into digital form from existing analogue resources. Where resources are 'born digital', there is no format but the digital object.
> Digital materials include texts, databases, still and moving images, audio, graphics, software

and web pages, among a wide and growing range of formats. They are frequently ephemeral, and require purposeful production, maintenance and management to be retained.

(UNESCO 2003a, 1)

As Fiona Cameron points out, discourse on digital heritage has been largely focused on the status of digital media as heritage and of original and authentic objects, referencing the writing of Walter Benjamin (1968) and Jean Baudrillard (1994) (Cameron 2008). There has been little critical discourse of digital heritage, even though the 'ascription of heritage metaphors to cultural materials in a digital format means that digital media has become embedded in a cycle of heritage value and consumption, and in the broader heritage complex' (Cameron 2008, 171). The UNESCO *Charter on the Preservation of the Digital Heritage* is seen to exemplify the uncritical induction of digital cultural heritage materials into wider processes of globalisation and heterogenisation (ibid). Of particular issue is the Charter's emphasis on ensuring maximum public access to what has been encoded through UNESCO programming as the 'Memory of the World', or 'Information for All', while still protecting personal privacy. Article 2 of the Charter states that:

The purpose of preserving the digital heritage is to ensure that it remains accessible to the public. Accordingly, access to digital heritage materials, especially those in the public domain, should be free of unreasonable restrictions. At the same time, sensitive and personal information should be protected from any form of intrusion. (UNESCO 2003a, 2)

As I will describe in more detail below, members of the Doig River First Nation made important decisions to keep elements of their digital cultural heritage out of public circulation as a way to maintain the power of heritage objects. Their leading participation in intangible heritage safeguarding projects was crucial in this regard. As with the creation of ethnographic documents, including the documentation of intangible cultural heritage, digital heritage is shaped by systems of heritage value and subjective evaluation about what to preserve – in this schema, what to make public – and what to keep in private circulation or allow to be lost. The discourse of loss of heritage permeates the digital heritage charter, in which digital media 'is at risk of being lost to posterity' (Article 3, *The threat of loss*) and 'unless the prevailing threats are addressed, the loss of digital heritage will be rapid and inevitable' (Article 4, *Need for action*). The UNESCO *Convention for the Safeguarding of the Intangible Cultural Heritage* (UNESCO 2003b) also mobilises a discourse of loss, echoing the language of salvage anthropology, but warns against contemporary homogenising forces of globalisation that are implicit in the digital heritage charter:

Recognizing that the processes of globalization and social transformation, alongside the conditions they create for renewed dialogue among communities, also give rise, as does the phenomenon of intolerance, to grave threats of deterioration, disappearance and destruction of the intangible cultural heritage, in particular owing to a lack of resources for safeguarding such heritage. (UNESCO 2003b, 1)

Digital technologies – including digital video, audio and photography, as well as computer word processing programs for field notes, electronic maps and Geographic Information Systems,

social media and digital archives – have become normative tools and economically viable resources for the documentation and preservation of intangible cultural heritage and its indelible connections to material culture, the natural environment and social, political and economic conditions. That much of the documentation of intangible cultural heritage around the world will be 'born digital' means that meaningful participation by stakeholder communities in the documentation and safeguarding of their cultural heritage is more important than ever before. Such participation from cultural communities, groups and individuals is emphasised in Article 15 of the Convention, titled *Participation of communities, groups and individuals,* which states that:

> Within the framework of its safeguarding activities of the intangible cultural heritage, each State Party shall endeavor to ensure the widest possible participation of communities, groups and, where appropriate, individuals that create maintain and transmit such heritage, and to involve them actively in its management. (UNESCO 2003b, 7)

According to Richard Kurin, this represents a shift in perspective on the role of culture bearers in determining best practices for safeguarding:

> Governments, or university departments or museums, cannot just assume that they have permission to define intangible cultural heritage and undertake its documentation, presentation, protection, or preservation. Community participation is meant to be significant and meaningful – involving the consent of community leaders, consultation with lead cultural practitioners, shared decision making on strategies and tactics of safeguarding and so on. Article 15 strongly empowers the community in the operation of and realization of the Convention.
>
> (Kurin 2007, 15)

During my fieldwork with the Doig River First Nation between 2004 and 2008, I co-curated (with Amber Ridington) a collaboratively produced virtual museum exhibit of the oral narratives and song called *Dane Wajich – Dane-ẕaa Stories and Songs: Dreamers and the Land* (2007). The project used digital cultural heritage from the *Ridington/Dane-ẕaa Digital Archive*. Archival media were exhibited online alongside contemporary documentation of narrative and song that had been created by members of the Doig River community in the course of the project. *Dane Wajich* used collaborative methodologies that placed elders, youth and other community participants in leading roles. It modelled a strategy for community involvement in the documentation of intangible heritage that is in keeping with the emphasis of the 2003 UNESCO *Convention for the Safeguarding of the Intangible Cultural Heritage* on roles and responsibilities of local communities in safeguarding what they determine to be endangered and significant (Hennessy 2010).

In the following section, I show how community participation in decision making about which elements of ethnographic documentation to make public in the virtual exhibit, and which to restrict from wider access, made intangible heritage and *digital* objects central to conversations about ownership and control of cultural documentation. While community leadership in intangible heritage safeguarding efforts made use of available digital technologies to mobilise digital cultural heritage and to create new born-digital objects, it had results that are in tension with the maximum-access emphasis of the 2003 UNESCO *Charter for the Preservation of the Digital Cultural Heritage*, and point to the importance of local strategies for the safeguarding of digital cultural heritage and the forms of intangible heritage that it represents.

GAAYĘĄ'S DRUM

In July of 2005, at a *Dane Wajich* planning meeting in Doig River First Nation's band hall, I videotaped a Dane-ẕaa elder named Tommy Attachie as he spoke about a moose-hide drum skin. The drum skin had been painted with a map of heaven by a Dane-ẕaa *nááchę* named *Gaayęą* more than a hundred years before. It had been inherited by Garry Oker, who was the Chief of Doig River at that time, and who brought it to the planning meeting. As I have described elsewhere (Hennessy 2010; Ridington and Hennessy 2008), Tommy Attachie used *Gaayęą's* drum at this meeting, and at subsequent planning meetings, to eloquently articulate the connections between Dane-ẕaa material culture, oral narrative and land. The drum, the material manifestation of the dreamer's medicine power and experience of heaven, was described as integrally connected to successful hunting and survival on the land, as well as to foreknowledge of the drastic changes associated with the colonial settlement of Dane-ẕaa territory. As with other Doig River local projects that were facilitated by the digitisation of the Ridington/Dane-ẕaa Digital Archive, such as audio CDs of drumming and singing performances and video documentaries about history and culture, *nááchę* songs and drawings have become central foci of the Doig River First Nation's media productions. These media convey the continuity of knowledge and *nááchę* practices and present an alternative cultural history of the region that competes with colonial and industrial narratives.

Gaayęą's drum was used by Tommy Attachie to define a methodology for documenting Dane-ẕaa intangible heritage; in the following weeks in that summer of 2007, our group travelled to seven places in Dane-ẕaa territory where youth, elders, ethnographers and linguists recorded videos documenting traditional narratives, life histories and histories of *nááchę* in *Dane-ẕaa Záágeʔ* (the Beaver language) and English. These videos and their translations became central elements of the virtual exhibit and in early drafts of the exhibit, photographs of *Gaayęą's* drum as a part of the production process and archival photographs of Charlie Yahey holding a special double-sided drum also made by *Gaayęą* were also featured prominently throughout the online project. However, at the end of a nearly two-year period of exhibit post-production and community consultation carried out by co-curator Amber Ridington and me, the decision was eventually made to remove all images of *nááchę* drums and drawings from the exhibit. Meaningful community participation in digital documentation and presentation of oral narratives opened up local debate over the ownership and control of Dane-ẕaa digital cultural heritage. The debate was centred on ownership of ethnographic documentation and control over its circulation in digital form.

OWNERSHIP OF CULTURAL DOCUMENTATION

As Dane-ẕaa ephemera have become ethnographic objects, they have become physical objects (tapes, film, photographic prints); as these ethnographic documents of intangible cultural heritage have been digitised, they have become digital cultural heritage (digital files and storage devices) that are owned, traded, copied and remixed. As Dane-ẕaa intangible cultural heritage has been collected, digitised and made accessible to Dane-ẕaa communities in the form of the *Ridington/Dane-ẕaa Digital Archive*, it has also been claimed as property. The contents of the *Ridington/Dane-ẕaa Digital Archive* are 'copyrighted by the collectors for their use' (Ridington and Ridington 2003, 67). This can be so because, under the *Canadian Copyright Act*, the act

of the creation of a document – for example, pressing 'play' on a digital audio recorder – is an assertion of ownership and a legal right to control the use of the document (Canada 1985–10 March, 2010).[1] This technicality has underscored the practice of academic anthropology, where the copyright of the ethnographic object, and by proxy the legal right to publish, distribute, or even sell these 'creative works' has long rested with the researcher, rather than with the subject of ethnographic study him or herself (Marcus and Clifford 1985). While the contents of the *Ridington/Dane-zaa Digital Archive* are copyrighted by the collectors for their use, the Ridingtons have also declared the intention that copyright be shared 'by the Dane-zaa peoples represented by the four Dane-zaa bands' and that permission to use the material be sought by the copyright holders (Ridington and Ridington 2003, 67). In the original grant application to digitise the collection, it was stated that:

> Dane-zaa heritage is collectively owned, and a great number of generations contribute to our cultural heritage. The documentation of our peoples' heritage in the Ridington Dane-zaa Archive represents indigenous intellectual property and although it is collectively owned, it will be curated by the Doig River First Nation at their museum, and will be made accessible to all Dane-zaa peoples. (Ridington and Ridington 2003, 67)

While this statement is meant to protect the rights of the collectors to continue to use the material for academic research and publication, and the rights of Dane-zaa peoples to have a say in how and by whom their cultural heritage is used and reproduced, it also illustrates a basic contradiction at the heart of debates over cultural property – that collectively owned intangible expression becomes the property of an individual through the act of documentation. This contradiction was illuminated in the digitisation and return to Dane-zaa communities, when Indigenous intellectual property rights were granted, but exclusive copyright – ownership – was not, and given the collective nature of ownership of Dane-zaa oral narrative, could not easily have been done.

Because the painted moose-hide drum made by the *nááchę Gaayęą* was central in defining the methodology for cultural documentation in the *Dane Wajich* project, a photograph of the *nááchę* Charlie Yahey holding a painted drum made by *Gaayęą* was chosen by Doig River project participants from the *Ridington/Dane-zaa Digital Archive* to be featured on the draft home page of the virtual exhibit. However, shortly after this decision was made, co-curator Amber Ridington and I were made aware that descendants of Charlie Yahey at the neighbouring Blueberry River First Nation were concerned that photographs of their relative were being used by the Doig River First Nation without their consent. Under the direction of the Doig River Chief and Council, we visited with family members at Blueberry to discuss the use of Dane-zaa digital heritage in the project. The family ultimately decided that they did not support the use of these images of Charlie Yahey by Doig River at that time and the Doig River Chief and Council accordingly agreed that individual stakeholders in cultural documentation, or their descendants, should be consulted for permission to display their cultural heritage and that this decision should not be

1 Section 18 of the *Canadian Copyright Act*, 'Copyright in Sound Recordings', states that: the maker of a sound recording has a copyright in the sound recording, consisting of the sole right to do the following in relation to the sound recording or any substantial part thereof: (*a*) to publish it for the first time, (*b*) to reproduce it in any material form, and (*c*) to rent it out, and to authorize any such acts.

made by band councils without specific family permission. All archival media related to Charlie Yahey was subsequently removed from the *Dane Wajich* exhibit. Community involvement in intangible heritage documentation and subsequent engagement with digital cultural heritage in this case both identified and challenged national legal regimes of ownership and facilitated the articulation of a local intellectual property rights discourse.

Control of Digital Cultural Heritage

The use of the images of *nááchę* drawings and drums in the exhibit also raised questions about the extent to which the power of tangible objects is translated into digital representations, and, accordingly, the appropriateness of making these images publicly visible elements of digital cultural heritage. During the post-production of the *Dane Wajich* exhibit it was suggested that the drum skin made by the *nááchę Gaayęą* that had been used by Tommy Attachie to define the project's documentary methodology should be restored and installed in an exhibit in the Doig River First Nation's museum. However, when Amber Ridington and I consulted with local elders about this possibility, we were surprised to find out that some did not think the drum should be displayed publicly at all. As I have described in detail elsewhere (Hennessy 2010; Ridington and Hennessy 2008), local protocols for the care and handling of *nááchę* drums and drawings were raised by some elders as a reason to keep the drum out of uncontrolled public circulation. Some also felt that photographs of the drum should be treated in the same way and kept out of view. While some people, particularly those of younger generations, felt that circulating digital images of the drum would have no negative effect, the decision was made to remove all images of *nááchę* drums and drawings in accordance with more conservative perspectives. Images of *nááchę* drums were replaced with the unpainted drums made by Dane-zaa who are not themselves *nááchę* and which are used in contemporary performance at Doig River.

While Dane-zaa ethnographic documentation and digital heritage has been interpreted and circulated by anthropologists, it has also been reintegrated into Dane-zaa social, religious and political life. I have often entered someone's home to hear the songs of Charlie Yahey and other elders playing in the background, or see portraits taken of community members displayed on the wall. Charlie Yahey's voice 'has become as familiar to people who never knew him as it was to those who attended his Dreamers' Dances' (Ridington and Ridington 2006, 20). Drummers and singers at Doig River, some of whom learned directly from Charlie Yahey and other singers recorded by Robin Ridington, have enriched their repertoire by listening to recordings of their elders. They continue to sing and perform them at Tea Dances for the community and the general public.

These media are also used in significant ways to negotiate unequal relations of power. Recordings of *nááchę yine?* (dreamers' songs), used in culturally appropriate contexts, are considered by some to be powerful tools in their spiritual and political lives. As the former Doig River First Nation Chief Kelvin Davis told me in the summer of 2007, when the ability of the band to resist incursions of government-sanctioned industrial development on their land was exhausted, the Ridingtons' recordings of *nááchę yine* had power to disrupt the ravenous extraction of oil and gas. When used with proper respect, the power of *nááchę* as a form of resistance remains embedded in the magnetic tape and digital code of copies from the ethnographic archive:

> There were – the industries were back in there trying to – there was a big [natural gas] pool there. They say it was two percent globally, which is huge in volume and, so it – it really

bothered me because we're trying to protect it and we didn't have any mechanism to deal with the province, or we didn't have no agreements with anybody.

So it was tough for us to really do anything as council back then. But one day I went out there and I remember what my mother told me. She said, the prophet, a long time ago, the great prophets used to say, even the land misses the songs. I remember that.

So I had these dreamers, these songs, so I put all my four windows down and I played it and I drove around this hill and I prayed. I ask God, I said, 'Lord, this is where our people survived, it's because you willed it. Look at the damage they're doing. Look at the destruction. We're – we're – this place won't be the same. Where are the animals going to go?'

And I left it at that. Within two years, that … dried up, all they were sucking up was water. And that, to me, is a testimony in itself. Very, very powerful, once you believe it in your heart. So that's – for me, that's what I experienced …

The recordings of the songs, of the prophet's songs, are very powerful and if … you use it the right way, it will be effective. But if you use it the wrong way, then the meaning of the song and the power of the songs, I believe will be, my mother told me years ago, prophets used to say, 'Don't play with these songs'. If the song giver wants to, he can take the – the spirit of the songs back and all it is, is going to be, is just songs, that's it, nothing more. (Davis 2007)

Chief Davis emphasises that the power of the *nááchę yine?* was maintained through proper, respectful use of the songs. Such preservation of the power of the songs is dependent on his intangible knowledge of their care, even in digital form. His account of the power of dreamers' songs on tape is consistent with findings of scholars working with Indigenous communities and digital cultural heritage in other parts of the world. For example, the Maori scholar Deirdre Brown (2007), working with Maori material culture, has shown that the 'spiritual and emotional qualities that give their cultural treasures or *taonga* meaning and significance have the potential to be transferred to the digital copy like photographs or moving images beforehand' (Cameron 2008, 181). The creation of new forms of electronic *waka* (vessels) to meet cultural needs offers a way of 'subverting technologies of domination by cultural institutions' (ibid, 180). In another example, from Australia, Kim Christen has shown how Warumungu women balanced the need to document and preserve Dreaming songs with satisfying interest from the public in Warumungu traditions; she describes how decisions were made about the 'open' and 'closed' nature of certain songs, the most public of which were recorded and distributed on CD (Christen 2006, 420). These essential qualities of digital heritage were further applied by Christen and collaborators to the very design of archiving software for Warumungu communities; the *Mukurtu Wumpurrarni-kari Archive* allows users to dictate the terms of their access to digital cultural heritage. Their interactive website *Digital Dynamics Across Cultures* (Christen *et al* 2006) demonstrates Warumungu systems of proper information sharing based on protocols for how, when and by whom information should be accessed (Christen 2009). In these examples, communities with their own requirements for the documentation, safeguarding and preservation of digital heritage are mobilising the power of the heritage industry 'to become self-determining agents in creating their own autobiographies. That is, to tell their own truths about culture, to embrace and challenge and also resist prevailing heritage regimes of classification' (Cameron 2008, 180). Exercising agency in the documentation of intangible cultural heritage, and control over the use of new technologies to preserve and safeguard digital heritage, are central in these efforts (Christen 2005).

Conclusion

Digital code, that at the most primary level is programmed to make copies, has displaced the 'natural' duplication constraints of analogue media (Lessig 2008). Unlike the tools and codes of ownership associated with the dissemination of analogue ethnographic documents – master copies, duplication technologies and distribution media – computers are simultaneously tools for the production *and* distribution of digital cultural heritage (Cameron 2007). In the era of the 'born digital' heritage object, the safeguarding of intangible cultural heritage and the preservation of digital cultural heritage are not separate projects. I have argued that, as with the ambiguous boundary that distinguishes verbal utterances from object (Cruikshank 1992), efforts to document and safeguard what UNESCO has defined as intangible cultural heritage must be understood, and critiqued, in relation to the UNESCO discourse on the preservation of digital heritage. The multiple methods and ontologies through which Indigenous peoples around the world are appropriating new technologies to articulate their own social, cultural and political visions (Srinivasan 2006) demonstrate the value of meaningful community participation in efforts to safeguard their digital cultural heritage, including the development of information systems that challenge Eurocentric heritage categories. Indeed, as heritage categories (tangible, intangible, natural) are increasingly understood to be arbitrary and interconnected (Kirshenblatt-Gimblett 2004), so are the meanings and consequences of words and things, in ephemeral, analogue and digital form. As Julie Cruikshank reminds us, 'Indigenous peoples do not define land rights, self-government, control of material culture, or control of images in ethnographic monographs, fiction and film as separate issues with distinct boundaries' (Cruikshank 1992, 6). Her point is emphasised by former Doig River First Nation Chief Kelvin Davis, who told me 'even the land misses the songs' (Davis 2007).

Acknowledgments

My gratitude goes to the Doig River First Nation, to *Dane Wajich* exhibit co-curator Amber Ridington and to Robin and Jillian Ridington. Thanks also to Patrick Moore, Billy Attachie and Marlene Benson for their *Dane-zaa Záágé?* orthographic transcriptions, which I use in this chapter.

Bibliography and References

Baudrillard, J, 1994 *Simulacra and Simulation* (trans S F Glaser), University of Michigan Press, Ann Arbor

Benjamin, W, 1968 The Work of Art in the Age of Mechanical Reproduction, in *Illuminations* (eds H Arendt and H Zohn), Jonathan Cape, London, 217–51

Brody, H, 1988 *Maps and Dreams: Indians and the British Columbia Frontier*, Douglas and McIntyre, Vancouver and Toronto

Brown, D, 2007 Digital Cultural Heritage and Indigenous Objects, People, and Environments, in *Theorizing Digital Cultural Heritage: A Critical Discourse* (eds F Cameron and S Kenderline), MIT Press, Cambridge, Massachusetts and London, England, 77–91

Burley, D V, Hamilton, J S, and Fladmark, K J, 1996 *Prophecy of the Swan: The Upper Peace River Fur Trade of 1794–1823*, University of British Columbia Press, Vancouver

Cameron, F, 2007 Beyond the Cult of the Replicant: Museums and Historical Digital Objects – Traditional Concerns, New Discourses, in *Theorizing Digital Cultural Heritage: A Critical Discourse* (eds F Cameron and S Kenderline), MIT Press, Cambridge, Massachusetts and London, England, 49–75

—— 2008 The Politics of Heritage Authorship: The Case of Digital Heritage Collections, in *New Heritage: New Media and Cultural Heritage* (eds Y E Kalay, T Kvan and J Affleck), Routledge, London and New York, 170–84

Canada, 1985 – 10 March, 2010 *Copyright Act (R S, 1985, c. C-42)*, Department of Justice, Ottawa

Christen, K, Cooney, C, and Ceglia, A, 2006 *Digital Dynamics Across Cultures* [online], available from: http://www.vectorsjournal.org/issues/03_issue/digitaldynamics/ [14 August 2010]

Christen, K, 2005 Gone Digital: Aboriginal Remix and the Cultural Commons, *International Journal of Cultural Property* 12 (3), 315–45

—— 2006 Tracking Properness: Repackaging Culture in a Remote Australian Town, *Cultural Anthropology* 21 (3), 416–46

—— 2009 Access and Accountability: The Ecology of Information Sharing in the Digital Age, *Anthropology News* (April), 4–5

Cruikshank, J, 1987 *Life Lived Like a Story: Cultural Constructions of Life History by Tagish and Tuchone Women*, University of Nebraska Press, Lincoln and London

—— 1992 Oral Tradition and Material Culture: Multiplying Meanings of 'Words' and 'Things', *Anthropology Today* 8 (3), 5–9

—— 1998 *The Social Life of Stories: Narrative and Knowledge in the Yukon Territory*, University of British Columbia Press, Vancouver

Davis, K, 2007 Personal communication (interview with author), 1 August, Doig River First Nation

Doig River First Nation, 2007 *Dane Wajich – Dane-ẕaa Stories and Songs: Dreamers and the Land* [online], available from: http://www.virtualmuseum.ca/Exhibitions/Danewajich/ [14 Aug 2010]

Hennessy, K, 2010 Repatriation, Digital Technology, and Culture in a Northern Athapaskan Community, unpublished PhD thesis, University of British Columbia

Kirshenblatt-Gimblett, B, 1991 Objects of Ethnography, in *Exhibiting Cultures: The Poetics and Politics of Museum Display* (eds I Karp and S D Levine), Smithsonian Institution, Washington and London, 386–443

—— 2004 Intangible Cultural Heritage as Metacultural Production, *Museum International* 56 (1–2), 52–65

Kurin, R, 2007 Safeguarding Intangible Cultural Heritage: Key Factors in Implementing the 2003 Convention, *International Journal of Intangible Heritage* 2, 10–20

Lessig, L, 2008 *Remix: Making Art and Commerce Thrive in the Hybrid Economy*, The Penguin Press, New York

Marcus, G E, and Clifford, J, 1985 The Making of Ethnographic Texts: A Preliminary Report, *Current Anthropology* 26 (2), 267–71

Ridington, A, and Hennessy, K, 2008 Building Indigenous Agency Through Web-Based Exhibition: Dane-Wajich – Dane-ẕaa Stories and Songs: Dreamers and the Land [online], available from: http://www.archimuse.com/mw2008/papers/ridington/ridington.html [14 August 2010] Museums and the Web, Montreal

Ridington, R, 1978 *Swan People: A Study of the Dunne-za Prophet Dance*, Vol 38, National Museums of Canada, Ottawa

—— 1981 Beaver Indians, in *Handbook of North American Indians* (ed J Helm), Smithsonian Institution, Washington, DC, 350–60

—— 1988 *Trail to Heaven: Knowledge and Narrative in a Northern Native Community*, Douglas and McIntyre, Vancouver

—— 1990 *Little Bit Know Something: Stories in a Language of Anthropology*, Douglas and McIntyre, Vancouver

Ridington, R, and Ridington, J, 2003 Archiving Actualities: Sharing Authority with Dane-zaa First Nations, *Comma* 1, 61–8

—— 2006 Hunting for Stories in Sound: Sharing Ethnographic Authority, in *When You Sing It Now, Just Like New: First Nations Poetics, Voices, and Representations*, University of Nebraska Press, Lincoln and London, 16–27

Ridington, R, Ridington, J, and Doig River First Nation, 2004–2010, *The Ridington/Dane-zaa Digital Archive, Dane-zaa Archive Catalogue* [online], available from: http://fishability.biz/Doig [14 August 2010]

Ridington, R, and Ridington, T, 1970 The Inner Eye of Shamanism and Totemism, *History of Religions* 10 (1), 49–61

Srinivasan, R, 2006 Indigenous, Ethnic, and Cultural Articulations of New Media, *International Journal of Cultural Studies* 9 (4), 497–518

Stoler, A L, 2002 Colonial Archives and the Arts of Governance, *Archival Science* 2 (1), 87

UNESCO, 2003a *Charter on the Preservation of the Digital Heritage*, available from: http://portal.unesco.org/ci/en/ev.php-URL_ID=13367&URL_DO=DO_TOPIC&URL_SECTION=201.html [17 November 2010]

—— 2003b, *Convention for the Safeguarding of the Intangible Cultural Heritage*, available from: http://unesdoc.unesco.org/images/0013/001325/132540e.pdf [17 November 2010]

Conversation Piece:
Intangible Cultural Heritage in Sweden

Ewa Bergdahl

Can you say something about yourself and your personal interest in ICH?

I have been involved in museum work in Sweden for the last 30 years in different positions, carrying out a variety of tasks. Independent of where or in which museum, intangible heritage has always been very important to me, because I regard it as creating the context and supplying the detailed knowledge for the interpretation of material culture and the environment. In other words, through ICH the physical objects and places come alive and their meaning and their history can be understood and interpreted.

During my years as director of *Ekomuseum Bergslagen* in the late 1990s, this fact was most apparent. In this 'landscape museum', which involves many different sites spread out across a large geographic area, the main emphasis was on mining and industrial processes connected to metalworking. We dealt with a kind of cultural heritage where the skills and knowledge of iron making, the craft skills and traditions connected to mines and industrial plants in this specific region in Sweden, were paramount. The experience of working with local inhabitants, volunteers and members of local societies made me understand the great importance of recognising all people as active agents; it was these individuals who were responsible for handing over their knowledge of cultural heritage to the next generation. Such knowledge was encapsulated as habitual behaviours, rituals, norms, values, skills and experiences; however, because these forms of ICH were moulded and manipulated, the process was a dynamic one and ICH changed as people left their own stamp on their heritage.

I feel it is difficult to grasp the meaning of ICH if you try to define it as something 'concrete'. It is the continuous transformation of people's life patterns and intangible heritage which stresses the need for world-wide engagement in the creation of processes that will sustain all bearers and performers of ICH. In my opinion this could be a global mission (such as UNESCO have suggested through the 2003 Convention), but only if the process takes due regard of human rights.

In Sweden, were there policies already in place that have dealt with intangibles before UNESCO's 2003 Convention?

Safeguarding ICH has been one of the most difficult public tasks to fulfil in Swedish society. The legislation of conservation of heritage in Sweden has a long history, dating back to the middle of the 17th century, when the first declaration of heritage was stipulated by the king. An inventory was made in 1630 of imposing prehistoric monuments in order to establish the history and glory

of Sweden and to verify its status as a nation. The National Heritage Board was created at the same time (20 May 1630) as an official body responsible for these activities.

The local heritage movement in Sweden, which began in the late 19th century, has been dealing with ICH at all levels. The local heritage movement in Sweden was – and still is – above all rooted in the countryside, where thousands of local groups were organised as a reaction to the rapid industrialisation process in the late 19th century. The interest in preserving folklore, craft skills, traditional customs, life patterns and architecture grew and was the inspiration for the creation of *Nordiska Museet* and the open-air museum *Skansen* in 1891 at Djurgården, in Stockholm. Collections of objects were combined with documentations and records of folklore, tales, songs and dialects from all parts of Sweden. The linguistic researcher and teacher Artur Hazelius, who was the creator of *Skansen*, was convinced that all the houses and buildings needed to be filled with living beings – animals and humans – to be understandable and interesting.

Reconstructed old farms with specific regional details and with men and women in traditional costumes demonstrating handicrafts and all kinds of daily work was, at that time, something totally new. Visitors were astonished and delighted and *Skansen* became very popular. Many contemporary colleagues to Arthur Hazelius were, however, annoyed, and maintained that this new museological concept was a catastrophe. It was regarded as 'unscientific' and even harmful. However, other folklore researchers liked it and stressed the possibilities of raising the standard of general education. A lively debate went on for many decades.

Meanwhile, other ICH-inspired associations were born, including The Swedish Handicraft Association (1899), The Swedish Folk Dance Ring (1920) and The National Archive of Ballads (1951). In the middle of the 1970s, the government of Sweden launched a new policy on culture and heritage, with new visions and objectives. It was recommended that strong regional cultural institutions (in all kinds of culture fields) were supported or established. Regional museums were created in the counties and given economical and human resources to enlarge the field of activities and to take responsibility for interpreting and presenting the history and cultural heritage of their regions. These circumstances influenced the Swedish museum sector. The combination of a powerful local heritage movement and a cultural policy stressing the importance of democracy, life-long learning and local and regional perspectives provided a good basis for a growing interest in the ecomuseum concept.

These 'new' museums were greeted with interest amongst only a few of the museum directors. The idea that a museum could work without being situated in a building was not totally strange, since *Skansen* and a great number of other local 'Skansen-like' constructions in Sweden were well established. But included in this new museum concept was also the idea that the whole landscape, with its original nature resources, villages, buildings, industries, roads and railways, could be looked upon as a museum's collection and part of the museum's exhibition. The ecomuseum was an arena where local inhabitants took care of local historical sites and at the same time lived and worked in the area. Between 1979 and 1995, eight ecomuseums were created in Sweden. When the whole cultural landscape constitutes the basis for a museum then the conservation and transmission of intangible cultural heritage assumes new significance.

When the history and culture of a place play an essential part in contemporary life, heritage plays an important role. The creation of ecomuseums was supported by politicians in small and medium-size municipalities, who wanted to combine sustainable development and a growing economy based on tourism, yet still respect local history and heritage. Strong emphasis was placed on people's memories, traditions, values and rituals, and less on physical objects and

collections. Antiquarians and historians have claimed that physical places and sites are necessary to maintain local identity and a sense of belonging; however, places without stories connected to them are perceived as abstract, difficult to relate to and – probably also because of that – of lesser importance to people. Despite this, today's Swedish Cultural Heritage Legislation still places much greater emphasis on the preservation of material culture – objects, buildings and archaeological monuments – than it does on life patterns, traditions, skills and folklore.

You have described a little about how ICH was conceptualised within Sweden before the 2003 Convention, but could you say more about this?

Expressions of ICH are often used as national symbols and nationalistic elements of décor and this was true in Sweden. In the late 19th century artists and authors went on pilgrimages to Dalecarlia and other farming regions in Sweden, where old traditions, costumes and rituals were still in use. Their work strongly influenced art, design and literature and created a mythological picture of Sweden which is still alive and frequently used by the tourism industry.

ICH in Sweden, as in many other countries, is transformed into potential tourist products; ICH was seen to have the ability to create economic capital. It is easy to use ICH as a kind of ornament in shaping signifiers of tourist establishments and being part of tourist experiences – this is happening everywhere in the world. As a result, many national minorities and other local groups are forced to start 'performing' their own cultural expressions in order to earn money from visitors and tourists. This phenomenon has escalated in areas where the possibility of survival from traditional life patterns and economies has diminished. One of the most flagrant and tragic examples of this is the situation of the Maasai in eastern Africa, where the tribe's original culture has been transformed into a heavily standardised set of clothing, dances and songs. Even if the same flagrant examples cannot be found in Sweden, there are several similarities in the tourism business's use of ICH for its own purposes; for example, we can observe how Swedish midsummer traditions are stereotypically maintained within a relatively narrow set of songs, dances, dishes and traditional costumes. This is most obvious concerning Dalecarlia, but in the north of Sweden the Sami people are also exploited in the same way.

What initiatives and projects are already underway in order to safeguard cultural practices in Sweden?

The Institute of Language and Folklore in Sweden was created in 2006. It was the first official authority with the mission to make an inventory of dialects, traditional geographical and personal names, folklores and memories, all of which are forms of ICH. It replaced the former Institute of Dialects and Folklores (SOFI). In the beginning of the same year, NAPTEK started: a national programme about local and traditional knowledge concerning the conservation and sustainable use of biological diversity. These constructions of public bodies are both attempts to draw attention to the current imbalance between the tangible and the intangible heritage and to facilitate the Swedish process of adaption to several international recommendations and conventions.

There are many examples of local groups and NGOs which organise their members towards the safeguarding of ICH. Since the middle of the 1970s there has been a growing interest in industrial heritage in Sweden, especially among former workers and employees. This is the result of closures of small or middle-sized workshops and industries in combination with left-wing

oriented policy and radical movements during this period. This interest has also been influenced by new museological ideas, reflecting the concept of the ecomuseum, which involves local people and volunteers.

There are about 2200 small local museums in Sweden, mainly in the countryside and in small towns and cities, representing all kind of interests; these include museums in mining areas and museums devoted to shipbuilding, textile manufacture, dairying and metalworking. Collections – if there are any – are kept in factories and industrial buildings. Volunteers do the work. When former employers start to document and create a memorial symbol of their own – like a museum – they appear to do this because they suppose nobody else cares, or perhaps no-one else has the knowledge and skills?

The extended growth of these 'museums of work' is due to the confidence that ordinary people lack in heritage institutions and museums, since many of them fail to represent or describe the reality the workers know. Museums created by local people are based on their own local experiences and are important 'containers' of ICH. The old traditional national and regional institutions were almost all built up in the late 19th century with the purpose of expressing the upcoming ruling classes' interests and ideologies. They also represent the ruler's efforts to strengthen a national identity among Sweden's inhabitants. The community-based institutions raise the question of who has the right and power to define heritage in society today.

Let me give you an example. A group of men who had worked in the derelict stonemasons' workshop in the village of Råbäck (situated in the western part of Sweden close to the community of Hällekis on the shore of Lake Vänern) gathered together in order to conserve the remaining parts of the buildings and equipment. They wanted to keep the history of the workshop alive, practise their skills and tell the rest of the world about the working conditions there. After two years of volunteering on this restoration project they turned to the National Heritage Board in Stockholm, asking for some advice. The experts from the National Board went to the site, met the workers and inspected the old workshop. They declared that with its engines and tools the workshop was 'unique and complete' and represented significant historical cultural values. In order to retain these values, the workers were instructed not to change anything or make any further repairs to the old energy transmission system or the equipment in the buildings. When the experts returned a couple of years later, all the equipment was still in place in the workshop, but everything had been cleaned, carefully renovated, polished and lubricated. The engines were now in use.

With the purpose of bringing to life the knowledge of how to run the engines, the workers had made the machinery work and they started to demonstrate to visitors how the equipment was used. The experts from the National Heritage Board were at a loss. In their opinion, based on their theoretical academic knowledge of industrial heritage, the site was completely destroyed; to them the repairs and renovation work had destroyed the site's historical patina. What is clear, however, is that the workers had concentrated on a different aspect of heritage: their knowledge and skills of the process of stone-cutting. Their own abilities had enabled them to restart the engines and by doing so they gave themselves the chance to preserve and develop their professional knowledge and know-how, which would have otherwise been lost.

This example shows very clearly the complicated balance between safeguarding ICH and the preservation of tangible heritage. Depending on which kind of heritage is ranked highest, the experience of the remains of the stone-cutting workshop will differ. Whose interpretation of

cultural heritage has priority? Are the physical engines – *per se* – of higher cultural value than the know-how of the former workers and their skills to use them?

How is the current term, 'intangible cultural heritage', conceptualised in Sweden?

In Sweden, ICH has never been defined as something continuously changing or as an ongoing process, in which heritage is transmitted and transformed at the same time from generation to generation and also from one ethnic group to another. A consequence of this fact is that ICH in general has either been connected to tangible objects or 'preserved' in audiovisual documentation, such as recorded folk music, folklore, tales and local traditions told by informants. Since the beginning of the 1970s this work has been directed and supported by the Institute of Dialects and Folklore (SOFI), which also has the responsibility for documenting ICH, as defined above, and for the archives, where the evidence and records are kept. But ICH has never been defined as a process which will also facilitate the conditions for users and actors.

What is currently happening in Sweden with respect to the 2003 Convention?

Among the UNESCO-listed phenomena today there are two representatives of ICH in Sweden, consisting of personal archives with manuscripts, diaries and other literary remains. One is from the motion picture director Ingmar Bergman and the other from the author Astrid Lindgren. Both are considered to be part of the ICH of the world.

In the autumn of 2009 an official report was presented to the Swedish government with the recommendation to ratify and enter into the 2003 Convention, the process of which was completed by Sweden in December 2010 (ratified 26 January 2011). Ratification means that our national legislation must be adjusted to meet the Convention's framework, its intentions and the guidelines for safeguarding ICH that it puts forward. The Swedish government has given five authorities (among which The Institute of Language and Folklore has the head responsibility) in the heritage sector the task of constructing the general outlines for handling and adapting the Swedish legislation to the Convention for ICH. During this work, discussions have been devoted to selecting criteria to identify cultural heritage, how to evaluate its various manifestations, and how to handle ICH in particular.

What plans are being made with respect to safeguarding ICH at the national/regional/local levels in Sweden?

There are no official national plans presented so far, since Sweden has only recently completed the ratification process. However, the first official report (2009) was circulated widely amongst authorities, institutions and NGOs in the cultural heritage sector. However, the report – unfortunately in my view – avoided raising the specific issue that ICH is a constantly living and changing heritage. This dynamic nature of ICH was mentioned, but not analysed in the text.

At the regional and local levels there are many examples of actions and standpoints, showing a growing interest in ICH as a concept of transmission and transformation.

A very good example of this is seen in Laponia, where attempts are being made to create acceptance (or at least a sort of concordance) between the regional authorities in the region of Norrbotten and the Sami people living and using the land. Laponia, in northern Lapland, is the

largest designated World Heritage Site in Sweden. This sparsely populated area consists of extensive forests, mountains and marshlands covering 9400 square kilometres. It also has the greatest concentration of glaciers within the country. This is one of only 25 nature–culture combined World Heritage Sites in the world and it is one of four sites on the World Heritage List where Indigenous people still live.

Sami people are an ethnic minority and have the status of Indigenous people as a result of the United Nation's *Declaration on the Rights of Indigenous People*, from 13 September 2007. Today, there are seven modern Sami villages within the area. Reindeer stock-raising has been their primary source of income, which in some areas is still significant. While not all of the Sami people are herders, 300 herders live in these villages, keeping roughly 50,000 reindeer. The Laponia villages consist of large home communities stretching from the lowland in the coastal areas up to the mountains. The herders and their reindeer move seasonally within this area. The Sami show great respect to their natural resources and surroundings, contrasting strongly with the ways in which the settlers from the south of Scandinavia treated this land. The Sami culture has left few physical traces in the landscape. The archaeological materials show traces of human occupation dating from approximately 8000 BC; however, these traces are unobtrusive and difficult to see. When Laponia was designated by UNESCO as a World Heritage Site in 1996, opinion was divided about how to develop this large area whilst keeping all of its values intact. Reindeer husbandry faces increasing difficulties from the pressures of modern industry. In particular, water reservoirs and hydroelectric power plants have destroyed many migration paths in the landscape, which has resulted in the flooding of grazing lands. Infrastructural development, such as the construction of modern roads and railways, has also cut off the migration routes and caused damage to pasture areas. The land has suffered from deforestation, again diminishing the possibilities for reindeer husbandry.

Interestingly, the nomination for World Heritage status was welcomed by the Sami since the proposed declaration highlighted the high value of the traditional culture of the Sami people and the landscape where they were living. However, it can be argued that the World Heritage designation has profoundly affected the ICH of the Sami people. In recent years, conflicts between the Sami and regional and national authorities have increased. As Laponia was increasingly promoted as a World Heritage Site, where the most significant values consist of 'untouched' nature and wildness, the modern reindeer husbandry has been looked upon as an obstacle. This is mainly due to the fact that snow-scooters and helicopters are now used by the Sami for herding purposes. On the one hand, the authorities have tried to convince the herders that using more 'traditional methods' was most appropriate for maintaining the site. On the other hand, however, the Sami have argued that the use of modern breeding methods was crucial for their livelihood to survive.

After years of discussions and accusations between the two groups, a reconciliation process began with identifying the values they share in common, as well as generating a management plan for the World Heritage Site that could be accepted by all. These events marked the start of what, in Sweden, has become known as 'the Laponia process'. The process of negotiation and discussions has lasted roughly 20 years and is currently drawing to a close. One important key to the solution has been the identification of Sami ICH in its contemporary context. In order to sustain crucial reindeer herding and breeding practices, modern methods have been adopted, such as the use of snowmobiles, as noted earlier. The institutions and authorities fighting for preservation restrictions in the area have been forced to accept that sustainable preservation of Laponia is only possible if the Sami can continue to use the landscape for reindeer husbandry.

Only by regular grazing and moving herds within the area will it keep its specific appearance and qualities.

What are the responses from the public, academics and heritage sector professionals in Sweden to the 2003 Convention and the concept of ICH?

In the preliminary work towards the official report about Sweden's ratification of the ICH Convention, a web questionnaire was sent to 450 authorities, organisations and NGOs. Half of the recipients were museums and about 40 of them were organisations representing minority groups in Sweden (Sami, Jewish, Finnish, Mienkiäli, Romani). The majority of the respondents consider ICH to be valued equally with tangible cultural heritage. Inevitably interests and preferences differ between respondents. The organisations representing the minority peoples expect the Convention to enable minorities to define, interpret and express their own ICH and have the right to take care of archives and records on their own. Many of the museums indicated that they were struggling with a lack of financial resources to document modern life patterns, values and traditions as a result. Definition and identification of ICH is a common interest amongst almost all of the respondents. Many respondents stressed the importance of not only looking upon ICH from a preservation perspective but furthermore to include a perspective on utilising it. Still others spoke of the need to coordinate concerns about ICH with the European Landscape Convention and the Framework Convention for the Protection of National Minorities. The interest in ICH among researchers has also rapidly increased and ethnologists, folklorists and anthropologists are today more devoted to the production and construction of ICH and to what they as academics call 'memories'.

How are museums and heritage organisations involved in safeguarding ICH in Sweden?

Most of the Swedish museums – at all levels – are concerned with ICH and are currently discussing how to preserve and safeguard intangible values. This is often part of their visions and tasks. The regional and national museums have, according to their specific duties and tasks given by the authorities or the government, responsibility for ICH in their geographical or specialist area. Many of the regional museums document daily life in their region, which will mirror different perspectives on ICH such as traditional seasonal rituals, multicultural activities and life patterns among specific groups.

Since 1977 a network among the museums in Sweden called SAMDOK (Contemporary Documentation) has been working to support, connect and inspire the museums to maintain contemporary documentation. The SAMDOK secretariat organises seminars and workshops where issues of methods and ICH are discussed. Around 80 museums are members of this network.

At the national level, both *Nordiska Museet* and the Agency of the National Archives in Sweden, together with the Swedish National Heritage Board (NHB), handle ICH issues and are constantly involved in developing methods of safeguarding and possibilities for increasing the accessibility of ICH.

What problems do you foresee as emerging from UNESCO's guidelines for safeguarding ICH in Sweden?

In the text of the 2003 Convention, the issue of preservation versus use (and therefore transmission) is mentioned, but the Convention text lacks a clear position on the subject and no hints on how to solve this contradiction are given.

It is obvious that inhabitants of a local society are able to define their cultural heritage by themselves, and they do, even though they have no power to declare this right or to have their opinions officially approved. The right to self determination about what ranks as heritage ought to be a matter of course, but in a global or even a national perspective it is not. The preference and values of local people are often opposed to those of the experts at the national level and almost every time the experts' opinions will be decisive.

The ongoing discussions on the Convention will even more bring this question to a head. All culture in its intangible forms is continuously created and recreated in living social contexts. If the ICH is interpreted or replaced by objects and stored in museums and archives, it will lose its significance and meaning to people. Stored objects without history and without connection to human beings are impossible to understand. The same will happen with oral traditions, languages, dances, music, art and all performance culture if these cultural expressions are not practised and used by contemporary people.

In a world characterised by ongoing and increasing globalisation, the result will be more and deeper contacts between different ethic groups and more multicultural expressions. The rapid change from mono- to multi-culture in many European countries has highlighted the problem of how to define ICH, not only connected to ethnicity but furthermore to ways of life and various life patterns among people with different ethnic backgrounds living together at the present time. This is true in Sweden, where some 10% of inhabitants do not have Swedish-born parents, besides the minority groups of Finnish, Sami and Jewish people.

If there are any foreseeable problems, what alternatives could be used in order to safeguard ICH effectively?

There is always a risk that the 2003 Convention will be counterproductive and miss its main purpose, namely to safeguard ICH and to promote its varied values. This will be the case if the identification process is led by authorities and agencies who will define the ICH for people. Without a bottom-up process and involvement of the bearer of the ICH in every local case, there will never be a chance to preserve or transmit this heritage. Furthermore, there must be a high consciousness among the professionals in the museum and heritage sector on the vagueness and the permanent evolution of all intangible values.

Swedish legislation on preserving cultural heritage does not currently include ICH. The official report on Sweden's ratification of the 2003 Convention has presented an inventory of laws that give protection to some of the aspects of ICH. A few of these laws are directly relevant to different forms of ICH, for example the *Law of Protection of Designs and Trademarks* from 1970, the *Law of the Protection of Unusual Personal Names* from 1982 and the *Law of Protection of Language* from 2009. Without any specific legislation on ICH, safeguarding must always be made in reliance of the users in the present time and based on voluntary actions and decisions.

Are any alternative methods being used at this time in Sweden?

As mentioned above, there are initiatives both at local and regional levels, which show the importance of ICH. Nowadays initiatives such as ecomuseums and local industrial museums are good examples. The Local Heritage Movement in Sweden, together with some of the popular movements and their strong influence on society both politically and economically during the long period of Social-Democratic governance, are all dealing with ICH, but from different perspectives. If you chose to define ICH in a broad sense, those traditions of organising wide groups of people in self-steering democratic work would be counted as an important ICH of Sweden.

What are the strengths of the 2003 Convention with respect to implementing it in Sweden?

In the work of safeguarding culture heritage, Sweden has moved from only regarding objects and individual places as valuable to a far more overarching view, including all objects and places in a broader context and put in a frame of environmental areas and landscapes. As a result of this development into a more inclusive approach, reviews of individual objects and sites have included a review if their ICH intangible qualities have been observed as valuable and the qualities of ICH have been observed and described.

The overlapping benefit with the Convention for the safeguarding of ICH will probably not be found in the creation of general international regulations and laws, but rather in a growing consciousness of the double significance in all cultural heritages. Thanks to this growing awareness, heritage may in the future be understood and handled as one of the most fundamental basic elements in a sustainable society.

The Swedish National Heritage Board has, in its preparatory work before the ratification of the Convention, predicted the difficulties mentioned above. The Board has stressed the fact that expressions of culture, languages and traditions are in constant change, since they are in permanent use by people. It has recommended that UNESCO considers the close relationship between the tangible and the intangible cultural heritage when designating new World Heritage Sites. The Board has also pointed out the need to clarify the intangible cultural values embedded in the already-listed World Heritage Sites.

One of the suggestions is a proposal to change the Operational Guidelines for the World Heritage Sites in general in such a way that safeguarding and handling ICH will be included in the management plans. The so-called process of Laponia, as mentioned above, is an example of a successful way to include ICH in the management plan of the site.

Most important for the future will be to find possible ways of connecting the two Conventions and to find out how to work within their regulations without risking the protection of one form of cultural heritage at the cost of the destruction of the other. In my opinion the most desirable solution, though I consider it to be an unrealistic utopia, would be the fusion of the two different Conventions into one to safeguard both tangible and intangible values in the same document.

Even if the ongoing work with ratification of the Convention for safeguarding ICH has so far not led to any possible or visible incorporation, the ICH Convention will hopefully imply that the connection between the tangible and the intangible expressions of peoples and their cultures is given more attention and that this eternal relationship will be regarded as the base for all work with evaluation of cultural heritage in the future. This might lead to a relaxation of

the ever-present contradiction between preservation and use. Then we might agree on wordings which will express a means of careful use of our heritage. This is a way of promoting respect to both tangible and intangible cultural values and of respecting local variation.

Africa's Rich Intangible Heritage: Managing a Continent's Diverse Resources

George Abungu

Introduction

A frica is a continent endowed with a diverse and rich heritage that ranges from the cultural and natural to the immovable, movable and intangible. These manifestations are often intertwined through ways of living, believing, healing, dying and celebrating, to name a few. Most importantly, the heritage of Africa is also brought to life through the partnership of nature and culture, where the intangible gives meaning to the tangible and both provide Africa with its rhythmic cycles of life.

For centuries, Africa's diverse intangible heritage has shaped the world through processes such as diffusion, acculturation and influence, as well as through the movements of its peoples. The ICH of the continent is represented through a multitude of traditions, practices and beliefs. In particular, it can be found in the knowledge and wisdom of its elders, artists, artisans, builders and musicians, among many others. It can also be located in its poems and in the rhythms of its drumbeats, or in the sites of memory, historical landscapes and works of art.

Moreover, the ICH of the African continent, as dynamic and rhythmic as it is, is also delicate and fragile after suffering centuries of discrimination, destruction and displacement under colonialism and religious Puritanism. Yet, it is this very ICH that still defines the continent's many faces; it maintains cultural diversity in the face of numerous challenges posed by a fast, globalising world. It is a heritage that has its feet in the old and the new, and these lines between the past and present are as interwoven as the strands of a Zulu basket.

This chapter examines selected ICH of the continent in terms of their typologies and breadth, attributed values and management systems, as well as the continuities and discontinuities that have taken place as a result of the continent's history of slave trade, colonisation and other forms of subjugation, extraction, domination and resistance. Owing to this fractured and complex past, Africa's ICH has undergone various forms of valuing, mostly from the bottom up. The valuing of ICH has also occurred from the outside, where non-Africans, in particular, engage in interpreting (or misinterpreting) African cultures and often create the notion of a bygone heritage that does not belong to the present. This is evidenced in the conflict between African traditional practices and religions and the Western-introduced Christian religion, which has led to historical ruptures, as well as those in heritage/cultural practices. In the process of all these ruptures, Africa's peoples have learned to use the power of silence, where ICH often becomes the means for asserting power and retaining its place.

More specifically, there are numerous examples of cultural practices that were 'banned' by colonial powers but continued in secret places. In countries such as Benin, Kenya and Nigeria

these included different kinds of practices meant to nurture society's soul. Expression of these cultural practices, beliefs and knowledge systems often took place when most needed – during sacrifices, spirit propitiation and other ways of worship and interceding with ancestral spirits. It can be argued that the colonial powers, and their strong Christian faith in particular, encouraged an intolerance to fermenting intercultural dialogue that could lead to mutual respect for other peoples' heritage and values, including Africa's ICH, and has the potential for creating harmony among humanity.

Nevertheless, over the years, this intolerance of Africa's heritage, even by African governments, has also led to apathy and disdain for anything cultural. In many cases, this has led to a lack of support and recognition of culture as the foundation of thriving nations. Additionally, this apathy is often reflected in the lack of explicit mentions of 'culture' in most constitutions of African states (except at times by drawing from the rights engrained in freedom of conscience and beliefs and rights to freedom of expression and association). However, it is important to note that this anomaly is now being corrected in many African countries' new or revised constitutions. For example, Kenya's new constitution states that culture provides a basis for national cohesion and development (see Attorney-General of Kenya 2010).

In contrast, UNESCO, through its recent conventions and recommendations concerned with cultural expression, has come to recognise that heritage goes beyond the tangible and immovable of architectural and aesthetic significance to the areas of the intangible, memory and knowledge transfer. Since the beginning of the 21st century, the 2003 Convention and the 2005 Convention regarding Cultural Diversity have become landmarks in not only protecting humanity's diverse heritage but also meeting UNESCO's original goal of creating human understanding and peaceful co-existence among peoples by knowing and appreciating diversity. In this light, the continent of Africa provides an excellent platform for these discussions owing to its rich array of ICH.

Africa's Intangible Heritage and its impact on the world (reverberations across the world)

On this continent of many faces and contradictions, African peoples are known for their friendliness, charm, welcoming attitude and a forgiving spirit – even to the most hideous acts of oppression and subjugation by others. However, Africa is also not a continent of innocents. There has been a plethora of inhumane beliefs and practices acted out on one another; the atrocities in Rwanda, South Africa, Sierra Leone and Liberia can serve as examples. In any case, there is no doubt that, through its ICH, Africa has contributed immensely to the world of art, music, dance, sports, mathematics and civilisation in general.

Indeed, even though African art has at times been derogatorily cited by the West as being 'tribal' or 'primitive', it has not stopped mesmerising international art dealers, museum professionals and connoisseurs (Rodney 1973; Mazrui 1986; Davidson 1995). Moreover, various periods of artistic experimentation and development of specific art schools or forms have, at one time or another, been influenced by African art (North 1994; Davidson 1995; Meldrum 2006). For example, it has been noted that Picasso once admitted that he had reached the end of his creativity until he accidentally chanced upon a collection of African masks (North 1994; Meldrum 2006). When he saw the masks, it is believed he had a 'eureka' moment and claimed later that this was art taken to its highest perfection (North 1994; Meldrum 2006). It is no secret that

Picasso popularised the technique of African carvers through his paintings and thus revolution-ised Western art thereafter.

Furthermore, it is common knowledge that Western music is heavily influenced by African beats (Wilson 2001). In general, Africa has not only provided musical instruments, beats and dances but is also credited with revolutionising what is now considered 'Western music'. The talking drums, the *mbira* African finger piano, eight string *nyatiti* and one string *orutu*, and hundreds of other musical instruments, have contributed in one way or another to the musical heritage of the world. It is now accepted that the root of almost all modern pop music, jazz, blues, rock and roll, hip-hop and reggae has a direct connection to Africa. Indeed, through trade, slavery and other historical connections, there are unmistakable influences of West African village songs in church choirs throughout the United States, Latin America and, increasingly, in Europe and parts of Asia (Mazrui 1986; Wilson 2001). While in the latter two regions this music has spread through its popularity internationally, in the Americas the music traversed continents through the slave boats as thousands of Africans were transported across the Atlantic to work in the plantations of the West and Caribbean. With them they carried in their memory the songs and beats of the mother continent, possibly the only possession they could carry and subsequently recreate in their new-found homelands. Performers such as Michael Jackson, Ella Fitzgerald, Bob Marley and countless other international stars have all acknowledged their debt to African rhythms, melody and cadences. It is said that even Elvis Presley was first marketed as the 'white kid who could sing like a black' (Steyn 2003).

Often portrayed as the 'Dark Continent', devoid of any civilisation before the arrival of whites, it is certainly no longer a secret that a significant amount of the wisdom upon which Western civilisation rests, such as philosophy, mathematics, medical knowledge and various branches of science and arts, have their origins not with the Greeks, as is commonly taught, but in Africa (see, for instance, Newsome 1983; Finch 1983). There is also evidence that many of the Greek philosophers and mathematicians spent years studying in Egypt before returning to Greece to spread the knowledge they had learnt (Lumpkin 1983). If this is true, then Africa's knowledge systems have been of immense value to human civilisation. Africa's role as a pioneer of education and knowledge generation appears to be further confirmed by the existence within the continent of some of the oldest centres of education worldwide (see Van Sertima 1983). This is also a part of Africa's ICH.

Heritage, the intangible in the tangible: shifting shapes of power

As opposed to the Western world, it is difficult to discuss the tangible in the absence of the intangible in Africa. Often, it is not the physical manifestation that matters, but the meaning behind its forms and uses that is provided through its meanings, values and associated histo-ries. Nonetheless, Western scholars of the past, who followed in the tradition of the colonial powers and Judeo/Christian philosophy, have tended to define African heritage from within the physical domain and, thereby, divorced of the immaterial. Africa's ICH – be it songs and dance, rituals and rites, religion and religious practices, art and craft – were not regarded as important (although they were sometimes collected as objects of curiosity) and most were systematically destroyed and replaced by Western substitutions. Where tangible heritage was deemed worthy of protection, it was the physical attributes that were highlighted and, at times, the heritage was appropriated through some imagined theory of diffusion that traced its origins to a place outside

the continent. The following examples, which draw on various sites from throughout Africa, as well as nearby Mauritius, demonstrate the power of ICH, particularly those intangible cultural expressions and knowledge systems that are inextricably linked to heritage sites. In particular, the discussions examine how this power can be used for the control of – and struggle for – freedom of expression, belonging and identity.

GREAT ZIMBABWE

When numerous African countries gained independence they used their ICH, which included collective memories and symbolism, as a means to reclaim ownership of their histories, identities and pride of place. For instance, in 1980, an African country won its independence from colonial rule and renamed itself Zimbabwe from its colonial name of Rhodesia. It was seen as a patriotic act: choosing the name of a prime heritage site and not some wandering individual whose acts changed the political landscape in southern Africa immensely. This change of name was not only an act of re-contextualising a country and a people's identity but also served as a means of rallying the diverse groups together and asserting local ownership of its heritage as a symbol of pride, freedom and identity. To the locals, Zimbabwe was theirs – their ritual space as well as their shrine.

Interestingly, Great Zimbabwe was a heritage site used as a symbol of colonial domination, based purely on its architectural and aesthetic attributes to suit the colonial narrative of Africa. However, at independence, its value rose beyond its physicality to the intangible meanings and symbolisms associated with it by those who knew it most. Thus, it became a post-colonial point of reference for the reclamation of rights and identity that were once denied, based on the unwritten but accepted ownership of the heritage and its use by the people. With independence and the renaming of the country, there was the claim to rightful ownership of the land based on the people of Zimbabwe as the true inheritors of its heritage. Great Zimbabwe provided the best symbolic icon of this 'new' ownership, identity and legitimacy.

At first, the common person believed that all these changes would also bring a shift in ownership of the site from using it for touristic purposes to it becoming a sacred site and shrine. Nevertheless, as is often the case with appropriated heritage from local communities, the previous ruptures had created another permanent element: the site was no longer just the symbol of the Zimbabwe nation, but also a tourist attraction and a World Heritage Site open to all. As under colonial rule, the post-colonial Great Zimbabwe remains a contested heritage site, particularly in its use and interpretation. Accordingly, its use by the local community as a sacred and ritual space continues whilst bearing the characteristics of a prestigious research and tourism location.

With its nomination as a World Heritage Site, Great Zimbabwe achieved the status of being representative of our cultural diversity and, in turn, is considered universally important. The site no longer subscribes only to the local conservation approaches, such as access restrictions owing to its being a sacred and ritual space, but also to the international principles that allow people who are not vetted by tradition to place their footprints on the site in the name of research, conservation and tourism. Thus, it subscribes to the global language of a site of outstanding universal value from the point of view of its architectural and historical significance (aesthetic value), rather than the one prescribed by the local people of its deep-seated ritual and religious significance. This duality of meaning – one based on the 'scientific' recognition as a place of great architectural achievement and the other on the traditional use as a sacred and religious site

of utmost significance – has not, however, compromised the importance of this heritage and it remains the heartbeat of the nation.

The example of Great Zimbabwe demonstrates that because of the local communities' attachment to it as a sacred site, its historical experience as a site of disposition, segregation and subsequently a symbol of freedom loaded with intangible heritage acts, at a most basic level, as a barometer to measure the health of a country. It is a site with many histories, faces, uses, expectations and interpretations, but, even more importantly, it holds the spirit of the nation and its pride of place, demonstrating the power of heritage and how this can influence the political and economic as well as the social well-being of a country. While the tangible – the dry stone walling architecture – is the manifestation of the physical experience and knowledge of a people and a nation, the ICH is what provides the meanings and history behind the stone structures, as well as the spiritual, social and political attachments to the space and the means to embed it into the national psyche.

The Manyika

Zimbabwe is not exceptional. With regard to the rock art of the Manyika in Mozambique, the power of ICH defines not only the relationship between the local people and the powers that be, but also between the different power structures in the form of 'official' government and the 'unofficial' traditional authority that come with the control of natural phenomena. Here, the ICH is represented by the practices that are used in conjunction with the rock art as part of daily life. While recognised as national heritage, the rock art in Manyika is used as a medium in rain-making rituals. It is managed by a custodian whose responsibility includes carrying out the rituals and other spiritual interventions.

While researchers often see rock art as a scientific field of study that demonstrates human developments and achievements over time, the local community in Manyika view the rock art as a powerful sacred entity that can be used to cause rainfall and, as such, lead to good harvest. Most importantly, this is a phenomenon that ensures a good quality of life. In essence, it is a utilitarian sacred space with unspoken, and yet understood, features of supernatural proportions. Therefore, its significance rests not only on its beauty, aesthetics, colour or historical context, but on the very intangible qualities that can be deciphered solely through the spirit medium.

Owing to these intangible qualities that impact upon the lives of its local communities directly, the control, use and manipulation of the site leads to a contestation between the heritage custodian (traditional) and the government chief (official). Since the rock art is a medium for rain-making, and the local communities depend on rain for their well-being, the custodian is a powerful, respected person in the area, more so than the government chief. From the perspective of the Manyika communities, the heritage and its custodian are more valued than the government representative, who is perceived to be an authority imposing upon the local level without bringing direct benefits. The troubled relationship between these two parties defines the power and authority of those competing forces and, thereby, the conservation of the heritage (in both tangible and intangible form) as a priority area. For a researcher to carry out any work on the rock art, they must not only get the permission from the custodian of the heritage, but must also adhere to the ritual practices associated with norms and behaviours demanded of people going into these places. Additionally, they must get 'express' blessings from the custodian either

directly, or through their representatives. These include libations around the rock art before any work can start.

This illustrates an interesting mediation process between different kinds of knowledge forms relevant to a site that is both sacred and of Western scientific interest. Moreover, the ability of the Indigenous knowledge and beliefs to assert its value within other knowledge systems and processes of valuing is an assertion that the 2003 Convention seeks to emphasise (see UNESCO 2003, Article 2). The assertion of Indigenous knowledge as power is based on the long-tested, practised and passed-over knowledge system that often is not written anywhere else and, as such, it is not accessible to Western heritage management systems. This demonstrates the great value of ICH and its interrelationships with all other forms of heritage and particularly with the people who practise them. Most significantly, it is an area that 'Western thinking' is grudgingly beginning to accept.

MOUNT KENYA

Mount Kenya, the second tallest mountain in Africa, is known for its rugged top. As a World Heritage Site, it has been recognised for its natural beauty and diverse ecosystem. To the local communities, this mountain, or 'Kirinyaga', from where the name Kenya originates, has always been an important ritual and religious space because it is viewed as the home of their God, 'Ngai'. Nevertheless, as a result of the alienating practices of the colonial period, local communities were separated from these lands and spaces of spiritual significance. Mount Kenya became, and has remained, a nature 'reserve', protected from its true owners and users, those who embody its ICH. Specifically, the site has been re-contextualised to reflect, as well as highlight, only its physical and natural values, eliminating all of the cultural and spiritual attributes imbued by its local communities. This omission, which can be found in numerous management plans and policy documents for protected 'natural areas', misinterprets landscapes and their connections to people (a phenomenon often referred to as the 'park mentality'), and, therefore, denies essential ICH. In this light, Mount Kenya has become a preserve of researchers and mountain climbers, a place where the local communities are not welcomed.

Despite this exclusion, local spiritual persons, including leaders and laymen, have been known to climb the mountain and various sects demanding usage have sprung up in defiance of authorities. For instance, within the last few years, a group calling itself 'Mungiki', who subscribe to traditional African religion, have claimed Mt Kenya as their holy place. The government has interpreted these demands as a challenge to its authority, which has resulted in numerous clashes between the police and the adherents of the Mungiki sect who want access to their 'higher altar'. Moreover, a number of deaths have also been linked to these battles for control of the site. In essence, the sect realises the power of the ICH embedded in the mountain and any sacrifice in gaining access – including the loss of life – is deemed worthy. Here, in the re-contextualisation of Mt Kenya and the subsequent denial of its locally derived ICH, the government decides why it is important. In turn, only natural and aesthetic values have been attributed to it and, thus, it becomes 'threatened' by the cultural activities of the Mungiki and other similar groups.

This particular example illustrates the circumstances in which new meanings can arise as uses and contexts change. As a way of reasserting their past, the Mungiki uphold ritual and religious practices such as tobacco sniffing, oath-taking and oathing, which are considered, within Christianity and by extension the government, as unacceptable. In any case, these practices are popular

with the youth, particularly those who are unemployed and who feel culturally and economically dispossessed. It is believed that there are nearly 5 million members of this sect in a population of 38 million, a significantly large group who seek to reaffirm aspects of their identity that are held in this 'denied' ICH (Abungu 2008a; 2008b).

MAURITIUS

Intangible heritage – whether associated with a form of tangible heritage or remaining as practice or memory – can play a major role within the national psyche, especially in the politics of identity, belonging, representation and equality. For instance, it has been suggested that Mauritius, a small island state in the Indian Ocean, had no human population until the Portuguese discovered it in the 16th century (Blackhouse 1844; Pridham 1849; Grant 1862). In the following decades, European farmers settled there and their black slaves from mainland Africa tilled the land as it became a sugarcane-growing country. Over 200 years ago, some slaves, tired of exploitation and providing labour for free, rebelled against their masters and escaped to the only place where they could not be traced, Le Morne Mountain. In the difficult terrain of this mountain area, they made their homes and became known as 'maroons' (Teelock 1998; Teelock and Alpers 2001).

In later periods after the abolition of slavery, the colonial British authorities substituted slave labour with cheap immigrant labour comprised of indentured servants from India. Large numbers of people were brought to work on the plantations under extremely difficult conditions. All of them entered into Mauritius at a place called Aapravasi Ghat, in the capital, where they were discharged to the various plantations across the island. In the early 20th century, Aapravasi Ghat took on a new role as a sacred place to the descendants of the indentured labourers. In this light, it became symbolic of their suffering and, most significantly, the triumph of exploited groups of people who survived the vagaries of a new and unknown place to become the ruling majority of the country.

In contrast, Le Morne was viewed as a symbol of resistance to the exploitation and oppression by one group over another: the white colonial farmer over the black/Creole slave. It was perceived by those who claim slave descent as not only a symbol of their suffering but also a statement of defiance in the face of cruelty and harsh conditions. Their resistance was interpreted as a longing for freedom of both the mind and the body. In 2006, Aapravasi Ghat became a World Heritage Site particularly because of the role it plays as a memorial place of forced labour, suffering and the survival of the human spirit. At the time, there was a significant amount of pressure on the Mauritian government to include Le Morne on the list in order to balance the ethnic, historical and linguistic equation. Similarly to Aapravasi Ghat, Le Morne did not qualify for World Heritage status on the basis of having only unique physical attributes. Instead, Le Morne was viewed as calling upon the memory of the place as a site of slave refuge and of outstanding human suffering, as well as, subsequently, a place of independence, human freedom and dignity.

At independence, the Mauritian nation had declared the maroons the first freedom fighters, since their battles began 200 years ago. Le Morne is also celebrated on the Mauritian National Day of Commemoration as the place where Creole music was first staged after independence, owing to the fact that it had been prohibited by the colonialists for years on the basis that it was music specifically created for political agitation. The Rastafarians, a growing force in Mauritius, had also appropriated Le Morne as their sacred site.

However, even though Aapravasi Ghat is younger and smaller in size, it was inscribed onto the

World Heritage List before Le Morne. In turn, this became a politically complicated issue in a country where a delicate balancing of ethnic interests is essential. To the politicians, it became an issue of ensuring that the narratives of differing groups are represented on a national scale. Could people mistakenly interpret the listing of Aapravasi Ghat before Le Morne to mean that the government of the majority, who have Indian roots, was neglecting one part of the society? If so, could people be forgetting that the African slaves built the foundation of the country with their sweat and blood? Following the listing of Aapravasi Ghat, heritage discussions became a national priority; it was clear that Le Morne had to be included on the list and nothing was spared in doing so. This was a point that the two dominant, yet differing, political parties had agreed on.

While Le Morne deserved to be a World Heritage Site and was well prepared for this recognition, it was the delegation that attended its inscription that was truly remarkable. Often, countries do not send more than two ministers to the committee deliberations and, in most cases, it is just one. However, for Mauritius this was different: four ministers were in attendance, led by the minister for justice. This time, instead of crying with emotion when the site was listed, as was the case with Aapravasi Ghat's inscription, it was a happy *fait accompli*. A few minutes after the listing, both the president and the prime minister had been informed accordingly. The nation was at peace again. The state of potential conflict that had prevailed following the listing of one of the competing two sites had been negated and everybody's heritage interests and rights had been officially acknowledged. Since then, Mauritius has not proposed any other sites and, as such, not a single minister has had to attend the subsequent World Heritage Committee meetings. Instead, the delegation is comprised of not more than three people under the leadership of the assistant principal secretary in the Ministry of Arts and Culture.

The listing of both Aapravasi Ghat and Le Morne as World Heritage Sites provides an example of the central role heritage, as represented by its intangible elements, can play in a nation's politics of power. In the case of Mauritius, it was deemed that if Le Morne did not make it to the list, disastrous political consequences could follow. The cost of developing a good nomination dossier and sending four ministers to Paris to defend a national cause was not taken for granted. Here, heritage matters as national reconciler, as well as in creating a balance within the political discourse. In this case, it was the intangible, the hidden meanings and symbols of a people's struggles and triumph, that propelled these events forward.

ROBBEN ISLAND, SOUTH AFRICA

Robben Island is a textbook example of why, and how, heritage plays a significant role in a nation's national psyche. Specifically, heritage has been used to call upon a place associated with important events and experiences to create a certain sense of national identity and cohesion. From its origins as a pit stop for the Dutch for provisions and stocking of fresh foods on their way to the East during the 17th century, Robben Island has become a place of many histories, including its most prominent use as a site for confinement and punishment.

In the 17th century Robben Island was used to confine those who resisted colonial and other forms of occupation by the Dutch, being the place where the first leaders of resistance to Dutch occupation, not only from the Cape but also from Eastern colonies, were jailed. Subsequently, it also assumed the role of a place where the weak and the sick were confined, both as a colony for people living with leprosy, and as a place for the mentally ill. During World War II, the island served as a garrison, with some of the largest guns mounted in the southern part of Africa, to

protect the British and their allies' interests. In its later years, however, it served as a prison, for both common law offenders and political prisoners. Today, it is best known for its role as a place of confinement for political prisoners who opposed the racist regime during Apartheid and who, subsequently, contributed immensely to freedom in South Africa.

It is on the basis of this history of struggle against racism and discrimination, and what has been referred to as 'the triumph of human spirit' (Kathrada 2004), that Robben Island was listed as a World Heritage Site. Nevertheless, it is a site with numerous layers of history and is a good example of how heritage can be created, crafted and selected to meet the demands and needs of the time and of a people seeking healing and transformation.

When studying the narratives and interpretations of the Robben Island Museum, one can contextualise them within the new nation's history. The need for a message of reconciliation and forgiveness underpinned the initial years of the narrative, but as time passed, and more research was conducted, the nation began to question itself in terms of reconciliation and what it means within contemporary conditions. This inquiry led to a slow movement in modifying the presented narratives to be more inclusive of diverse and conflicting stories – hence the emphasis on 'multiple narratives' (Prins-Solani, *pers comm* 2006; Abungu *et al* 2006).

In turn, 'resilience', rather than 'triumph', became the key message of Robben Island. This notion was viewed as essential for understanding the nature of the interpretation of the past within the present context. How does the present influence the narrative and what stories should be highlighted? Was it not critical for a nation that was poised to obliterate itself through civil war to emphasise and focus on reconciliation and use the very powerful symbolism of Robben Island to rally people behind this effort? Moreover, as the nation evolved under different leadership, spaces for debate and difference were encouraged, which, thereby, allowed for the spaces within the narrative to broaden, as well as become more inclusive, without the fear of creating civil strife. Was it not necessary in the new nation to create clear boundaries between what was right and what was wrong? In essence, a turning away from the past requires a repositioning of that which was moral. Most important to this process is the value of the intangible as memory. It is the associated ICH that helps to create a new national identity, self-articulated and based on symbolism and iconography that is selected, rather than being externally imposed.

Indeed, as the ticket sales continue to rise and the story being told is increasingly sought, Robben Island is considered to address national needs such as job creation, social well-being, reconciliation and justice, as well as broader historical social/economic agendas and rhetoric. Thus, like elsewhere, heritage has continued to be created, crafted and selected to meet the needs of both local and global contexts. However, it is important to remember that the stories of Robben Island are based on a whole range of narratives and depend on the issues being addressed. In any case, while the built heritage is certainly significant, without these intangible elements the impact would not be as forceful.

ELMINA AND CAPE COAST, GHANA

In Ghana, the World Heritage Sites of Elmina Castle and Cape Coast Castle stand out as national symbols of Ghana's long-standing position in global trade as well as places of remembrance. These two castles were built by the Dutch at the end of the 15th century to act as the stepping stones to the rich interior of Ghana, which then became known as the Gold Coast owing to its rich gold deposits. Later, they served as the military and trade garrisons for the exploitation

of gold and slaves from the interior of Ghana and West Africa. These remainders of European exploration and subsequent conquest have become remnants of not only the European footprint but also of past European actions, including the slave trade. However, these sites are valued by different groups of people for a variety of reasons.

To the Ghanaians, the sites are viewed as national treasures, World Heritage, tourist attractions and symbols of globalisation that has been achieved long before other parts of Africa. They are the representation of a glorious past: of wealthy and well-organised societies of royal splendour and power capable of negotiating and working with other powers of equal weight. These are the heritage sites visited by dignitaries, including presidents from across the world on official visits to the country. For instance, the president of the United States, Barack Obama, visited Cape Coast in 2009. One wonders whether the son of a Kenyan man and an American woman with his wife and daughters of African American descent, as they walked the grounds and the rooms within the castle, had the same feelings, experiences and expectations between themselves and between them and the Ghanaians.

It is common that a large number of African Americans who make the pilgrimage to these sites that saw their ancestors shipped forcefully to the New World are overcome with emotion. Visitors view Elmina and Cape Coast as symbols of the loss of hope – the separation of people from their land of birth and subsequent oppression and forced labour in new and unknown places. In essence, they are a symbol of suffering and death. It is said that even the painting and maintenance of the buildings that make them look 'presentable' has attracted the ire of some of the descendants of the African enslaves, who see such acts as glorifying the past mistakes and rewriting history to portray an image of the conditions of slave trade and slavery as clean and 'pretty'. The question here is how should the story be told and, most importantly, by whom? How does one deal with these intangible features? In this case, it can be argued that the ICH of these two sites consists of deeply felt sentiments, meanings and stories that are not often written, but that undergo various stages of narration and reinterpretation. These aspects of ICH are given new meanings and are forced to meet new demands as decision-makers and needs change.

ICH PROGRAMMES IN KENYA

What is most important to stress is that ICH can be a tool that is used for political expediency and economic benefits, as well as the empowerment of people at a whole range of geographical scales. In this sense, ICH can be used to rally or divide a population, as noted throughout the earlier examples. Its meanings and uses can also change as a result of the processes of conceptual construction and deconstruction, contextualisation and re-contextualisation.

From the 1990s, the National Museums of Kenya partnered with international organisations, such as the United Nations Development Programme (UNDP) and the International Labour Organisation (ILO), to set up a centre for the revival and development of Swahili culture. The museums, working in the preservation of Swahili heritage on the coast of Kenya, had realised the potential of Swahili ICH in particular and enhancing their heritage, in general. However, the museums also recognised the danger that was posed to Swahili ICH through the potential loss of knowledge in arts, craft and masonry.

Working with the development partners, the museums established what has become known as the Swahili Cultural Centre in Mombasa and Lamu, where young men and women from the older part of these two towns are trained in the development of various arts and building tech-

niques as part of protecting the tangible and intangible heritage of the Swahili. The same people are also trained in business studies and, therefore, are more equipped to start their own businesses when the training is completed. Through this programme, training in heritage has created a pool of young people who have become qualified in ICH skills and are now able to be employed in the building and art industries required for the conservation of towns and other items of material culture. Moreover, they have increasingly become self-employed and business entrepreneurs. Today, the knowledge of this ICH, which was otherwise disappearing at a quick rate, is contributing directly to the national economy through job creation, wealth creation, poverty alleviation and sustainable tourism development. It can be considered that this programme seeks to use the knowledge of the past in order to empower the present generation and ensure a better future for those to come.

Another example of how heritage has been used for economic benefits and social empowerment can be found with the Kaya Sacred Forests. These forests are one of only six World Heritage Sites to have been listed under both the 1972 and 2003 UNESCO conventions. The Kaya Sacred Sites of the Miji Kenda people, on the coast of Kenya, are areas that are protected under traditional laws as well as by government legislation as gazetted sites. Recognised as World Heritage Sites in 2007, some of these sacred sites have been partially opened up for visitation and for various economic activities. In particular, Kaya Rabai, which is located a few kilometres north-west of Mombasa, has attracted support from various partners, including a number of embassies in Kenya. In addition to taking care of the sites physically and spiritually, the elders are also currently involved with economic ventures such as bee-keeping (honey production) and nursery development for forestation purposes.

In these brief examples, it is clear that heritage plays a role that ranges from the spiritual (intangible) to the economic (tangible) well-being of local communities. Nevertheless, it is important that such heritage is treated as a living body of mutable meanings and values so that any commercialisation or commoditisation activities are approached with sustainability in mind. This is even more significant for the heritage of sacred nature and places. Thus, all efforts should be made to ensure that the value of the heritage or place is understood and considered first before any commercial values are determined.

There is, however, no shortcut to achieving an ideal situation in heritage conservation; the process must include negotiations, consultations, community involvement and the spirit of inclusivity of all the stakeholders. It is through listening to many differing voices and needs that proper management systems, including appropriate legal frameworks, can be put in place to protect and conserve heritage, including intangible characteristics. From personal experience in partnering with communities in various areas of conservation – listing and safeguarding the Kayas and living towns of the Lamu World Heritage Site, working with communities to preserve their art and craft practices, including masonry and other Indigenous knowledge systems, and being an international consultant for assisting communities and governments in facilitating working heritage management systems – one principle has become very clear: one either places the people (stakeholders and/or communities) at the centre or one does not achieve the required ideal situation. Prioritising the involvement of local communities and other relevant stakeholders does not mean consulting with them once in a while and only when required; on the contrary, it means walking with them through the journey of brainstorming, planning and developing heritage management approaches, as well as co-managing with them. While this may not be the case in all instances, consultation and active engagement is the only way to success. This is even

more crucial when dealing with ICH, as it is engrained in the daily lives, memories, thoughts and practices of communities, groups and individuals.

Conclusion

As with almost every place in the world, there is a whole range of ICH in the form of songs, dance, folklore, storytelling, memories, meanings and values, to name a few, that forms the rhythm of the sounds of the African continent. In general, these expressions help to describe, valorise and facilitate the understanding of the heritage landscape of the continent, including those sites described earlier. Here, the approach has been to demonstrate the close link between tangible and intangible in the continent of Africa by discussing more of what I term the 'intangible within the tangible'. Thus, ICH is not confined to selected human actions and practices, but also can be expanded to include spaces, whether man-made or natural.

All heritages are fluid, dynamic and full of contradictions and contestations. Most significantly, it is through engaging with the heritage – and by reconstructing and deconstructing its meanings and uses – that it becomes alive, providing opportunities for dialogue and renewal according to the needs of time. ICH in Africa is certainly not cast in stone and cannot be boxed. It is intertwined with the movable and immovable, where no clear-cut lines and smooth edges can be discerned. Its meanings, uses and interpretations are part of processes of continual negotiation between various interest groups that include local communities, governments and other segments of society.

However, as dynamic and rhythmic as the ICH in Africa is, it is also delicate and fragile and requires recognition, nurturing and use for it to be alive and sustainable. The unique nature of African ICH, where the intangible and tangible are intertwined and the intangible gives meaning to the tangible, contributes to the continent's rhythmic circle of life and, therefore, needs to be maintained and promoted. It is undoubtedly this rich ICH that still defines the continent's many spirits, maintains the cultural diversity and continues to hold the knowledge and wisdom of the past in the face of a rapidly globalising world.

Part of this ICH has always been embedded in the form of the knowledge held by the elders. However, as the elders of the various 'nations' go through natural attrition and the systems of knowledge retention and transfer collapse as a result of various external factors, Africa continues to lose its knowledge base. Thus, the very libraries and archives held in the memory of the elders get 'burnt' through death and omission while little is being done to address this. The practice in Asia (notably Japan and Korea) of recognising and declaring wise elders as national treasures could be part of such a solution. Nevertheless, a lasting solution must come from the continent itself, from the communities at a grass-roots level. African states must find ways of ensuring the continuity of succession of elders and wise people for the benefit of knowledge development, retention and transfer over generations without stifling the inevitable changes taking place within and around the various 'nations' and societies.

It is important to note that the continent of Africa has always been a contributor to the world's knowledge development through its ICH. Indeed, Africa can be seen as a universal knowledge bank which every world citizen has a responsibility not only to utilise but to sustainably protect and preserve for now and for posterity. Its delicacy and fragility requires urgent management attention. Africa's ICH is our common heritage, a heritage of all humanity that the world has a responsibility to protect, share and cherish.

BIBLIOGRAPHY AND REFERENCES

Abungu, G, 2008a Archéologie, pillage et restitution: la destruction du futur de l'humanité, in *L'Avenir du passé. Modernité de l'archéologie* (eds J P Demoule and B Stiegler), Editions La Découverte, Paris, 154–70

—— 2008b Universal Museums: New Contestations, New Controversies, in *Utimut: Past Heritage – Future Partnerships, Discussions on Repatriation in the 21st Century* (eds M Gabriel and J Dahl), International Work Group for Indigenous Affairs and Greenland National Museum & Archives, 32–42

Abungu, G, and Abungu, L (eds), 2006 Africa: A Continent of Achievements, *Museum International* 58 (1–2)

—— 2009 *Lamu. Kenya's Enchanted Island*, Rizzoli, New York

Abungu, G, Prins-Solani, D, and Langa, P, 2006 *Conservation Management Plan for Robben Island World Heritage Site*, RIM, Cape Town, South Africa

Abungu, G, Ndoro, W, and Mumma, A (eds), 2009 Cultural Heritage and Law: Protecting Immovable Cultural Heritage in English-Speaking sub-Sahara Africa, *ICCROM Conservation Studies* 8, ICCROM, Rome

Appiah, K A, 2004 *The Ethics of Identity*, Princeton University Press, Princeton

—— 2006 Whose Culture Is It? *New York Review Books* 53 (2), 38–40

Attorney-General of Kenya, 2010 *The Proposed Constitution of Kenya* [online], available from: http://www.nation.co.ke/blob/view/-/913208/data/157983/-/l8do0kz/-/published+draft.pdf [22 March 2011]

Blackhouse, J, 1844 *Narrative of a Visit to Mauritius and South Africa*, Hamilton Adams, London

Davidson, B, 1995 *Africa in History: Themes and Outlines*, Simon and Schuster, New York

Finch, C S, 1983 The African Background in Medical Science, in *Blacks in Science: Ancient and Modern* (ed I Van Sertima), The Journal of African Civilizations Ltd, Inc, 140–56

Grant, C, 1862 *The History of Mauritius or the Isle de France, and from the Neighbouring Islands from their First Discovery to present time*, W Bulmer and Co, London

Kathrada, A, 2004 *No Bread for Mandela, Memoirs of Ahmed Kathrada Prisoner No 468/64*, Zebra Press, Cape Town, South Africa

Lumpkin, B, 1983 Africa in the Mainstream of Mathematics History, in *Blacks in Science: Ancient and Modern* (ed I Van Sertima), The Journal of African Civilizations Ltd, Inc, 100–109

Mazrui, A, 1986 *Africans: The Triple Heritage*, Little Brown and Co, New York

Meldrum, A, 2006 Stealing Beauty, *The Guardian* [online], 15 March, available from: http://www.guardian.co.uk/artanddesign/2006/mar/15/art [12 July 2011]

Newsome, F, 1983 Black Contributions to the Early History of Western Medicine, in *Blacks in Science: Ancient and Modern* (ed I Van Sertima), The Journal of African Civilizations Ltd, Inc, 127–39

North, M, 1994 *The Dialect of Modernism: Race, Language and Twentieth-century Literature*, Oxford University Press, New York

Pridham, C, 1849 *An Historical, Political and Statistical Account of Mauritius and its Dependencies*, T and W Boone, London

Prins-Solani, D, 2006 personal communication (meeting with the author), date unknown

Rodney, W, 1973 *How Europe Underdeveloped Africa*, Tanzania Publishing House, Dar-Es-Salaam, and Bogle-L'Ouverture Publications, London

Steyn, M, 2003 The Man Who Invented Elvis: Sam Phillips (1923–2003), *The Atlantic* [online], October,

available from: http://www.theatlantic.com/magazine/archive/2003/10/the-man-who-invented-elvis/2809/ [12 July 2011]

Teelock, V, 1998 *Bitter Sugar: Sugar and Slavery in 19th Century Mauritius*, Mahatma Gandhi Institute Press Moka, Mauritius

Teelock, V, and Alpers, E A, 2001 *History, Memory and Identity*, Nelson Mandela Centre for African Culture and the University of Mauritius, Mauritius

UNESCO, 2003 *Convention for the Safeguarding of the Intangible Cultural Heritage*, UNESCO, Paris

Van Sertima, I (ed), 1983 *Blacks in Science: Ancient and Modern*, The Journal of African Civilizations Ltd, Inc

Wilson, O, 2001 'It Don't Mean a Thing if it Ain't Got That Swing': The Relationship Between African and African American Music, in *African Roots/American Cultures: Africa in the Creation of the Americas* (ed S Walker), Rowman and Littlefield Publishers Inc, Lanham, MD, 153–68

The Silence of Meanings in Conventional Approaches to Cultural Heritage in Jordan: The Exclusion of Contexts and the Marginalisation of the Intangible

SHATHA ABU-KHAFAJAH AND SHAHER RABABEH

It is through understanding the meaning and nature of what people tell each other about their past; about what they forget, remember, memorialise and/or fake, that heritage studies can engage with academic debates beyond the confines of present-centred cultural, leisure or tourism studies. (Harvey 2001, 320)

INTRODUCTION

This chapter identifies the intangible as being memories and stories involved in the meaning-making process of archaeological sites that are generally referred to as cultural heritage. These memories and stories are shaped and reshaped by local communities' perceptions of, and experiences in, archaeological sites. They are also governed by contemporary contexts and cultures rather than intrinsic values that scholars assign to cultural heritage. In this sense, memories and stories anchor archaeological sites to the present and thereby transform them into cultural heritage. Thus, it is the intangible that makes the tangible material of the past meaningful for people.

This chapter weighs the anthropological approach to cultural heritage against conventional approaches. While conventional approaches are based on passive evaluation and 'scientific' intervention, the anthropological approach explores people's memories, stories, experiences and sense of place in order to define, evaluate and approach cultural heritage. Conventional approaches were recognised in the early ICOMOS conventions (ie Athens and Venice Charters) and were part of the colonial legacy in post-colonial contexts such as Jordan. While post-colonial contexts are embracing conventional approaches in their top-down management of cultural heritage, Western contexts are increasingly recognising the anthropological approach as a dynamic approach to the past and its material. This has been reflected in the latest ICOMOS charters concerned with cultural heritage (eg Burra Charter, Nara Document and Ename Charter).

The role of the intangible – that is, people's memories and stories – in establishing meanings for archaeological sites in the capital of Jordan, Amman, and the World Heritage Site of Petra is being investigated. Therefore, the chapter challenges the conventional approach to cultural heritage in Jordan that is based on excluding people and marginalising the intangible for being considered irrelevant and unscientific.

Excluding the intangible: marginalising culture, context and continuity in
conventional approaches

This chapter investigates meaning as 'organised structures of understanding and emotional
attachments, by which grown people interpret and assimilate their environment' (Marris 1986,
4). Meaning in this sense allows for the intangible – individuals' experiences, thoughts, feel-
ings and attitudes – to be approached as part of the mechanism through which the tangible is
perceived, identified and evaluated as cultural heritage.

Meanings developed for artefacts and objects in daily life are increasingly explored in cultural
studies. In these studies, culture is perceived, according to Raymond Williams (1988, 90), as a
way of life that represents certain meanings and values. For example, du Gay *et al* (1997, 3–4) use
the 'circuit of culture' to explore the meaning-making process of cultural artefacts. In this circuit,
meanings are constructed through a dynamic process that involves five key concepts: representa-
tion, identity, production, consumption and regulation. These concepts are inextricably linked
in a dynamic and interchangeable relationship that enables artefacts to acquire meanings and
therefore be part of a cultural industry.

Despite the usefulness of the 'circuit of culture' as an analytical tool, it focuses on artefacts
as commodities to be consumed. This chapter goes beyond the 'circuit of culture' by exploring
attachment to material of the past not as commodities to be consumed but rather as part of an
individual's place and contemporary contexts. It draws on different aspects of production and
consumption, such as stories and memories, in order to locate material of the past within its
contemporary contexts and to clarify the mechanism through which material of the past accu-
mulates meanings among lay people.

The definition of meaning as a 'structure of understanding and emotional attachments' (Marris
1986, 4) highlights individuals' interactive communication with objects as a fundamental prereq-
uisite for the meaning-making process. This structure of understanding and attachments can be
probed using Raymond Williams' (1977, 132–4) arguments about the 'structure of feelings'. In an
attempt to understand how individuals make sense of the world around them, Williams (1977,
132) identifies the 'structure of feelings' as:

> *characteristic elements* of impulse, restraint, and tone … with specific internal relations, at
> once interlocking and in tension … a *social experience* still in process, often indeed not yet
> recognized as social but taken to be private, idiosyncratic, and even isolating, but which in
> analysis (though rarely otherwise) has its emergent, connecting, and dominant characteristics
> [my italics]. (Williams 1977, 132)

Accordingly, creating actively lived and felt meanings is contingent on active interaction between
individuals and their contexts. Following Williams' (1977, 132) 'structure of feelings', one can
suggest that in order for any meaning to be constituted, a dynamic interaction between indi-
viduals and their surrounding contexts should take place. This interaction is governed by certain
elements – to be described in this chapter as cultural elements, as they stem from one's culture
(eg knowledge, beliefs, feelings and behaviour) – as well as the different contexts and cultures
within which this interaction takes place. As the meaning-making process is influenced by indi-
viduals' perceptions as well as contexts, they do not necessarily resemble realities, but rather
reflect individuals' understandings of these realities (Coser 1992, 26). Therefore, the meaning-
making process is a subjective process that involves people's stories and memories.

Interaction between individuals and their contexts, and the role of this interaction in constructing meanings for material culture, is increasingly recognised when defining cultural heritage. For example, Dicks (2000, 74–5) observes that material of the past hardly has a meaning in, and of, itself. Rather, meanings are generated through continuous encounters between individuals and their environment. In response to this interaction, meanings keep changing and developing through time and place, as well as from one individual to another. Hall (1997, 61) concludes in his study of meaning that 'it is us – in society, within human culture – who make things mean, who signify. Meanings, consequently, will always change from one culture or period to another.' In this sense, cultural heritage is identified as a social communication process in which material of the past is encoded and decoded according to influences from contemporary contexts and ways of life, as well as individuals' experiences and perceptions.

The interactive process of perception is fundamentally influenced by, among many factors, individuals' cultures, thoughts, knowledge, experiences, memories and feelings (Jencks 1969, 20). In Hall's (1997, 3) words: 'it is by our use of things, and what we say, think and feel about them – how we represent them – that we give them a meaning'. Accordingly, the meaning-making process is governed by the subjective aspects of life such as thoughts, beliefs, knowledge and feelings. This subjectivity is increasingly recognised in studies that acknowledge ethnographic and anthropological methods as being an adequate means to approach the past and its material (eg Low 2002, 31–4, 47; Mason 2002, 7; Loewenberg 1996, 3–4, 8; Layton 1989, 16). Such approaches are claimed to provide a dynamic alternative to the conventional, uni-disciplinary identification, evaluation and conservation of cultural heritage (Mason 2002, 7; Low 2002, 31).

The main purpose of any conservation activity is to maintain continuity of the past into the future. In this sense, continuity is an organising element that 'represents for an individual his identity; for a society its cultures; and for mankind, perhaps, the half-hidden outline of a universal philosophy' (Marris 1986, 12). Meanings of things are contingent on their continuity in life and, in many cases, meanings of life are derived from continuity of certain people, things and conditions (Hallam and Hockey 2001). This sense of continuity is inextricably linked to a sense of identity as it '[conveys] the ideas of timeless values and unbroken lineages that underpin identity' (Graham *et al* 2000, 41; see also Lyons and Papadopoulos 2002, 8; Lowenthal 1985, 62). Thus, continuity is an active element that provides stability to life by anchoring it to the past, and therefore contributes to individual as well as collective identities. The physical continuity of the past into the present is 'the basis for creating … a contact with the past that is direct and real' (Lipe 1984, 4). Thus, continuity provides direct and dynamic interaction, which is an essential prerequisite for meaning construction.

Therefore, meanings are governed by contemporary contexts and cultures. These factors are interrelated in a dynamic relationship as each of them influences the other. They act upon material of the past to deliver meanings. Far from being a reflection of intrinsic or socio-cultural and economic values that scholars developed to understand material of the past, contemporary meanings developed by local contexts and communities anchor material of the past to the present. This anchoring is crucial for transforming material of the past into cultural heritage.

This process of transformation came to the fore as a result of critical engagement with conventional approaches to the past and its material. The conventional approaches have their roots in Western theories and practices concerned with material of the past that are dated back to the Renaissance period (Cleere 1989, 7). They were the subject of many international conferences that were conducted under the patronage of, and adopted by, the United Nations Educational,

Scientific and Cultural Organisation (UNESCO) (Meskell 2002, 568) and the affiliated special-ised organisations, such as the International Council of Monuments and Sites (ICOMOS). The recommendations of these conferences formed charters such as the *Athens Charter for the Restoration of Historic Monuments* 1931 (Athens Charter) and the *International Charter for the Conservation and Restoration of Monuments and Sites* 1964 (Venice Charter). These charters played a vital role in sustaining and disseminating the Western theories and practices concerned with material of the past which were identified in these charters as cultural heritage. The charters have been adopted and applied to almost all the different cultural contexts in the world (Taylor 2004, 419). These approaches focused on the tangible aspects (ie monumentality and aesthetic value; see Athens Charter, Article 7a), and the acts of material preservation. Despite the importance of such acts, their conduction sacrificed cultural continuity for the benefit of highlighting the 'original' aesthetic value. Similarly, by acknowledging the original material and design as the main source of significance (see Venice Charter, Article 9) conventional approaches failed to recognise cultural diversity and continuity in cultural heritage.

Many scholars challenged the conventional approaches and demonstrated their inefficiency in different parts of the world (eg Price 2000; Byrne 1991; Wei and Aass 1989). This scholarly critical engagement is far from being the case in post-colonial contexts, where colonial legacies and representations were embraced (Byrne 1991, 270; 2005, 26). The following section exam-ines these approaches and their influence on the way the material of the past was perceived and approached in the post-colonial context of Jordan.

CONVENTIONAL APPROACHES EMBRACED: THE POST-COLONIAL CONTEXT OF JORDAN AS A CASE STUDY

The dominance of conventional approaches resulted in the marginalisation of local communities, contexts, cultures and knowledge, especially among marginalised communities and post-colonial contexts (Byrne 1991, 274; Wei and Aass 1989, 6, 8; Bowdler 1988, 521–2). Jordan is one of these contexts. Having the ultimate authority for 'identifying, recording, evaluating, and managing the Kingdom's archaeological sites' (Costello and Palumbo 1995, 548), the Department of Antiq-uities of Jordan (DAJ) started its work, since its establishment under the British mandate in 1924, with special interest in Classical monumental sites such as Petra and Jerash (Costello and Palumbo 1995, 547; Palumbo *et al* 1993, 70).

Interest in monumentality and aesthetic value was in most cases at the expense of other values of that past. Not only was the recent past neglected but the contemporary local communities were dislocated and marginalised if their existence contradicted with conserving and presenting monumental archaeological sites. A prominent example of this 'blind' interest in the ancient, mainly Classical, past is demonstrated in the government's decision to demolish the lively Ottoman village of Umm-Qais in 1967 in order to facilitate the archaeological excavation of the Greek, Roman and Byzantine archaeological sites in the village (Daher 1999, 37). Although this decision was reversed under pressure from local and international architects and anthropologists interested in the village, the inhabitants were eventually forced to evacuate their village in order to 'facilitate' the professionals' work in the archaeological part of Umm-Qais in 1976 (Daher 1999, 38).

Another example comes from the World Heritage Site of Petra. The rock-cut tombs of Petra, dated from the 1st century BC to the 2nd century AD (McKenzie 1990), have been inhab-

ited by the Bedu (sometimes referred to as Bedouin) since at least, according to historical and ethnographic data, the early 19th century (McKenzie 1991, 140; Russell 1985, 20). 'The Bedoul [one of the Bedu's families] of Petra', remarked Russell (1985, 17), 'obviously considered themselves distinct from other populations in southern Jordan by claiming descent from the ancient inhabitants of the site who had first carved the tombs and caves at Petra.' Therefore, the Bedoul claimed a strong attachment to Petra and saw their life in it as being a cultural continuity of the Nabataeans'. The Bedoul are now working in the archaeological site of Petra as souvenir shop keepers.

In 1968 a programme was launched to create Petra National Park. One of the first recommendations of the programme's plan was to relocate the Bedoul away from the site (Russell 1985, 30). Consequently, the Jordanian government built a new housing project for the Bedoul in the village of Umm Siehoun to the north of the ancient city of Petra and relocation of the Bedoul began in 1985 (Shoup 1985, 288), the same year Petra was inscribed as a World Heritage Site. In 1994 the government explained that the Bedoul must be moved again, as Umm Siehoun was to be converted into a tourist village (Simms and Kooring 1996, 23). Although Umm Siehoun was not converted into a tourist village, other traditional ones, such as Khirbet al Nawafleh and Taebet Zaman, were. The people of those villages are now living in scattered concrete houses that lack the intact character of the village that once shaped people's social and cultural lives.

LIBERATING CONVENTIONAL APPROACHES: CELEBRATING THE INTANGIBLE

UNESCO conventions concerned with material of the past underwent a dramatic shift after the Venice Charter. The *Australia ICOMOS Charter for the Conservation of Places of Cultural Significance* (the Burra Charter) is a response to contexts where the concept of conservation goes far beyond the acts of material preservation upon which conventional Western approaches concentrate their efforts. In 1979 – 15 years after the formulation of the Venice Charter – Australia ICOMOS established one of the first charters to be based on a specific context: the Australian context. The charter capitalises on the notion of place and its role in enhancing local communities' lives (Australia ICOMOS 1979).

The notion of place, as the Burra Charter introduces it, includes both the tangible and the intangible aspects of place (Australia ICOMOS 1979, Article 1.1). In this sense, the cultural significance is immediately derived from both tangible as well as intangible characteristics. This implies that the fabric of place is valued in the same way that memories and stories about place are valued (Article 1.2). This acknowledgement of the intangible resulted in the recognition of local contexts in *The Nara Document on Authenticity* (1994). This document emphasised approaches to cultural heritage as a 'bottom-up' process, based on interaction, cooperation and dialogue between professionals and local communities (ICOMOS 1994b).

A charter that was initially designed to address the way in which the significance of cultural heritage is communicated among lay people is the *ICOMOS Ename Charter for the Interpretation of Cultural Heritage Sites*. Meanings of cultural heritage, according to the Ename Charter, are approachable only through considering tangible and intangible values, natural and cultural aspects, as well as the different contexts of cultural heritage (ICOMOS 2004, 3). Because of this inclusive approach to meaning, the charter pays attention to social context, as it requires that technical and professional standards of interpretation should be appropriate for the social context in which it is practised (ICOMOS 2004, 4). The charter highlights cultural traditions as a source

of information that is crucial for the interpretation process. It considers local communities' involvement in interpretation programmes as one of the main principles on which interpretation should be based (ICOMOS 2004, principle 2). Therefore it acknowledges local communities and their contexts, experiences and knowledge as valid sources of meanings that can be integrated with the management process of cultural heritage. The charter sees that developing 'a sense of personal connection' to a cultural heritage place can be obtained only through emphasising the different meanings of that place (ICOMOS 2004, principle 3.6).

As the above-discussed charters demonstrate, Western approaches to the past were able to shift towards more inclusive and democratic approaches. Many Western scholars working in post-colonial contexts established strong relationships with local communities to facilitate their conventional approach of restoration. For example, Joukowsky (1998, 109), in her work at Petra Great Temple in Jordan, collaborated with Dakhilalleh Qublan, a member of the Bedoul, to consolidate the Temple. Qublan's work was also observed and reported by a local scholar, Rababeh, in his experimental study aimed at understanding the construction technique of Petra's monuments (Rababeh 2005). In this regard the ancient locals' knowledge and experience was a valid source of scientific information, as well as providing background on the general meanings of Petra's monuments.

However, the Western approaches that were adopted during colonialism and which persisted in the post-colonial context of Jordan hardly changed. On the contrary, they were fostered by the 'top-down' structures of the post-colonial governments. The persistence of 'top-down' approaches to cultural heritage in Jordan prevents local scholars from being part of the international debate about the intangible. For them, archaeological sites are either tourist destinations, or academic arenas, or both. Local contexts, knowledge and experiences are viewed as being completely irrelevant.

Moving towards more democratic and inclusive approaches in Jordan is challenged by prototypical concepts about local communities' attitudes towards archaeological sites. Local communities in this context are constantly perceived as a 'problem' that threatens material of the past. The main approach to this 'problem' is based on emphasising the need to spread public awareness of the importance of the past among local communities (eg Palumbo *et al* 1993, 72), or separating archaeological sites from the surrounding context by fences, which defines them as a territory belonging to the government. In this situation, it is unexpected that local scholars should explore archaeological sites as part of people's contemporary contexts, culture and issues. Therefore, the following section explores this unexpected area of research and questions the role of the intangible – the people's stories and memories – in constituting meanings for archaeological sites.

This exploration is based on fieldwork conducted in Jordan in 2004, 2008 and 2010. During this fieldwork the researchers conducted in-depth interviews with members of the local community of Amman and Petra regarding archaeological sites that exist within their contexts. To protect the identities of the interviewees, all names used are pseudonyms. Obviously, the language used to conduct the interviews was Arabic, the language spoken in Jordan, and the responses were then translated into English by the authors.

The responses given by the interviewees were in reply to the following main question and its subsidiary questions:

 1. What can you tell me about this *athar* (archaeological sites)?
 A. How long have you been living close to the *athar*?

B. What do you know about it?

C. What do you like/dislike about it?

D. Do you go there; why, how often, with whom, what do you do there?

E. Do you talk amongst each other about the site? What do you say?

F. Do you think this site is part of your culture and heritage?

'On the basis of their culture': reversing the 'top-down' and reviving the intangible

The archaeological sites about which the researcher interviewed members of the local community are small sites existing adjacent to the respondents' residences or workplaces in Amman, as well as the Bedoul of Petra (see above). The in-depth and interactive engagement with the respondents allowed the researcher to explore their cultural knowledge and the meanings they attach to these sites. The accounts demonstrate that the local community is fully aware of their exclusion from the practices concerned with the archaeological sites in question. However, this did not prevent them from being critically engaged with these practices, as well as with the tangible and intangible aspects of these sites.

Attachment to place is achievable through certain mechanisms that are based on the individual's capacity to experience a sense of control over a place. The ultimate attachment is expressed through the 'humanisation' process of place. This process anchors a place to private as well as public memories (Korpela 1989, 241). Whilst exploring cultural heritage in the Roman theatre in Amman (Fig 6.1), many respondents referred to the theatre as *Darajat Fer'on* (the Pharaoh steps). When asked about the reason behind this name, the following response given by Awwad, a 70-year-old male, represents an explanation widely accepted by the rest of the respondents:

> we know the *Room* [the Roman as mentioned in the Koran; the holy book of Islam] were here too. *Fer'on* [the Pharaoh] had his cities and theatres built in Egypt and maybe Palestine, but not in here. We call it [in reference to the theatre] *daraj* [steps] because it looks like *daraj*, and we ascribe it to *Fer'on* because we know *Fer'on* more than we know the Romans ... we know him very well ... he is mentioned a lot in the Koran, and he was oppressive and if he built *daraj* [steps] they would be like these you see in here.

Ascribing the theatre to a pharaoh is influenced by people's familiarity with the name, brought about by the repetitive mentioning of pharaohs as powerful and oppressive characters in the Koran. Naming an archaeological site in this way is part of a process through which archaeology is accommodated in people's culture. It familiarises the past by allowing people's culture to have an influence on the meaning-making process of that past. Thus, the name transfers the theatre from a general archaeological site that belongs to an ancient culture into something that represents people's thoughts and ideas and that is directly influenced by their culture. In this case, giving the Roman theatre a specific name instead of the general one is evidence of strong attachment between the local community of Amman and the archaeological site of the Roman theatre. The intangible part of the respondents' culture – their knowledge, beliefs and thoughts – are part of the mechanism through which the tangible is perceived, identified and evaluated.

Similarly, a monument in Petra, identified as a temple (Rababeh 2005), is famously known among the locals, as well as the scholars, as *Qasr el-Bint* (the girl's palace). According to Umm

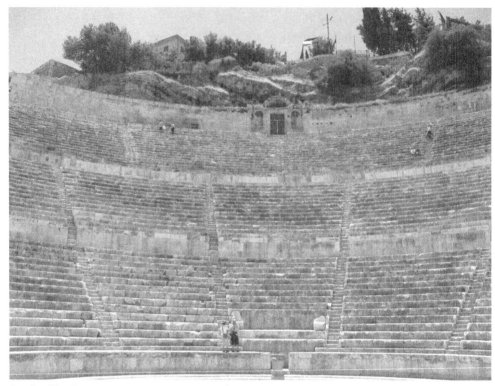

Fig 6.1. The Roman theatre in Amman, 2004

Rihan, a 50-year-old female, this girl was a pharaoh's daughter who was married to a Nabatean king, and the palace was her wedding gift. Umm Abdalla, a 30-year-old female, continues:

> The girl was so beautiful and the king has to impress her by building a palace for her that was not very different from her father's … We have lots of stories about the girl and her palace and servants and clothes, we tell them to our children. You might not agree, I know you won't. You people [scholars] have your own sources that are different from ours, but for us this place is about this pharaoh's daughter … Just like nowadays, the girl must marry from someone who is as rich as her father, otherwise the husband will feel less and the marriage will crumble.

Accordingly, the monument was not only 'humanised' by giving it a specific name and a specific story but also anchored to the present traditions of marriage. It represents an encounter between the physical environment, represented in *Qasr el-Bint*, and people's imagination, stories and traditions. Apparently, the local community's interpretation of the monument was faced with rejection from local scholars. This was evident when Umm Abdalla weighed her story against the scholars' interpretation. Regardless, Umm Abdalla, as well as another three female respondents, insisted that their story of *Qasr el-Bint* is very popular among the tourists who are 'lucky enough to tour Petra without a tour guide [and therefore] … mingle with us and talk about this place

without being guided by a man or a book' (Sana', a 20-year-old female). It is worth mentioning that the architectural style in Petra is strongly influenced by the ancient Egyptian architecture of the tombs (Rababeh 2005).

Another name that remained in the memory of Amman's respondents and shaped part of the recent history of Amman was *Jesr al-Khalaeleh* (al-Khalaeleh Bridge). Al-Khalaeleh is one of the families that have lived in Amman since the beginning of the 20th century. The bridge was one of the features of Amman that were lost during urban expansion in the city centre in the 1980s (Palumbo *et al* 1993, 78–9). A photograph of the bridge was provided by one of the respondents who said that he found it printed in one of his father's books, and was fascinated by the fact that Amman had a bridge and a river too.

Although it has been physically demolished, the memory of the bridge is still vibrant among some respondents. Umm-Mahmood, a 75-year-old female, recalled the time when the *ain* (a water spring) existed. She pointed out:

> Maybe it is hard to believe it now, because of the lack of water, it does not even rain as it used to be, but Amman had a river … Ain Ghazal [an archaeological site famous for its statues, which is a few kilometres away from the theatre and which literally means the water spring of the deer] was named as such because of the water … My brothers used to fish there. When I tell my grandchildren about this I can feel that they don't believe me. It is all gone. Even the bridge is gone … the family of al-Khalaeleh, I don't know any of them, but this is how we name things in our lives. Al-Khalaeleh is a big family in the country. Maybe they used to live beside the bridge, who knows?

The researchers failed to find any tourist signs indicating the location of the bridge or the 'famous' archaeological site of Ain Ghazal. Ahmad, a 45-year-old male respondent, commented on the absence of the bridge from the 'record' of the city by stating that 'the past does not matter any more, what matters is the *athar* that the tourists come to see. Who would care about a bridge that once existed in Amman, or a river that one day, until 40 years ago, crossed Amman?' Ahmad believed that the memory of the bridge might not be important for marketing Amman as a tourist destination; however, such a memory can 'give people hope … Amman can be again a land with water … you see, this memory is important for the future of Amman but the Government wants instant money from tourism'. The memory of the bridge is part of the process through which Amman is perceived by some members of the local community. However, the marginalisation of this memory prevents the younger generation, as well as tourists, from understanding the recent past of Amman and the inspiration that can be provided by this past.

Some of the respondents' accounts about the Roman theatre in Amman were derived from their memories as members of the Circassian community in Amman. The Circassians are Muslims from the Caucasus Mountains in northern Europe who were encouraged by the Ottoman Empire to settle in Jordan and to counterbalance the Bedouins (Conder 1892, 355). The Circassians mainly occupied Amman from the 1880s and, despite their small numbers, have continued to play an important role in many aspects of Jordanian society until the present day (Held 2006, 331; Massad 2003, 60, 218). The Circassians' settlement in Amman dominated the memories of the elderly respondents and constituted a crucial part of their attachment to Amman and its archaeological sites.

For example, Abu-Nart, a 68-year-old male, was born in one of the theatre's rooms in 1936.

Being born in the theatre is not a unique occurrence among the first generations of the Circassian community in Amman. The theatre is part of a more public memory that reflects their immigration from Caucasus and their settlement in Jordan as it was used by these immigrants as the first station for their settlement in Amman.

For Abu-Nart, this experience of immigration and settlement in the theatre captures the essence of his culture and therefore transforms the theatre into his own cultural heritage. He reflected on this experience as follows: 'we [the Circassians] carried our culture, our religion, and fled Russia where we were oppressed, we settled first in here [Amman and the theatre] and established our culture in Jordan and as part of Jordan, this is our *turath* [heritage] … the theatre has special place in our hearts not because it is the theatre you see, but because it is part of our *turath*'. Culture, in this account, exists out of place and therefore it enabled the Circassians who came from outside the Arab world to be accepted in other places as 'insiders' rather than immigrants. According to Abu-Nart, this meaning of culture as being independent from place enabled:

> people from all over the Arab world, from Palestine, Syria, Iraq, Saudi Arabia, and even from Europe like us [the Circassian] … to get together in Amman as one nation by that time. The history repeats itself, with what is going on in Iraq, as you see, many Iraqi people live in Amman, and if you stand in the theatre you will hear all the Arab dialects.

However, although the 'placelessness' of culture enabled the Circassians to be accepted in Amman, it was necessary for this group of people to anchor their culture to a place – the Roman theatre – which is, as the above account demonstrates, transformed through people's memories and stories from archaeological site into cultural heritage.

However, Abu-Nart noticed that these meanings of the theatre are not appreciated by the government. He explained that these accounts are 'not what the government wants to show to the tourists, they want to show them museums [in reference to the transformation of the theatre's rooms into display rooms for archaeological and heritage objects] and *athar*. They don't want them to see our *turath*.' Heritage, in this sense, is about the interaction between archaeological sites and people, and the life generated from this interaction.

Similarly, Abu-Ghaleb, a 63-year-old male, observed:

> The rooms where many Circassians, and maybe other immigrants and travellers, used to live, are now used to exhibit things … They [the government] don't want to remember that time when the theatre was alive and full of real people, now you see foreign tourists … In old days the theatre was full of real life, people selling and buying and running for their living, not a handful of tourists and young people who come here to kill their time.

The above account weighs the recent past against the present of the Roman theatre. According to this account, the archaeological site in the recent past was full of 'genuine' life in which people interacted with each other as part of their daily lives. The Roman theatre in this sense is an arena where life happened. This life was ignored in the recent intervention in the Roman theatre which focused on preserving the tangible objects and the 'original' past of the theatre, while the more recent and relevant one was excluded and absent from the interpretation signs.

In Petra, many members of the local community observed that the government ignores the recent past of Petra, and only emphasises the past which appeals to tourists. As mentioned

above, the Bedoul see their life as a cultural continuity of the Nabateans' (see Russell 1985, 17). Unfortunately, this meaning of Petra has been marginalised as it is considered irrelevant to the tangible cultural heritage of Petra. For example, Mahdi, a 25-year-old male, pointed out that none of the interpretation signs mention that the Bedoul lived in the caves of Petra until 1985 (see above). Mahdi's account in this regard resembles that of Abu-Ali, a 75-year-old male, who emphasised that:

> In Petra people complain about the fact that the Government and the tour guides do not explain to tourists how we, today, are related to those who built and lived in Petra 2000 years ago. All the work done in Petra [conservation work] is done to conserve the stones to attract more and more tourists. It does not matter what we think about that … We feel that we are part of the people who lived here, we are their descendants. They were traders, we are traders, they lived here, we are living here, in their own land, which is ours. But this is not what the government sees. They do not see us, they see only stones.

Therefore, the Bedoul's sense of identity is strongly derived from the Nabataean culture. This sense of continuity is worthy of acknowledgement by the government and the local tour guides. This acknowledgement can 'distinguish Petra even more as a place that still belongs to the present through the people who lived in it until some years ago, and who believe, deep inside, that this place was built by their ancestors, just like the modern Egyptian feel their ancestors built the Pyramids' (Adnan, a 35-year-old male). The bond established with the place of Petra is also evident in Abu-Ali's words: 'They were traders, we are traders, they lived here, we are living here, in their own land, which is ours.' This bond is part of the Bedoul's cultural traditions, which is, as the Ename Charter emphasised (see above), a crucial part of the interpretation process in any cultural heritage site. Neglecting cultural traditions means marginalising local communities, their contexts and their way of life. Despite the persistence of the conventional approach to cultural heritage in Jordan, the anthropological approach is evident in the locals' perception of, and attitudes towards, archaeological sites and levels of intervention in them. Bringing the anthropological approach forward is contingent on local scholars' recognition of locals' memories and stories concerning archaeological sites, and acknowledgement of them as being valid and relevant to the recent UNESCO charters.

Conclusion

Tangible cultural heritage is accommodated in people's lives through the intangible; people's knowledge, feelings, memories and stories. While the West is increasingly embracing the intangible as a tool to approach the physical remains of the past, post-colonial contexts such as Jordan are clinging to conventional approaches that perceive the intangible as being irrelevant to the 'science' of cultural heritage management. This perception prevents local scholars from engaging with local communities with regard to the archaeological sites within their contexts. The fieldwork conducted in this study challenges this perception. It provides examples of the respondents' mental interaction with archaeological sites on the basis of their own memories and stories. It is through these memories and stories that the archaeological sites in question constitute meanings that are relevant to people's culture and daily life. Such meanings might not be relevant to the tourism industry, but they are directly derived from local communities' culture. These meanings

'expand' material of the past beyond its physical nature and make it part of people's culture (ie cultural heritage).

Bibliography and References

Al-Asad, M, 2001 *The Socio-economic Dimensions of Conserving an Architectural Heritage* [online], available from: www.worldarchitectureorg/articles/alasad05htm [2 March 2003]

Bowdler, S, 1988 Repainting Australian Rock Art, *Antiquity* 62 (236), 517–23

Byrne, D, 1991 Western Hegemony in Archaeological Heritage Management, *History and Anthropology* 5, 269–76

Cleere, H F, 1989 Introduction: the Rationale of Archaeological Heritage Management, in *Archaeological Heritage Management in the Modern World* (ed H F Cleere), Unwin Hyman, London, 1–19

Conder, C R, 1878 *Tent Work in Palestine: Record of Discovery and Adventure,* Alexander P Watt, London

Coser, L A, 1992 Introduction, in *On Collective Memory* (ed M Halbwachs), University of Chicago Press, Chicago, 1–30

Costello, J, and Palumbo, G, 1995 A Program to Develop a National Register of Cultural Heritage Properties in Jordan, *ADAJ* XXXIX, 541–52

Daher, R, 1999 Gentrification and the Politics of Power, Capital, and Culture in an Emerging Heritage Industry in Jordan, *Traditional Dwellings and Settlements Review (TSDR): Journal of the International Association for the Study of Traditional Environments* X (II), 33–45

—— 2000 Dismantling a Community's Heritage: 'Heritage Tourism: Conflict, Inequality, and a Search for Social Justice in the Age of Globalisation', in *Tourism and Heritage Relationships: Global, National and Local Perspectives: Reflections on National Tourism* (eds M Robinson, N Evans, P Long, R Sharpley and J Swarbooke), The Centre for Travel and Tourism in association with Business Education Publishers Ltd, Sunderland, 105–28

Dicks, B, 2000 *Heritage, Place and Community,* University of Wales Press, Cardiff

Du Gay, P, Hall, S, Janes, L, Mackay, H, and Negus, K, 1997 *Doing Cultural Studies: the Story of the Sony Walkman,* Sage, London

Graham, B, Ashworth, G J, and Tunbridge, J E, 2000 *A Geography of Heritage: Power, Culture and Economy,* Oxford University Press, New York

Hall, S, 1997 'The Work of Representation', in *Representation: Cultural Representations and Signifying Practices* (ed S Hall), Sage, London, 13–74

—— 2005 Whose Heritage? Un-Settling 'The Heritage', Re-imagining the Post-nation, in *The Politics of Heritage: The Legacies of 'Race'* (eds J Littler & R Naidoo), Routledge, London, 23–35

Hallam, E, and Hockey, J, 2001 *Death, Memory and Material Culture,* Berg, Oxford

Harvey, C D, 2001 Heritage Pasts and Heritage Presents: Temporality, Meaning and the Scope of Heritage Studies, *International Journal of Heritage Studies* 7 (4), 319–38

Held, C C, 2006 *Middle East Patterns: Places, Peoples, and the Politics,* Westview Press, Colorado

Joukowsky, M, 1998 *Petra Great Temple, Volume I,* Petra Exploration Fund, Brown University, Providence, RI

Jencks, Ch, 1969 Semiology and Architecture, in *Meaning in Architecture* (eds Ch Jencks and G Baird), Barrie & Rockliff: the Cresset, London, 10–25

Korpela, K M, 1989 Place-identity as a Product of Environmental Self-regulation, *Journal of Environmental Psychology* 9, 241–56

Layton, R, 1989 Introduction: Who needs the past?, in *Who Needs the Past: Indigenous Values and Archaeology* (ed R Layton), Unwin Hayman, London, 1–20

Lipe, W D, 1984 Value and Meaning in Cultural Resources, in *Approaches to Archaeological Heritage: A Comparative Study of World Cultural Resources Management Systems* (ed H F Cleere), Cambridge University Press, Cambridge, 1–11

Loewenberg, P, 1996 *Decoding the Past: The Psychohistorical Approach,* Transaction Publishers, New Brunswick and London

Low, S M, 2002 Anthropological-Ethnographic Methods for the Assessment of Cultural Values in Heritage Conservation, in *Assessing the Values of Cultural Heritage* (eds M de la Torre and R Mason), Getty Conservation Institute, Los Angeles, 31–49

Lowenthal, D, 1985 *The Past is a Foreign Country,* Cambridge University Press, Cambridge

Lyons, C L, and Papadopoulos, J K, 2002 Archaeology and Colonialism, in *The Archaeology of Colonialism* (eds C L Lyons and J K Papadopoulos), Getty Conservation Institute, Los Angeles, 1–23

Marris, P, 1986 *Loss and Change*, Routledge, London

Mason, R, 2002 Assessing Values in Conservation Planning: Methodological Issues and Choices, in *Assessing the Values of Cultural Heritage* (eds M de la Torre and R Mason), Getty Conservation Institute, Los Angeles, 5–30

Massad, J, 2003 *Colonial Effects: The making of national identity in Jordan,* Columbia University Press, New York

McKenzie, J, 1990 *The Architecture of Petra,* Oxford University Press, Oxford

—— 1991 The Beduin at Petra: The Historical Sources, *Levant* 23, 139–46

Meskell, L, 1998 Introduction: Archaeology Matters, in *Archaeology under Fire* (ed L Meskell), Routledge, London, 1–12

Palumbo, G, Abu Dayyeh, A, Amr, Kh, Green, J, Kanan, R, Kraczkiewicz, E, Shartz, C, Shwemat, M, and Waheeb, M, 1993 Cultural Resources Management in Jordan, 1987–1992, *ADAJ* XXVII, 69–81

Price, C, 2000 Following Fashion: The Ethics of Archaeological Conservation, in *Cultural Resources Management in Contemporary Society: Perspectives on Managing and Presenting the Past* (eds F P McManamon and A Hatton), Routledge, London, 213–30

Rababeh, Sh M, 2005 *How Petra was Built: An analysis of the construction techniques of the Nabataean freestanding buildings and rock-cut monuments in Petra, Jordan*, British Archaeological Reports/Hadrian, Oxford

Russell, K W, 1985 Ethnohistory of the Bedul Bedouin of Petra, *ADAJ* XXVII, 15–35

Shoup, J A, 1985 The impact of tourism on the Bedouin of Petra, *The Middle East Journal* 39, 277–91

Simms, S, and Kooring, D, 1996 The Bedul Bedouin of Petra, Jordan: Traditions, Tourism and an Uncertain Future, *Cultural Survival Quarterly* 19, 22–5

Taylor, K, 2004 Cultural Heritage Management: A possible Role for Charters and Principles in Asia, *International Journal of Heritage Studies* 10 (5), 417–33

Wei, Ch, and Aass, A, 1989 Heritage conservation: East and West, *ICOMOS Information* 3, 3–8

Williams, R, 1977 *Marxism and Literature*, Cambridge Press, Cambridge

—— 1988 *Keywords,* Fontana Press, London

7

Conversation Piece: Intangible Cultural Heritage in India

Vasant Hari Bedekar

Can you say something about the diverse nature of India and its peoples in relation to ICH?

India's rainbow peoples represent great diversity and their ICH appears interrelated and interdependent. Archaeological and historical evidence has provided us with an understanding of the successive periods of Indian history, which in turn facilitates reconstructions of our cultural history. However, recent research has focused on the cultural study of distinct communities and has yielded valuable insights into the contemporaneous aspects of tangible and intangible cultural heritages.

Contemporary intangible cultural traditions have distinct observable forms and it is possible to consider them objectively as expressions of human behaviour. In India references are made to intangible cultural traditions in prestigious publications, but also in newspapers, which in my opinion are reliable bearers of evidence concerning the current patterns of individual and collective human behaviour.

Is language a very significant form of ICH in India?

Language is an important vehicle of intangible cultural heritage all over India and is common to all communities irrespective of their religion. Sanskrit is the oldest language, but we are unsure where it originated, whether in India or elsewhere. Its relation with the people who lived in India during different periods is now a matter of intense debate. Efforts are currently being made to document and conserve tribal languages; the magazine *Dhol* ('Drum') has been very active in this regard. These languages – which have no written form since they are transmitted only orally, but embody the life and society of ancient civilizations – are fast disappearing owing to a lack of developmental support from the Indian Constitution. As a consequence, no school or college is funded to teach these languages. Another problem is that younger tribal members are beginning to regard their own language as flawed or irrelevant. This rejection of the tribal language has a damaging effect on their identity and could potentially lead to the loss of their mother tongue. The Bhasha Research and Publication Centre of Baroda (BRPCB) has launched a drive to document these tribal languages and has begun to publish magazines for Adivasi languages and for nomadic Banjara and Charas tribes. The BRPCB organised a national conference in March 2010 to create awareness about the Indian languages threatened with extinction. Interestingly, the Indian census counts only languages which are spoken by more than 10,000 persons, yet in the census report for 1961, 1652 mother tongues were listed. Today, several hundred of these are

no longer traceable. It is feared that in the next 50 years we will witness the extinction of most of the languages spoken by the nomadic communities and tribal peoples.

There is linguistic disquiet among Indians because local people feel that their mother tongues are being neglected at state level. Many popular personalities in literature and the arts are increasingly rushing to the rescue of their mother tongues. Recently, a famous writer and columnist established a 'Matrubhasha Vandana Yatra' (salute to mother tongues) movement to encourage people to be proud of their linguistic heritage. He has reportedly stated that the idea for the movement was provoked by the news of a student studying in an English-medium school in Andhra Pradesh being forced to display a board proclaiming: 'I will never again speak in Telugu'.

Another example can be found in the recent loss of the last member of the Andamanese tribe, the Bo:

> An indigenous Andamanese tribe – Bo – has disappeared with the death of its last member. Boa Senior (85), who died last week, was also the last speaker of the Bo language, London-based indigenous advocacy group 'Survival International' said. The Bo were believed to have existed for 65,000 years, making them the descendants of one of the oldest human cultures. Boa's loss was a bleak reminder of what had been allowed to happen to other tribes of the Andamans who were ravaged by disease epidemics and robbed of their land when the British colonized the Andaman Islands in 1858. (Arshad 2010)

It is important to stress that the threat to native Indian languages is rooted in the spread of English, and not from one another; India now has more English-speaking people than England. An increasing number of people, including those in slums and rural areas, have come to the conclusion that English provides a 'passport to prosperity'. As a result, English-speaking schools are being constructed at a rapid rate and, subsequently, there is a drastic fall in enrolment at local language schools. In Mumbai, the Maharashtra state government is thinking of converting vernacular schools to English-medium owing to this increasing demand. Similarly, communities of Jain monks are switching to English to attract young people (Chhapia 2008).

It is a coincidence that I am responding to your questions on the International Mother Language Day on 21 February 2010. Several special events are being organised in India to celebrate the spirit of motherland and the significance of mother tongues, including poetry recitals and exhibitions of books at libraries. These can be viewed as being part of a protest against the dominance of English. India is a multilingual society and there is a need to recognise and validate plural linguistic identities. Currently, 22 languages are treated with equal status as the official languages of India, including Hindi. Pluralistic cultural diversity is also found in all other forms of intangible cultural heritage tradition, such as music, pictorial arts, literature, myths and legends.

You have mentioned the amazing diversity of language, but isn't this mirrored in religions too?

India is home to almost all of the world's religions. Hinduism is acknowledged as the most popular faith, with a multitude of differing intangible cultural expressions relating to myths, religious principles and practices. In particular, there are several interrelated varieties of Hinduism and innumerable sects. Such configuration is a combination of concepts as well as practices, which facilitate groups of people to worship several deities throughout their lives. It is said

that India has 3.3 million gods, which can be described as 'polytheism'. However, it can be argued that using the term 'henotheism' (or 'kathenotheism') is more suitable since it denotes the worship of a number of gods, one at a time.

Much of the complexity in intangible cultural traditions in India can be attributed to the ability of individuals, as well as groups, to tolerate the practices of fellow citizens in choosing their own religion, their own gods and goddesses. Such religious pluralism is exemplified in cases where individuals openly worship gods of several faiths. For instance, there is a story of *Hasti Bibi* (laughing lady) (Manish 2010), a Sufi saint who was given a gift by Allah, ensuring that whoever comes to her doorstep with worries will leave smiling. At her small roadside shrine in Ahmedabad, all kinds of people go for help on Thursdays from 6 am until midnight, where offerings of Jalebi (a popular sweet) are made by devotees. There are hundreds of these roadside shrines in all towns and cities across India, providing evidence of the popularity of Sufism. It is a mystical order specialising in ritual music and dance; thousands of pilgrims of all castes flock to the tomb of Khwaja Muin Al-Din in Ajmer for the annual Urs festival. Sufi philosophy asks individuals to free themselves from national, racial and religious boundaries, uniting them in universal brotherhood, encouraging love and understanding through self-denial and kind deeds.

Baroda was the place where the great Sufi mystic musician Pir Inayat Khan was born in 1882 and where he lived. He was a pupil of Professor Maula Baksh, who was founder of the first Academy of Indian Music in India. Even as a child Inayat showed flair for poetry, music and religion. He became a linguist, with remarkable mastery of several languages, including Sanskrit, Gujarati, Marathi, Urdu, Hindi, Persian, Arabic and English. He learnt vocal and instrumental music, considering it a sacred and divine art; he composed religious songs in praise of Hindu deities. Between 1900 and 1910 he toured India and came into contact with many musicians as well as Sufi mystics, and visited Europe and the USA, giving lecture demonstrations on Indian music, philosophy, mysticism and Sufism. We think of him as a champion of the intangible cultural heritage of India.

From what you describe, it appears that there is a widespread acceptance not just of other religions but also of other cultures. Is that true?

In India one witnesses a fanatical approach to the concept of cultural plurality. The founding fathers of the Indian Constitution wanted to avoid situations where more populous and more economically strong states could overwhelm others and the solution lay with the unification of the whole nation, encouraging the development of all states. Communities were encouraged to decide their cultural identities and evolve strategies to plan their material progress consistent with their chosen identities. The result is the rich variety of intangible cultural traditions. By and large the dangers inherent in majority rule and religious bigotry were avoided for the sake of tolerance, freedom of faith and co-existence.

During certain periods of history in India, centripetal and centrifugal forces appeared to be influencing both tangible and intangible cultural traditions. On the one hand, the styles of arts and crafts patronised by the emperors percolated to provincial and countryside areas, whilst on the other hand the intangible expressions were transported from villages to the metropolitan centres when artists were employed in the royal workshops. However, this hierarchical exchange has changed dramatically today and even long-held traditions are challenged. For example, the heroes of the epic stories and legends which were worshipped throughout India are subject to

reinterpretation; almost all those individuals who figured in well-known epics, legends and myths in which they are mentioned by name, their actions and roles, have been reinterpreted. Heated discussions continue in academic seminars and debates; they have been published and have even been the subject of televised debates. Some institutions have faced physical attacks by the champions of new ideologies because their members of staff express opinions contrary to those held by political organisations. Such behaviour is disturbing to those who value liberty and freedom of expression and runs contrary to the notion of the acceptance of cultural plurality I mentioned earlier. It appears that some aspects of intangible cultural heritage are in danger of being used as a propaganda tool for non-cultural, political objectives. This indicates that not all historical inter-community rivalries in India are forgotten and that there is sometimes tension amongst communities that wish to construct their identities on the basis of their intangible heritage.

Has the wealth of intangible cultural heritage been used to foster tourism in India?

All Indian communities have their worth in terms of income from tourism. The field of intangible cultural heritage requires minimum investment to become income-generating. It is also easier to recreate 'the mystic spell' if knowledgeable and clever people adopt appropriate strategies to use the intangible heritage to support the interpretation of tangible heritage at authentic sites. In the contemporary Indian situation the field has great potentiality but it also poses special challenges.

The challenges, I imagine, are due to the complex ICH associated with the main religions. Can you say more about this in relation to Hinduism?

All three mainstream religions have contributed to India's pool of intangible heritage. Such heritage is found in the ways in which people lead their daily lives throughout the seasons. Hindu rites, rituals, customs and traditions represent a rich intangible heritage. They include familiarity with the various gods and goddesses and the special days in the year when individual deities are to be worshipped. Hindus have evolved their own system of calculating time, have their own calendars and know the days of festivals and those dates auspicious for marriages. They have created their own astronomy which also serves as their basis for astrology and know the appropriate methods of decorating the deities with flowers and costumes. There are, for example, ten incarnations of Vishnu and a Hindu is expected to know the significance of each of them. Hindus regard the god Vishvakarma as an engineer amongst the gods and since machinery and equipment is used in industries and homes the blessings of Vishvakarma are sought before starting work.

Hindus hold nature in great reverence, revering 'mother earth', so farmers pay special tributes to land before using ploughs and woodcutters and ask the permission of trees before felling them. Rivers and lakes are sacred and each of them has an associated myth; Hindu girls are often named after the rivers of India. Trees are important too; indeed all Indian religions have special trees which are considered sacred. A leading botanist, Prof S D Sabnis, has even made elaborate plans for an arboretum which will contain all the trees revered by all religions (Chaturvedi 2009). Of course Hindus consider cows as sacred, being equated with motherhood and being an abode of gods. Similarly, many birds and the cobra are revered.

Indians believe in reincarnation and Hindus believe in the mythology of 84 lakh births, where

a body takes the form of a human being, 30 lakh births as a plant, 27 as insect, 14 as birds, 9 as fish, and 4 as other animals. A human form is considered as a stepping stone either to hell or to heaven and therefore should be used for spiritual progress during the four recognised stages of life of every individual. Of course, special significance is given to the intangible cultural heritage traditions connected with marriage, which is viewed as an opportunity for emotional harmony and the sharing of grief and happiness of each partner. Two families come together to continue the traditions of the community and assist the couple to develop a foundation for a home and separate family. However, many families compare the horoscopes of the prospective bride and groom to ensure a good match; compatibility is based on eight parameters, including mutual attraction and affection, health, intellectual attainment and temperament. In addition there are complex traditions and rituals to finalise marriages, with the usual highlight being the tying of loose ends of the scarves and veil. Interestingly, each community has evolved distinct traditions of conducting marriage feasts and the transfer of the bride to her new home.

Indian peoples frequently have to migrate in order to find work. What impact does this have on ICH?

India is a country where migrations have continually taken place; these are not simply movements of individuals but of whole communities. Intangible cultural traditions are one area of research that provides evidence for the routes of these migrations. Evidence is clearly observable in the contemporary lifestyles of people everywhere in India. For example, migrant labourers who leave their native villages to seek wages inevitably carry their songs, dances, culinary skills and pastimes; attempts to document such existing cultural expressions are being made by sociologists and other university researchers.

Migrant workers who travel small distances from their native villages regularly go back to pay respect, worship their own deities, or to take part in festivals. On these occasions it is possible to trace the routes of contemporary migrations by following the people, who often cover long distances on foot, in processions, singing folk songs and displaying their flags. The urge to undertake such journeys is culturally oriented, hence these pilgrimages offer significant intangible imagery of cultural relationships. However, nowadays it is not only rural people who undertake trips to remote places connected with religious traditions. Myths and legends have grown around such pilgrimage centres, and they are becoming the focus of a growing cultural tourism industry. The Indian diaspora has made a significant contribution to this specialist branch of tourism.

You mentioned horoscopes earlier. Is the significance of other ritual practices widespread in the country?

Horoscopes are commonly used all over India, not just for people but for new-born animals in public zoos, or to decide the titles of plays and TV serials (Pandya 2009). They are consulted for harvesting, for launching public projects and for filing nominations for election to assemblies and parliament.

All over India there are people who claim to be able to defend individuals against evil spirits. These so-called 'magicians' lure the gullible to offer sacrifices; at one notorious shrine in Gauhati, Assam, one may watch the sacrifice of hundreds of goats. The widely accepted myths of goddesses who took lives to save human communities offer respectability to such practices. India also has a multitude of public festivals that incorporate dances, dramas and songs which are supported

by powerful politicians and respected wealthy traders for the sake of popularity and the growth of their businesses. Witchcraft is practised openly, especially by people keen to gain money and prosperity.

The fear of the unseen and unknown is a natural experience, but the fear of one's fate after death is especially strong. All sects in India have evolved their own cosmologies in which post-death destinies of individuals are foretold, accompanied by ritual and myth. Practices at funerals also require adherence to strict codes which are part of our intangible heritage.

It seems then that ICH is really important to all people in India?

Intangible cultural heritage has assumed great significance in daily life in India, especially in relation to the dynamics of community identities which appear to be in flux. Each of the 2586 distinct communities uses their intangible cultural heritage to construct their identities. Any loss of this asset might endanger and weaken the very basis of identities. There was no problem in the past, when relative cultural isolation enabled them to retain their distinctiveness, but this is not the case today. Their economies demand the establishment of networks, and nothing remains hidden from the media and administrative authorities. Heritage has also acquired tourist value and any ethnic peculiarity can become a marketable item.

This search for distinctiveness and novelty has percolated into the fashion industry; enter-prising businessmen and photo-journalists have combed India to identify the unique, whether this be tangible or intangible manifestations of culture. What was beyond price has become marketable or a commercial commodity. This fact of life has to be taken into account by the champions of community identities. There is an important debate in India's heritage sector regarding authenticity and about the tensions between the genuine intangible heritage and their imitations – in dance, song or stories – provided for the tourist. Intangible cultural heritage activities and traditions need to be safeguarded by making full use of the UNESCO Convention. New relationships must be forged between the producers, guardians and consumers of intangible cultural heritages.

What is currently happening in India with respect to the 2003 Convention and its approach to safeguarding intangibles?

In general, India supports the aims and safeguarding measures that are promoted through UNESCO's 2003 Convention. This is most reflected by India's ratification of the 2003 Conven-tion in the autumn of 2005, several months before it came into force worldwide, as well as its involvement in the promotion of the Convention through several international meetings. In particular, a year before ratification, the UNESCO office in New Delhi hosted a meeting to promote the Convention and encourage its ratification amongst Asian Member States. More-over, in 2006, delegates from India participated in the first session of the Intergovernmental Committee for the 2003 Convention, where procedures for its implementation were discussed. In early 2007, an expert meeting concerned with elaborating the selection criteria for the two international lists, the *Representative List of the Intangible Cultural Heritage of Humanity* and the *List of Intangible Cultural Heritage in Need of Urgent Safeguarding*, was also convened by representatives from the Indian Ministry of Culture and UNESCO office in New Delhi. The

purpose of the meeting was to debate and draft criteria for deciding which ICH elements would be inscribed onto the two lists.

Furthermore, the process of nominating ICH expressions for international recognition on the *Representative List* has proved to be quite popular within the Indian context. At present, eight cultural practices have been inscribed onto the list. However, it is important to mention that three – the tradition of Vedic chanting, the Ramayana performance and the Kutiyattam theatrical tradition – were originally recognised through the Masterpieces Programme, beginning in 2001. In connection to the inscription, the Kutiyattam tradition, which represents a very old form of Sanskrit theatre from Kerala, is also subject to a UNESCO-sponsored safeguarding project. The aims of this project centre on creating networks of ICH practitioners and researchers to strengthen the practice as well as to expose it to new audiences and, thus, develop broader community relationships. The other five ICH listed expressions, which were selected in the past three years, concern folk song, dance and religious traditions from various areas in the country. One of the ICH expressions inscribed onto the list in 2009, Nowrouz-i Jamshidi, is a New Year's celebration that spans the geographical territories of Azerbaijan, Iran, Kyrgyz Republic, Pakistan, Turkey, Uzbekistan and India. While it can certainly be considered that this increased recognition may benefit the livelihoods of associated practitioners, the safeguarding projects and initiatives are still in their infancy and, thereby, any outcomes have yet to be assessed.

BIBLIOGRAPHY AND REFERENCES

Arshad, S, 2010 Andaman Tribe Bo goes extinct, *The Times of India*, Ahmedabad, 7 February, 9

Chaturvedi, D, 2009 Great message: A garden that promotes religious harmony, *The Times of India*, Ahmedabad, 11 February, 3

Chhapia, H, 2008 How Jain Munis are switching to English to attract youth, *The Times of India*, Ahmedabad, 12 May

Manish, K, 2010 Hasti Bibi likes Jalebis, Crest Edition, *The Times of India*, 20 February, 11

Pandya, H, 2009 In Rajkot, 300 cubs named by horoscope, *The Indian Express*, Ahmedabad, 10 April

Applying the Intangible Cultural Heritage Concept

Reflections on the Implementation of the UNESCO 2003 Convention for the Safeguarding of Intangible Cultural Heritage in France

CHRISTIAN HOTTIN AND SYLVIE GRENET

INTRODUCTION

For the past decade a team of French anthropologists have worked together under the auspices of the Ministry of Culture in the *Laboratoire d'anthropologie et d'histoire de l'institution de la culture* (LAHIC) and successfully developed numerous research studies on the anthropology of heritage – that is, the study of heritage objects and policies using the tools of anthropology. These efforts have contributed to a better understanding of the relationship that local inhabitants have with historical sites, the role of archaeology in society and the history and evolution of social history museums. Research has also led to seminars on 'heritage emotions', the collective responses to the danger and/or damage to monuments (Fabre 2000; Voisenat 2008; LAHIC 2010a; Fabre and Iuso 2010). One area that appears to have been largely ignored is the attitude of heritage professionals to their work within the sector, often framed within the language and ideals of 'projects' and 'assessments'; this is equally true for emerging concerns about intangible cultural heritage (hereafter ICH).

With respect to ICH, new possibilities have emerged from the fact that the 2003 Convention gives heritage bearers, as opposed to heritage professionals, a pivotal role in its safeguarding. Professionals and scholars must define for themselves new attitudes and outlooks that differ from the more conventional ways in which heritage has been preserved, particularly at the national level. New strategies are required, differing from the traditional museum-based paradigm of preserving, interpreting and displaying heritage, particularly as the 2003 Convention sheds new light on forms of heritage that, up until now, have been given little attention by the policies of States Parties. The Convention has created a structure for safeguarding which may be one of the reasons for its current high profile and its increasing national and global recognition (UNESCO 2011).

In light of these new developments, this chapter explains how a department situated within the French Ministry of Culture has begun to implement the 2003 Convention. It has been aided by the help of both past and present research conducted by historians and anthropologists active in the field of cultural policies, such as Chiara Bortolotto, Valdimar Hafstein, Laurent-Sébastien Fournier and Dorothy Noyes (Noyes 2003; Grenet and Bortolotto 2011). In the following sections, we examine how the notion of ICH within the French context has been dealt with in recent years, by both UNESCO and the French Ministry of Culture. In addition, the notion of 'community' in France is discussed in relation to the nomination of several intangible cultural

expressions for the international ICH lists and national inventory, such as 'French gastronomic meals', a Corsican singing tradition and the Aubusson tapestry.

Ethnological Heritage in France: a brief history

The administrative system responsible for anthropological heritage within the Ministry of Culture can be characterised in large part by the work of scholars, or scholarly societies, in understanding the threatened lifestyles of rural communities (LAHIC 2010b). Traditionally, these rural populations were studied using the same approaches as those used to research the lives of native peoples of the French colonies.

French anthropology has always had a close relationship with museums. For instance, at its opening in 1878, the Trocadero museum dedicated a space to French anthropology (Dias 1991). This association of anthropology with the museum sector began during the 19th century and continued for over a century. This relationship also found its footing during the *Front Populaire* and the creation in 1937 of the Museum for Popular Arts and Traditions (*Musée des Arts et Traditions Populaires*) in the basement of the new *Musée de l'Homme* (the latter being dedicated to more general anthropology). After World War II, the museum team, led by George-Henri Rivière, succeeded in launching some studies in the French regions testifying to its national mission (Marcel-Dubois *et al* 2009) and leading to the emergence of 'French ethnology' (Christophe *et al* 2009). For 30 years, the *Musée des Arts et Traditions Populaires* was the centre of the discipline; it followed a way of working that was structured by the relationship between the heritage institution (the museum), which collects and classifies objects, and the laboratory, the *Centre d'Ethnologie Française* (one of the main research centres of the *Centre National de la Recherche Scientifique* (CNRS)). When the museum opened at its new location in the avenue du Mahatma Gandhi in 1975, the '*Arts et Traditions Populaires*' movement was nearing its end; however, new initiatives, brought forward by other anthropological associations, ecomuseums and community museums, were beginning to flourish and, thus, this notion of 'ethnological heritage' was beginning to take on new forms.

As a result of this new movement, a council dedicated to 'ethnological heritage' was created in 1980 within the French Ministry of Culture, which was shortly thereafter assisted by an administrative 'mission'. According to the terminology used by the French Government, a 'mission' can be referred to as a service temporarily organised for the accomplishment of a precise task, or a long-term administration that is small in size and in charge of a peripheral field of action, such as that discussed here. Through teaching sessions, the *Mission du Patrimoine Ethnologique* (Ethnology Mission) sought to educate ethnologists concerned with cultural practices in France to use more efficient research methods. During the 1980s the 'heritage chain' of French ethnology became a rather loose framework, beginning with the definition of research themes to the diffusion of their findings and subsequent valorisation of ethnological heritage. The state, which widely patronises public research institutions like CNRS, universities and private associations, promotes research endeavours without constraining the ways in which they are carried out. Hence the approach to understanding ethnological heritage in France is representative of a system of state administration that is not based on specific laws; it differs greatly from how other forms of tangible heritage (such as archaeological sites and monuments) are identified, conserved and managed (Jacquelin 2008).

Consequently the very nature of the work of the Ethnology Mission is at odds with adopted

practices within the broader heritage sector. The complex information system of the Ministry of Culture relies on the accumulation of a substantial amount of data that have been structured according to practical formats that allow for comparative analyses; however, despite recent efforts, the studies produced in the field of ethnological heritage have almost always taken a more academic approach, with the production of memoirs and reports. These studies are then republished as academic articles, feature in conference papers and often result in books. This organisation of information is incompatible with the techniques used by the other heritage institutions, which seek to integrate heritage information on a national scale by collecting data in a standardised format.

Most significantly, the themes defined by the Council for Ethnological Heritage – originally similar to the investigations of the heritage sector at large, such as the heritage of rural life and industry – have shifted. They now focus on the anthropological examination of contemporary societies, but without taking into consideration the evolution of wider heritage policies in the French cultural field. Understanding this historical and organisational context of French ethnological heritage, and the body that has been created to define and study it, helps to explain why the Ministry of Culture has had significant difficulties in implementing the 2003 Convention. The following section examines these difficulties in more detail, emphasising the issues raised during the ratification process of the 2003 Convention.

Disharmonies between the French Ministry of Culture and UNESCO

In 2004, when, according to the anthropologist Jean-Louis Tornatore (Tornatore 2011), the Mission for Ethnological Heritage was 'at its worst', the process of ratifying the 2003 Convention was underway in France. He was specifically referring to the fact that the Ethnology Mission was lacking appropriate personnel, had little financial support and had lost its role in setting the policies of ethnological heritage in France. Despite these perceived problems, the Ethnology Mission was chosen as the relevant body for the implementation of the Convention owing to its concern for intangible aspects of culture, even though numerous other options for its implementation were available at the time. Between 2003 and 2008, the period of time crucial for launching the 2003 Convention, the following events occurred that are of particular importance: in 2003, the text was approved by UNESCO; in 2006, it was ratified by 30 States, including France, and the General Assembly formed along with the election of the first Intergovernmental Committee (UNESCO 2010a). French representatives were subsequently elected to the Committee, a tenure that lasted only two years but enabled France to play an important role in the framing of the notion of ICH.

During France's involvement with the Committee, several ordinary and extraordinary meetings were held: Algiers (ordinary, 2006), Chengdu (extraordinary, 2007), Tokyo (ordinary, 2007) and Sofia (extraordinary, 2008). In general, these meetings focused on formulating the Operational Directives, which can be viewed as the legal backbone of the 2003 Convention, enabling the application of its principles at an international level. In June 2008 they were approved during a General Assembly meeting with the participation of more than 110 States Members. The Istanbul Committee, which formed during a meeting in late 2008, opened the first normal cycle of the 2003 Convention's implementation.

Ministry Hesitations

In late 2007 the Italian ratification of the 2003 Convention was celebrated by two key events that revealed the political and academic nature of its text. First, an international conference was held at the National Library and brought together scholars, members of the national associations who represented local groups from particular towns and provinces, and intangible heritage practitioners (Central National Library 2007). Second, on the following day a large gathering of traditional folk groups and associations active in the ICH domain were invited to walk along the Imperial Forums Avenue. The conference and gathering serve to exemplify the importance of ICH for the Italian government.

In contrast, no such events marked its ratification within France. Even though a process for nominating intangible cultural expressions for the Masterpieces Programme (one of the precursors of the 2003 Convention) already existed, the only important event to raise public awareness concerning the ICH domain was the annual day held at the *Maison des Cultures du Mondes* within the *Festival de l'Imaginaire* (Tornatore 2011). This Festival aims to bring traditional music and dance from all over the world to the public. Nevertheless, this event lacks any direct links to the political process of increasing the visibility of ICH at the national level. Indeed, the process of designating certain expressions of culture as ICH within France has unfolded in a more discreet and unfocused manner. This is mainly a result of the fact that the 2005 UNESCO *Convention on the Protection and Promotion of the Diversity of Cultural Expressions* has garnered most of the attention of the Ministry of Culture.

Before being approved by the chambers of Parliament, the 2003 Convention was examined by the Conseil d'Etat. It was found that the report of the General Assembly of the Conseil d'Etat, from 13 October 2005, revealed a certain hesitation on behalf of some members in ratifying the 2003 Convention, particularly in reference to the national inventory of ICH that must be compiled (Conseil d'Etat 2005). Specifically, it was expressed that a lack of clarity concerning the selection process for the national inventory made it difficult to understand. Moreover, it was felt that certain intangible cultural expressions, such as religious festivals, could be excluded and, thus, the associated communities would not be recognised. Similarly, tensions could develop between the state and those communities whose heritage was not selected. Nevertheless, other members of the General Assembly highlighted the leading role of France in reference to ethnological research in general and implementing the 2003 Convention in particular. It was felt that respect needed to be given to the practices of our 'human brothers and sisters' (Conseil d'Etat 2005) and acknowledged that the 2003 Convention aims to treat groups and communities equally; however, it was important to stress that it is the state that retains the most control with regard to its implementation. The advice given by the Conseil d'Etat was therefore favourable, without any reservations or interpretative declaration, and, therefore, the implementation of the 2003 Convention in France was authorised (Conseil d'Etat 2005).

The administrative support that is to be given to the 2003 Convention has become a contentious point within the Ministry of Culture. Consequently it is important to consider why the Ethnology Mission was given the official responsibility of designating and managing ICH within the French context. Normally, relations with UNESCO are the responsibility of the Department for International Affairs of the Ministry of Culture. So, for example, the application of the 1972 *Convention Concerning the Protection of the World Cultural and Natural Heritage* lies within the domain of the Department for International Affairs as part of its 'Heritage Section'. It would

appear that the Ministry of Culture recognised a new system or approach was necessary to deal with ICH and realised that the close connection between ICH and ethnology might provide a way forward. The similarity of the official definitions of 'ethnological heritage' and 'intangible cultural heritage' and the relationship between ethnology and material culture may also have been important. However, these factors do not totally explain the choice of the Ethnology Mission.

In France, the large number of public bodies in charge of the ICH 'domains' (UNESCO 2003, Article 2) that are defined within the 2003 Convention – such as the Department of Music, Dance and Theatre, the Delegations for Visual Arts and Languages and the Directions of Museums, Archives and International Services – contrasts greatly with the administrative authority for monumental heritage, which is the sole responsibility of the Direction of Architecture and Heritage. The ethnology service lies within the Direction of Architecture and Heritage and it can be argued that because the 2003 Convention is viewed as a strategic element of French cultural diplomacy, a stronger system of implementation could – in theory – be put in place by being part of this body.

The uncontested influence of the French delegation within UNESCO

While the French cultural administration had a significant impact on adopting the 2003 Convention, it was the French delegation within UNESCO that strongly influenced its implementation between 2006 and 2009. In particular, at the heart of France's involvement with promoting and implementing the 2003 Convention during these years lies the actions of one man, Cherif Khaznadar, the former Director of the *Maison des Cultures du Monde* and President of the Culture Committee of the French National Commission for UNESCO. Using his long-standing experience in raising awareness about living heritage and his extensive knowledge of cultural matters at an international level, he led the French delegation for the two years that France was represented within the Intergovernmental Committee, as noted earlier.

During the Committee meetings, France, along with other delegations, defended the notion that the act of safeguarding ICH is the central principle of the 2003 Convention. This position led to a favouring of the *List of Intangible Cultural Heritage in Need of Urgent Safeguarding* over the *Representative List of the Intangible Cultural Heritage of Humanity*, the two main tools of the 2003 Convention for promoting the importance of ICH internationally (for further discussion see Blake 2006; Hafstein 2009). France sought to prioritise the Urgent List within the Operational Directives, as published in 2008. In addition, the French delegates also aimed to facilitate an increase in access of the candidacies for the Representative List by minimising the importance attributed to the inscription process. It was felt that the Representative List should not be given the same amount of prestige as is awarded to the 'exceptional' elements recognised by the World Heritage List and within the previous Masterpieces Programme. Through downplaying their 'masterpiece' qualities, attention could be placed on the importance of those elements inscribed onto the Urgent List, which, it was believed, bears most of the goals of the 2003 Convention.

Highly regarded during the official and informal discussions of the early committees, Cherif Khaznadar, the head of the French delegation, was elected in June 2008 as President of the General Assembly of the States Parties for the following two years. Consequently, it became his task to head the debates of the second assembly and to ensure that the Operational Directives were officially approved.

Temptations and attempts

Since its enactment in 2006, the 2003 Convention has undergone significant modifications – not in its text, but in its application. For example, for a certain time during the drafting stages, the idea emerged that the Representative List should be extremely restrictive; however, it was later decided that it should be a simple system of recording forms of ICH (in the debates during the General Assemblies from 2009 to 2010). The idea of periodic inscription onto this list was also discussed. Confronted with these hesitations, it was not only the information given by the public services to the communities that changed but also the strategy to be developed for the grounding of the 2003 Convention. For instance, is a State-consulting body really necessary if two or three elements, or more, were inscribed on the Representative List? Another example can be found in the nomination process, which, within France, is treated as a 'candidacy file' and is central to the examination process. The first 'file' was created in June 2008, with the first nominations compiled in September of the same year. In principle, the process should require a lengthy period of time, but in reality, for the first nomination round, the timeframe was rather short.

Moreover, the Ministry of Culture has demonstrated significant hesitancy with regard to the expectations and impacts of the 2003 Convention beyond the drafting stages. Indeed, it was very difficult to address issues while having only a vague text available. In addition, translating the Convention text into national law has proved to be quite difficult. Therefore, the temptation has arisen to link the policy of ICH to the pre-existing system for conserving cultural heritage in France. In particular, the preservation of memories and oral histories through pre-existing archival methods has been looked upon as an efficient way forward. The following sections explore two main 'avenues of action' put forward by the 2003 Convention – the communication, or promotion, of ICH and the process of creating national inventories – in order to shed light on safeguarding ICH as a process that has not yet found its equilibrium.

Promoting the 2003 Convention

In order to connect the various services within the administration (each in charge of one 'domain' of ICH), the Ministry of Culture has established, since 2006, a council, gathering members of all sections concerned (such as music, dance, foreign affairs and languages, amongst others). Composed of a dozen members, it meets four or five times a year. Originally, this council acted as a forum for the exchange of information about the actions of UNESCO with regard to ICH. More recently, it has become the body in charge of the examination and evaluation of the candidacy files, even though it lacks a solid institutional foundation that might accommodate this process more effectively. However, it can be argued that its actions have led to a better identification of ICH within the Ministry of Culture as a result of its wide-ranging scope.

At the same time, the French Ministry of Culture had to face an increasing range of demands from various groups and associations, as well as from citizens who have become concerned with the 2003 Convention and the recognition it grants them (UNESCO 2003, Article 2). Utterly disorganised at the beginning, a series of efforts such as safeguarding programmes, inventory campaigns and candidacy projects gained momentum after a period of roughly 18 months. During this time, various actors – both inside and outside the government – became involved, such as those who represent the strong network of traditional music and dance centres that bring together the associations active in the different French regions in preserving these cultural

practices. For example, in late 2007, several centres for traditional music and dance organised a congress dedicated to ICH in Nantes. This congress provides one of the first examples of an event organised by the people concerned with specific kinds of ICH in response to national efforts. This meeting was mainly devoted to the exchange of information, particularly in relation to traditional music and dance and the emergence of the 'ICH' category and concept.

In late 2008, another congress of roughly 300 people (practitioners, representatives of associations, local authorities, university staff and state representatives) took place in Rennes, the capital of Brittany. Unlike the Nantes meeting, this congress consisted of representatives of all the official UNESCO 'domains' of ICH and marked the beginning of the Call for the Recognition of ICH in Brittany, a manifesto based on the work of several associations that would be widely distributed in order to obtain the signature of local representatives (Dastum 2010). In connection to this report, many local meetings took place throughout the region, including the creation of a working group that sought to prepare several intangible cultural expressions for nomination and possible inclusion on both the Representative and Urgent Lists. These cultural practices comprise traditional dances, songs and Breton games and sports. Currently, the collective is still active: the first files have been deposited, the next ones are in preparation, and the support of local authorities in emphasising ICH in local cultural policies is becoming stronger. On the same note, a similar gathering took place in Auvergne in 2009, followed by another in the Languedoc region in 2010. The representatives of state and regional governments are invited; however, the associations remain the main organising force.

The arts and crafts domain, as represented through regional and local associations, is relatively less organised despite the efforts of the *Société d'Encouragement des Métiers d'Art* (SEMA), which is devoted to the promotion of traditional crafts in France and has started an in-depth inventory campaign with the Ministry of Culture. It is important to note that a 'living human treasures' system (*les maîtres d'art*) has already been instituted within France, enabling craftsmen to be trained under the supervision of a master in the rarest and most difficult crafts with the financial support of the state.

Nonetheless, candidacy projects aimed at inscribing French ICH on UNESCO's international lists continue to grow. Recently, the Corsican singing tradition 'paghjella' has been given global attention through its inclusion on the Urgent List in 2009, a process that began three years earlier (UNESCO 2010b). Additionally, three candidacy projects have been established between 2008 and 2010 in the region of Limousin. They concern Aubusson tapestry weaving, the making of Limoges porcelain and several religious demonstrations from particular Limousin villages. For instance, in 2008, the Aubusson tapestry weavers, with the help of the Ethnology Mission, presented a file for the inscription of tapestry weaving specific to this little town. The following year the town of Limoges, the capital of the region renowned for its porcelain, began to work on a file specifically devoted to porcelain crafts. The project was supported by local craftsmen and industrial firms and should be successful by 2012. Finally, in 2010, a collective that gathered the organising committees of 17 traditional processions (the renowned 'ostentions limousines') was set under the supervision of a curator, himself engaged in the practice of this ritual. It is remarkable that this project, one of the first to focus on religious practices, is led with the active support of several non-religious councils. It can be argued that their support of this candidacy project demonstrates how the social values of a particular expression of intangible heritage – even if it is religious in nature – are considered most significant.

Similarly, the French-administered territories and overseas departments outside of Europe

have also become increasingly interested in the 2003 Convention. In 2007, a seminar devoted to sharing information about ICH was organised in the city of Sainte Anne (Guadaloupe) at the same time as the Gwoka Festival of the archipelago, an event that attracts a great number of Caribbean ICH practitioners. Additionally, in 2008, a file was deposited for the inscription of Maloya, a performing arts tradition from Réunion Island in the Indian Ocean. Furthermore, a candidacy project, which will hopefully be concluded in 2011, is underway with respect to nominating the Marake, an initiation ritual practised by the Wayana Indians of French Guyana, for the Urgent List.

The National Inventory of ICH

According to the 2003 Convention, States Parties are obliged to compile national inventories of the ICH within their territories (see UNESCO 2003, Article 12). The logistics of fulfilling this obligation has revealed itself to be particularly challenging within the French context. On the one hand, since the 1960s, there has existed a service dedicated exclusively to the inventory of national heritage which differs from the safeguarding policy of the Historical Monuments section of the Ministry (Heinich 2009). Consequently, France is deprived of any methodological tradition, and of any proven competencies, in the area of identifying and designating ICH. However, on the other hand, the former function of the 'ethnological heritage production chain' mentioned earlier, predominantly based on reports, was not appropriate for the description of ICH practices since they were described in a way that made them incomparable to each other.

More generally, the very notion of inventories, reminiscent of folklore and epistemological regression, is considered too reductive and problematic by the national anthropological community. In response, resistance by this community, whose members are sometimes present within the public service itself, has led in the first instance to a limiting of the inventorying exercise to a compendium of existing sources, recapitulating the printed books or the databases that list the 'elements' of ICH, such as recordings or illustrations of practices, and artefacts. For example, the title of a colloquium held in late 2007 at the *Institut National du Patrimoine* in France, 'The Intangible Cultural Heritage: Inventing One's Inventory', bears traces of these first hesitant steps (Hottin and Grenet 2007). It was only in the second instance, following international exchanges with countries such as Estonia, Belgium and Canada, that the idea of an inventory of living practices of ICH was strengthened (see, for instance, UNESCO 2007). In particular, inspiration has been drawn from the Inventory of Ethnological Resources of Intangible Heritage (*Inventaire des Ressources Ethnologiques du Patrimoine Immatériel*, or IREPI), which was initiated by the Ministry of Culture in Québec and led by Professor Laurier Turgeon of Laval University (see Laval University 2006). The main principle of this inventory is to be elaborated with the active support and participation of all the communities involved. As a result, since late 2007 and the colloquium noted above, 15 surveys have been undertaken to test the files that have been compiled, the configuration of the categorical fields and the survey methodology, which has been undertaken by the communities of the particular ICH expressions, whether by community members themselves, through a representative association, or mediated by researchers (see Ethnology Mission 2010).

THE STATE VERSUS LOCAL COMMUNITIES AND UNESCO

It is important to stress that the structure for implementing the 2003 Convention makes the governments of States Parties the only direct partners of UNESCO. This is particularly problematic since it aims to uphold the importance of involving local communities in safeguarding efforts through encouraging national governments to work at the local level in compiling inventories, conducting research and facilitating safeguarding and relevant training programmes, as well as preparing nominations for the international lists (UNESCO 2003, Article 15). Within the French context, it can be questioned how the goals of the 2003 Convention can be reconciled with the rules of international diplomacy, especially as a result of the strong tradition of centralising preservation efforts and, as examined below, a general wariness amongst practitioners. The following discussion focuses on the inscription process for the Representative List owing to the fact that it represents a rather obvious aspect of the overall approach to safeguarding ICH as put forward by the 2003 Convention – that is, safeguarding by means of promotion.

WHICH 'COMMUNITIES' *À LA FRANÇAISE*?

The Napoleonic drive to emancipate Jews within Europe – giving them rights as individuals, but not as a nation – still guides, implicitly and explicitly, the action of the French state services vis-à-vis its multitude of communities. During the debates on the application of the 2003 Convention, the very use of the term 'community' has raised issues amongst civil servants (Conseil d'Etat 1980). The fact that it had already been used in the definition of ethnological heritage, and that the debates at the Conseil d'Etat had eliminated all ambiguity on the use of the term, were not taken into consideration (Conseil d'Etat 2005). On this note, it is worth emphasising that in France there is no 'community' other than the national one. For instance, Corsica is defined as a 'territorial collectivity' with a particular status, but the notion of 'community' or, even more, of a distinct 'people' is not included (Conseil d'Etat 1980). These reluctances may also be fuelled by the fear that recognising 'communities' can lead to encouraging 'communitarianism', a phenomenon that may promote societal division, as well as possible secession from the united body of the French nation.

In this context of non-recognition, which is also exacerbated by the vague definitions of 'community' offered by UNESCO, how can a text that gives 'communities' central importance be implemented? Rather than creating an *a priori* definition that would have been reductive, devoid of empiricism and inevitably deprived of legitimacy, the contours of the French definition for 'community' were drawn in a pragmatic way through the use of contacts that had been made while facilitating certain projects, and by pondering the coherence of the supposed community mentioned in the candidacy files for the Representative List. This search for a coherent interpretation of the UNESCO criteria has led the Ministry of Culture to reject certain candidacies, especially when it was considered obvious that the 'elements' proposed for inscription played no part in the contemporary identity of a given community. As an example, a project put forward by an old town with rich material heritage, which was eagerly supported by its elected representatives, was rejected because the 'element' – three authors of literary or philosophical works from the Middle Ages – was considered not representative of the modern identity of the associated community, even though the literary works were known worldwide. In essence, the circularity of the relationship between the community and the element was compromised, which is precisely in

opposition to the definition of ICH given in Article 2 of the 2003 Convention (UNESCO 2003, Article 2). It was felt that the works of these three authors are not a part of the living practices of the people who now live in this town.

In any case, the first candidacy projects, intended for the 2008–9 cycle of inscriptions on the Representative List, were evaluated by UNESCO between the spring and autumn of 2009. Because of a lack of classification at the national level, it was then left to the international organisation, UNESCO, to define these French communities. The first files were dedicated to intangible cultural expressions belonging to small groups of people, or practitioners. In general, these expressions were united by a common skill set, or by the sharing of particular knowledge, without necessarily implying the existence of a wider community, whether social or geographical. For instance, the art of timber-frame scribing was inscribed on the Representative List in 2009 in association with the 'community' of carpenters working in the domain of traditional timber-frame scribing throughout France (see UNESCO 2010c; Ministry of Culture 2010). Here, it is apparent that the sharing of a particular skill has constituted the community – that is, a professional regrouping without any geographical or statutory unity has been made. Within this 'community', some of the carpenters belong to the 'compagnonnage' system, a professional organisation that strongly structures the shared identity of its members as part of a social group (Adell-Gombert 2008). Most significantly, it also acts as an education centre that was created in order to support the success of the candidacy during the nomination process. Similarly, the intangible cultural expression of falconry, which was recently inscribed on the Representative List, has been associated with a community of hunters scattered from Belgium to the Republic of Korea, including the United Arab Emirates (which led the candidacy file), Mongolia, the Czech Republic and Syria (UNESCO 2010d). Again, this example demonstrates how it is only the cultural practice that provides the link between these geographically spread groups.

FROM THE INITIAL ATTEMPTS TO THE BUILDING PROCESSES

The time period for the first nominations was very short and thus it was difficult to put into place processes for selecting, monitoring and evaluating the candidacies at the national level. As a result, it was necessary to make choices between the 'spontaneous' candidacies that seemed to fit the terms of the Convention and those that appeared to be irrelevant. Moreover, it was imperative to encourage nominations from throughout France in accordance with the definitions found within the 2003 Convention text, and through formal and informal exchanges during the different Intergovernmental Committees, which aimed to capture its spirit. In effect, a compromise between top-down and bottom-up approaches to promoting ICH was developed. One candidacy strongly supported by the state, the cow-running chase from the Camargue region, has suffered from this haste; whilst another, the Corsican paghjella, supported by its community (an association of practitioners and local government representatives) in a delicate power struggle with the state, was positively evaluated by UNESCO (see Saumade 1994; 1998; UNESCO 2010b). This mixed approach to facilitating and selecting candidacy projects can be argued to encourage diversity, whether geographical, social or according to the ICH domains; however, owing to the lack of national classification and selection programmes, UNESCO remains the ultimate judge. This can be viewed as indicative of the state's inability, after creating the Ethnology Mission 30 years ago, to clearly identify the elements of its living heritage according to the frameworks that direct the whole administration of heritage preservation under the Convention.

In contrast, the second cycle of candidacies, which took place during 2009 and 2010, has been marked by a rationalising spirit, including a desire to institutionalise nomination procedures. Driven by the Ethnology Mission, the new process of nominating, monitoring and evaluating selected examples of ICH has taken the form of a 'conscious choice', even if these processes must remain flexible and adaptable to different contexts. For the most part, a time period of roughly 12 months has been set for the preparation and development of the candidacy files, which entails the establishment of a direct relationship between the ICH practitioners and the Ministry administration, and the identification of a 'working group' associated with the practitioners, local communities and state representatives. As an example, the working group for the Alençon lace candidacy consisted of the head of the lace-makers' workshop (*Atelier Conservatoire de Dentelle*), delegates from the *Mobilier National* (a state service to which the workshop is linked), representatives from Alençon (town government and Museum of Fine Arts and Lace), and the Ministry of Culture. Several meetings for evaluating the candidacy project process have been convened in preparation for the final examination to be held by the Ministerial Committee that decides if the selected ICH can be nominated to UNESCO via the French Permanent Delegation.

It is important to mention that the failure of the candidacy of the religious processions of Locronan, a Catholic pilgrimage festival which takes place every five years in Brittany, has influenced the development of the aforementioned new procedures. In particular, after an initial period of acclaim in 2008, the Locronan project, piloted *in situ* by an ethnologist specialising in the processions of Brittany, became the subject of increasingly vehement critique from some community members who own the fields through which the procession travels. As a result of the land owners prohibiting the pilgrims from crossing their fields, the project was eventually abandoned. This contestation raised the issue of the role of anthropologists and ethnologists in the implementation of the 2003 Convention. Some community members argued that they are too distanced from the needs of local people, as well as from the social, economic, political and cultural contexts in which their ICH is expressed. Moreover, the local press propagated the negative suggestion that once the procession had been designated as 'ICH' by UNESCO, constraints would be placed on its practitioners, in much the same way as historical monuments are preserved. Here it can be considered that the notion of monumental heritage – as opposed to that which is intangible and living – characterises the viewpoint people have of state-sponsored heritage management. Eventually, an information and conciliation meeting led to confrontations between supporters, opponents and governmental representatives, and to the withdrawal of the project. The unsuccessful candidacy of the processions of Locronan provides an example to build upon for the future: what is the role of the scientist, or scholar, within the 2003 Convention, and what is intended by the word 'community'?

It can be suggested that these nomination candidacies – both recently completed or in the process of consideration – have led to the identification of communities that, in visual terms, form concentric circles. For instance, the first, smaller circle can be argued to represent practitioners who embody the ICH element and directly manage its transmission, such as the singers of the paghjella from Corsica, the Aubusson tapestry weavers, or the eight remaining lace-makers of Alençon. Accordingly, a second, and wider, concentric circle represents the territorial groups, representatives and populations that support the inscription process and are, thereby, recognised through UNESCO as sharing a common identity based upon the particular ICH expression selected (see Fig 8.1). The following example demonstrates how this construction of community

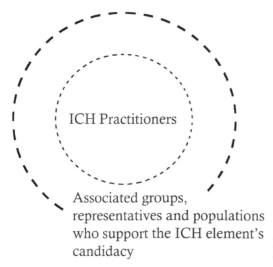

ICH Practitioners

Associated groups,
representatives and populations
who support the ICH element's
candidacy

Fig 8.1. Stakeholders of ICH during
the nomination process.

groups can be problematic, particularly for intangible cultural practices that are expressed on a broad scale.

The Case of French Gastronomy

In recent history, one of the most commonly discussed nomination projects for the Representative List is the general tradition of 'French gastronomy'. The very nature of the element proposed, which is the source of immense passion amongst the French people, and a 'characteristic' of France often explored by foreign writers, predisposed this candidacy to high visibility within the media (see, for example, Makine 2006). Its announcement by the president of the Republic, which was widely relayed and commented upon, made it a popular subject of polemics. Most noteworthy is the fact that this candidacy was not suggested by the close circle of the 'Great Chefs' of French cuisine, nor was it solely a political initiative from the Presidency. The idea of recognising French gastronomy originated in a university research department, a foundation functioning within the *Institut de France* and hosted by the François Rabelais University in Tours. In particular, the candidacy file was pushed forward by an eminent geographer, Jean-Robert Pitte, former President of the Sorbonne University (Paris IV), and the historian Julia Csergo, Professor at the University of Lyon II. As for the scientific committee in charge of the candidacy, a number of scholars from human and social sciences were also gathered together.

While this linkage of academic and political interests can be considered quite common in France, it is certainly a unique characteristic of the project. Moreover, these political and academic ties also account for the difficulty in appropriating the candidacy project by the non-academic, cultural and scientific institution of the heritage administration. Nonetheless, this 'adventure' has culminated in UNESCO recognition, as it was officially inscribed on the Representative List in November 2010 as 'the gastronomic meal of the French' (UNESCO 2010e). In addition, despite the motivations of Pitte and Csergo, it can also be argued that it represents the official starting point of the implementation of the 2003 Convention in France. This is mainly because of its

popularity – that is, awareness of the text and its principles will be raised far beyond the close circles of heritage and anthropology.

In itself, the candidacy of French gastronomy raises as many questions about the 2003 Convention as the 2003 Convention raises about the candidacy: can a nation of 60 million people, legally defined as a 'national community', manifest itself as a community in the sense given by the 2003 Convention, and in a circular relationship with an element that situates itself in an immaterial heritage sphere that is little explored by the majority of projects? We are no longer in the domain of performance, nor in the technical area, but in the historical and social depth of incorporated representations that can be detected through a multitude of signs, almost impalpable, and that are problematic to sum up in one file of about 20 pages. To assimilate France to its gastronomy can be understood in terms of an advertisement for travelling to France, but to demonstrate it in the short and formalist format of a UNESCO file is like sending out an SOS. At last, more than others, this candidacy raises the issue of the frontier between explicit and implicit selection criteria for intangible heritage (Heinich 2009).

THE WAY FORWARD

For the first four years of its implementation, the team at the Ethnology Mission had the opportunity on multiple occasions to present the 2003 Convention text to a wide-ranging group of audiences – from politicians, ethnologists and historians to musicians, dancers and representatives of NGOs, amongst others. Although there were a variety of responses, it can be stated that apathy was never encountered. Additionally, the understanding of what constitutes 'intangible cultural heritage' has certainly changed over this time period (see Hottin 2008). Four years ago it was still common within France to view ICH as pertaining only to digital heritage, or heritage that has become virtual and dematerialised. During this same period, a public report on the intangible assets of the State created much confusion about the differences between 'intangible cultural heritage' and 'cultural intangible heritage', which focuses on cultural trademarks and brands such as the valorisation of the trademark 'Louvre' (Grenet and Pierre 2008). On the whole, however, the contacts made by the Ethnology Mission with ICH practitioners, professional groups and associations for candidacy projects have become a good indicator that the ICH concept, as intended by UNESCO, is becoming better understood. Even if the candidacy files and nominations are not all successful, almost all of them are now relevant to how ICH is defined in the official texts.

At this stage it is possible to suggest that the most concerned actors – communities and representatives of local, regional and state authorities – view the 2003 Convention as a means for safeguarding a heritage that is as important as any other, and for which there has not existed any protective laws. Indeed, a large number of ICH practitioners are content to find a system of recognition and legitimacy even though it is also acknowledged that the 2003 Convention operates within a framework of international relations between states, and the extent to which communities, groups and individuals are involved in the safeguarding process remains vaguely defined. Nevertheless, some recent initiatives, such as the Breton association *Dastum*, dedicated to the knowledge of traditional music and dance, bear testimony to an interest in making ICH a part of cultural policies beyond marketing or tourism motivations.

Although it appears that the communities that work with the Ethnology Mission have exhibited a real enthusiasm, the academic community has taken a more sceptical stance. Currently,

it is certain that, for a number of anthropologists, the 2003 Convention, at worst, represents a serious epistemological regression and, at best, serves as an object of study, as both a concept to be deconstructed and an approach to examine further. Historians, geographers and ethnologists, whether from academia or the cultural administration, view the 2003 Convention and its 'intangible cultural heritage' concept as a field for applied researchers, where they can engage in research programmes, participate in inventory-making and assume full authority over the preparation of the candidacy file projects. In this light, academia is no longer confined to its 'ivory tower' and it will be important to observe, in the future, the response that it will bring to the growing popularity of professionalising actors of the ICH world, such as the possibility of university courses focused on safeguarding it. This is a new field for ethnologists to occupy – one that is part of the 'professional heritage enterprise' and requires a view of cultural expressions and beliefs as heritage to be safeguarded, curated and managed (Rautenberg 2009).

Unfortunately, the situation is less clear on the side of the heritage administration. In general, the 2003 Convention is often viewed as a text originating from the 'outside' and, thus, not intended for government officials. It is also quite astonishing how difficult the implementation of the 2003 Convention has been when taking into account the ease with which the 2005 Convention for Cultural Diversity was embraced. In other words, if UNESCO is equating ICH with respect for intercultural dialogue, peace and cultural difference (the aims of the 2005 Convention), then it would have been logical to assume that implementing the 2003 Convention would have been less problematic during the past four years.

Furthermore, the French state has, for more than three decades, favoured a series of cultural and/or heritage actions that draw together the segments of a heritage chain for intangible heritage: fundamental and applied research, diffusion and valorisation, publications on ethnological heritage, information and transmission among the centres for traditional music and dances, support of master crafts makers (often compared to the Living Human Treasures programme of Japan), and the complex network of ecomuseums and community museums. These activities, programmes and initiatives allow one to hope that they will, in the future, be the places for mediation of ICH. In essence, these heritage chain 'links' need to be strengthened and knit more closely together, a movement that the 2003 Convention can help facilitate. However, existing only to the eye that sees it as it is, every heritage has its intangible aura; ICH policies have the ability to reveal the intangible features hidden within the tangibility of the object. Any heritage policy that devotes care only to tangible objects would definitely expose itself to the opinion that it is not seeing the wood for the trees.

Bibliography and References

Adell-Gombert, N, 2008 *Des hommes de devoir, les campagnons du tour de France*, Editions de la Maison des sciences de l'homme, Paris

Blake, J, 2006 *Commentary on the UNESCO 2003 Convention on the Safeguarding of the Intangible Cultural Heritage*, Institute of Art and Law, Leicester

Central National Library, 2007 *Le nuove Convenzioni UNESCO: Il coinvolgimento delle Regioni e degli Enti Locali nella loro attuazione e promozione* [online], available from: http://www.lahic.cnrs.fr/spip.php?article307 [20 December 2010]

Christophe, J, Boëll, D, and Meyran, R, 2009 *Du Folklore à l'ethnologie*, Editions de la Maison des science de l'homme, Paris

Conseil d' Etat, 1980 *Décret n° 80–277*, Conseil d'Etat, Paris

—— 2005 *October 13, 2005 Report*, Conseil d'Etat, Paris

Dastum, 2010 *PCI – UNESCO: 37 collectivités publiques s'engagent / Ar galv sinet gant 37 kumun ha strollegezhioù publik* [online], available from: http://www.dastum.net/FR/actualites.php [17 January 2011]

Dias, N, 1991 *Le musée d'ethnographie du Trocadéro (1878–1908): anthropologie et muséologie en France*, Édition du Centre national de la recherche scientifique, Paris

Ethnology Mission, 2009 *La recherche en ethnologie* [online], available from: http://www.culture.gouv.fr/mpe/ [14 January 2011]

—— 2010 *Inventaire des inventaires des patrimoine culturel immatériel* [online], available from: http://www.culture.gouv.fr/culture/dp/ethno_spci/invent_invent.htm [14 January 2011]

Fabre, D, 2000 *Domestiquer l'histoire: ethnologie des monuments historiques*, Editions de la Maison des sciences de l'homme, Paris

Fabre, D, and Iuso, A, 2010 *Les monuments sont habités*, Editions de la Maison des sciences de l'homme, Paris

Grenet, S, and Bortolotto, C (eds), 2011 *Le patrimoine culturel immatériel*, Editions de la Maison des science de l'homme, Paris

Grenet, S, and Pierre, J, 2008 Kate Moss et les bars de Cayenne: enthnochic et actifs immatériels, *Culture et Recherche* (116–17), 23

Hafstein, V, 2009 Intangible Heritage as a List, in *Intangible Heritage* (eds L Smith and N Akagawa), Routledge, London and New York

Heinich, N, 2009 *La Fabrique du patrimoine*, Editions de la Maison des sciences de l'homme, Paris

Hottin, C, 2008 Anti-monumental? Actualité du patrimoine culturel immatériel, *Monumental* (1), 70–3

Hottin, C, and Grenet, S, 2007 Le patrimoine culturel immatériel en Europe: inventer son inventaire, paper presented at the symposium of the *Direction de l'architecture et du patrimoine et l'Institute national du patrimoine*, 30 November, Paris

Jacquelin, C, 2008 Protéger l'immatériel: les arènes de Bouvines du Bas-Languedoc, *Culture et Recherche* (116–17), 48–9

LAHIC, 2010a *Les émotions patrimoniales* [online], available from: http://www.iiac.cnrs.fr/lahic/spip.php?article186 [14 January 2011]

—— 2010b *Genèses de l'anthropologie: le paradigme des derniers* [online], available from: http://www.iiac.cnrs.fr/lahic/lahic/spip.php?article369 [14 January 2011]

Laval University, 2006 *Bienvenue sur le site de l'Inventaire des ressources ethnologiques du patrimoine immatériel (IREPI)* [online], available from: http://www.ethnologie.chaire.ulaval.ca/ [14 January 2011]

Makine, A, 2006 *Cette France qu'on oublier d'aimer*, Flammarion, Paris

Marcel-Dubois, C, Falc'hun, F, and Auboyer, J, 2009 *Les archives de la mission de folklore musical en Basse-Bretagne de 1939 du Musée national des arts et traditions populaires* [DVD], Comité des travaux historiques et scientifiques, Paris [1 June 2010]

Ministry of Culture, 2010 *Les charpentier d'Europe et d'ailleurs* [online], available from: http://www.charpentiers.culture.fr/ [14 January 2011]

Noyes, D, 2003 *Fire in the Plaça: Catalan Festival Politics after Franco*, University of Pennsylvania Press, Philadelphia

Rautenberg, M, 2009 Mais pourquoi n'avance-t-on donc pas? Le surplace de la 'professionalization chez les ethnologues', in *Ethnologie(s): nouveaux contextes, nouveaux objets, nouvelles approches* (ed G Ravis-Giordani), Editions du Comité des travaux historiques et scientifiques, Paris, 83–99

Saumade, F, 1994 *Des sauvages en occident: Les cultures tauromachiques en Camargue et en Andalousie*, Editions de la Maison des sciences de l'homme, Paris

—— 1998 *Les tauromachies européennes: La forme et l'histoire, une approche anthropologique*, Edition du comité des travaux historiques et scientifiques, Paris

Tornatore, J, 2011 L'inventaire comme oubli de la reconnaissance, à propos de la 'prise' française pour la sauvegarde du patrimoine culturel immatériel, in *Le patrimoine culturel immatériel* (eds S Grenet and C Bortolotto), Editions de la Maison des science de l'homme, Paris

UNESCO, 2003 Convention for the Safeguarding of the Intangible Cultural Heritage, available from: http://portal.unesco.org/en/ev.php-URL_ID=17716&URL_DO=DO_TOPIC&URL_SECTION=201. html [30 March 2011]

—— 2007 *Principles and Experiences of Drawing up ICH Inventories in Europe, 14–15 May, 2007, Summary Report from the Discussions* [online], available from: http://www.unesco.org/culture/ich/doc/src/00203-EN. pdf [14 January 2011]

—— 2010a *Intergovernmental Committee for the Safeguarding of Intangible Cultural Heritage* [online], available from: http://www.unesco.org/culture/ich/index.php?pg=00009 [14 January 2011]

—— 2010b *The Cantu in paghjella: a secular and liturgical oral tradition of Corsica* [online], available from: http://www.unesco.org/culture/ich/index.php?lg=en&pg=00011&USL=00315 [14 January 2011]

—— 2010c *The Scribing Tradition in French Timber Framing* [online], available from: http://www.unesco. org/culture/ich/index.php?lg=en&pg=00011&RL=00251 [14 January 2011]

—— 2010d *Falconry, a Living Human Heritage* [online], available from: http://www.unesco.org/culture/ich/ index.php?lg=en&pg=00011&RL=00442 [14 January 2011]

—— 2010e *The Gastronomic Meal of the French* [online], available from: http://www.unesco.org/culture/ich/ index.php?lg=en&pg=00011&RL=00437 [14 January 2011]

—— 2011 *The States Parties to the Convention for the Safeguarding of the Intangible Cultural Heritage* [online], available from: http://www.unesco.org/culture/ich/index.php?lg=en&pg=00024 [14 January 2011]

Voisenat, C, 2008 *Imaginaires archéologiques*, Editions de la Maison des sciences de l'homme, Paris

Government and Intangible Heritage in Australia

Lyn Leader-Elliott and Daniella Trimboli

Australia's response to ratifying the UNESCO *Convention for the Safeguarding of the Intangible Cultural Heritage* has been cautious. Its original refusal to ratify the Convention appeared to soften with a change of national government in 2007, but in 2012 there is still no sign that Australia will become a party to the Convention.

There has been a closed Federal government enquiry into ratification but no information relating to it has been publicly released (Cassidy 2010). The Federal focus is on issues relating to Australia's Indigenous populations and not the many immigrant community cultures whose heritage could also be covered under the Convention. Several organisations which made submissions to the preliminary enquiry have posted them on the internet, and these do discuss the Convention's importance to immigrant communities as well as Indigenous Australia. Views differ on whether Australia should ratify the Convention. This chapter summarises the processes undertaken so far and the limited publicly available views of parties who have expressed interest in it. It also outlines the range of connected policies and programmes operating within Australia.

Australian political context

Australia has a Federal system of government, in which the Federal Constitution defines the powers of the national government (also called the Australian, Commonwealth or Federal government). State governments hold the residual powers. Section 51 (xxix) of the Commonwealth of Australia Constitution Act (Attorney-General's Department 2003) gives the national parliament power to make laws with respect to external affairs, and under this power the Australian government ratifies international conventions. In many cases, the powers required to implement international conventions across Australia are actually held by the state governments, not the Commonwealth, which means that agreements with states must be reached and each state must take action of its own, if the terms of a convention are to be applied nationally.[1]

Most states have separate legislation and bureaucratic structures for each of natural, Indigenous and 'historic' (ie non-Indigenous, post-colonisation) heritage. Moveable cultural heritage and intangible heritage are administered separately from the agencies that list and manage places of heritage significance and are lodged within agencies responsible for arts and culture. Again,

[1] When Australia first ratified the World Heritage Convention in 1974, the Commonwealth established the Australian Heritage Commission which compiled a register of the National Estate, but, as the states hold power over planning and development legislation and run the so-called national parks, the Commonwealth's legislation could only directly affect places owned by the Commonwealth government or in the two Territories. It was some years before all the states introduced cultural heritage legislation (eg New South Wales set up a Heritage Council in 1977; Queensland in 1992).

all these functions are shared between national and state governments. Commonwealth and state governments also share responsibility for museums and collections, education, Aboriginal and Torres Strait Islander affairs and multicultural and ethnic affairs – all areas relevant to the UNESCO *Convention for the Safeguarding of the Intangible Cultural Heritage*. This dispersal of responsibility amongst and within governments adds to the complexity of implementing such a wide-ranging Convention.

When UNESCO adopted this Convention in 2003, the then-conservative[2] Australian Government withheld from ratifying it, together with nations with similar colonial pasts or complex immigrant societies such as Canada, New Zealand, South Africa, the United Kingdom and the United States. At the December 2007 Federal election, the Australian Labor Party (ALP), led by Kevin Rudd, won government. Amongst its election policies, the ALP had pledged to 'consider ratifying' the *Convention for the Safeguarding of the Intangible Cultural Heritage* and 'to ratify and give effect to' the related *Convention on the Protection and Promotion of the Diversity of Cultural Expressions* (Garrett 2007, 15). These commitments were made, briefly and inconspicuously, in the section of the ALP arts policy relating to Australian arts and artists overseas.

The Rudd government did ratify the *Convention on the Protection and Promotion of the Diversity of Cultural Expressions* in October 2009 (DEWHA 2009a), but there is no public indication that the same will happen with the Convention on Intangible Heritage. In fact, the government has not given any public information on what consideration is being, or has been, given to this issue since it was elected. No minister has issued press releases on it. There is no mention of it in the annual reports of the responsible department (DEWHA 2008; 2009b) and no announcements have been made about a review being held. Nevertheless, our research showed that several cultural organisations had posted on their websites submissions they had made to an enquiry on whether Australia should ratify this Convention, and that this initiative was being taken from within the Literature and Indigenous Culture Branch of the Arts and Culture Division of the Department of the Environment, Water, Heritage and the Arts (DEWHA).

Having read the submissions, it was possible to deduce what questions the Commonwealth had asked them, but the terms of reference of the enquiry and background information were still missing. Direct enquiry to DEWHA elicited this information:

> The Department of the Environment, Water, Heritage and the Arts conducted a preliminary consultation process within Government and with a broad sample of relevant stakeholders including a range of major cultural institutions, Indigenous organisations, major arts and cultural bodies, universities, major heritage organisations, peak community councils, intellectual property organisations and relevant state and territory agencies.
>
> Many organisations indicated that the content of their submission was confidential and not to be made publicly available. As the Department did not specify at the time that submissions may be made publicly available, we are not in a position to make submissions available now. However, a small number of organisations elected to publish their submissions on their website, for example the Australian Human Rights Commission.
>
> If the Government decides to initiate the formal process of considering accession, the treaty steps provide opportunities for public comment on the Convention. As part of this process,

2 Australia's major conservative party is called the Liberal Party.

relevant agencies and organisations across jurisdictions would be consulted on the likely issues and opportunities arising from the implementation of the Convention.

The Government is currently considering the outcomes of the preliminary process. If the Government decides to commence the process of acceding to the Convention the formal treaty approval process includes public hearings and a report to Parliament. (Cassidy 2010)

In addition to the Australian Human Rights Commission (AHRC) mentioned by Cassidy, submissions were sourced on the web from Blue Shield Australia (2008), the Collections Council of Australia and the Federation of Ethnic Communities' Councils of Australia (FECCA).[3] Australia ICOMOS'[4] response was made available to the authors, although it has not been posted on the web. Several other fragments were picked up from web searches, including an internal email from within the DEWHA itself. Unfortunately, none of the other categories of organisation mentioned by Cassidy has made their submissions public, and the Commonwealth has not released the names of organisations from which they sought comment.

The Commonwealth conducted its preliminary consultation outside the bureaucracy by writing direct to the organisations it had identified as being relevant. The concerns of the Australian government agencies previously consulted by DEWHA were communicated to those organisations in its letter inviting them to take part in the 'preliminary consultation' on the Convention (Buckley 2009). Issues of concern to the national government agencies can be summarised as:

- The vagueness of the UNESCO *Convention for the Safeguarding of the Intangible Cultural Heritage* meant it might be difficult to apply in practice;
- listing certain elements of intangible heritage, especially Indigenous intangible heritage, can be culturally inappropriate;
- there are difficulties associated with giving preference to one group over another;
- there is potential for conflict over who might have the right to speak for different cultural groups given the dislocation of many Aboriginal groups from their traditional lands and the possible negative effects of interfering in changing intangible cultural heritage;
- Australia has a number of programmes already in place that cover aspects of the Convention and there may be no clear-cut need for Australia to ratify the Convention. (Australia ICOMOS, n.d.)

Submissions from the organisations show that DEWHA asked them to comment on the following questions:

1 Whether they would support ratification and why?
2 Would ratification change the way they undertook their activities to protect Australia's intangible heritage and how?
3 What would be the resource implications?

3 FECCA is the national peak body representing Australians from culturally and linguistically diverse backgrounds (FECCA 2009).
4 ICOMOS (International Council on Monuments and Sites) is an international NGO dedicated to the conservation and protection of cultural heritage places. Its Australian committee is known as Australia ICOMOS.

4 Which of their existing activities supported the protection of Australia's intangible heritage, and how would these activities fit the requirements of the Convention if Australia were to ratify?

The DEWHA letter to organisations concentrated overwhelmingly on concerns about working with Indigenous cultural heritage, and did not mention Australia's immigrant multicultural heritage.[5] DEWHA is clearly aware of this aspect, however, as is shown in what appears to be an internal DEWHA memo from the department's Indigenous Language and Culture section on a Review of the Protection of Movable Cultural Heritage Legislation. The unnamed correspondent notes that the main section of the latter review seems to be on the assessment of significance, 'which may have some cross over or relevance with intangible cultural heritage' (as indeed it does), and goes on to say:

> Australia's diverse and multicultural nature would require us to consider a wide range of intangible cultural heritage for inclusion on a possible list, including:
> The cultural knowledge systems, rituals and practices of Australia's Indigenous peoples;
> The knowledge associated with distinctive cultural 'Australian' traditions, skills, arts, trades and practices; and
> 220 years of immigrant history – particularly the living link to countries of origin as well as an evolving diaspora of cultures. (DEWHA, n.d.)

Responses from cultural organisations

A summary follows of the general issues raised in the publicly available submissions to DEWHA.

Their consensus is that Australia should ratify the Convention, although reasons for this position vary depending on the focus of the organisation making the submission. All responses sound some notes of caution, indicating a need for further consideration and discussion. The overarching reason given for supporting ratification is the perceived importance of protecting intangible elements of Australian culture that have been disregarded or avoided because of their complexity. This has at its core a strong belief that protecting and celebrating Australian intangible cultural heritage is vital for Australian identity as a complex, multi-ethnic society.

The Federation of Ethnic Communities Councils of Australia (FECCA) wrote that 'the Convention under consideration provides an important opportunity for Australia to demonstrate its commitment to safeguarding its unique Intangible Heritage derived from immigrants' cultures' (FECCA 2008, 2). It refers to traditions of performance 'found in the hybrid cultures derived from immigrants' cultures and their host cultures', and especially to the cultures of displaced peoples whose original cultures have been obliterated by war or occupation, and which can only be found in Australia (FECCA 2008, 2). It notes that 'The Convention provides for ensuring the continuity of cultural diversity of the heritage of humanity' (FECCA 2008, 3).

Submissions also argue for the ability of intangible cultural values to enrich the lives of Australians and promote cultural respect and prosperity. Since intangible heritage is essentially

[5] Australians claim more than 250 ancestries and speak more than 400 languages at home (Australian Bureau of Statistics 2007).

about how we live our culture – the doing, the creating, the feeling – the submissions argue that identifying and safeguarding these elements will benefit Australians on all number of levels – including socially, culturally, environmentally, ecologically and economically. The Australian Human Rights Commission (AHRC) suggests that intangible cultural heritage is the thread that binds our lives as Australians together; the 'critical nexus between human and environmental ecologies ... a glue that holds together humanity's relationship with the physical world and between groups that make civil societies' (AHRC 2008, 4). Submissions suggest that formal intangible heritage recognition will strengthen our sense of self and our understanding of how this self connects to place and help to 'keep alive intangible practices' by allowing 'an individual or community to re-create an intangible practice' (Collections Council of Australia 2008). They also suggest that it will ultimately benefit cultural industries, including tourism and the arts (AHRC 2008, 6) and build a richer cultural existence, aiding funding for community festivals and product development linked to intangible heritage (Collections Council of Australia 2008).

The submissions suggest that while this type of argument is gaining some currency at the national level, there is little formal action to ensure it becomes more than just an aim. Thus, one of the key arguments made for Australia to ratify the Convention is that it will force the Commonwealth to actively commit to intangible heritage through legislation. Ratifying it would put a 'national system' in place that would make 'implementation mandatory' (FECCA 2008, 2; AHRC 2008, 3). The AHRC, the FECCA, the Collections Council of Australia and Australia ICOMOS all agree that ratifying the Convention would make a significant international statement on which the Commonwealth would be obliged to follow through. As the AHRC (2008, 5) argues, ratifying the Convention would be 'an historically progressive legacy of the [Labor] government' which would prove its 'commitment to its First Nations, its immigrant communities, and to its overall recognition of the importance of the physical environment ... and to human and cultural rights'. The Collections Council of Australia (2008) supports this, noting that it is important for Australia's intangible cultural heritage to be recognised on the world stage, as it helps develop formal awareness of, and commitment to, cultural heritage at national, state and local levels. That is, having an official framework would force the government to act and, importantly, to filter this action through the states to create more meaningful intangible heritage policy.

Linked to this argument is the importance of networking. By and large, the Convention is seen as being something that would bring Australian intangible heritage stakeholders together – creating critical national networks and a proactive community committed to intangible heritage in Australia. FECCA (2008, 2–3) argues that ratifying the Convention would 'bring together the stakeholder communities and relevant Government agencies', allowing for greater cooperation and a greater success of heritage and related cultural organisations. Indeed, the Collections Council of Australia admits that, if it were not for this recognition of intangible heritage, their entire organisation would be registered null and void.[6] Australia ICOMOS (n.d., 2–3) noted that ratification of the Convention would allow for 'exchange of experience with other highly diverse societies', including those that have ratified the Convention, thus bringing 'a broader range of disciplines into the heritage field' and leading to 'enriching benefits for heritage prac-

6 The Collections Council's federal funding was subsequently discontinued and the Council ceased to exist at the end of April 2010.

tice generally'. In this way the submissions agree that the Convention would allow for increased dialogue, where all Australian cultural groups would have the space to flourish in their respective diversities.

Overall, the submissions focus on the positive aspects of the Convention, but some – especially the AHRC submission – also show some apprehension about putting the Convention's vision into practice because intangible cultural heritage is dynamic. Another set of concerns revolves around privacy and access, ownership and authorship, and potential divisiveness of preferencing some heritages over others. Australia would be required under the Convention to identify and document intangible heritage through consultation with relevant parties and creating inventory lists which would indicate its significance and urgency (UNESCO 2003, 7–8).

The AHRC (2008, 10) suggests that managing the high level of culturally diverse intangible heritage, including religious diversity, would be complex and potentially restrictive for some groups. It argues that this is more likely given the current lack of attention or clarity presented in the Convention on how it plans to manage dissonance (ibid). Not all Australians are likely to agree on what reflects their intangible heritage – and indeed, not all members of any one community will be in accord. The AHRC is not convinced that the Commonwealth has the capacity to negotiate this kind of conflict (loc cit). Australia ICOMOS (n.d., 5) also expresses concern over the Convention's vagueness on the potential problem of divisiveness. However, both ICOMOS and the Collections Council (2009) believe there is a relatively sound level of awareness about this issue and that there are programmes in place to deal with it, such as UNESCO's *Memory of the World* Programme and the *World Heritage Convention*.

The AHRC (2008, 10) has reservations about the listing process itself:

> The question of inventories is a significant one. Listing the intangible cultural heritage of Indigenous peoples, especially secret and sacred knowledge (while important from the point of safeguarding) may pose serious issues of privacy and access. Moreover, the responsibility for such inventories could be exclusively custodial to the host communities and need appropriate measures to ensure that the listing does not violate traditional rights. It must be emphasized that any responsibilities of cultural institutions dealing with intangible cultural heritage is [sic] different from the way they have dealt with tangible heritage where safekeeping has been a practice.

Australia ICOMOS has taken a lead role internationally in arguing for inclusion of intangible values, including social and spiritual values, in heritage listings of sites and cultural landscapes. It points out that Australia already has systems for community groups to be involved in identifying expressions of cultural heritage for listing, including both Indigenous and non-Indigenous communities, and in managing confidential information, and that listing of places with intangible values has been managed consultatively for some years. It notes that:

> in relation to both [Indigenous] sacred sites and heritage place management all Australian jurisdictions have guidelines and processes in place that deal daily with the identification of who speaks for country and practice. These include elders, traditional owners, native title holders and those with 'historic connections' resulting from more recent associations with country.
>
> (Australia ICOMOS, n.d., 5)

It suggests that, in considering the potential for divisiveness, the most important question is 'how to establish a system which minimises this potential' (n.d., 5). And it points out that the Convention itself acknowledges that intangible culture is constantly recreated and that it has no intention of 'freeze-framing' living heritage (n.d., 6).

Throughout its submission, Australia ICOMOS (n.d.) expresses surprise at the negative approach taken by the Commonwealth to the Convention and suggests that there are positive aspects of the Convention that need to be considered. It concludes that there are areas that need to be worked through, and would like to see 'more informed exploration of the possibilities ... before a firm view for or against ratification of the Convention should be made' (n.d., 7).

RELATED PROGRAMMES IN AUSTRALIA

Although the Australian government has not ratified the UNESCO *Convention for the Safeguarding of the Intangible Cultural Heritage*, government programmes across the country support it in various ways. Stephen Cassidy, the responsible officer in DEWHA, advised the authors that:

> Australia is an active proponent of the preservation of intangible cultural heritage and there is extensive work already being undertaken in Australia in collecting, recording and preserving our unique Australian stories by organisations such as our major cultural institutions; the National Museum of Australia, the National Library of Australia, the National Archives of Australia, the National Film and Sound Archive and the Australian Institute of Aboriginal and Torres Strait Islander Studies.
>
> Indigenous organisations, major Australian arts and cultural bodies, heritage organisations and educational and research bodies are also currently involved in important efforts to document traditional and intangible knowledge ...
>
> The *Convention on the Protection and Promotion of the Diversity of Cultural Expressions* focuses specifically on cultural goods, services and activities. It relates to intangible cultural heritage through its recognition of the importance of linguistic diversity and the value of traditional knowledge.
>
> In this context, the National Indigenous Languages Policy announced by the Australian Government on 9 August 2009 aligns with the provisions of both Conventions.
>
> The Australian Government will continue to protect and promote intangible cultural heritage through its existing national cultural measures and programs including the broad range of both Indigenous and non-Indigenous cultural programs managed by this Department and ongoing involvement in international debate.

Other DEWHA activities supporting Indigenous culture not mentioned specifically by Cassidy include:

- Indigenous Culture Support Program supporting Indigenous culture in communities;
- National Arts and Crafts Industry Support Program supporting the Indigenous visual arts industry and Aboriginal art centres;
- Indigenous Broadcasting Program supporting Indigenous radio and media;
- National Indigenous Contemporary Music Action Plan;

- Partnership programs respecting traditional knowledge and involving Indigenous people in managing the environment and cultural heritage.

(DEWHA 2009b)

It is not possible to discuss all of these areas of government activity in this chapter, and therefore we briefly review some implications of Australia's ratification of the *Convention on the Protection and Promotion of the Diversity of Cultural Expressions*; trends in cultural heritage legislation and practice; and programmes for maintaining Indigenous languages and ethnic community intangible heritage.

Convention on the Protection and Promotion of the Diversity of Cultural Expressions

This Convention (UNESCO 2005, 1) was established to recognise cultural diversity as a 'defining characteristic of humanity'; a celebration of the way our cultural diversity might help us to unify through difference. It focuses on expressions, those things 'that result from the creativity of individuals, groups and societies, and that have cultural content' (2005, 5). It aims to create a space for cultural groups to 'express and to share with others their ideas and values' and allow them 'freedom to create, disseminate and distribute their traditional cultural expressions and to have access thereto, so as to benefit them for their own development' (2005, 2). In Australia, this Convention should apply to Indigenous and non-Indigenous cultures.

A 2010 review of Indigenous heritage legislation across Australia noted that the Cultural Diversity Convention recognises 'the importance of traditional knowledge as a source of intangible and material wealth, and in particular the knowledge systems of indigenous peoples ... as well as the need for its adequate protection and promotion'. It noted that, for instance, registers of Aboriginal and Torres Strait Islander heritage sites throughout Australia take into account the sacred and spiritual aspects of the sites and their customary use as well as their physical elements (Government of Western Australia 2010, 4–10).

But, in general, it is not at all clear that it covers enough of the same ground as the *Convention for the Safeguarding of the Intangible Cultural Heritage*, and its intended role as a 'cultural counterbalance to the World Trade Organization' is a long way from spiritual values and language (Graber 2006, 553).

Cultural heritage legislation

Intangible heritage is increasingly being taken into account in both heritage policy and legislation at Commonwealth and state level. The major Federal legislation is the *Environment Protection Biodiversity Conservation Act 1999*, which covers cultural and natural heritage and requires a five-yearly State of the Environment report to be presented to parliament (DEWHA 2010b). Jane Lennon's (2006, 39) paper for the 2006 report noted that the breadth of heritage activity had extended beyond places to 'incorporate intangible heritage – language, oral tradition, craft skills and performing arts'.[7]

Intangible cultural values are taken into account in assessing the significance of heritage places, including cultural landscapes, and heritage listings for many places include reference to

[7] Work on the 2011 report was underway at time of writing.

cultural or spiritual values, especially for Aboriginal sites. In a 2010 report on national heritage, the Australian Heritage Council[8] expressed its view clearly:

> Heritage can be something you can touch and see but it can also be things you can't, like music, stories, spoken history and traditions. Heritage represents all the things that make Australia and Australians unique. It helps us remember where we came from and where we belong. Heritage is all the things that make up our story, tangible and intangible, and as we value them we must protect them. (Australian Heritage Council 2010, 2)

Australia has taken an active role in international discussions on the importance of spiritual values and other intangible cultural elements of places and landscapes (see, for example, McBryde 1997; Truscott 2000; Logan 2004; Sullivan 2008). Australia ICOMOS' (n.d.) letter to the Commonwealth noted that 1999 amendments to the Burra Charter strengthened 'acknowledgement of a community's associations with a place and its meanings for them, including associations relating to traditional practice' as part of cultural heritage values of places.

State governments in Queensland, South Australia and Victoria have reviewed their heritage legislation to recognise that understandings of Aboriginal heritage have changed over time so it is 'no longer confined to archaeological sites, or traditional material objects, but encompasses landscapes, language and stories' (Government of South Australia 2008, 2). The government of Western Australia is undertaking a review of its *Aboriginal Heritage Act 1972* in 2010.

In South Australia, the Kaurna National Cultural Heritage Association Incorporated (2009, 2) notes that the broad definitions of 'sites, objects and remains' are a strength of the *Aboriginal Heritage Act 1988* (SA), indicating a recognition that heritage relates to 'all parts' of Aboriginal people, and 'should be managed as a whole'. In 2006 and 2003 respectively, Victoria and Queensland introduced new Aboriginal heritage legislation which recognised that protecting and conserving Aboriginal cultural heritage needs to be based on respect and understanding of Aboriginal knowledge and cultural practices (Kaurna National Cultural Heritage Association Inc 2009, 6). Queensland's Cultural Heritage Acts Review (2008, 2) notes that previous legislation defined Aboriginal and Torres Strait Islander heritage as 'identifiable physical or tangible evidence of occupation' and that this was ineffective, leaving traditions, customs and history unrecognised. New Queensland legislation, in the form of the *Aboriginal Cultural Heritage Act 2003* and *Torres Strait Islander Cultural Heritage Act 2003*, aims to address this by building its management on knowledge, traditions and cultural practices (Queensland Government 2008, 2).

Australia also has legislation to protect moveable cultural heritage, and the museums sector is committed to establishing special protocols and guidelines in consultation with Indigenous representatives and in association with Commonwealth, State and Territory Aboriginal and Torres Strait Islander Heritage protection legislation (Museums Australia 2009).

Maintenance of Indigenous Languages and Records Program
In September 2009, two Federal ministers (Macklin and Garrett) announced a new national approach to preserving Indigenous languages, the Maintenance of Indigenous Languages and

8 The Australian Heritage Council 'is an independent body of heritage experts established under the *Australian Heritage Council Act 2003*, that advises the Minister for the Environment, [Water], Heritage and the Arts on heritage matters' in regard to place (Australian Government 2010).

Records program (MILR). This came in response to the 2005 National Indigenous Languages Survey, which found that of the original 250 Australian Indigenous languages, 110 were 'critically endangered' and only 18 were considered strong (DEWHA, n.d.). This survey found that individual states had language support strategies, but inconsistencies and varying standards between them made it hard to coordinate efforts to ensure survival on a national level, and that there were limited educational courses for people/teachers wanting to learn how to teach Indigenous languages (Department of Education, Employment and Workplace Relations 2008, x). The new MILR programme, managed by DEWHA,

> supports a broad range of projects, including documentation and recording of Indigenous languages and the development of language resources and language databases to assist with the development and delivery of programs through language centres. It also supports greater coordination between language organisations, activities that promote Indigenous languages in the wider community and innovative projects using multimedia and new technologies.
>
> (DEWHA 2010a)

A first-year commitment of AUS$9.3 million towards Indigenous language programmes was made as part of a total contribution by all Australian governments of AUS$38.6 million 'towards interpreting and translating services' to operate across Indigenous communities in remote regions (Macklin and Garrett 2009).

Indigenous education and language programmes in Australia are inextricably linked and debated vigorously. A major position paper by Indigenous leader Noel Pearson on 'Indigenous Education and Equality' renewed wide public discussion in 2009. The Indigenous languages scholar Christine Nicholls commented that there is a big, and somewhat unreasonable, expectation placed on students regarding the level and speed with which they will learn a new Indigenous language, which, in accordance with the languages programmes, they must do at the same time as having to acquire English literacy (Nicholls 2009, 95). Only a small population of teachers are trained in teaching English as a second language, which means they do not necessarily have the skills to adequately teach students an Indigenous language effectively (Nicholls 2009, 94). Complicating this is the high incidence of health problems amongst Indigenous students in remote communities, which make learning difficult. Faced with all these problems, 'Aboriginal people find themselves repeatedly confronted by illogical, inadequate and often ill-supervised government projects' (ibid). Nicholls suggests that although education is one important approach to this aspect of Indigenous intangible culture, the effects of such programmes are often wasted in the absence of supporting policy, including that pertaining to housing and health. She urges a degree of caution regarding the new programmes, warning that it could simply be another example of 'political grandstanding' – where the current government refuses to adopt or build on the previous government's policy for political reasons rather than effective policy reasons. In other words, she suggests, a tokenistic effort to be seen as the government that 'fixed the Aboriginal problem', without any genuine desire to address the core issues (2009, 96). The new programmes cannot be a panacea for deeply entrenched problems (see, for example, Pearson 2009a; 2009b; Leigh 2009).

ETHNIC CULTURAL PROGRAMMES

The Federal government has had programmes supporting cultural diversity since the late 1970s: ethnic radio broadcasts in multiple community languages began in 1975; ethnic television programmes followed in 1979; and the excellent Special Broadcasting Service has been broadcasting nationally since 1983 (Multiculturalaustralia, n.d.). Each state runs programmes supporting cultural diversity. For instance, Multicultural SA funded over 90 projects for different South Australian ethnic communities in the first half of 2009. Some of the grants to sustain intangible cultural heritage were to the Association of Chinese Writers to run Chinese painting and calligraphy classes; the Australian Druze Ladies Auxiliary to produce a Lebanese recipe book; the Awiel [Sudanese] Community Association to purchase traditional costumes; the Bosnia and Herzegovina Muslim Society of SA to develop a dance group; and for many communities to run festivals where their cultures are performed (Multicultural SA 2009). All states and the territories also support Multicultural Festivals each year.

CONCLUSION

Although it has made no statement to this effect, the Australian national government appears to be unwilling to ratify the UNESCO *Convention for the Safeguarding of the Intangible Cultural Heritage*. It conducted its 'preliminary consultation' in a highly selective manner which allowed for no public discussion and focused on the difficulties that unnamed Federal agencies suggested would accompany ratification, especially as they relate to Indigenous cultures. It seemed to rely on programmes directed at Indigenous cultural maintenance, its 2009 ratification of the *Convention on the Protection and Promotion of the Diversity of Cultural Expressions* (although the intent of the two Conventions is different), and existing practices of the cultural heritage sector.

Intangible heritage is included in consideration of heritage places, moveable objects and collections at a national level, particularly in regard to Indigenous heritage. All Australian governments have programmes that support the arts and cultural practices of this very diverse population, although it has not been possible to discuss them in detail here. DEWHA as the agency responsible for this Convention has surprisingly not raised multicultural or ethnic affairs as an area for consideration in this context.

Continuing debate about the diverse nature of Australian society and culture will ensure that respect for the values and beliefs of others remains the subject of public discussion and that changes to heritage legislation and practices will continue to be made.

Real concerns have been expressed about the implications of ratifying the *Convention for the Safeguarding of the Intangible Cultural Heritage* in Australia. We believe that the best way to address them is to bring discussion formally into the open.

BIBLIOGRAPHY AND REFERENCES

Attorney-General's Department, 2003 *Commonwealth of Australia Constitution Act compiled with amendments 25 July 2003* [online], available from: http://www.comlaw.gov.au/comlaw/comlaw.nsf/440c192858 21b109ca256f3a001d59b7/57dea3835d797364ca256f9d0078c087/$FILE/ConstitutionAct.pdf [16 March 2010]

Australia ICOMOS Secretariat, n.d. Letter from Peter Phillips to Paul Salmond re: Ratification of UNESCO *Convention for the Safeguarding of the Intangible Cultural Heritage* (probably late 2008)

Australian Bureau of Statistics, 2007 *2914.0.55.002 – 2006 Census of Population and Housing: Media Releases and Fact Sheets, 2006,* released 27 June 2007 [online], available from: http://www.abs.gov.au/AUSSTATS/ abs@.nsf/7d12b0f6763c78caca257061001cc588/5a47791aa683b719ca257306000d536c!OpenDocument [10 May 2011]

Australian Government, 2010 *Australia's National Heritage* [online], Australian Government, Department of the Environment, Water, Heritage and the Arts, Canberra, available from: http://www.environment.gov. au/heritage/publications/about/pubs/national-heritage.pdf [28 February 2010]

Australian Human Rights Commission (AHRC), 2008 *Ratification of 2003 UNESCO Convention for the Safeguarding of Intangible Cultural Heritage*: Australian Human Rights Commission Submission to the Department of Environment, Water, Heritage and the Arts [online], 5 November, available from: http:// www.hreoc.gov.au/legal/submissions/2008/20081105_UNESCO.html [4 May 2011]

Blue Shield Australia, 2008 *UNESCO Convention for the Safeguarding of the Intangible Cultural Heritage*: Extracts from the Blue Shield Australia letter to the Australian Government [online], available from: http:// www.collectionscouncil.com.au/Portals/0/UNESCO%20in%20flier.pdf [15 February 2010]

Buckley, K, 2009 Personal communication with author (email exchange with author), 23 November

Cassidy, S, 2010 Personal communication with author (email exchange with author), 5 February

Collections Council of Australia, 2008 *Submission regarding the UNESCO Convention for the Safeguarding of the Intangible Cultural Heritage* [online], 11 September, available from: http://www.collectionscouncil.com. au/intangible+cultural+heritage.aspx [15 March 2010]

Commonwealth of Australia, 2008 *Australian Heritage Council* [online], available from: http://www.direc-tory.gov.au [17 March 2010]

Department of Education, Employment and Workplace Relations, 2008 *Indigenous Languages Programmes in Australian Schools: A Way Forward* [online], available from: http://www.dest.gov.au/sectors/school_educa-tion/publications_resources/profiles/Indigenous+Languages+Programs+in+Australian+Schools+%E2%80% 93+A+Way+Forward.htm [11 December 2009]

DEWHA (Department of Environment, Heritage Water and the Arts), 2008 *Department of Environment, Heritage Water and the Arts annual report 2007–2008 volumes 1 and 2* [online], available from: http://www. environment.gov.au/about/publications/annual-report/07–08/index.html [4 May 2011]

—— 2009a *Arts and Culture: Cultural diversity 'Australia is a party to the UNESCO Convention that covers cultural diversity'* [online], updated 13 October 2009, available from: http://www.arts.gov.au/culturaldiver-sity [12 February 2010]

——2009b *Department of Environment, Heritage Water and the Arts annual report 2008–2009 volumes 1 and 2* [online], available from: http://www.environment.gov.au/about/publications/annual-report/08–09/ index.html [15 November 2009]

—— 2009c *Indigenous Languages – A National Approach* [online], available from: http://www.arts.gov.au/ indigenous/languages_policy [11 December 2009]

—— 2010a *Maintenance of Indigenous Languages and Records* [online], available from: http://www.arts.gov. au/indigenous/MILR [30 March 2010]

—— 2010b *State of the Environment Reporting* [online], available from: http://www.environment.gov.au/ soe/index.html [23 March 2010]

—— n.d. *Maintenance of Indigenous Languages and Records (MILR) Program Guidelines 2010–11* [online], available from: http://www.arts.gov.au/__data/assets/pdf_file/0007/90376/milr-guide-10–11.pdf [23 March 2010]

FECCA, 2009 *Federation of Ethnic Communities Council of Australia* [online], available from: http://www. fecca.org.au/ [26 March 2010]

—— 2008 *Submission of the Federation of Ethnic Communities' Councils of Australia on Australia's possible ratification of the UNESCO Convention for the Safeguarding of the Intangible Cultural Heritage (the Convention)* [online], available from: http://www.fecca.org.au/submissions/2008/submissions_2008037.pdf [23 October 2009]

Garrett, P, 2007 *New directions for the Arts* [online], Australian Labor Party, September 2007, available from: http://www.alp.org.au/download/now/new_directions_for_the_arts.pdf [5 December 2009]

Government of South Australia, Department of the Premier Cabinet, 2008 *Review of the Aboriginal Heritage Act 1988: Scoping Paper* [online], available from: http://www.aboriginalaffairs.sa.gov.au/ahaReview/documents/aha_review__scoping_paper.pdf [11 December 2009]

Government of Western Australia, Department of Indigenous Affairs, 2010 *Aboriginal Heritage Act 1972 Discussion paper: Register of places and objects* [online], available from: http://www.dia.wa.gov.au/Documents/HeritageCulture/AHAdiscuss.pdf [16 February 2010]

Graber, C B, 2006 The New UNESCO Convention on Cultural Diversity: A Counterbalance to the WTO?, *Journal of International Economic Law* 9 (3), 553–74

Lennon, J L, 2006 *Natural and cultural heritage, theme commentary prepared for the 2006 Australian State of the Environment Committee, Department of the Environment and Heritage, Canberra* [online], available from: http://www.deh.gov.au/soe/2006/commentaries/heritage/index.html [36 March 2010]

Kaurna Nation Cultural Heritage Association Inc, 2009 *Review of the Aboriginal Heritage Act 1988 (SA): Submission* [online], 30 October, available from: http://www.aboriginalaffairs.sa.gov.au/ahaReview/documents/subs/08_Kaurna%20Nation%20Cultural%20Heritage%20Association%20Inc.%AHA%20 Submission.pdf [11 December 2009]

Leigh, A, 2009 Radical Hope: Correspondence, *Quarterly Essay* 36, 127–30

Logan, W S, 2004 Introduction, Voices from the periphery: the Burra Charter in context, *Historic Environment* 18 (1), 2–8

Macklin, J, and Garrett, P, 2009 *Media Release: New national approach to preserve Indigenous languages* [online], available from: http://parlinfo.aph.gov.au/parlInfo/download/media/pressrel/95DU6/upload_ binary/95du61.pdf;fileType%3Dapplication%2Fpdf [11 December 2009]

McBryde, I, 1997 The cultural landscapes of Aboriginal long distance exchange systems: can they be confined within our heritage registers?, *Historic Environment* 13 (3–4), 6–14

Multiculturalaustralia, n.d. *Making Multicultural Australia Brief History of SBS* [online], available from: http://www.multiculturalaustralia.edu.au/doc/sbs_3.pdf [4 April 2010]

Multicultural SA, 2009 *Multicultural Grants Scheme 2008–09 Round One* [online], available from: http:// www.multicultural.sa.gov.au/documents/MulticulturalGrantsSchemeRoundOne2008–09Successful.pdf [23 March 2010]

Museums Australia, 2009 *Review of Protection of Movable Cultural Heritage Act 1986*: Museums Australia submission (March 2009)

Nicholls, C, 2009 Radical Hope: Correspondence, *Quarterly Essay* 36, 93–102

Pearson, N, 2009a Radical Hope: Education and Equality, *Quarterly Essay* 35, 1–105

—— 2009b Radical Hope: Correspondence, *Quarterly Essay* 36, 131–6

Queensland Government, Department of Natural Resources and Water, 2008 *Indigenous Cultural Heritage Acts Review: Review paper* [online], September 2008, available from: http://www.derm.qld.gov.au/cultural_ heritage/pdf/ch_acts_review.pdf [11 December 2009]

Sullivan, S, 2008 More unconsidered trifles?: Aboriginal and archaeological heritage values: integration and disjuncture in cultural heritage management practice, *Australian Archaeology* 67, 107–15

Truscott, M, 2000 'Intangible Values' as Heritage in Australia, *Historic Environment* 3 (5), 22–30

UNESCO, 2003 *Convention for the Safeguarding of the Intangible Cultural Heritage* [online], 17 October, Paris, available from: http://unesdoc.unesco.org/images/0013/001325/132540e.pdf [15 February 2010]

—— 2005 *Convention on the Protection and Promotion of the Diversity of Cultural Expressions* [online], 20 October, Paris, available from: http://unesdoc.unesco.org/images/0014/001429/142919e.pdf [4 May 2011]

—— 2009 *Australia Ratified Conventions* [online], available from: http://portal.unesco.org/la/conventions_by_country.asp?contr=AU&language=E&typeconv=1 [5 December 2009]

Proud to be Dutch? Intangible Heritage and National Identity in the Netherlands

Léontine Meijer-van Mensch and Peter van Mensch

This paper builds on the distinction between three key stakeholders with regard to the preservation of heritage in general and intangible heritage (hereafter ICH) in particular. In particular, these are the source community itself, local and national authorities and heritage professionals. In the Netherlands, the debate surrounding ICH is rather recent. The 2003 UNESCO *Convention for the Safeguarding of the Intangible Cultural Heritage* has stimulated discussion among professionals, but in a limited sense. In the last few years, however, the topic has been addressed by politicians and, as a consequence, ICH has entered public debate. In some ways, more than tangible heritage, ICH has become the focal point of a national debate on identity. The instrumentalisation – ie the political use – of ICH and the role of the three stakeholders in the Netherlands are discussed using the St Nicholas festivities (an old Dutch tradition) and the celebration of the abolishment of slavery (a new shared tradition) as two examples.

National identity as political issue

Francis Fukuyama argued in *The End of History and the Last Man* (1992) that the progression of human history was complete. The struggle between ideologies ceased as a result of the fall of the Berlin Wall in 1989 and the end of the Cold War, when political and economic liberalism would triumph. In reality, one ideology replaced the other. Throughout Europe, the last decade of the 20th century ushered in a remarkable revival of interest in national identity that is reminiscent of late 19th-century nationalism. At the very start of the 21st century, public debate on national identity in the Netherlands was provoked by the journalist Paul Scheffer. In his essay 'Het multiculturele drama' (approximate translation: 'The multicultural disaster'), Scheffer reflected on multiculturalism and the impact of immigration within the Netherlands (Scheffer 2000). Even though Scheffer is a prominent member of the *Partij van de Arbeid* (Labour Party, the main socialist party in the Netherlands), his ideas found resonance in right-wing circles.

Scheffer's main argument focused on the idea that ethnic minorities are over-represented in statistics concerning unemployment, poverty, criminal activity and school drop-out. He claims multicultural policy has made politicians blind to this fact. Indeed, the idea of a multicultural society has proven to be a failure. The culture of tolerance, and meeting its limits, works alongside a self image that is no longer authentic. A farewell to the cosmopolitan illusion in which many would-be intellectuals wallow is necessary. Scheffer's essay can be considered as a reaction to a strongly felt social and political insecurity stemming from the increasingly multicultural composition of Dutch society. In essence, traditional values have been viewed as challenged by these recent societal transformations. In this atmosphere, new populist political parties have

emerged: *Leefbaar Nederland* (1999) and *Lijst Pim Fortuyn* (2002). Even though their lifespan was short (both parties were dissolved in 2008), their political impact was enormous. The issue of national identity – and with it ICH as the expression of norms and values – entered the political arena, a process that was fuelled by events such as the attacks on the World Trade Center (New York, 11 September 2001), the assassination of film-maker Theo van Gogh (Amsterdam, 2 November 2004) and the wars in Iraq and Afghanistan. In this political debate, not just the (assumed) political ideology of the Muslim community in the Netherlands but also their cultural traditions of wearing headscarves, shaking hands between men and women, and ritual slaughter, to name the most contested, were at stake.

The social and political debate on multiculturalism and national identity culminated in the foundation of two new political parties: the *Partij voor de Vrijheid* (2005) and *Trots op Nederland* (2007). Both parties were founded by dissident members of parliament of the *Volkspartij voor Vrijheid en Democratie* (People's Party for Freedom and Democracy), a traditional conservative–liberal party. The *Partij voor de Vrijheid* (Party for Freedom) was founded by Geert Wilders, and *Trots op Nederland* (Proud of the Netherlands) was founded by Rita Verdonk. Both politicians created a distinct profile for themselves as a nationalist and populist right-wing political movement with an assimilationist stance on the integration of immigrants, particularly Muslims, into Dutch society. Both politicians advocate a national identity based on so-called indigenous traditions, avoiding a critical reflexive attitude towards Dutch history and associated ICH. Specifically, both politicians tend to instrumentalise ICH by appropriation and rejection, introducing the dichotomy between 'us' and 'them'.

Us and them

This dichotomy is clearly illustrated by the speech delivered by Rita Verdonk on the occasion of the official launch of the *Trots op Nederland* party in April 2008. During this speech, Verdonk marked the difference between 'us' and 'them' by stating that '"we" are proud of the Netherlands and "they" propagate a "down-with-us" mentality'. 'Our culture', Verdonk continued, 'originates from a year-long battle of our ancestors, of citizens of the Netherlands, who sometimes have sacrificed their lives for our liberties, the richness which we enjoy today, and our democratic values [...] By nature, the Dutch do not discriminate! For ages we are a welcoming people' (Verdonk 2008). Moreover, these values are being threatened by, according to Verdonk:

> A strong down-with-us movement which for years tries to convince us that our culture does not exist, and which considers our values and norms to be inferior in comparison to other cultures. They even call into question the St Nicholas festivities. And, everywhere they want to erect monuments about slavery to portray us as bad. (ibid)

This speech highlights a great reluctance to reflect on colonialism, slavery and racism as intrinsic parts of Dutch heritage. Being 'Proud of the Netherlands' (and its history) evidently does not include the creation of monuments to draw attention to slavery and its heritage. At the same time, this pride seems to include the neglect of controversial elements of the age-old tradition of the celebration of the name day of St Nicholas. Interestingly, it is precisely the connection between the transatlantic slave trade and the St Nicholas festivities that Verdonk chooses to deny.

Before discussing the two heritage phenomena referred to by Verdonk, it is necessary to

focus on the dichotomy between 'us' and 'them' in relation to the process of heritage creation. In most discussions about ICH, an emphasis is placed upon the 'communities, in particular indigenous communities, groups and, in some cases, individuals, [who] play an important role in the production, safeguarding, maintenance and re-creation of the intangible cultural heritage, thus helping to enrich cultural diversity and human creativity' (UNESCO 2003, Preamble). However, the Convention does not provide any further definition of these particular groups and individuals. Accordingly, this issue was dealt with at a recent meeting organised by the Intangible Heritage Section of UNESCO and the Asia/Pacific Cultural Centre for UNESCO in Tokyo, in March 2006 (Cang 2007, 49). At this meeting participants agreed on the identification of five interest groups. These distinctions serve to clarify the roles and positions of various actors in the ICH field. The defined interest groups are:

- Individuals within or across communities with distinct skills, knowledge, experience or other characteristics
- Groups of people within or across communities who share characteristics such as skills, experience and special knowledge, and thus perform specific roles in the present and future practice, re-creation and/or transmission of their intangible cultural heritage
- Specific communities as networks of people whose sense of identity or connectedness emerges from a shared historical relationship
- Society as the totality of the population of a country
- Multinational or scattered communities, who relate to a single heritage that is not limited to one geographical area or country (Cang 2007, 49–50).

The discussion about heritage usually focuses on the actors defined as Group 3. This focus is discussed by Emma Waterton and Laurajane Smith in their introductory paper in a special issue on 'Heritage and community engagement' of the *International Journal of Heritage Studies* (Waterton and Smith 2010). Waterton and Smith have shown that the heritage sector 'is dominated by a particular notion of community, one that overlooks the fact that representation of reality can have powerful effects on any group under construction' (ibid, 9). They conclude that 'real life communities are not only misrecognised but misrepresentations of identity become institutionalised in the heritage process' (ibid, 12). The present paper follows this line of thought by discussing the interaction between Group 2 and Group 3, in particular between politicians and heritage professionals (as groups of people that perform specific roles) and specific communities with shared historical relationships. On all levels, processes of inclusion and exclusion can create 'us' and 'them' dichotomies, but Verdonk's instrumentalisation of this dichotomy illustrates the point made by Waterton and Smith and emphasises the necessity to study the interaction between interest groups.

Source communities, politicians and professionals

The 2003 Convention identifies three categories of stakeholders. Apart from the communities as mentioned above, the Convention refers to national governments (the States Parties) and professionals. The Convention requires states to foster the 'creation or strengthening of institutions for training in the management of the intangible cultural heritage and the transmission of such heritage through forums and spaces intended for the performance or expression thereof'

(UNESCO 2003, Article 13). The 1989 *Recommendation on the Safeguarding of Traditional Culture and Folklore*, a precursor of the current Convention, is even more explicit on the role of professionals and professional institutions in the conservation of heritage. The Recommendation mentions archives and museums, as well as 'collectors, archivists, documentalists, and other specialists in the conservation of folklore' (UNESCO 1989, Article C).

The identification of the three categories of stakeholders is not without importance. Reporting on a conference on signification, organised by *the Instituut Collectie Nederland* (Netherlands Institute for Cultural Heritage) and the *Rijksdienst Cultureel Erfgoed* (National Service for Cultural Heritage) in November 2009, Frans Schouten concluded that the dynamics of the interaction between the three 'players' was hardly an issue in the professional debate. During the conference, the discussion was dominated by professionals, claiming a natural and exclusive right to 'pass objectified, informed and verifiable judgments upon the value of heritage' (Schouten 2010, 36). Schouten strongly criticised one of the propositions expressed at the conference considering 'value judgments as being independent from decision making processes'. This position of heritage professionals has been described by Laurajane Smith as the 'Authorised Heritage Discourse' (Smith 2007, 5). In this discourse, heritage *is* the thing rather than the cultural values or meanings that the material thing may symbolise (see also Kirshenblatt-Gimblett 2004). To Smith 'all heritage is intangible, and may usefully be viewed as a cultural process of meaning and value production' (ibid, 4). As a consequence, Smith's definition of heritage is 'a cultural process or performance that is concerned with the production and negotiation of cultural identity, individual and collective memory, and social and cultural values' (ibid, 2).

The Authorised Heritage Discourse refers to the dichotomy between 'we' as professionals and 'them' as the source communities. Smith's definition of heritage can also be seen to represent contemporary practices of 'liberating culture' from this discourse (Kreps 2003). In this light, the New Heritage Discourse advocates co-creation and co-curatorship. Kreps contends that 'by identifying and naming the material and non-material elements that constitute their environment, people realize their right to their world and gaining control over it' (ibid, 10). In museology, this approach had been labelled new museology, community museology, people's museology, or sociomuseology (van Mensch 2005). One of the foundations of this participative paradigm is the 1976 *Recommendation on Participation by the People at Large in Cultural Life and their Contribution to It* (ibid, 181). According to this Recommendation, 'participation by the greatest possible number of people and associations in a wide variety of cultural activities of their own free choice is essential to the development of the basic human values and dignity of the individual' (UNESCO 1976, Preamble). Here, participation takes the form of 'an assertion of identity, authenticity and dignity' (ibid). This assertion 'should not result in the formation of isolated groups but should, on the contrary, go hand in hand with a mutual desire for wide and frequent contacts, and that such contacts are a fundamental requirement' (ibid).

The participative paradigm involves a new view on professionalism. Behind this view is the conviction that the process of attributing heritage values (musealisation) is not exclusively a responsibility of heritage professionals. It is primarily a responsibility of the source community itself. In effect, the role of the professional can be defined as facilitator rather than authority (Meijer and van Mensch 2008, 6). However, at the same time, the professional contributes to a critical reflexive discourse. In participative projects the core role of the heritage professional should centre upon the mediation between the source community and the institution in the process of attributing value. One risk often encountered in participative projects is the romantici-

sation, or nostalgicisation, of heritage, where negative or sad meanings tend to be omitted by the heritage institution (Meijer-van Mensch 2009, 108). Therefore, the heritage professional should reflect critically on these nostalgic tendencies during heritage-making. Indeed, this element of nostalgia is a driving force behind the instrumentalisation of heritage espoused by politicians such as Rita Verdonk.

In terms of ICH, the relationship between professionals and source communities is a sensitive one (Alivizatou 2008). By definition, the 'safeguarding of intangible heritage means measures aimed at ensuring its viability' whilst respecting its dynamic nature (UNESCO 2003, Article 2.3). In the 1989 Recommendation, an interesting distinction was made between 'conservation' and 'preservation' in order to define the two perspectives on ICH: the professional versus the community. While the evolving character of ICH cannot always be directly protected, heritage that has been fixed in a tangible form could very well be conserved by professional institutions. Preservation of living heritage, on the other hand, requires measures be taken to guarantee the status of and economic support for such traditions (UNESCO 1989, Articles C and D). Kreps uses the term 'preservation' in a similar way, as opposed to traditional conservation (Kreps 2003, 14). The term preservation is used here in the same sense as the term 'cultural conservation' is used by, for example, the Smithsonian Institution's Center for Folklife and Cultural Heritage. To the Center, 'cultural conservation is a scientific and humanistic concern for the continued survival of the world's traditional cultures' (ibid, 13). By introducing the term indigenous curation, Kreps emphasises that this 'scientific and humanistic concern' should not be limited to professional institutions. Indigenous curation is a means for the safeguarding of ICH, but is simultaneously a form of ICH itself (Kreps 2009, 199).

In view of the polarities between conservation and preservation, and between professionals and source communities, as outlined in the 1989 Recommendation, it is important to develop a method in assessing the signification of both tangible and intangible expressions of culture that is not specific to institutionalised musealisation processes only. Such a method is provided by the Collections Council of Australia, where its guide to assessing the significance of collections, *Significance 2.0*, refers to the 'values and meanings that items and collections have for people and communities'. It states:

> At a simple level, significance is a way of telling compelling stories about items and collections, explaining why they are important. Significance may also be defined as the historic, artistic, scientific and social or spiritual values that items and collections have for past, present and future generations. These are the criteria or key values that help to express how and why an item or collection is significant. (Russell and Winkworth 2009, 10)

It is evident that this method involves the perspectives of creators and users. In particular, it is not aimed at resolving 'conflicting view points, or determin[ing] which is right or wrong, especially where the parties have cultural or spiritual attachments to an item or collection. The statement of significance can reflect the nature and substance of multiple points of view' (ibid, 13). Within the Netherlands, two intangible cultural expressions can be used to illustrate how a disconnect between professionals and source communities has become central to public debate. Specifically, the tradition of Sinterklaas and the commemoration of slavery are discussed in the following sections. Both case studies are selected also because of the ways politicians increasingly try to raise

their voices as self-declared defenders of the integrity of ICH, thus challenging professionals to take position in an increasingly politicised debate.

SINTERKLAAS

The celebration of the name day of St Nicholas of Myra (6 December) is a Roman Catholic feast that survived the Reformation in 16th-century Netherlands. Since St Nicholas is the patron saint of children, the festivities are predominantly focused on children and the giving and receiving of presents. The main celebration takes place on the evening before the actual name day (*Sinterk-laasavond*), but festivities begin earlier in the season. On 6 December, all festivities suddenly come to an end: shopkeepers replace every reference to St Nicholas with images of Santa Claus, a legendary figure based on the same 4th-century saint.

From October each year, St Nicholas decorations start to dominate the city and in the super-markets special candy fills the shelves. At the end of November, St Nicholas officially arrives in the country. Although, historically, he lived in Myra (now southern Turkey), Sinterklaas is supposed to come from Spain. According to tradition, he arrives mid-November by an old-fash-ioned steamboat, an event that is broadcast live on Dutch television. A week later, St Nicholas is officially welcomed in all major Dutch cities at roughly the same time. Despite the multitude of 'copies' throughout the country, there is only one national St Nicholas. During the weeks prior to his broadcast arrival, the whereabouts of the 'real' St Nicholas is discussed on special news programmes.

St Nicholas wears bishop's robes, including a red cape and mitre, and holds a crosier, a long gold-coloured staff with a fancy curled top. He is accompanied by a group of black-faced assis-tants in colourful dresses, the so-called *Zwarte Pieten*. Their main task is to collect the wishes of the children and to distribute the presents. In the days leading up to 5 December, young children put their shoes in front of their chimneys and sing special songs. Often the shoe is filled with a carrot or some hay for the horse of St Nicholas. The next morning, they will find a small present in their shoe, ranging from a bag of chocolate coins to a bag of marbles, or some other small toy. In the evening, Sinterklaas brings presents to every child who has been good in the past year. This is often done by placing a sack of presents outside the house or living room, after which a neighbour or parent bangs the door or window, pretending to be Sinterklaas' assistant. Another option is to hire or ask someone to dress up as Sinterklaas and deliver the presents personally.

Commercial interests have played an important role in the survival of the St Nicholas feast. Interestingly, the same interests were the main reason why, in the 1980s and 1990s, the tradi-tional celebration of Sinterklaas was threatened by the imported celebration of Santa Claus. Still, Santa Claus has never become a familiar guest in Dutch families. On the contrary, Sinterklaas seems to be more popular than ever in recent years. To what extent this is related to the need for traditional symbols in a rapidly changing society has still to be explained, but, as shown by the speech of the Dutch politician Rita Verdonk, the feast is considered to be a cornerstone of Dutch identity. When the *Centrum voor Volkscultuur* (Centre for Popular Culture) made a list of the most popular traditions in the Netherlands, Sinterklaas ended up in first place (www.traditie.nl/top-100_67.html). And, when discussion started on the 2003 Convention, Sinterklaas was proposed as the first Dutch example of ICH to be included in *The Representative List of the Intangible Cultural Heritage of Humanity*, one of the main promotional instruments of the 2003 Convention.

The initiative to have Sinterklaas included in *The Representative List of the Intangible Cultural Heritage of Humanity* brought about a professional discourse about the necessity to define the celebration and its repertoire (Koops *et al* 2009). The iconography of Sinterklaas originates from the illustrated children's book *Sint Nicolaas en zijn knecht* (Saint Nicholas and His Helper), written in 1850 by the teacher Jan Schenkman (1806–1863). This book introduced the concept of Sinterklaas delivering presents through the chimney, riding onto the roofs of houses on a white horse and arriving from Spain by steamboat (van Melle 2009). Thus, it can be argued that, even though the celebration as a children's feast is much older, the present-day celebration is also partly a reinvented tradition with a highly standardised repertoire. When national television took control of the celebration, the repertoire was enriched by a contemporary narrative, leaving the basic iconography intact.

Based on the role that television plays, the traditional narrative became more flexible, allowing for new elements. One example can be found in the concern for the mysterious disappearance of St Nicholas on the night of 5 December, as mentioned earlier. For children with autism spectrum disorders (such as autism and Asperger syndrome), Sinterklaas, with its associated festivities and intrinsic relationship between fantasy and reality, is difficult to cope with. Moreover, it is particularly difficult to accept the uncertainty of what happens to St Nicholas after Sinterklaas emerges. Accordingly, parents of children with autism, united in the *Nederlandse Vereniging voor Autisme*, have pleaded for years for the staging of an official farewell party with a steamboat that would take St Nicholas back to Spain. In 2009, farewell parties were organised in a couple of towns. It might be possible that an 'official' farewell party will be included in the Sinterklaas news programmes on national television in 2010 as a result of these growing sensitivities.

The flexibility of the narrative and associated iconography was especially challenged by two elements: the cross on St Nicholas' mitre and the nature of the *Zwarte Pieten*. The mitre is the ceremonial bishop's head-dress. According to the standardised iconography, St Nicholas' mitre should be decorated by a cross. As such, the St Nicholas mitre is atypical compared with the historical mitres and contemporary mitres in use by Roman Catholic bishops. Nevertheless, the removal of the cross from the mitres of St Nicholas in some Dutch cities caused a considerable amount of political turmoil. In order to emphasise the religiously neutral character of the celebration, it had been decided that Christian symbolism would be abandoned. On 18 November 2009 two members of parliament belonging to the *Christen Democratisch Appel* – the main centre-right Christian democratic political party – attempted to stage a political debate on this issue. They stated that:

> there is no reason why the Christian origin of Saint Nicholas and the celebration of his feast should be anxiously hidden. The arrival of many new ethnic groups with their own cultures, feasts, customs and religions cannot mean that the Christian roots of our own culture, feasts and customs will be renounced.

They then demanded that the Minister of Culture should 'stand up for the preservation of a typical Dutch feast such as Sinterklaas, with all its symbols and references'. In response, the national newspaper *De Volkskrant* asked its readers to give their opinion. Considering the progressive, intellectual, leftish political orientation of the newspaper, it is surprising that 71 per cent of the 4100 reactions were in favour of retaining the cross on the mitre. The minister of culture (member of the Dutch Labour Party), however, did not see any legal basis to interfere. He argued

that the iconography of Sinterklaas is rooted within a 19th-century secular context and has very little to do with religious symbolism. Besides, historical images of St Nicholas up to the 19th century never show a cross on his mitre. The discussion about the cross is an example of how a tradition is hijacked by politicians to strengthen their position in the debate on multiculturalism. Both the removal of the cross, as well as its retention, express a desire for political control.

A more significant issue has emerged with respect to the identity of St Nicholas' helpers, *Zwarte Piet*. *Zwarte Piet* is of African origin in the traditional iconography, most often being depicted with black curly hair and full lips. During the first ceremonial entry of St Nicholas in Amsterdam (in 1934), Surinam sailors were asked to act as *Zwarte Piet*; however, *Zwarte Piet* is usually a white person painted black (Lakmaker 2009). In addition, it is commonly found that children are painted black as well. Nonetheless, the question remains: why black? Most frequently, the explanation that is used refers to the duty of *Zwarte Piet* to climb through the chimney to deliver presents to the children (Lamers 2009, 443). This seems to be a naïve explanation that serves to avoid any reflection concerning racial connotations. Another, more historically informed, explanation has *Zwarte Piet* as a representative of the devil, transformed into the archetypal Moor, who serves as a servant or enslaved person.

Based on medieval oral traditions, St Nicholas was accompanied by a chained devil. The chains represented the triumph of good over evil and light over darkness. This tradition is still in practice in Central Europe, particularly in the alpine regions where *Krampus* accompanies St Nicholas during the pre-Christmas season. The character *Krampus* is a mythical figure with devil-like connotations, most commonly depicted with horns and a tail. Traditionally, young men dress up as *Krampus* and roam the streets frightening children and adults, especially young women (Peet 2008, 3). By doing so, these young men are playing with the deep-rooted archetypal female fear of the abuse of sexual power.

After the Dutch became involved in the transatlantic slave trade, the symbolism of blackness gained a new 'realness' with respect to the skin colour of *Zwarte Piet* (ibid, 3). Possible evidence for this shift from devil symbolism to representing the enslaved can be found in Schenkman's book, noted earlier (1850). As depicted by Schenkman, the servant is most probably influenced by the omnipresent (re)presentation of figures of African origin in 17th- and 18th-century Dutch portrait paintings (van Melle 2009, 451). By the end of the 19th century, the image of *Zwarte Piet* became connected with the colonial hegemonic view of Africans as an inferior race, put forward by missionaries and scholars of the time.

From the end of the 19th century the racist dimension of *Zwarte Piet* has been increasingly criticised and debated. With the introduction of immigration from Surinam and the Antilles, for example, a new critical reflection emerged that focused on the role and image of *Zwarte Piet* as the simple and clumsy black servant. In 1994, an Amsterdam action group demonstrated in favour of 'an anti-racist Sinterklaas': a Sinterklaas without *Zwarte Piet* (Lamers 2009, 441). In later years, similar protest actions were organised 'against degrading racist impersonations of Black people' (ibid, 442). As a reaction, *Zwarte Pieten* were painted in a wide variety of colours. However, the traditionalist lobby did not surrender to these deconstructivist approaches and soon the *Zwarte Pieten* were painted black again. Any reference to slavery was rejected as being irrelevant, and too politically correct. Accordingly, it was maintained that a children's feast should not be spoiled by political statements (ibid, 443).

SLAVERY

The contemporary discussion on Sinterklaas highlights a certain ambivalence concerning the Black perspective on Dutch history. This is also demonstrated by the way the commemoration of slavery is treated in Dutch society. In general, the memory of slavery is not perceived as intrinsic to Dutch identity. This notion has been expressed within Rita Verdonk's speech, which contended that slavery is not 'our' concern, it is 'their' history (Verdonk 2008). Addressing the issue of ownership with regard to the heritage of slavery, Glenn Willemsen (former Director of *Nationaal Instituut voor Nederlands Slavernijverleden en Erfenis*), in a lecture for Reinwardt students, highlighted the use of Dutch pocket diaries. In particular, all public holidays are indicated within these diaries, including the holy days of the main religions. The diaries indicate Mother's Day, Father's Day and World Animal Day, to name a few; however, 1 July, the National Commemoration Date for the Abolition of Slavery, is not recognised. Even though it marks the day in 1863 when the Dutch government ended slavery in Surinam, it can be argued that this date is not part of the Dutch collective memory. Before becoming a national commemoration day in the Netherlands, the day was already celebrated as the *Keti Koti Dey* (Keti Koti: 'shattering the chains') by the Surinam community.

Between the 15th and 19th centuries the Netherlands was one of the greatest colonial powers of the world and deeply involved in the slave trade that operated from Africa to the Caribbean. Nonetheless, the Netherlands was one of the last countries to abolish slavery. They outlawed the slave trade in 1863, only after considerable pressure from Great Britain. Moreover, it took the Netherlands more than a century to begin a public and political debate on slavery. The absence of a community of descendants of slaves in the country itself was an important factor in the delay in commemoration. After Surinam won independence in 1975, the subsequent increase in immigration to the Netherlands rendered the memory of slavery in Dutch society more visible. The number of new immigrants reached a critical mass and, thereby, Surinam people began to organise themselves and express their ICH.

Owing to the fact that the population had reached a critical mass within the Netherlands and yet was still a minority group, the Surinam people began to pay more attention to the 1 July commemorations. In general, for this group, it is a day of social rituals. A large number of Surinam women wear an *angisa*, a colourful cloth wrapped and folded in special ways. Every way of wrapping and folding has a specific meaning, usually referring to the period of slavery (Stam 2006, 64). When the *Centrum voor Volkscultuur* made its list of the Top 100 Dutch Traditions, the *Keti Koti* festival was listed in 58th position (www.traditie.nl/top-100_67.html). Interestingly, the festival ranked lower than the making of *Broodje Pom* (53rd), a popular Surinam dish and one of the few Surinam intangible cultural expressions that have became a part of Dutch culture as a whole.

The grass-roots call for a national platform on the topic of slavery resulted in the creation of the *Landelijk Platform Slavernijverleden* (National Platform for the History of Slavery) in 1999. This platform, and its cooperation with the Dutch government, set in motion a chain of events with regard to a national commemoration of slavery. On 1 July 2002, a National Slavery Monument (designed by Surinam sculptor Erwin de Vries) situated in Oosterpark in Amsterdam was unveiled by Queen Beatrix and Mayor Job Cohen (this date subsequently became the National Commemoration Date for the Abolition of Slavery). On this occasion, the minister Rogier van Boxtel offered excuses for the Dutch slave trade. However, instead of it being a day of affirmation

and reconciliation, the day ended in great disappointment for the Surinam community. The presence of the queen, ministers, mayor and other high officials created a dynamic which excluded a large part of the source community. Many Surinam people felt as if their memory had been stolen from them (van Kempen 2006, 249).

The National Slavery Monument is referred to as a 'static monument', as opposed to the 'dynamic monument' that is evolving as a result of the work of the *Nationaal Instituut voor Nederlands Slavernijverleden en Erfenis*, or NiNsee (National Institute for the Study and Legacy of the Dutch Slave Trade and Slavery). This institute opened its doors to the general public on 1 July 2003. Specifically, NiNsee was founded to create opportunities for the telling of the 'other side' of the story, referred to as the 'black perspective'. The mission of NiNsee is 'to develop and position itself as the national symbol of the shared legacy of Dutch slavery and the collective future of all Dutch people' (www.ninsee.nl).

In the exhibition 'Breaking the Silence', NiNsee offers different perspectives on the history of slavery and represents these events for future generations as a means of fostering identification and shared memory. Although the focus of the exhibition is on oral testimonies that share the views of enslaved persons or their offspring, it also offers a historical perspective on the origins of slavery, the slavery system, the legacy of dehumanisation and the beginnings of the abolitionist movement. To contextualise these themes, the words of slave traders, the enslaved and abolitionists are used to present different perspectives on these issues. Moreover, the provocative questions used in the exhibition give the visitor a chance to understand the depths of the problematic legacy of the Dutch history of slavery. Furthermore, NiNsee has developed a guided tour along the 'forgotten' *lieux de mémoire* connected with the history of slavery in Amsterdam. The intention is to add the stories behind these places of memory to the collective memory of the city and, thereby, the country.

In recent years, the professional canonisation of Dutch history and heritage has begun to incorporate the memory of slavery. After discussions in parliament about the basic knowledge of Dutch history and culture, the minister of education, culture and science initiated the design of a historical and cultural Canon of the Netherlands during 2005, which was published in 2006 (Van Oostrom 2007). The minister was inspired by the emphatic conviction that there exist significant deficiencies in the knowledge of today's young people of Dutch history and culture. Moreover, this knowledge should be viewed in the context of growing tensions about national identity. To a certain extent, the Canon is an implicit definition of what it is to be Dutch. Most significantly, slavery is one of the 50 topics (van Oostrom 2007, 162–3). Reference is made to the National Slavery Monument and NiNsee, although none is made to the *Keti Koti Dey*.

Another more recent project can be viewed as the Dutch equivalent of Pierre Nora's *Les Lieux de mémoire* (1984–1992). This initiative, which is academic in nature, is based on discussions between Pierre Nora and Dutch historians (Wesseling 2005, 17). Throughout the four volumes the remembrance of slavery is mentioned several times, referring to places in the Netherlands as well as in South Africa, Surinam and the Caribbean. By focusing on places, the approach of *Plaatsen van herinnering* is different from that of *Les Lieux de mémoire*. Thus, by neglecting the ICH dimension of remembrance, professional involvement tends to exclude source communities from the process of signification and appropriation. At the same time, professional involvement has the additional danger of reducing living heritage to historical monuments.

Discussion

More than ever, national identity has become a key concern within the Netherlands and with this has come an interest in the meaning of heritage, and particularly ICH. Indeed, tangible heritage has hardly been a subject of public debate in recent years; this is probably because tangible heritage has a long tradition of professionalised and institutionalised care. In contrast, safeguarding ICH is less professionalised and institutionalised, making it vulnerable and open to political instrumentalisation. In this political instrumentalisation professionals play an ambivalent role. On the one hand, professionals create meaning and visibility. Traditions are being identified as both nationally and internationally important, as well as being selected for the national Canon. Sinterklaas, as well as *Keti Koti Dey*, appears in the list of the Top 100 Dutch Traditions. Currently, Sinterklaas is being considered as a possible candidate for The Representative List of the Intangible Cultural Heritage of Humanity. Slavery is included in the national Canon and in the list of key places of memory.

These two case studies are examples of the complex relationship between ICH and society as the totality of the population of a country. In the public debate on the Sinterklaas celebration it is often assumed that the celebration is national heritage. Even though the celebration shows a remarkable flexibility in significance and repertoire, it is only reluctantly accepted, or even blatantly rejected, by immigrant communities. The *Keti Koti* celebration is still very much community-specific heritage. Even though the history of slavery is considered to be part of the nation's collective memory, *Keti Koti Dey* is hardly accepted as national heritage nationwide. The case studies show that, in the interaction between specific communities and society as the totality of the population of a country concerning ICH, politicians as well as heritage professionals play an important role.

Bibliography and References

Alivizatou, M, 2008 Contextualising Intangible Cultural Heritage in Heritage Studies and Museology, *International Journal of Intangible Heritage* 3, 44–54

Cang, V G, 2007 Defining Intangible Cultural Heritage and its Stakeholders: the Case of Japan, *International Journal of Intangible Heritage* 2, 46–55

Fukuyama, F, 1992 *The End of History and the Last Man*, Penguin Books, London

Kirshenblatt-Gimblett, B, 2004 Intangible Heritage as Meta-Cultural Production, *Museum International* 56 (1–2), 52–65

Koops, W, Pieper, M, and Boer, E, 2009 *Sinterklaas verklaard*, SWP Publishers, Amsterdam

Kreps, C F, 2003 *Liberating Culture. Cross-Cultural Perspectives on Museums, Curation, and Heritage Preservation*, Routledge, London

—— 2009 Indigenous curation, museums, and intangible cultural heritage, in *Intangible heritage* (eds L Mith and N Akagawa), Routledge, London, 193–208

Lakmaker, J, 2009 De blijde incomste, *Ons Amsterdam* 61 (11/12), 428–33

Lamers, M, 2009 De zaak Zwarte Piet, *Ons Amsterdam* 61 (11/12), 440–3

Meijer, L, and van Mensch, P, 2008 Teaching theory, practice and ethics of collecting at the Reinwardt Academie, *Collectingnet* 4, 6–7

Meijer-van Mensch, L, 2009 Thuis in Zoetermeer: een pleidooi voor minder honkvast denken, in *4289, Wisselwerking. De 'Wonderkamer' van Zoetermeer* (eds A Koch and J van der Ploeg), Stadsmuseum Zoetermeer, Zoetermeer, 107–9

Peet, K, 2008 Zwarte Pieten. The Representation and Reproduction of Powerlessness, unpublished Masters paper, Reinwardt Academie

Russell, R, and Winkworth, K, 2009 *Significance 2.0. A guide to assessing the significance of collections*, Collections Council of Australia, Rundle Mall

Scheffer, P, 2000 *Het multiculturele drama*, NRC Handelsblad, 29 January, 6

Schenkman, J, 1850 *Sint Nikolaas en zijn knecht*, Bom, Amsterdam

Schouten, F, 2010 Over het waarderen van erfgoed, *Volkscultuur Magazine* 5 (1), 35–7

Smith, L, 2007 General Introduction, in *Cultural Heritage. Critical Concepts in Media and Cultural Studies* (ed L Smith), Routledge, London, 1–21

Stam, D, 2006 *Immaterieel Erfgoed in Nederland*, Nationale UNESCO Commissie, Den Haag

UNESCO, 1976 *Recommendation on Participation by the People at Large in Cultural Life and their Contribution to It* [online], available from: http://portal.unesco.org/en/ev.php-URL_ID=13097&URL_DO=DO_TOPIC&URL_SECTION=201.html [28 March 2011]

—— 1989 *Recommendation on the Safeguarding of Traditional Culture and Folklore* [online], available from: http://portal.unesco.org/en/ev.php-URL_ID=13141&URL_DO=DO_TOPIC&URL_SECTION=201.html [28 March 2011]

—— 2003 *Convention for the Safeguarding of the Intangible Cultural Heritage* [online], available from: http://portal.unesco.org/en/ev.php-URL_ID=17716&URL_DO=DO_TOPIC&URL_SECTION=201.html [28 March 2011]

van Dijk, M, 2009 Heritage as Cultural Action. The dynamic concept of Intangible Cultural Heritage, unpublished Masters thesis, Reinwardt Academie

van Kempen, M, 2006 Paramaribo: slavernijmonument Kwakoe. Herdenking van het slavernijverleden in de Nederlandse West, in *Plaatsen van herinnering. Nederland in de negentiende eeuw* (eds J Bank and M Mathijsen), Uitgeverij Bert Bakker, Amsterdam, 239–51

van Melle, M, 2009 Amsterdamse vormgevers van Sinterklaas, *Ons Amsterdam* 61 (11/12), 448–53

van Mensch, P, 2005 Nieuwe museologie. Identiteit of erfgoed?, in *Bezeten van vroeger. Erfgoed, identiteit en musealisering* (ed R van der Laarse), Het Spinhuis, Amsterdam, 176–92

van Oostrom, F, 2007 *A Key to Dutch History*, Report by the Committee for the Development of the Dutch Canon, Amsterdam University Press, Amsterdam

Verdonk, R, 2008 Nieuwe beweging, andere politiek, beter Nederland!, *Trots op Nederland*, 3 April [online], available from: http://www.trotsopnederland.com/index.php?pageID=3&messageID=26 [28 March 2011]

Waterton, E, and Smith, L, 2010 The recognition and misrecognition of community heritage, *International Journal of Heritage Studies* 16 (1–2), 4–15

Wesseling, H L, 2005 *Plaatsen van herinnering. Een historisch succesverhaal*, Uitgeverij Bert Bakker, Amsterdam

Intangible Cultural Heritage in Wales

Andrew Dixey

Introduction

If the legendary visitor from Outer Space (or even a researcher from much nearer) tried to find an official definition of ICH in Wales, he or she would be sorely tested. The small amount of information regarding ICH that is available reminds one of the early encyclopaedia entry: 'WALES, See ENGLAND' (*Encyclopaedia Britannica* 1898, vol XXIV, 325). The influence of the 'authorised heritage discourse' (AHD) within the UK and the political implications of implementing the 2003 Convention keep the mainstream heritage sector very much based on the tangible (see Smith 2006). The dichotomy of tangible and intangible heritage described by Ardouin (2007, 125) has not been resolved; Hassard's (2009, 285) plea that the UK 'must surely now embrace the idea of the intangible by ratifying the 2003 Convention' has not been acted upon. Moreover, the difficulty in extricating English views from wider UK perspectives, particularly in the political sphere, is evidenced in Smith and Waterton (2009). In their discussion on ICH in England, 'England' or 'English' are used 15 times and 'UK' or 'British' 16, with no obvious reason for the change of wording (see Smith and Waterton 2009). This difficulty in differentiating between the UK as a concept and attributing any particular view to it as a whole, including what may be very different views held in its constituent parts, is shown in the differing responses to the 2003 Convention, as discussed later.

In the three years between the launch of the 2003 Convention and its official enforcement in 2006, there had, in fact, been growing interest in ICH within the UK, even if the official line was not positive (see UNESCO UK 2006a, 3–4; Hansard 2009). Following the re-establishment of the UK National Committee for UNESCO in 2004, UNESCO Cymru Wales (2005) and UNESCO Scotland (2006) Committees were set up and saw potential in further developing the idea, with the Wales Committee undertaking a 'pilot study to create a database and set up an inventory' (UNESCO UK 2006b, 20). This was successfully completed in 2007 and demonstrated that there was interest at the grass-roots level in Wales for the Living Heritage project and that a database could be set up, given adequate resources (Edwards 2011). The database covered the domains listed in the 2003 Convention: Oral Traditions and Expressions (including Language as a Vehicle of the Intangible Cultural Heritage); Performing Arts; Social Practices, Rituals and Festive Events, Social Networks and Values; Knowledge and Practices Concerning Nature and the Universe; Traditional Craftsmanship Skills; and two domains, Welsh Icons and Wales Abroad, which are specifically relevant to Wales. Another idea from the Wales Committee was to get the concept of the Eisteddfod[1] recognised by putting it forward to UNESCO for inscription on the ICH Representative List (UNESCO UK 2006c, 3–4; Edwards 2011). However,

[1] See later for definition and discussion of the Eisteddfod.

such recognition through the tools of the 2003 Convention, such as the Representative List, can only occur if and when it is ratified by the UK State Party. In 2008, the Scotland Committee decided to explore (through Museums Galleries Scotland) the notion of 'Scottish ICH' as if ratification had occurred. In particular, the Scotland Committee commissioned a report that led to a £363,485 grant to Napier University by the UK's Arts and Humanities Research Council to set up an online wiki inventory of ICH in Scotland (Museums Galleries Scotland 2008; ICH Scotland 2009). This approach was discounted in Wales in part because it was considered too costly and may potentially involve difficulties in the motivating and training of the public to input their responses (Edwards 2011).

In 2007, the UNESCO Wales Committee organised the second annual meeting of the UK National Commission for UNESCO in Cardiff, an event that was opened by the then Director-General of UNESCO. A break-out session on ICH was included and the findings of the Welsh Pilot Study were reported and discussed, but no proceedings have been published. The Pilot Study was not continued immediately into a full scale project and when the Committee was ready to continue there was a lack of resources, particularly in the area of culture. This meant that the Wales Committee had to concentrate on a smaller range of work until 2010, although, as examined later, funding for projects linked to the Llangollen International Musical Eisteddfod, an example of Welsh ICH, have continued (UNESCO UK 2010, 13–14). The Wales Committee's interest in developing the ICH Project does still remain, however (Edwards 2011).

The Heritage Lottery Fund (HLF), which has a standard ethos and structure across the UK, does recognise that its regions have different populations and communities, and accommodates these differences through flexibility in their rules (Anon, *pers comm* 2010a). Accordingly, it has recently begun recognising what can be considered 'less material' and, thus, intangible forms of heritage. For instance, the HLF seeks to fund the following projects: 'We have invested in all kinds of heritage that is not only based on buildings, collections and landscapes but focuses on those things we can't touch: histories, memories and languages and customs' (Heritage Lottery Fund 2009).

Elsewhere, the term 'cultural traditions' is also used as an example of what might be acceptable, but tangible heritage was the dominate form of recognised 'heritage' in previous years (Heritage Lottery Fund, n.d.). More recently, an emphasis has been placed on local communities and their identities, which has led to an explosion in oral history and reminiscence work. Such projects rarely focus on ICH as defined in the 2003 Convention. The folk development organisation for Wales, *trac: music traditions wales*, states that the 'Heritage Lottery in Wales does not respond well to music or ICH. It appears that this is not the case in England, with projects such as The Northumbria Anthology receiving major investment from the [HLF] fund' (trac 2006). However, there is one HLF-funded initiative that aims to promote folk singing and dancing in the context of the Eisteddfod in Wales, as discussed later in this chapter.

The historic environment service of the Welsh Assembly Government (WAG), Cadw, seems to take a similar AHD-based view as its counterpart in England, English Heritage, in that tangible heritage takes precedence (Smith 2006; Hassard 2009; Smith and Waterton 2009). It is this disappointing scenario of (in)action by government departments and quangos that puts a question mark against the attitude within UK officialdom. The Chair of the Wales Culture Committee may state that 'the (UK) government is definitely not negative to ICH' (Edwards 2011), but others voice alternative views (Hassard 2009; Lovett 2011).

MUSEUMS AND ICH IN WALES

Pitchford (2008, 45) notes that 'a preoccupation with the past lies at the heart of the concept of "heritage"', which is particularly problematic when thinking of the intangible forms of heritage that are living and evolving today. Indeed, as conducted by the author, a small pilot survey of museums across Wales has indicated that there is a misunderstanding concerning what constitutes ICH. Of the ten museum professionals who responded, not one demonstrated a familiarity with the ICH concept without it being further explained. In addition, there was also confusion over who, at each museum, might deal with enquiries about ICH. After further explaining the concept, two professionals expressed the opinion that there is no interest in the field at their respective museums. Of the remaining museums, it was noted that oral history collection and research and community outreach work had occurred in the past, or was underway. One professional mentioned an interest in doing work on the local dialect, but doubted that time would become available to carry it out.

Similarly to the work of the HLF, Welsh museums professing any interest in ICH are usually, if at all, concentrating on oral history and/or community outreach projects. Moreover, while some museums include elements of ICH such as crafts, belief systems, dance and folklore within their portfolio, all inevitably concentrate on their tangible manifestations. For instance, Amgueddfa Cymru/Museum Wales, the multi-site national museum, uses the term 'intangible cultural heritage' once on its website when referring to the national archive of oral testimony held at St Fagans: National History Museum (formerly the Welsh Folk Museum and the Museum of Welsh Life) (National Museum Wales 2009). This extensive collection, the majority of which is in Welsh, is reflective of a strong interest in the various dialects and local speech characteristics that were considered to be in danger of disappearing in 1958, when the archive was established (Briody 2007; Thomas 2005, 1). It was certainly true that the number of monoglot Welsh speakers was in decline at that time; however, the dialects of English used in Wales were almost totally ignored.

At St Fagans there has continued to be a 'remit to represent "the life and culture of the nation … including in its illustration the activities of the mind and spirit – speech, drama, and music – as well as of the hand"' (National Museum Wales 2009). Mason (2004, 18) highlights that this was by no means new:

> For cultural nationalists since the 19th century, the act of creating an institution like a national museum has been and continues to be an act of assertion – a gesture designed to claim recognition for that identity and an attempt to translate a set of intangible beliefs about the special quality of a certain cultural group into an identifiable, material and visible presence.

She concludes that this 'nation-building' continues as St Fagans attempts to answer the call of the newly devolved political situation within Wales (Mason 2007). Nevertheless, the museum at St Fagans is more widely recognised for its collection of re-erected buildings from across Wales, including a Unitarian chapel and a late medieval church, displayed in an attempt to represent the Reformation period. Yet, neither of these buildings is interpreted to allow insight into the Christian belief and socio-political systems that brought them into being. Both buildings are used occasionally for public or private religious services even though neither plays much of a role in a living, evolving heritage. Exemplifying this tendency to view heritage as a window into the past, they serve to represent a heritage and a time that, for many, has otherwise disappeared from view.

Opened in 2007, Oriel 1 is a gallery space within St Fagans that is dedicated to exploring the identities of people who are living in Wales today (McAleavey 2009). In particular, attempts have been made through outreach projects to engage and link with immigrant communities, such as those categorised as Muslim and Italian. Accordingly, the Eid and Puja exhibitions, which were recently developed, have offered a glimpse into the heritages of these communities that are generally closed to the rest of the population. However, those who thought that Oriel 1, the first gallery to open at St Fagans after the political devolution of 1999, would help drive a nation-building process in Wales have been disappointed (McAleavey 2009, 59). The identity of those who consider themselves 'Welsh' is frequently expressed in terms of the intangible: a predominantly Christian-based belief system which for most is given a nodding acknowledgement only at weddings or funerals. The identity also revolves around the Welsh language as a vehicle for cultural expression, whether spoken or merely acknowledged in its absence.

Carter (2010) gives a useful account of the changing Welsh identity past, present and future, showing how rural depopulation, the industrial revolution and subsequent industrial decline have affected the use of the Welsh language. Additionally, in his insightful essay on the BBC TV series *Gavin and Stacey*, Jewell (2009) demonstrates how the use of Welsh idioms and cultural markers creates a comedic tension through 'opposing' the Welsh and English characters in each episode. For instance, when Bryn, one of the Welsh characters, is asked by the English characters to 'say something in Welsh', he replies that it is a 'constant source of embarrassment to me, but Welsh is not my mother tongue'. On this note, Jewel (2009) explains: 'Bryn's attitude in this scene also indicates how important the Welsh language is to his own sense of self. Even though he cannot speak it, it remains as critical to his own cultural identity.' This would be true – but is rarely voiced – for significant numbers of Welsh people who do not speak Welsh.

SAFEGUARDING THE EISTEDDFOD

Although it would be wrong to suggest that ICH exists in Wales only when associated with the Welsh language, the cultural practices and traditions that use Welsh as a vehicle for transmission do represent a significant aspect of the living and ever-changing ICH in 21st-century Wales. One example concerns the Welsh Eisteddfod. An Eisteddfod is a gathering that aims to encourage competitions, originally concentrating on the composing, reciting and singing of poetry. Small local Eisteddfodau are still held across Wales. What can be regarded as the pinnacle of this tradition is the National Eisteddfod: an annual, peripatetic cultural gathering now focused on competitions in many forms of ICH. Specifically, there are competitions in literature, poetry, prose, recitation, singing, dance and instrumental music. The highest honours are the two traditional poetry composition competitions: one in free style and the other in a tightly codified style, or Cynghanedd, which uses an intricate, ancient system of repetition of consonants and internal rhyme that is written in strict traditional metres. Many of these competitions are keenly fought under strict rules, although they still exhibit the slow evolution of this form of ICH.

Evidence of the recognition of the Eisteddfod as 'Welsh ICH' can be found with the Wales Committee's attempt to promote the Eisteddfod internationally through inscription on the 2003 Convention's Representative List. One can draw parallels with the international recognition gained for the Baltic states by the 'designation in 2003 of the Baltic Song and Dance Celebrations', with particular regard to the link to their maintenance of Baltic identity during the Nazi and Soviet eras (UNESCO UK 2006a, 3). Nonetheless, the process of gaining international

recognition for the Eisteddfod is now stalled until the UK government ratifies the 2003 Convention, as noted earlier.

Winning a competition at the National Eisteddfod is highly prestigious and can be a springboard to national, as well as possible international, stardom. Indeed, the 'National' can be viewed as the pinnacle of one's performance, which is usually proceeded by many years of honing skills and competing in small village, local area and regional Eisteddfodau. Nevertheless, there has been a notable drop in numbers of competitors in the smaller Eisteddfodau, particularly since the early 1990s. As a result, in 2006, the HLF funded a project in Wales in conjunction with the Wales Eisteddfod Society in order to promote the knowledge and skills associated with Eisteddfodau. According to the Society, they sought to: 'Plan, organize and develop workshops in the traditional cultures of Wales (folk dancing, folk singing, and *Cerdd Dant*) during the next two years with an emphasis on traditional methods of their transmission' (Cymdeithas Eisteddfodau Cymru, n.d.) (author's translation).

As seems to be so often the case for projects such as this, it is difficult to obtain publicly available information on any continuing legacy from this project. Much of what is available was published when the project was set up and is often undated. In this case, there were obviously some positive outcomes at the time, but a follow-up bid to the HLF in 2008 was apparently refused owing to a lack of funds (Anon, *pers comm* 2008). Although based on anecdotal evidence, one such outcome was that many of those introduced to folk dancing in West Wales are continuing to dance even though there has been no increase in the number of competitions in the small Eisteddfodau, which is mainly due to the problem of securing experienced judges (Hughes 2011). In contrast, folk singing in Pembrokeshire has benefited from a significant increase in both competitors and competitions (Hughes 2011).

The idea of Eisteddfod as an event of 'bringing together' became important after World War II to people who were looking to encourage a spirit of reconciliation between nations. For example, the Llangollen International Musical Eisteddfod is well-known for bringing together groups from all over the world to compete in the small town of Llangollen in north-east Wales. However, in order to reduce potential language barriers, it refocused on the aural and musical arts, including folk dancing. As such, the International Musical Eisteddfod is now known for interesting, colourful folk groups from all over the world competing in folk dancing, as well as for solo and choral singing competitions in a standard and yet modern 'classical music' style. This change from competitions bound by a common linguistic cultural focus to one bound by an adherence to the predominant Western European classical music tradition (what might be termed the Authorised Musical Discourse, or AMD), demonstrates an enartment (cf Howard 2003) that has been occurring in the Welsh-language Eisteddfod world for well over a century (see Cleaver 1968 for an example of how singing in a 'natural style' was being encouraged, which implies that this was not happening at the time). In this light, 'folk' music has been relegated to play a secondary role to the more prominent 'classical', or 'fine art', style of music. The voice used in the folk songs is not that of the classically trained opera singer, neither is it one that would be immediately recognised as 'folk' or 'traditional' within other European traditions, even that of England. Nevertheless, it is important to note that, in the literary competitions, the Welsh language is central to their expression and the changes that occur tend to have a more organic evolution.

The musical competition that has been least influenced by Western European musical styles is *Cerdd Dant*, or 'string music'. This is a unique Welsh singing style where poetry is sung whilst

a harp is played. One of its unusual aspects is that the harp plays the tune (*alaw*) and the words are sung to a sub-tune that harmonises with it. The *Cerdd Dant* Society, which celebrated its 75th anniversary in 2009 and holds its own annual national festival, the *Gŵyl Gerdd Dant*, was established to codify a form and, thereby, give structure to a tradition that was felt to be deteriorating. Since its early days, there has been considerable evolution in the form, but it still bears strong similarities to the original style. However, the singing style has not been immune to the influence of the AMD; changes of intonation and voice production that facilitate projection have been favoured over the natural, conversational voice of the past. Indeed, some hold the view that the pace of stylistic change has become too rapid and that the style is now overly technical and beyond the reach of 'ordinary people' (Anon, *pers comm* 2010b).

These types of change experienced by these Welsh examples of ICH resonate with Cang's (2007) description of the *Gujo Odori* in Japan, where the participants legislate for themselves and maintain the tradition, whilst allowing for a rather slow evolution. With regard to the National Eisteddfod and its associated traditions, change is accepted as an important aspect of its vitality as heritage. If these are self-sustaining examples of ICH, then does it matter that there is no official recognition of them as such? Nonetheless, the self-sustaining element itself relies on the commitment of individuals to maintain the ICH as tradition-bearers, where loss of these individuals, for whatever reason, could lead to the loss of the ICH itself (after Cang 2007, 54). In this sense, there is certainly a case for an official framework that would safeguard against this loss whilst not being so prescriptive, or dogmatic, in its structure that the natural evolution of ICH becomes impaired.

The Traditions of the *Plygain* and *Mari Lwyd*

In addition to the Eisteddfod, which has garnered a significant amount of attention in recent years, there also exist relatively informal traditions, such as the centuries-old *Plygain*, a particular church service, and the *Mari Lwyd*. Both of these living traditions are associated with the Christmas period known as *Y Gwyliau*, or 'the holidays', which span from Christmas to 12 January. Although the term *Plygain* is debated, it is generally understood as deriving from *pulli cantus*, or the cock's crow (Ifans 1983, 59). This is because *Plygain*, a form of Christian service that pre-dates the Reformation in Wales, traditionally started before dawn on Christmas Day, people entering the church in darkness, symbolically leaving into light. Currently, only a few places adhere to this pre-Reformation timing; instead, most are organised as a peripatetic series of *Plygain* services from the beginning of Advent until 12 January, with each church holding only one.

The traditional form of *Plygain* consists of a short service of prayer, reading and congregational carol, after which the *Plygain* is declared 'open'. Depending on the depth of the tradition in the surrounding local community, this might start with a planned carol, after which the order of the carols, which are sung *a capella*, is not pre-planned but chosen on a fairly *ad hoc* basis by participants. It should be noted that even where individuals or groups have breathed 'new' life into this old tradition, carols are sung as a contribution to Christ in devotion, as opposed to being performances. In this light, there is much less influence from the AMD on these traditions – as opposed to the more well-known singing at Eisteddfodau – with the natural voice predominating. Moreover, the carols can be considered unusual for Western Europe as they both tend not to confine themselves solely to the birth of Christ, but seek to celebrate His life story,

and originally spanned a large number of verses. Accordingly, the carol verses of *Plygain* are traditionally sung from personal, hand-written notebooks. The carols are often of a considerable age, and a few, such as *Myn Mair* and *Ar Fore Dydd Nadolig*, are believed to pre-date the Reformation (Kinney and Evans 1987, 51–2). They are most typically sung by a male trio of alto, tenor and bass, where the openness of the resulting harmonies and minor keys give the carols a particularly haunting character. Even though some groups have attempted to introduce English language carols, they have not been successful. Thus, *Plygain* remains a Welsh-language example of ICH.

During the past three decades a revival of this tradition has gained strength, which is mainly due to a growing recognition of its unique Welsh character. Additionally, an increase in the publishing of books of the carols has helped to strengthen their popularity since, previously, they were difficult to obtain. Nonetheless, there are still some carols which are sung by only one or two families. There are also moments of excitement when two groups are known to have the same carols in their repertoire because it is unacceptable to have a carol repeated within the same service. In recent history, notable changes have occurred, such as the relaxation of the regulation of only having male singers. This shift reflects the fact that when ICH is safeguarded by its practitioners it can more easily evolve in response to broader societal changes, such as the movement towards gender equality. However, it is important to highlight that one carol, which is the very last to be sung in the *Plygain* tradition, *Carol y Swper*, is still a male-only event. As the last carol, it signals the traditional supper held afterwards for all participants. Furthermore, the tradition is sustained in its 'heartland' of Powys and Denbighshire by generally rural communities, many of whom travel for long distances to attend a service. In contrast to festivals such as the National Eisteddfod, it can be quite difficult to obtain scheduling information for the *Plygain* 'circuit' since it is primarily for the participants and not a tourist affair.

Even more difficult to 'stumble across' is the tradition of the *Mari Lwyd*. Also associated with Christmas, its origins are shrouded in even greater mystery. Whilst it can be considered as part of the wassailing and ritualistic masked-disguise traditions of north-west Europe, it focuses on the *Mari*: a horse's skull carried on a pole with a white sheet attached to hide the bearer. Whether its origins stem from animist horse worship, linked to the turning of the year, is a continuing debate (see Ifans 1983, 126). It is ironic that the most complete description of the *Mari Lwyd* is by the Rev William Roberts (1852), who described it in detail, including many examples of the verses. His purpose was to show how debased it was, being 'a mix of old pagan and catholic, or "papist", rites' (Roberts 1852, 18). Since it is the fullest account in existence from the 19th century, it tends to be used as a standard for other versions (see Owen 1978, 49–62; Ifans 1983, 105–35). Interestingly, Roberts' (1852) descriptions provide a good example of when the importance of having a well-recorded, detailed source is possibly over-emphasised. Most significantly, this can lead to a fossilisation of the tradition, in that it must adhere to how it was represented in that particular period, in this case the mid-19th century. As the popularity of oral reminiscence across communities, whether in schools, museums or in HLF-funded projects, increases, and as it becomes easier to record and store oral testimony/reminiscence, there is a danger that this is seen to be the ICH and not simply a record of it at a particular instant. The uniqueness of the *Mari Lwyd* lies in its use of an actual skull, as opposed to the false masks of the other European traditions (Alford 1978), and the playing of a linguistic game (*pwnco*) between those within the visited house and the *Mari Lwyd* party outside. Once again, Welsh verses are used, traditionally extemporised using a particular metre. Beginning with the party outside, they introduce themselves and speak of their mission to bring good luck to the visited inhabitants. At this point, a

ritualistic 'battle', or *pwnco*, is enjoined: the inhabitants must keep the party outside for as long as possible and yet must also gain good fortune for the coming year through eventually allowing the party's entrance into their home. As the competition goes back and forth, the verses can become bawdier with insults exchanged about poor singing ability, poor quality of refreshment, homeowners' morals and worse! When the 'battle' has finally reached its end, the *Mari Lwyd* party enter the home and each member sings an introduction of the 'character' they are playing. Once inside, food and drink are enjoyed by all. In previous centuries, monetary payment was given by the residents to the *Mari Lwyd* party; however, this aspect of the tradition has mainly disappeared (Hando 1951, 24).

Once widespread, especially in South Wales, the disappearance of the *Mari Lwyd* from a particular locality strongly corresponds with the fading of the Welsh language from everyday use. In reference to the 1920s, Hando (1951, 23) gives an example from Caerleon, Gwent: 'They sang in Welsh, but they didn't understand the words …'. The ability to extemporise verses, even if paraphrased from a store of those previously used, is non-existent for those without the intimate knowledge of Welsh that is gained through daily use. As the use of Welsh diminished during the 20th century, the *Mari* became a mere adjunct of a sub-wassailing, carolling visit and generally disappeared from view, having become the apparatus of a particularly unusual form of begging around Christmas. Indeed, it is a moot point whether the *Mari Lwyd* and other similar traditions in the wassailing vein could be considered in many instances as ritualised begging in their original forms. Their formality gave them a respectability within a community that otherwise would not allow it, described by Martin as a 'tension between sanctioned seasonal visitors and common beggars' (2008, 85).

On a more personal note, I am lucky to have met, and sung against, the last of the true participants of the *Mari Lwyd* tradition. Hailing from Llangynwyd, a rural village not far from Maesteg, Cynwyd Evans had been raised in an island of Welsh-speaking agricultural communities that were surrounded by an industrialised coal-mining area. At seven years old, he would go around with a party of fellow boys to any of the village farmhouses and expect a vigorous defence from within, before being warmly welcomed inside. By the time I met him in the mid-1990s, he was in his eighties and took the *Mari* out only on New Year's Eve to a number of local pubs. Here, the tradition has become a mere shadow of its former self: the 'battle' that once ensued now consists merely of some verses sung outside and then again after entry. Cynwyd's son, Gwyn, in common with many in the area, had not been brought up to speak Welsh and the living tradition, as a part of his particular locality, died with Cynwyd in 1997 (Celfyddydau Mari Arts 1999). Gwyn does continue to take the Mari to visit local pubs and clubs on New Year's Eve to collect money for local charities.

Since the 1970s a number of groups interested in Welsh folk traditions have attempted *Mari Lwyd* revivals in various parts of the country. Only a few tend to last more than a couple of years since the initial interest usually wanes. A HLF-funded project in South Wales, based on the *Mentrau Iaith* (organisations that help develop local use of Welsh), 'organised workshops among community groups in order to raise their awareness of the festival' (Menter Abertawe 2006). They also 'created information packs that enabled others to learn more of the history and importance of the Mari Lwyd tradition and the Welsh language' (Menter Morgannwg 2006). As in the case of the Welsh Eisteddfod Society project discussed earlier, there seems to be little published evidence of any long-term impact on the local community. Another HLF-funded project has fared better: right on the border with England, Chepstow now has a procession with the *Mari*

Lwyd 'as part of a study of Welsh culture and tradition in a link between Chepstow school and the Widders Border Morris Side' (Forest of Dean and Wye Valley Review 2010). At least, there seems to be a continuation of the project, but it is not an attempt to recreate the tradition, as the *pwnco* element has been reduced to the singing of a few verses within a procession.

Indeed, there now appear to be few occasions when a visitor can be sure of seeing the *Mari*. In Llantrisant the local folk club visits pubs and clubs, even though, once again, the *pwnco* element of the tradition has diminished (Celfyddydau Mari Arts 1999). Two occasions when *pwnco* can be heard are the annual Christmas event at St Fagans, held in early December, and another held on New Year's Day at Llangynwyd (see World Wide Wales 2001). Both involve the visiting party having 'planted' members of their group within a particular building in order to indulge in a prepared form of *pwnco*. It is only when a party is specifically invited to a private house or event that the true, unknown element of the competition is experienced. Only a select group would know of the existence of these privately organised events and, as a consequence, it is extremely difficult to learn where the *Mari Lwyd* may be enacted.

CONCLUSION

This exploration of these three living traditions in Wales suggests, in light of the current ICH discourse, that there exists a continuum of categories for cultural practices across the globe. This continuum ranges from those that are less known, or 'unofficial', to those that are 'official' and, thus, recognised as 'ICH' in accordance with the definition put forward in the 2003 Convention (see Harrison 2010). Owing to the fact that the UK has yet to ratify the 2003 Convention, the living traditions found within its territory can be viewed as 'unofficial'. However, owing to an awareness of the 2003 Convention framework, as well as the efforts of the UNESCO Committees within the UK, some cultural practices are more 'official' than others. For instance, within Wales, the National and International Eisteddfodau can be viewed as 'official' since WAG helps support their associated societies and organisations through annual grants. Having the concept of the Eisteddfod listed as ICH under the terms of the 2003 Convention would definitely constitute an official acknowledgement, but this process has stalled, as detailed earlier. In contrast, the *Plygain* and *Mari Lwyd* traditions are 'unofficial' as a result of a lack of organising bodies and funding sources, despite the fact that a significant portion of the population is familiar with them. The closest either of these has come to official recognition was the grant given by the HLF to the *Mentrau Iaith* in 2004.

What these examples also demonstrate is that ICH in all its forms is dependent on people. Moreover, it needs a 'network of tradition bearers' (trac 2006, 4). Recording ICH can be straightforward enough, as can be an awareness or profile-raising strategy; however, it is the maintaining, nurturing and transmission of ICH between generations that is particularly difficult to ensure. These difficulties may stem from societal change, local depopulation and even changes in environmental legislation; although, in general, the survival of the most distinct forms of ICH within Wales is dependent upon a continuation of the Welsh language. Even though safeguarding language is not itself a part of the 2003 Convention, its significance as a 'vehicle for transmitting ICH' has certainly been highlighted (see UNESCO 2003, Article 2; Matsuura 2009). As a museum curator stated, 'performance lies at the heart of the offer' (Anon, *pers comm* 2009). This notion resonates with West and Bowman (2010, 308), who note: '[T]he criteria for World

Heritage significance have nothing to say about values for embodied experiences. But heritage sites, of global or lesser significance, are at their best when we feel a response rather than think it.'

A performance can garner a response even in the absence of a common language, but it can rarely be fully understood. This shows that the energy devoted to strengthening the use of the Welsh language in Wales can have a great impact on its associated forms of ICH. At the time of writing, WAG introduced new legislation on the Welsh language (NAW 2010), and the March 2011 referendum on the National Assembly, which assumes the right to develop laws without prior reference to the UK parliament, was approved by a voting majority. Indeed, the voting patterns have shown a marked change since 1997, when counties on the eastern side of Wales voted against the referendum to set up the Assembly. In 2011, all of these counties – except for Monmouthshire – voted to give the Assembly more power. Whether this is evidence of a change in a sense of 'Welsh identity' is something that will be discussed at length in other arenas. Nevertheless, trac has recently noted that developing folk music reflects an 'increase of Welsh identity in the wake of establishing the Assembly' (trac 2006, 5).

When Schama (2010) questioned the almost fetishistic revere of the object, he was rightly saying that a social culture could not be viewed merely via its tangible cultural heritage. By including the intangible, we can move to judging the richness of a culture by how well its ICH is maintained. In Wales there is a danger that there will come a time, after all the 'politicking', when the Welsh language is supposedly 'safe', national self-confidence is building, when we will finally turn our attention to the other forms of ICH, only to find that they have disappeared in the meantime. And *then* how will our extraterrestrial visitor view the culture of Wales?

Bibliography and References

Alford, V, 1978 *The Hobby Horse and Other Animal Masks*, Merlin Press, London

Anon, 2008 Ergyd I Eisteddfodau Bach, *BBC News* [online], 1 February, available from: http://news.bbc.co.uk/welsh/hi/newsid_7220000/newsid_7221600/7221606.stm [14 March 2011]

Anon, 2009 Museum professional, Personal communication (interview with the author), 26 October

Anon, 2010a Heritage Lottery Fund employee, Personal communication (interview with the author), 25 February

Anon, 2010b Professional in the field of traditional music, Personal communication (email exchange with the author), March

Ardouin, C, 2007 The Tangible and Intangible Heritage: Dichotomy or Integrated and Interdependent Realities?, in Conference Report: Tangible-Intangible Cultural Heritage: A Sustainable Dichotomy? The 7th Annual Cambridge Seminar (C Andrews, D Viejo-Rose, B Baillie and B Morris), *International Journal of Intangible Heritage* 2, 124–9

Briody, M, 2007 The Commission's Collectors and Collections, in *The Irish Folklore Commission 1935–1970, History, Ideology, Methodology*, Finnish Literature Society, Helsinki, 227–309

Cang, V G, 2007 Defining Intangible Cultural Heritage and its Stakeholders: the Case of Japan, *International Journal of Intangible Heritage* 2, 45–55

Carter, H, 2010 *Against the Odds: The Survival of Welsh Identity*, Institute of Welsh Affairs, Cardiff

Celfyddydau Mari Arts, 1999 *Mari Lwyd: Llangynwyd* [online], available from: http://www.folkwales.org.uk/arctd9.html [16 March 2010]

Cleaver, E, 1968 Singing and Presenting the Folk Song (abridged and translated by D R Saer), *Ontrac* 24 (15), Winter 2010, trac, Cardiff

Cymdeithas Eisteddfodau Cymru, n.d. (circa 2007) *Treftadaeth: Prosiectau Newydd* [online], available from: http://steddfota.org/index.php?option=com_content&task=view&id=15&Itemid=38 [16 March 2010]

Edwards, G, 2011 Personal communication (email exchange with the author), March

Encyclopaedia Britannica, 1898 9 edn, volume XXIV, 325

Forest of Dean and Wye Valley Review, 2010 *Mari Lwyd Studies at Chepstow School*, [online], 15 December, available from: http://www.forest-and-wye-today.co.uk/featuresdetail.cfm?id=3382 [14 March 2011]

Hando, F, 1951 *Journeys in Gwent*, R H Johns, Newport, 22–8

Hansard, 2009 *Traditional Crafts* [online], available from: http://www.theyworkforyou.com/debates/?id=2009–06–25c.1036.0 [16 March 2010]

Harrison, R, 2010 Heritage as Social Action, in *Understanding Heritage in Practice* (ed S West), Manchester University Press/Open University, Manchester, 240–77

Hassard, F, 2009 Intangible Heritage in the United Kingdom: the dark side of enlightenment?, in *Intangible Heritage* (eds L Smith and N Akagawa), Routledge, London, 270–88

Heritage Lottery Fund, n.d. *Heritage Matters in Wales* [online], available from: http://www.hlf.org.uk/inyourarea/Wales/Documents/HLF%20Magazine%20-%20English.pdf [16 March 2010]

—— 2009 Our Projects, Cultures and Memories [online], available from: http://www.hlf.org.uk/ourproject/projectsbysector/cultureandmemories/Pages/index.aspx [16 March 2010]

Howard, P, 2003 *Heritage: Management, Interpretation, Identity*, Continuum, London

Hughes, G, 2011 Personal communication (telephone interview with author), 15 March

ICH Scotland, 2009 The ICH Project: ICH in Scotland [online], available from: http://ichscotland.org/the-project/ [16 March 2010]

Ifans, Rh, 1983 *Sers a Rybana, Astudiaeth o'r Canu Wasael*, Gwasg Gomer, Llandysul, 105–35

Jewel, J, 2009 Gavin & Stacey: The secret of its success, *Western Mail Magazine*, 21 November, 12

Kinney, P, and Evans, M, 1987 *Canu'r Cymry II, Detholiad o Ganeuon Gwerin* (Welsh Folk Songs), Cymdeithas Alawon Gwerin, Cymru/Wales, 51–2

Lovett, P, 2011 A Voice to the Sector, speaking as vice chair of the Heritage Crafts Association on the panel of the plenary session of the joint *HLF/Radcliffe Trust seminar Heritage and Crafts: Working together to develop skills and sustain the sector*, 24 March, Mary Ward House, London

McAleavey, M W, 2009 Renewal or Betrayal? An Experiment in Reflecting Welsh Identity at St Fagans: National History Museum, *Folk Life: Journal of Ethnological Studies* 47, 58–65

Martin, N, 2008 Ritualised Entry in Seasonal and Marriage Custom, *Folk Life: Journal of Ethnological Studies* 46, 73–95

Mason, R, 2004 Nation Building at the Museum of Welsh Life, *Museum and Society* 2 (1), 18–34

—— 2007 *Museums, Nations, Identities*, University of Wales Press, Cardiff, 259–68

Matsuura, K, 2009 as quoted in *New edition of UNESCO Atlas of the World's Languages in Danger* [online], available from: http://portal.unesco.org/ci/en/ev.php-URL_ID=28377&URL_DO=DO_TOPIC&URL_SECTION=201.html [16 March 2010]

Menter Abertawe 2006 [online], available from: http://www.menterabertawe.org/dogfen/Adroddiad%20blynnyddol-heb%20luniau%2005–06.htm [14 March 2011]

Menter Morgannwg 2006 [online], available from: http://www.morgannwg.org/bromorgannwg/YFaril.html [14 March 2011]

Museums Galleries Scotland, 2008 Scoping and Mapping Intangible Cultural Heritage in Scotland Final Report [online], available from: http://www.museumsgalleriesscotland.org.uk/publications/publication/71/scoping-and-mapping-intangible-cultural-heritage-in-scotland-final-report [16 March 2010]

NAW, 2010 Proposed Welsh Language (Wales) Measure, National Assembly for Wales [online], available from: http://www.assemblywales.org/ms-ld7944-e.pdf [16 March 2010]

National Museum Wales, 2009 Research at Amgueddfa Cymru: Oral Traditions and Material Culture [online], available from: http://www.museumwales.ac.uk/en/1515/ [16 March 2010]

Owen, T M, 1978 Welsh Folk Customs, National Museum of Wales, Cardiff

Pitchford, S, 2008 Identity Tourism: Imaging and imaging the Nation, Emerald, Bingley

Roberts, W, 1852 Hanes Dechreuad 'Mari Lwyd' &c. &c., in Crefydd yr Oesoedd Tywyll Caerfyrddin (Carmarthen), Wales

Schama, S, 2010 What objects say about our times, FT.com, 22 January [online], available from: http//www.ft.com/cms/s/2/54efdff6–06df–11df-b058–00144feabdc0.html [29 January 2010]

Smith, L, 2006 Uses of Heritage, Routledge, London

Smith, L, and Akagawa, N (eds), 2009 Intangible Heritage, Routledge, London

Smith, L, and Waterton, E, 2009 'The envy of the world?': intangible heritage in England, in Intangible Heritage (eds L Smith and N Akagawa), Routledge, London, 289–302

Thomas, B, 2005 A Special Responsibility: Folk Life Archives at the Museum of Welsh Life, Dialect and Folk Life Studies in Britain: The Leeds Archive of Vernacular Culture in its Context, 19 March

trac, 2006 Notes from the Traditional Music Forum held at Galeri, Caernarfon, Gwynedd, 24 November, convened by the Arts Council Wales with trac: Music Traditions Wales [online], available from: http://www.trac-cymru.org/images/acw_documents/traditional-music-forum-proceedings.pdf [14 March 2011]

UNESCO, 2003 Convention for the Safeguarding of the Intangible Cultural Heritage, 2.3 & Section III, UNESCO, Paris

UNESCO UK, 2006a Appendix 1 – The Eisteddfod Project – Gwyn Edwards in Culture Committee, Summary of Decisions and Actions following Committee Meeting on 1 March 2006, 3–4

—— 2006b UK National Commission for UNESCO Culture Committee Meeting 16 June, 3–4

—— 2006c Session 12: Intangible Heritage, at UK National Commission for UNESCO Inaugural Conference, Nottingham, 16–17 June

— 2010 The Annual Summary of the Work of the UNESCO Cymru-Wales Committee 2009–2010, 13–14 [online], available from: http://www.unesco.org.uk/uploads/UKNCWalesAnnualSummary-eng.pdf [15 March 2011]

West, S, and Bowman, M, 2010 Heritage as performance, in Understanding Heritage in Practice (ed S West), Manchester University Press/Open University, 277–309

World Wide Wales.TV, 2001 [online], available from: http://www.worldwidewales.tv/movies/movie-162.swf [16 March 2010]

Conversation Piece:
Intangible Cultural Heritage in Botswana

Susan Keitumetse

Can you say something about yourself and your personal/professional interest in ICH?

I am currently a research scholar in cultural heritage tourism at the University of Botswana's Okavango Research Institute, Botswana. My interest in ICH spanned from my doctoral thesis, which was largely inspired by my disciplinary background in Archaeology and Environmental Sciences and Heritage and Museum Studies. Most of my archaeology (and consequently heritage) background tended to focus on tangible structures and, as I journeyed through my PhD thesis, it became apparent that, in order to achieve sustainable development in African cultural heritage management, a focus on both tangible and intangible aspects of heritage was inevitable. Since then, I have been publishing and researching on the subject of ICH in Botswana. More recently, UNESCO's intangible heritage section requested that I become an examiner for some of their applications for funding by African countries. I have also been involved as a consultant with a community-based intangible heritage inventorying project funded by the Flanders government through UNESCO.

Were there policies already in place in Botswana that have dealt with intangibles before UNESCO's 2003 Convention?

No, not specifically tailored and targeted to ICH management in its entirety. There exists, however, scattered practices that have always been biased towards intangible heritage associated with performing arts rather than the broader context of ICH. This is still the case, but I hope that since Botswana is one of the six sub-Saharan countries involved in the UNESCO pilot projects on community-based ICH inventorying, the situation may be different in the next few years. Moreover, the 2003 Convention has put forward five ICH domains that will hopefully address this loophole.

How is the current term, 'intangible cultural heritage', conceptualised in Botswana?

From my observation, and as noted earlier, I believe the term is conceptualised as 'performing arts'. From my field observation knowledge, indigenous knowledge associated with nature and the universe is not conceptualised as ICH. This limits the potential implementation of the 2003 Convention at the national level and has to be looked into further.

What initiatives/projects have been already underway in order to safeguard cultural practices?

From the 1970s, Botswana has had a policy that has been biased towards tangible heritage. This

mainly stems from the 1970 *Monument and Relics Act* Chapter 59:03, which was later amended to become the *Monument and Relics Act* No.12 of 2001. In 2001, the country developed another form of legislation, the 2001 *Botswana National Policy on Culture*. This new policy came closer to ICH management issues; however, it is not deliberately formulated for such issues. There are various activities that celebrate cultural practices that predominantly focus on the performing arts as a medium of ICH.

What is currently happening in Botswana with respect to the 2003 Convention?

The Government of Botswana ratified the 2003 Convention in 2010. Botswana is also among the six sub-Saharan countries that are participating in UNESCO's pilot project on Community Based Intangible Heritage inventories. Other participating countries are Lesotho, Malawi, Swaziland, Uganda and Zambia. Information on this project can be sourced on UNESCO's ICH webpages (www.unesco.org/culture/ich). In particular, this will build capacity of officials and community members in these countries to document their ICH in the future. Botswana's participation, therefore, enabled it to kick-start activities prior to ratifying the 2003 Convention.

What are the responses (public, scholarly, heritage sector professional) to the 2003 Convention and the ICH concept?

In the region, the response has not been as overwhelming as it should be. Within a disciplinary framework, however, it appears that there is significant appreciation that ICH is part and parcel of tangible heritage. The problem is that there is no established format through which ICH can be incorporated within the various existing disciplines. At the heritage sector professional level, there is much interest, largely due to the knowledge that safeguarding of ICH contributes to diversification of heritage products that can be implemented within the eco-tourism model, which is more community-based by nature.

 Within international organisations such as UNESCO, I have observed, through conversations with various individuals, that there is some form of 'competition' among experts, particularly discipline-based experts. There is some element of fear that the ICH inventory attracts all and sundry. This, however, in my observation emanates from an unfounded fear that the numerous lists of ICH 'elements' may overshadow the 'masterpieces' of World Heritage. As an archaeologist (tangible) and environmental scientist, I see the two as complementary to each other. UNESCO, therefore, has to encourage its related departments to work closely together in order to abate unnecessary competition that may lead to reduced visibility of its integrated projects.

How are museums and heritage organisations involved in safeguarding ICH?

In Botswana, the Botswana National Museum, through its department of ethnology, has spearheaded issues relating to heritage management since the 1970s. These, however, have been more focused on tangible heritage, rather than ICH. Nonetheless, the National Museum has of late forged significant relationships with certain communities among which they work and this relationship is currently extended to other initiatives such as the development of community-based cultural heritage tourism. In addition, the Department of Culture, which is relatively new to issues of community-based ICH management, is now becoming involved in community-based

ICH projects. The UNESCO project on community-based inventorying of ICH, as mentioned earlier, is one of the main projects through which the department of culture will build its capacity to work on management of ICH. One would hope that the combined efforts of the two departments will in the future result in an integrated, rather than isolated, approach to the management of ICH in the country.

What problems do you foresee as emerging from UNESCO's guidelines for safeguarding ICH within Botswana?

In terms of the 2003 Convention, the issues surrounding the creation of a national inventory are always debatable. Some cultural elements are more sustainable when they are not exposed, but nonetheless, knowledge about them can enrich the existence of humankind. In these situations, the approach, as per the 2003 Convention, can be difficult and care has to be taken. In particular, the Convention stresses this point, but complexity arises where opinion is divided on whether or not to expose certain intangible cultural expressions. The other problem faced by the implementation of the 2003 Convention concerns drawing the line between when an element has to be left alone to 'die off' and when it should be resuscitated. Often this seems straightforward, particularly where the majority is concerned. Nevertheless, most practitioners are not clear about when one should take the possible extinction of ICH as part of cultural dynamism and when one should heed the extinction and resuscitate.

At the institutional level, the problem that I see stems from institutional placement of efforts towards safeguarding of ICH. Consequently, this leads to issues of visibility and sustainability of ICH projects at a national level. In several of the countries involved in the UNESCO pilot project mentioned earlier, the issue of institutional entitlement versus institutional capability arises in most cases. For instance, in Botswana, the Botswana National Museum has both the personnel and the infrastructure, in terms of equipment and storage (archiving), to implement the project at a much lower cost. However, due to institutional entitlement (emanating from new departmental establishments), these ground achievements are often ignored, and the process starts from scratch. This delays progress and often it causes institutional resentment, sometimes resulting in the projects on safeguarding ICH at the national level becoming non-visible and unsustainable. It is, therefore, advisable for UNESCO and its stakeholders to first take stock of what has been ongoing and then fund projects that build on existing structures, rather than those that isolate efforts. This, I am certain, is a great challenge in most African countries.

If there are any foreseeable problems, what alternatives could be used in order to safeguard ICH effectively?

One main potential problem concerns the narrow perception of what constitutes ICH, such as the notion that ICH only represents living traditions of the performing arts. In terms of alternative ways forward, the approaches towards management of ICH have to focus on changing perceptions of what constitutes ICH so that it can be dealt with in its entirety, as opposed to the current prevalent bias towards performing arts in several parts of Africa. In addition, it will be helpful to take stock of any country's previous initiatives and build on that. This will expedite buy-in and allow for an effective approach towards safeguarding ICH.

Are any alternative methods being used at this time?

While the government of Botswana has recently ratified the 2003 Convention, there are currently ICH safeguarding initiatives that exist as appendices to scattered government initiatives such as festive celebrations, such as Independence Day and President's Day, rather than as outstanding initiatives that are solely aimed at safeguarding ICH. These are usually focused on the short term. In essence, practitioners are needed to move from this scattered approach and engage in writing funding proposals that will enable them to operate outside restricted funding from central governments if they are to make safeguarding of ICH visible enough.

What are the strengths of the 2003 Convention with respect to implementing it within Botswana?

The 2003 Convention has a lot of strengths at the national level. Firstly it establishes a platform within which the safeguarding of ICH could be duly recognised and lobbied. In other words, it has kick-started the process. Secondly it provides a framework and a structure within which resources for safeguarding of ICH could be accumulated. Finally, it supplies broad guidelines on how to approach general issues relating to safeguarding ICH.

The UNESCO Convention for the Safeguarding of Intangible Cultural Heritage and its Implications for Sustaining Culture in Nova Scotia

Richard MacKinnon

Introduction

For many people in the Canadian government and civic society, 'heritage' means material 'things', including buildings, artefacts and important objects.[1] With respect to Nova Scotia, we have a *Heritage Property Act* (1989) and a *Special Places Protection Act* (1989) to 'Provide for the Preservation, Regulation and Study of Archaeological and Historical Remains and Paleontological and Ecological Sites'. We also have numerous local, provincial and federal museums throughout the province that conduct research, conserve artefacts, produce exhibits and educate people about various aspects of Nova Scotia heritage, such as Les Trois Pignons Centre Culturel, the Museum of Industry and Pier 21, and Canada's Immigration Museum. The Heritage Division of the Nova Scotia Department of Tourism, Culture and Heritage currently provides heritage-related services and programmes throughout the province by operating 27 provincial museums and maintaining a provincial collection of artefacts and specimens.

In general, Canada has responded positively to the 1972 *Convention Concerning the Protection of the World Cultural and Natural Heritage*, with the designation of 14 World Heritage Sites, including Québec City, Québec, L'Anse aux Meadows Viking Settlement and Gros Morne National Park in Newfoundland, and the town of Lunenburg in Nova Scotia. Two new Canadian sites have been designated in 2009: the Rideau Canal in Ottawa and the fossil cliffs of Joggins, Nova Scotia. Accordingly, many Canadian communities, governments and individuals have supported the idea that the concept of 'heritage' is synonymous with our important physical and architectural monuments. New federal and provincial policies, foundations, historical societies, special interest groups and university programmes, established since the 1972 Convention, provide proof of the strong focus on tangible heritage. Moreover, as a result of world heritage designation, Québec City, Lunenburg and the L'Anse Aux Meadows, for example, have become major tourist destinations and serve as cultural icons in the construction of Canadian identity.

As discussed in several other chapters in this volume, heritage preservation is becoming an increasingly important industry owing to its potential for strengthening economies at a whole range of geographical scales. In turn, the concept of the intangible is also gaining widespread attention, particularly as a means for empowering local communities and sustaining cultural

[1] This chapter is based on an earlier paper that was presented at the Environment and Culture Conference, Sabhal Mòr Ostaig, Isle of Skye, Scotland, June 19–23, 2007.

identity expressions. Here, I explore the significance of the relatively new international heritage policy, UNESCO's 2003 Convention, and its implications for Nova Scotian culture. Furthermore, I discuss ICH-related initiatives in Cape Breton Island and within the Centre for Cape Breton Studies, Cape Breton University.

ICH in Canada

According to UNESCO, ICH refers to the body of cultural and social expressions that characterise communities, groups and individuals and is usually based on the idea of 'living traditions' (see UNESCO 2003, Article 2). In English Canada, the term that is most commonly used for these manners of cultural expression is 'folklore'. Moreover, in Québec, 'culture traditionnelle et populaire', or 'ethnologie', serve to categorise these cultural elements. Other terms used within the North American context include 'folk culture', 'traditional culture', 'traditional knowledge', 'patrimoine culturel immatériel', 'oral heritage', 'tradition' and 'our heritage of ideas, values and language' (Pocius 2002, 1).

While the focus of interest in Canada has been placed on tangible heritage, there exists a connection between the categories of tangible and intangible. Artefacts such as houses, clothing and crafts, for example, are material manifestations of intangible knowledge and skills. The performance of a dance involves the use of costumes; certain musical events require instruments; and storytelling is usually found in a particular physical setting such as a kitchen or a community general store. Indeed, objects are often the only surviving evidence of broader intangible cultural expressions. For instance, in many maritime communities in eastern Canada, nets, traps and other objects from the fishery can still be found on beaches or in museums. However, knowledge concerning the most suitable locations for where traps should be set, how nets are made and local terms for geographic features for water and land is disappearing quickly because fishing-based industries are in decline.

Similarly, while many museums preserve physical objects such as rakes, coal cars and photographs of former coal mines, traditional knowledge such as how to shoot a wall of coal, foodways of a mining family on shift work and miners' joke-telling is also disappearing. It may well be that every item of tangible heritage has an associated and complex intangible heritage. As Pocius (2002, 3) notes:

> Canadian intangible heritage consists of many activities including the stories we tell, the holidays we celebrate, the family events we find important, our community gatherings, the languages we speak, the songs we create and perform, our knowledge of our natural spaces, how we treat sickness, the foods we eat, the special clothes we wear, our beliefs and practices.

Furthermore, whether it is called 'folklore' or 'ICH', every community, group and individual across the world embodies some form of cultural knowledge, skills and identity expression, including those of Canada and, in particular, Nova Scotia.

As one main precursor to the 2003 Convention, UNESCO put forward the Masterpieces Programme, or the 'Proclamation of Masterpieces of the Oral and Intangible Heritage of Humanity', in 2001, with the aim of 'pay[ing] tribute to outstanding masterpieces of the oral and intangible heritage of humanity' (UNESCO 1998; Aikawa-Faure 2009). The Masterpieces Programme encouraged governments, non-governmental organisations (NGOs) and local

communities to identify and promote their ICH. It also encouraged individuals, groups, institutions and organisations to contribute to the management, preservation and promotion of this heritage. Although the Masterpieces Programme is no longer active, its inscribed elements have now been incorporated into the Representative List of the 2003 Convention. In a sense, this programme served to promote ICH through a similar mechanism as that of the World Heritage List.

When the 2003 Convention was approved in October 2003, Australia, the United Kingdom, the United States and Canada were among the few nations that abstained from ratifying it (Kurin 2004, 66). By June 2006, two months after it entered into force, the first session of the General Assembly of the States Parties was held, marking the beginning of the operational life of this new convention. Most importantly, ratification of the Convention continues (see UNESCO 2011). As the former UNESCO Director-General Koïchiro Matsuura noted, the exceptionally rapid ratification of the Convention bears witness to the 'great interest in intangible heritage all over the world ... and the widespread awareness of the urgent need for its international protection given the threat posed by contemporary lifestyles and the process of globalization' (UNESCO 2007). Nonetheless, since Canada has not ratified the 2003 Convention, it has not designated any cultural practices or living heritage expressions from within its territory as ICH.

One example of ICH that has been recognised by UNESCO and, thereby, inscribed onto the Representative List bears strong similarities to particular cultural practices found in Canada. This officially recognised cultural practice pertains to the Belgian carnival, Carnivale de Binche, which occurs in the town of Binche, south of Brussels in Belgium's Hainaut province. As UNESCO (2006a, 15) states: 'Each year, during the three days preceding Lent, it is host to carnival festivities that mobilize the historic centre and attract throngs of foreign visitors. With roots dating back to the Middle Ages, Binche's famed celebration ranks as one of Europe's oldest surviving street carnivals.' Lavish costumes, drumming, music and elaborate balls are all part of this tradition. Beginning on Shrove Tuesday, masqueraded merrymakers march through streets and cafes in the town. Men dress as women and lavishly dressed girls parade together. In addition, UNESCO (2006a, 15) explains: 'The carnival of Binche is a genuinely popular festival renowned for its spontaneity and the substantial financial commitment of its participants. The townspeople take great pride in the celebration and strive to preserve the precious craftsmanship and know-how associated with the carnival's traditional costumes, accessories, dances and music.'

These descriptions of the carnival – which can also be viewed as the reasons why it has been officially selected – are interesting because it bears similarities to two masking, carnival-like traditions in Atlantic Canada: the Christmas Mummering tradition of Newfoundland and the French-Acadian tradition, Mi-Carême, of Cape Breton Island, Nova Scotia. Christmas Mummering, also known as 'mumming' and/or 'janneying', is a tradition practised during the 12 days of Christmas. Brought to the island by English and Irish settlers, it includes the wearing of disguises, public parading, role-playing and more general merrymaking activities that are similar to the Binche carnival. Indeed, much scholarly attention has been paid to this tradition since the 1960s (Halpert and Story 1969; Faris 1969; Pocius 1988; Robertson 1984; Tye 2008). Additionally, the Mi-Carême, which is brought to life during Lent, includes the wearing of disguises and is found in the Acadian-French areas of Cape Breton Island and the Maritimes (Chiasson and Leblanc 1986, 193–4; Arsenault and Ross 2009).

Despite the fact that Canada has yet to subscribe to UNESCO's guidelines on recognising, promoting and potentially safeguarding ICH, it is clear that its aims are still applicable. It is also

apparent that the concept of 'ICH' – however it is termed – is one that is also valued, particularly in Nova Scotia. Most notably, the Living Human Treasures project, instituted by UNESCO in the early 1990s, resonates with initiatives that focus on supporting the livelihood of certain artists in Nova Scotia (see Kurin 2004; Aikawa 2004). For example, the Portia White Prize is given each year to an established artist who was either born in Nova Scotia or has been a resident of the province for the past four years. The prize amounts to $18,000 CAD (Canadian dollars) and includes the opportunity to name an emerging Nova Scotian artist or cultural organisation to receive a protégé prize of $7000 CAD. In 2007, Jolleen Gordon, an artist who has devoted her life to traditional basket-making, was the recipient of this award. Furthermore, the Prix Grand Pré is an annual award of $2000 CAD for Acadian Nova Scotian artists. It recognises creative or interpretive artists in any medium whose work reflects Acadian cultural values while demonstrating excellence and originality (Nova Scotia Department of Tourism Culture and Heritage 2009). The following section examines more closely the varied ICH of Nova Scotia and, in particular, safeguarding efforts that aim to sustain the Gaelic language.

THE PROVINCE OF NOVA SCOTIA

The province of Nova Scotia comprises numerous cultural groups: Mi'kmaq First Nations, Europeans (English, Irish, Scottish, Acadian French, Italian, Polish and Ukrainian, among others), Caribbean Black, Black Loyalists, Lebanese and other ethnic communities from around the world. Most evidently, these are communities, groups and individuals who have different ways of expressing their cultural identities and knowledge – a vast resource of diverse ICH expressions. Moreover, new Canadians bring their own living cultural traditions with them to the province, making Nova Scotia a profoundly multicultural region.

Nevertheless, a large percentage of the living traditions that are expressed by these diverse groups are threatened with the prospect of extinction. On Cape Breton Island, for example, the Mi'kmaq, Gaelic, Italian, Acadian French and Ukrainian languages, once prevalent in communities, are now considered threatened. There are few efforts to study, record and to help sustain these languages and their concomitant traditions. Similarly, much like other parts of the world, the province is currently undergoing social, cultural and economic changes owing to declining rural populations and the loss of traditional industries such as fishing, forestry, coal-mining and steelmaking. In light of this, tourism, as a source of revenue, is becoming more significant. For instance, more than 60 cruise ships visit Cape Breton in late summer and early fall. This influx of tourists usually occurs in conjunction with the opportunity to experience the changing foliage and the annual 10-day Celtic music festival, Celtic Colours (see Celtic Colours 2010).

Additionally, larger urban centres, such as Halifax/Dartmouth, are becoming centres of growth for the province. As this transition unfolds, traditional cultural knowledge and expression is changing as well as disappearing. Understandably, it is difficult to ascertain what traditions and local knowledge are being lost with the closing of the coal, steel and fishing industries, especially on Cape Breton Island. It is now crucial to make a concerted effort to record the cultural knowledge of fading industries that have been a part of Cape Breton Island and Nova Scotia for centuries. There is also a need to record aspects of ICH in all areas of Cape Breton and to make the material available in old and new media formats for educators in secondary and post-secondary schools. Most significantly, widening the definition of heritage to include these forms of ICH requires trained researchers to conduct fieldwork in communities and to work within

established institutions in gathering, recording, studying and providing access to these diverse aspects of Nova Scotian culture. One example of a relatively recent initiative that seeks to revitalise Gaelic – a unique aspect of Nova Scotian ICH – is examined in the following subsection.

SAFEGUARDING THE GAELIC LANGUAGE

The province of Nova Scotia represents the only region outside Scotland where the Gaelic language and associated cultural expressions still exist. Although the discourse stemming from the 2003 Convention is not particularly prevalent in Nova Scotia, the province has established one programme that demonstrates the importance of safeguarding ICH. While Gaelic is still spoken in Cape Breton, it is no longer a language of daily life and work. A recent study indicated that there were fewer than 500 native speakers (Kennedy 2002). Yet, a number of people throughout the province have expressed interest in preserving the language and formed the Gaelic Council in response. Having successfully lobbied the provincial government to fund efforts to save the language, they have embarked on a project to record the last native speakers to produce Gaelic teaching and learning materials.

Moreover, they have also been experimenting with the technique 'Total Immersion Plus', which was developed in Scotland for teaching new learners of the language (Reddy 2006). In brief, this 'immersion' programme does not focus on grammar and the technicalities of the language; on the contrary, it emphasises the development of conversational skills through practice with native speakers. The Nova Scotia Government opened Gaelic Affairs offices in Antigonish, Halifax and Mabou in 2007, and is interested in further developing language programmes and other Gaelic cultural programmes. Additionally, the Nova Scotia Highland Village in Iona, Cape Breton Island – a museum funded and operated by the province – employs fieldworkers who record Gaelic speakers.

The province also partly funds a new initiative called the Gaelic Activities Program in the Department of Tourism, Heritage and Culture. The Gaelic Activities Program is designed to help Nova Scotians learn from and work with other Gaelic communities. The province has signed a Memorandum of Understanding (MOU) with the Highland Council of Scotland to share resources, ideas, skills and experience (Province of Nova Scotia 2007). The aims of this government programme include increasing the number of Gaelic speakers in the province, improving the quality and effectiveness of Gaelic learning and promoting the inter-generational transmission of the language. All together, these aims seek to safeguard the knowledge of Nova Scotia's Gaelic tradition bearers, a project that certainly resonates with the overall intentions of the 2003 Convention. With a funding limit of $5000 CAD for each project, it supports community-based initiatives that preserve and develop traditional arts, such as music, dance, song and storytelling, which are considered to reflect Nova Scotia's distinct Gaelic culture. Furthermore, it seeks to enhance opportunities for interpreting Gaelic culture through new media, drama, visual arts, literature and film to enhance pride, appreciation and visibility for the language and associated cultural expressions.

The programme was developed after the province commissioned Dr Michael Kennedy to write a comprehensive study, Gaelic Nova Scotia: An Economic, Cultural and Social Impact Study, in which he highlighted the precarious state of the Gaelic language (Kennedy 2002). This was followed by a report, *Developing and Preserving Gaelic in Nova Scotia: Strategy for a Community-Based Initiative*, completed and presented by the Gaelic Development Steering

Group to the community and government in April 2004. What is remarkable about these activities is that they have been unfolding during the development of UNESCO's ICH policies, and particularly during the drafting and adoption of the 2003 Convention. It also indicates that there has been little understanding about UNESCO's initiatives on behalf of the province's representatives. However, it is important to note that the process of safeguarding Gaelic in Nova Scotia, including the resultant polices, was driven from the bottom up. In other words, these initiatives were pushed forward by Gaelic speakers, associated ICH practitioners and other local community members – the very people who were concerned that a living language was dying before their eyes – and ears.

At present, it is too early to tell if the programme has been successful, but the province's work in this area demonstrates the existence of government interest. The one-time minister of the Department of Culture, Heritage and Tourism and later premier of Nova Scotia, Rodney MacDonald, is a Cape Breton fiddler and school teacher from Mabou. It was under his direction that the Gaelic policy developed. He and his department were interested in developing policies that supported Gaelic culture and ICH in general. It remains to be seen whether the current government, led by Premier Darryl Dexter (elected in 2009), has a similar interest in Gaelic culture and safeguarding other forms of regional ICH.

Cape Breton University's Commitment to Promoting the Importance of ICH

Even though pioneering folklorists such as Helen Creighton and William Roy MacKenzie have worked extensively in Nova Scotia, folklore – including expressions of what is now considered ICH – is not a well-established discipline within Nova Scotia's universities (see, for example, Creighton and Senior 1950; Creighton 1962; 1966; 1968; 1993; MacKenzie 1909; 1919; 1963). Moreover, folklore, or ICH, is not heavily represented in the archival holdings of established provincial museums and relevant institutions. In any case, Cape Breton University, which draws on the resources of the Beaton Institute Archives and the Mi'kmaq Resource Centre, is the only university in the province to regularly offer courses in this discipline. Specifically, in October 2005, the University was granted approval by the Maritime Provinces Higher Education Commission to begin offering a Bachelor of Arts and Bachelor of Arts Community Studies major in Folklore Studies, as well as an allied concentration in Ethnomusicology, specialising in traditional music.

In addition, the University is currently developing a Master of Arts degree in Heritage Studies with a speciality in Public History, Folklore and Public Policy. The study of Folklore and Ethnomusicology allows students to analyse traditional music along with other aspects of cultural tradition. As a result of this unique academic offering, Cape Breton University is attracting students from around the world. In the last five years, students from Sabhal Mòr Ostaig, the Isle of Skye, the Royal Scottish Academy of Music and Drama in Glasgow, the University of Limerick in Ireland and from six states in the US have joined the programmes.

Furthermore, the Canadian federal government has established Canada Research Chairs across the country to improve the research infrastructure of our institutions of higher learning. The majority of these chairs are in Science and Technology; however, 20 per cent have been dedicated to the Arts and Social Sciences. Cape Breton University features three Canada Research Chairs, two of which are focused on Arts and Social Sciences. For instance, Dr Cheryl Bartlett's chair focuses on Mi'kmaq Aboriginal Science and exploring indigenous ways of knowing, folk

medicine and the study of Aboriginal worldviews. This chair has been established as a result of the fact that there are 13 Mi'kmaq communities in Nova Scotia. One of the languages spoken by a portion of these groups, the Algonquian language of Mi'kmaq, is considered threatened because there currently exist fewer than 5000 speakers.

It is also important to note that Cape Breton University has one of the highest *per capita* populations of Aboriginal students across Canada. In 2010, there were 250 Mi'kmaq students on campus from the five Aboriginal communities on Cape Breton Island: Eskasoni, Chapel Island, Membertou, Waycobah (once Whycocomagh) and Malagawatch. The University also has a Mi'kmaq College Institute on campus, which houses a student centre, faculty offices and the Mi'kmaq Resource Centre, as mentioned earlier.

Most significantly, my position as Canada Research Chair in Intangible Cultural Heritage has designated 'leadership in the study of Folklore and endangered traditional cultural expressions' as one of its goals (MacKinnon 2007, 343). As this chapter reflects, Cape Breton Island provides an ideal location for steering research, publication and policy development in this emerging field of ICH protection and management. As part of the Canada Research Chair in Intangible Cultural Heritage, the University has established a Centre for Cape Breton Studies to encourage and support research on or about Cape Breton Island. This Centre houses a state-of-the-art Digitisation Lab and a Music Performance Analysis facility. The establishment of a centre that is focused on living cultural practices and knowledge is a major step toward Canada developing a worldwide speciality in this area. Indeed, a regional centre such as this is important in the era of globalisation and its homogenising forces. It is our hope that deeper understandings of diverse traditions, folklore and cultural values will result from the Centre and its work. This, in turn, can influence public policy issues at the provincial and federal levels and can be generalised for global application in communities with similar issues.

In essence, the Centre for Cape Breton Studies is a multidisciplinary forum for faculty, under-graduate, graduate and post-doctoral students, as well as visiting researchers from other institutions and government agencies. The Centre sponsors lectures, academic conferences and public workshops on topics related to ICH. The Centre also produces a scholarly journal, *Material Culture Review/Review de la culture matérielle*, which focuses on both tangible and intangible heritage and circulates to more than 20 countries. The research conducted by this Canadian Research Chair is valuable to UNESCO and participating member states in their attempts to create a multilateral instrument for the safeguarding of ICH.

THE NON-RATIFICATION OF THE 2003 CONVENTION

One reason Canada has not supported the 2003 Convention is that the federal government is waiting to determine if there is any interest at the provincial level concerning this relatively new category of heritage. The Canadian federal government sees cultural policy as a provincial issue, so it is possible that it is awaiting provincial input and consideration. Despite the work of the Gaelic communities and Cape Breton University in Nova Scotia, only two Canadian provinces – Newfoundland and Labrador, and Québec – have coordinated large-scale efforts in promoting and safeguarding ICH. Most specifically, Québec has begun a complete inventory of the ICH of the province, an exercise that is mandated by the 2003 Convention for those states that have ratified it (see UNESCO 2003, Article 12).

The Québec provincial government has been interested in this area for many years. In fact, in

May 2006, Stephen Harper's Conservative federal government and the Québec Liberal premier, Jean Charest, signed an agreement enabling Québec to participate fully in UNESCO's activities as a member of the permanent delegation of Canada. Under the terms of the agreement, the government of Canada also committed a representative of the government of Québec as a member of the Executive Committee of the Canadian Commission for UNESCO. These steps to ensure that Québec has a permanent seat at the Canadian UNESCO table were approved in December 2006 (UNESCO 2006b).

In recent years, Newfoundland and Labrador developed a policy concerning its ICH. The first major international conference on ICH in Canada was held in Saint John's in the spring of 2006 (Heritage Foundation for Newfoundland and Labrador 2006, 2). At that conference, the blueprint was made for a Newfoundland policy; in turn, the Department of Tourism, Culture and Recreation has appointed an 'ICH officer' and is actively pursuing a digital archives initiative for recording ICH in collaboration with Memorial University of Newfoundland. Moreover, the province also designated $100,000 CAD for ICH projects in its 2009 budget.

Nonetheless, aside from the provincial/federal relations issue, I suspect one reason the Canadian government has not embraced the 2003 Convention is a result of historically tenuous relations with its indigenous groups. Land claim issues with First Nations groups in Canada have taken many years to negotiate and numerous others are presently stalled. By agreeing with the 2003 Convention, the federal government will need to devote more attention to protecting indigenous sacred spaces, languages and traditions. There are also vested interest groups who have benefited from defining heritage as the 'built environment' in Canada. Parks Canada, for example, operates numerous heritage sites across the country, including the 18th-century Fortress of Louisbourg reconstruction in Cape Breton Island. With budgets being trimmed, interest groups that currently receive federal funding do not want new programmes emerging – programmes that may reduce budget allocations to already committed areas.

Conclusion

Towards the end of his time as UNESCO Director-General, Koïchiro Matsuura stated: 'I was surprised, upon my arrival in UNESCO, to note the relatively low priority given to living heritage compared to the strong focus on the tangible part of the world's cultures. Over the past ten years, far-reaching and noble achievements have been attained' (UNESCO 2009). Echoing these sentiments, it can be asserted that there is interest in creating policies throughout Canada – at both the provincial and municipal levels – that serve to promote and safeguard living heritage expressions. Indeed, the potential exists for already instituted provincial policies, as well as new ones, to develop effective methods and plans for safeguarding ICH that will urge the federal government's Department of Canadian Heritage to revaluate its position. Once Canada decides to ratify the 2003 Convention, there will be a need, as well as a mandate, in Nova Scotia and beyond for training in documentation, creation of inventories, archiving and fieldwork.

I have seen projects where researchers with little training conduct oral history interviews with elders and members of local communities. Generally, what results is not useful for the student, the informant or the archives. If these provincial policies grow, there will be a need to further support these efforts of expanding, digitising and disseminating archives of information relating to ICH and, thus, such efforts will strengthen. Moreover, new forms of repositories, such as dialect banks and oral history archives, will need to be created. Through this, new media and

digitisation equipment allow ICH-based material to find its way out of the collections of archives and into classrooms and other venues where it is needed within communities.

As support grows in the Canadian provinces for promoting the importance of ICH, it will become more important at the federal level. At the same time, as more countries around the world become signatories to this international treaty, the Canadian federal government's position may begin to change. Support for the preservation of ICH could ultimately be a new cultural industry in Nova Scotia, and Canada as a whole, since new roles in collecting, documenting, archiving, educating and managing living forms of heritage will emerge. In turn, it can be argued that there will also be an increased need to recognise individuals, groups and communities who carry on and perpetuate intangible cultural expressions. Ultimately, by acknowledging, understanding and celebrating our traditions and practices, we will grow in our understanding of how individuals, groups and communities form identities and become rooted as citizens of localised areas, regions and nations.

BIBLIOGRAPHY AND REFERENCES

Aikawa, N, 2004 An Historical Overview of the Preparation of the UNESCO International Convention for the Safeguarding of the Intangible Cultural Heritage, *Museum International* 56 (1–2), 137–49

Aikawa-Faure, N, 2009 From the Proclamation of Masterpieces to the Convention for the Safeguarding of the Intangible Cultural Heritage, in *Intangible Heritage* (eds L Smith and N Akagawa), Routledge, London, 13–44

Arsenault, G, and Ross, S, 2009 *Acadian Mi-Carême: Masks and Merrymaking*, Acorn Press, Charlottetown, Prince Edward Island

Celtic Colours, 2010 *Welcome to Celtic Colours International Festival!* [online], available from: http://www.celtic-colours.com [14 April 2010]

Chiasson, A, and Leblanc, J D, 1986 *Cheticamp: History and Traditions*, Breakwater Books, St John's, Newfoundland

Creighton, H, 1962 Cape Breton Nicknames and Tales, in *Folklore in Action: Essays for Discussion in Honor of MacEdward Leach* (ed H P Beck), The American Folklore Society, Inc, Philadelphia, 71–6

—— 1966 *Songs and Ballads from Nova Scotia*, General, Toronto

—— 1968 *Bluenose Magic: Popular Belief and Superstitions in Nova Scotia*, Ryerson Press, Toronto

—— 1993 *A Folk Tale Journey Through the Maritimes* (eds M Taft and R Caplan), Breton Books, Wreck Cove, Nova Scotia

Creighton, H, and Senior, D H, 1950 *Traditional Songs from Nova Scotia*, Ryerson Press, Toronto

Faris, J C, 1969 Mumming in an Outport Fishing Settlement: A Description and Suggestions on the Cognitive Complex, in *Christmas Mumming in Newfoundland* (eds H Halpert and G M Story), University of Toronto Press, Toronto, 128–44

Halpert, H, and Story, G M, 1969 *Christmas Mumming in Newfoundland*, University of Toronto Press, Toronto

Heritage Foundation of Newfoundland and Labrador, 2006 *Intangible Cultural Heritage: Newfoundland Labrador* [online], available from: http://www.mun.ca/ich/ichstrategy.pdf [24 January 2011]

Kennedy, M, 2002 Gaelic Nova Scotia: an Economic, Cultural, and Social Impact Study, *Curatorial Report* 97, Nova Scotia Museum, Halifax, Nova Scotia

Kurin, R, 2004 Safeguarding Intangible Cultural Heritage in the 2003 UNESCO Convention: a critical appraisal, *Museum International* 56 (1–2), 66–77

MacKenzie, W R, 1909 Ballad-singing in Nova Scotia, *Journal of American Folklore* 22 (85), 327–31

—— 1919 *The Quest of the Ballad*, Princeton University Press, Princeton

—— 1963 *Ballads and sea songs from Nova Scotia*, Folklore Associates, Hatboro, PA

MacKinnon, R, 2007 Canada Research Chair in Intangible Cultural Heritage, *Ethnologies* 29 (1–2), 343–55

Nova Scotia Department of Tourism Culture and Heritage, 2009 *Culture – Prize Programs* [online], available from: http://www.gov.ns.ca/tch/culture_prizes.asp [4 August 2010]

Pocius, G, 1988 The Mummers Song in Newfoundland: Intellectual, Revivalist and Cultural Nativism, *Newfoundland Studies* 4 (1), 57–85

—— 2002 *Intangible Heritage*, paper prepared for the Department of Heritage Policy Branch, 21 February, Newfoundland

Province of Nova Scotia, 2007 *Memorandum of Understanding* [online], available from: http://www.gov.ns.ca/oga/mou.asp [24 January 2011]

Reddy, K, 2006 Growing Hope for Gaelic in Nova Scotia, *Shunpiking Magazine* 11 (48), 6–7

Robertson, M R, 1984 *The Newfoundland Mummers' Christmas House-Visit*, National Museums of Canada, Ottawa

Tye, D, 2008 At Home and Away: Newfoundland Mummers and the Transformation of Difference, *Material Culture Review/Review de la culture matérielle* (68), 48–57

UNESCO, 1998 *Regulations Relating to the Proclamation by UNESCO of Masterpieces of the Oral and Intangible Heritage*, UNESCO, Paris

—— 2003 *Convention for the Safeguarding of the Intangible Cultural Heritage*, UNESCO, Paris

—— 2006a *Masterpieces of the Oral and Intangible Heritage of Humanity: Proclamations 2001, 2003 and 2005* [online], available from: http://unesdoc.unesco.org/images/0014/001473/147344e.pdf [21 April 2010]

—— 2006b *Annual Report of the Secretary General, Canadian Commission for UNESCO* [online], available from: http://www.unesco.ca/en/documents/2006AnnualReportoftheSecretary-General.pdf [21 April 2010]

—— 2007 *UNESCO's Cultural Heritage Convention 'fully operational'* [online], available from: http://portal.unesco.org/culture/es/ev.php-URL_ID=39849&URL_DO=DO_PRINTPAGE&URL_SECTION=201.html [24 January 2011]

—— 2009 *UNESCO's Cultural Heritage Convention 'fully operational'*, closing speech by Director-General Koïchiro Matsuura at the 4th session of the Intergovernmental Committee for the Safeguarding of the Intangible Heritage, Abu Dhabi, 2 October, UNESCO Press Release No. 2009–109, available from: http://portal.unesco.org/culture/es/ev.php-URL_ID=39849&URL_DO=DO_PRINTPAGE&URL_SECTION=201.html [11 May 2011]

—— 2011 *The States Parties to the Convention for the Safeguarding of the Intangible Cultural Heritage (2003)* [online], available from: http://www.unesco.org/culture/ich/index.php?lg=en&pg=00024 [14 January 2011]

On the Ground: Safeguarding the Intangible

Acquiring the Tools for Safeguarding Intangible Heritage: Lessons from an ICH Field School in Lamphun, Thailand

Alexandra Denes

The 2003 *Convention for the Safeguarding of the Intangible Cultural Heritage* (ICH) represents a significant milestone in the field of cultural heritage management, insofar as it shifts attention to the importance of the intangible dimensions of culture, which has long been overshadowed by international heritage treaties focused on conserving material heritage. Apart from drawing attention to the oral narratives, performing arts, social practices and local knowledge and skills that constitute a vital source of the world's cultural inheritance, the ICH Convention also marks an important turning point with regards to the approach to heritage management, inasmuch as it explicitly calls for the participation of local culture bearers in the safeguarding process, from identification of elements of intangible heritage to the development of programmes and activities to revitalise ICH.

For all of its promise, however, when it comes to the practicalities of implementation, the ICH Convention presents a host of formidable questions and challenges, arguably one of the biggest challenges being how to equip the different parties involved at the national and subnational level with the concepts, methods and skills that are necessary for undertaking such an ambitious and complex project.

In response to this need, and as part of its commitment to the expansion of anthropological research and knowledge in Thailand and the Greater Mekong Sub-region, in August 2009 the Princess Maha Chakri Sirindhorn Anthropology Centre (SAC)[1] in Bangkok, Thailand, launched an Intangible Cultural Heritage Field School programme open to recent university graduates, mid-career professionals, educators and others involved in the heritage field in Asia. In keeping with its institutional mandate to support anthropological research, the aim of the ICH Field School programme was to equip participants with both the conceptual and practical tools to actively engage with intangible cultural heritage issues, with the corollary objective of fostering transnational collaboration and understanding of the region's shared heritage.

Led by a team of international experts in the fields of anthropology and museology and attended by 17 participants from the Asian region (Bhutan, Cambodia, Laos, Thailand, China), the pilot 15-day Field School focused on the role of museums in safeguarding, documenting and

[1] The Princess Maha Chakri Sirindhorn Anthropology Centre (SAC) is a government-funded, public organisation dedicated to anthropological research about Thailand and the Mekong region. The mission of the Centre is to promote tolerance and cross-cultural understanding through research, public events and activities.

revitalising intangible cultural heritage. Held in Lamphun Province in partnership with four local museums, the Field School offered participants the opportunity to apply newly acquired concepts and methods through an on-site practicum.

Drawing on the 2009 Lamphun Field School experience, this chapter aims to present several of the important lessons learned regarding the practical realities of implementing the ICH Convention. Firstly, this chapter will argue that capacity-building – particularly training which emphasises a reflexive, anthropological approach to engaging with communities – constitutes the fundamental first step in the ICH Convention implementation process. As we shall see, however, even with such training in place, there are no guarantees that all heritage professionals will be responsive to the new definitions of cultural heritage and participatory approaches to heritage management. This point relates to a second major lesson from the Field School: namely that every national context presents a unique configuration of social, political and historical factors which shape not only the content of intangible cultural heritage but also normative ideas about its value, management, transmission and representation as 'local' or 'national' heritage. This chapter will offer several illustrations of how these contextual factors influenced this process, leading to the valorisation of certain forms of intangible culture and the marginalisation and neglect of others.

CONCEPTUALISING THE FIELD SCHOOL: BRINGING ANTHROPOLOGICAL APPROACHES TO BEAR ON IMPLEMENTATION OF THE ICH CONVENTION

As noted by Peter Nas (2002), the United Nations mandate to safeguard intangible heritage represents a significant landmark in the discipline of anthropology, inasmuch as it is 'the first time that cultural expressions have been taken as a subject of worldwide intergovernmental policy in such detail' (143). Given anthropology's long-standing commitment to the study of human cultural diversity and the discipline's expertise in ethnographic research methods, there is no question that anthropologists are uniquely positioned to play a leading role in the global effort to safeguard intangible heritage.

And yet, as a survey of the anthropological literature on this topic reveals, most anthropologists take a sceptical view of the ICH Convention – one prevalent critique being that state-led, bureaucratic processes and standards for managing intangible heritage inevitably lead to the reification, disembedding and trivialisation of culture. As stated by Brown (2003), '[c]ultural heritage that is inventoried, declared an official treasure, sustained by self-conscious instruction, and surveilled by government oversight committees has lost much of the spontaneous creativity that gave it meaning in the first place.' Similarly, Skounti (2009, 77) argues that the classification of cultural practices as ICH initiates a 'recycling process' whereby cultural facts are alienated from their original contexts in the process of being turned into heritage. '[T]hese elements of intangible cultural heritage are not, and cannot be, the same ever again: they become other, including to those who own and perform them.' This is further echoed by Kurin (2004b), who points out that safeguarding selected elements of culture is not the same as safeguarding the modes of livelihood and social practice within which they are meaningfully embedded.

A second point of tension has to do with the Convention's definition of intangible heritage and both the implicit and explicit criteria for what forms of intangible heritage should be included on the official lists. In Article 2 of the Convention, the definition of intangible heritage places emphasis on those practices that have been 'transmitted from generation to generation', and

'which provide them [communities] with a sense of identity and continuity'. As suggested by Deacon (2004), the Convention implicitly values intangible heritage that is old, ethnically or regionally distinctive and pre-industrial. As such, it constructs 'the idea that intangible heritage is generally non-Western, regionally specific, pre-modern, pre-literate heritage, passed from generation to generation' (ibid, 32), to the exclusion of intangible cultural expressions which are more contemporary and hybrid and yet no less significant to the identity of communities (eg popular memory, such as oral history of experiences of oppression under apartheid in South Africa).

In developing the Field School curriculum, one of the primary aims was to engage participants in these debates, in order to encourage them to take a critical view of the ICH Convention rather than accept its definition and approach to intangible heritage at face value. Towards this end, lecture sessions on the ICH Convention included an overview and readings of the main critiques, such as the effects of the bureaucratisation of culture and the politics of heritage within the nation-state, while discussions encouraged participants to speak openly about identity politics and the contested nature of cultural heritage within their respective countries.

Given that the participants were heritage practitioners concerned with questions of implementation, however, it was important to move beyond critiques of the Convention towards practical applications. Towards this end, in subsequent sessions, Field School facilitators proposed that one potential means of mitigating the negative effects typically associated with the bureaucratisation of culture was for heritage practitioners to employ reflexive, ethnographic methods when working with communities of culture bearers to identify, research, document and safeguard intangible heritage. Emphasising the importance of stakeholder participation, respect for culture bearers and recognition of diverse points of view, these sessions presented a number of key ethnographic approaches, such as building rapport, participant observation, self-reflexivity, open-ended interview techniques, understanding context and identifying key informants.

Museums as Partners in Safeguarding Intangible Cultural Heritage

A second, cross-cutting theme of the pilot Field School was the role of museums in safeguarding intangible cultural heritage. SAC chose to focus on museums for two main reasons; the first being that museums – particularly local and community-based museums – are a core area of SAC's expertise. Thailand is unique in the Greater Mekong Sub-region in that it is home to more than 1000 local museums operated by monasteries, private citizens, schools and local administrative organisations. A majority of these museums were established since the 1980s, when Thailand's rapid economic development gave rise to a widespread sentiment of nostalgia for fading social practices and abandoned modes of livelihood. Other factors which contributed to the growth of local museums in Thailand included a 1981 policy issued by the Department of Religious Affairs, which stipulated that monasteries should provide museum facilities and collaborative endeavours between monasteries, educational institutions, local intellectuals and NGOs to establish local museums as a means of empowering rural, indigenous and ethnic minority communities (Paritta 2006; Srisak 2002).

Recognising the vital role played by these museums in documenting and transmitting local history and culture, in 2003 SAC launched the Local Museums Research and Development Project – a project aimed at surveying the needs and providing support and capacity-building for local museums in Thailand. Since this time, SAC has been working closely with Thailand's local and community-based museums to strengthen their capacity in conservation, curation,

interpretation, management and outreach. Through this work, SAC has learned a great deal about the needs and challenges faced by Thailand's local museums. For instance, in addition to basic conservation and cataloguing techniques, many museum keepers need tools and approaches for researching and documenting the intangible dimensions of their material collections, such as the stories about objects and the meanings and uses of handicrafts. They also require appropriate strategies for encouraging greater involvement and support of local communities.

A second reason why this theme was chosen for the Field School is because museums have been recognised internationally as important partners in the endeavour to safeguard intangible cultural heritage. On the question of which agencies should be responsible for implementing the ICH Convention, Kurin stated the following:

> Perhaps the most appropriate type of organization to take the lead role in the realization of the Convention is the museum, or a museum-like cultural organization. Content-wise, they often cover the areas included in the Convention – they are cultural preservation institutions by their very definition. (Kurin 2007, 14)

Indeed, according to the latest definition of the museum put forth by the International Council of Museums (ICOM) in 2007, a museum is an institution that 'acquires, conserves, researches, communicates and exhibits the tangible and intangible heritage of humanity and its environment for the purposes of education, study and enjoyment'.

And yet, the expansion of museum work to include intangible heritage presents a number of methodological challenges. Firstly, while most museum professionals are trained to manage collections of objects, working with intangible heritage entails the extensive involvement and active participation of communities who are the bearers of living culture. Secondly, whereas museum curators are generally accustomed to being the experts in how to curate, conserve and interpret their collections, working with intangible heritage calls for a very different approach to museum management – namely, one which recognises the culture bearers as the primary 'experts' vis-à-vis their own heirlooms, practices, narratives, knowledge and traditions. Therefore, to work with intangible heritage, museums must acquire the tools for learning from culture bearers and engaging with them as equal partners in decision-making about museum activities and representations. Thirdly, traditional museums have generally been defined and contained by their buildings. However, to contribute to the revitalisation of intangible cultural heritage, museums must endeavour to reach far beyond the walls of the museum to build lasting relationships with local constituencies.

Aimed at addressing these issues, the Field School was designed to provide museum and heritage practitioners in the Asian region with the conceptual tools and methods for learning about intangible heritage and incorporating intangible heritage into museum activities. Toward this end, the Field School featured lectures highlighting new museological approaches, such as indigenous curation (Kreps 2009), ecomuseums (Davis 2005) and community museology, as well as several case studies (eg Vanuatu Cultural Center, Reciprocal Research Network) illustrating novel participatory approaches to museum management.

Furthermore, in order to link the ICH Convention directly to museology, the Field School correlated the nine core activities of safeguarding cultural heritage as described in the 2003 Convention (identification, documentation, research, preservation, protection, promotion, enhancement, transmission, revitalisation) with the core museum activities (preservation, educa-

tion, research, collections, networking, display, restoration and communications). This linking of core areas of safeguarding ICH with core museum activities became the organising framework for the Field School practicum, which is further described below.

The Field Practicum: Lamphun Province and Four Local Museums

Lamphun Province, situated in northern Thailand, was selected as the site for the pilot Field School for its cultural and ethnic diversity, rich history and multitude of local museums. Established circa the 8th century CE, Lamphun, formerly known as Hariphunchai, was one of the first centres of Dvaravati Buddhist culture in Thailand. In the 13th century Hariphunchai was conquered and became part of the Lanna kingdom centered at Chiang Mai. In the 16th century Lamphun came under Burmese rule for two centuries, during which time many settlements were abandoned. In order to repopulate Lamphun following decades of warfare with the Burmese, in the early 1800s King Kawila of Lanna forcibly resettled thousands of ethnic Yong, Karen, Shan and Khuen populations from the present-day Shan state in neighbouring Burma. In the late 1800s the Lanna kingdom came under the rule of the central administration of Bangkok. The expansion of central Thai culture and administration into the north marks yet another turning point in Lamphun's history (Penth 2001). The diverse culture of present-day Lamphun still bears the traces of this complex past, and the province's 15 museums (state, private, monastery and community-based) play an important role in documenting and safeguarding this multi-faceted heritage.

Beginning on the fourth day of the Field School, participants were divided into four working groups, each of which was assigned to work with one museum in Lamphun Province, including one state museum (Hariphunchai National Museum) and three local museums (Ton Kaew Monastery Museum, Pratupa Monastery and the Urban Lamphun Community Museum). The working groups had a total of seven fieldwork sessions with their assigned sites. For each session, the groups applied tools and concepts from morning lectures and discussions, which were organised topically according to the nine areas of safeguarding in the ICH Convention mentioned above. For instance, on the first day of the practicum, the morning lecture sessions focused on ICH inventory concepts and techniques, which were then applied during the afternoon working groups at their respective museum field sites.

For their final project, the task of the working groups was to develop a plan for museum activities (exhibit, performance, educational activities, research and documentation) in consultation with the local community featuring one element of local intangible cultural heritage. For this project, the goal was not only to research, document, interpret, represent and educate – it was also to develop a plan that would support the future sustainability of the selected elements of intangible heritage within the community.

Since space does not permit a detailed description of each of the working group projects, in what follows I will focus on specific lessons learned at two of the sites. In the first example, from Hariphunchai State Museum, I hope to show how the politics of heritage within the Thai nation-state continues to shape the perception that state museums are storehouses for national treasures rather than sites for collaborative community engagement with heritage. In the second example, from the Urban Lamphun Community Museum – a local museum – I aim to show that what is valued and recognised as intangible heritage by the local community does not fit neatly within the parameters of ICH as defined in the Convention.

HARIPHUNCHAI STATE MUSEUM

First established in 1927, the Hariphunchai State Museum houses several permanent exhibits of regional artefacts dating to the Hariphunchai (800–1293 CE) and Lanna (1350–1950 CE) periods, including stone inscriptions, pottery and Buddhist art and sculpture. In keeping with the Thai Fine Arts Department mandate for national museums, which is outlined in the 1961 *Act on Ancient Monuments, Antiques, Objects of Art and National Museums,* the Hariphunchai State Museum's primary mission is to collect, display and preserve regional artefacts considered to be national treasures.

On their first day of fieldwork, the working group endeavoured to identify the role of the museum in the community and its level of engagement with community stakeholders. Through an interview with the museum's director, the team learned that the key role of the museum was to provide information about Hariphunchai and Lanna art and history to tourists (both domestic and international) and schoolchildren – considered the primary museum users – and secondly, to provide a space for occasional academic and cultural activities organised by local associations and to host events featuring regional artists.

In terms of the management approach, the working group found that the museum staff subscribed to the traditional conception of the museum as an official space where state artefacts were exhibited and interpreted by experts. As such, the museum did not consider intangible heritage as part of its mandate; nor did it consider it appropriate to involve local community stakeholders in museum planning, interpretation or decision-making.

Nevertheless, as part of the inventory of intangible heritage on the second day of fieldwork, the working group set out to identify some elements of intangible cultural heritage which might serve as a link between the museum collections to the living culture and social practices of Lamphun province. After a survey of Lamphun municipality, and in consultation with the museum director, the working group decided to focus their project on the intangible dimensions of the Phra Rod Buddha amulets which featured in the museum's permanent collection – namely, the production, ritual consecration, beliefs and oral narratives surrounding these amulets.

Buddhist amulets and votive tablets are found widely throughout Theravada Buddhist societies such as Thailand. Crafted to serve as symbolic reminders of the Buddha's teachings, sacred amulets are also believed to have magical properties for their wearers, bringing them wealth, health and protection. Amulets are also potent symbols of local historical and cultural identity, inasmuch as they are linked to mythic narratives of place and often associated with charismatic monks or local historical figures. The baked clay Phra Rod Buddha amulets and votive tablets exhibited at the Hariphunchai museum were originally discovered at the Mahawan monastery in Lamphun Province, one of the oldest temples of this region dating to the Hariphunchai period. According to Buddhist chronicles, Mahawan monastery was the first Buddhist temple established by Hariphunchai's first ruler – Queen Camadevi – and the site where hundreds of protective Phra Rod amulets were interred under a stupa or *chedi.*

As the working group learned from their interviews with Lamphun's local residents, the artefacts at the museum were not confined to the historical past. Rather, they were embedded within a complex web of living beliefs and practices surrounding the reproduction, sale, collection and use of Phra Rod amulets that took place beyond the walls of the museum.

Firstly, while the remaining original Phra Rod images were extremely valuable and rare, baked clay reproductions of the protective amulets were ubiquitous in Lamphun. Produced by monks,

traditional healers and laypeople, these reproductions were sold widely at roadside stalls, given as tokens and distributed as gifts at opening ceremonies and funerals. Through their interviews with local stakeholders involved in the reproduction of the amulets, the working group learned that each monastery had its own ritual protocol for the production and consecration of amulets. Those seeking to reproduce an original Phra Rod amulet were first required to request permission from the temple abbot and substantiate their 'good intentions' (ie exchanging amulets to raise funds for school or merit-making rather than purely commercial profit). Once permission was given, amulets had to be consecrated on the grounds of the monastery in order to be regarded as 'authentic'. In their research, the group also encountered contestation about the meaning and use of amulets, with some local informants critiquing the commodification of amulets and popular beliefs in their magical properties as being distortions of the amulet's function as a reminder of the Buddha's teachings.

In terms of outputs and recommendations, the working group observed that there was some information already available about the amulets in the museum (ie brochures); however, this information was very basic and did not provide information about the many meanings, living practices and beliefs surrounding the amulets. It was recommended that the museum could incorporate many of the groups' findings and materials (ie photographs and data on the living aspects of amulet production) into a museum exhibit called 'The Power of Phra Rod: Icon, Art and Magic', which would highlight the diverse meanings and practices surrounding the amulets. The exhibit could document the relationship between amulets and the local legends of Queen Camadevi, and how these narratives and practices are tied to the contemporary identity of Lamphun today. Such an exhibit could contribute to safeguarding the intangible aspects of the Phra Rod amulets, inasmuch as it would convey that the amulets are not just historical artefacts but rather are part of a larger, holistic system of meaning, belief, production and consecration.

With regards to educational and outreach activities to support the transmission of ICH, the team recommended a number of hands-on educational activities that could be linked to the proposed exhibit on 'The Power of Phra Rod'. For example, schoolchildren could be involved in the clay pressing of Hariphunchai motifs at the Pho Liang Daeng ceramic factory. Art classes could include several sessions on Hariphunchai arts and motifs, include a sculpting and carving workshop (either at the museum or on-site at one of several monasteries producing ceramic crafts). Adults could be involved in the pressing of real amulets at Wat Phra Yuen, as part of the museum's tram tour of Lamphun. The team also suggested that the amulet exhibit could be linked to actual events of amulet production at a local monastery and that a site visit (ie during the consecration process) could be linked to the museum exhibit.

Regarding promotion via local media, the working group recommended that a range of local media networks could be involved in the promotion of the exhibit, including the museum's friends and volunteer network, newspapers, local radio and local cable TV. Other informal networks included local schools and monasteries, regional universities, the Department of Fine Arts network, government offices of tourist promotion, Buddhism and cultural affairs, NGOs and INGOs (ICOMOS, UNESCO) and cultural institutions (ie SAC).

In terms of community involvement in the proposed plan, the working group recommended that abbots and monks continue to serve as 'instructors' and presenters for the exhibition at the museum and activities arranged at monasteries. It was also suggested that the terracotta factory of Pho Liang Daeng be invited to become a patron for supporting a terracotta workshop for local

schoolchildren, and that the Friends of the Hariphunchai National Museum network serve as volunteers during the preparation, implementation and follow-up of the exhibit.

In sum, the working group concluded that the Hariphunchai National Museum had numerous strengths, including academic knowledge and capacity regarding the region's art and art history, space for activities, a good location in the city centre and a good network with various types of communities (government agencies, monasteries, schools, patrons and private enterprises). However, the museum could expand the scope of its exhibits and do more to safeguard intangible cultural heritage by extending its collection into the research and documentation process, such as of the making of amulets in contemporary Lamphun (both production and consecration), especially of those who are trying to maintain these practices following established traditions. Furthermore, the museum could highlight 'living' aspects of the amulets (and other collections) by including video and audio records, as well as an archive (library or internet archive), possibly with the cooperation of other research institutions. Finally, the museum could develop more linkages to the community by fostering a network through activities (both formal and informal) and more on-site activities where terracotta arts and amulets are produced.

In response to the proposed plan, the museum staff expressed a number of reservations and concerns. Firstly, given the monetary value of the Phra Rod amulets, there was concern that such an exhibit would put the museum and monasteries at an increased risk of theft. A second reservation was that the exhibit would reinforce unorthodox interpretations and popular uses of the amulets – particularly the superstitious belief in their magical properties – which was not considered an appropriate message for a state museum whose official mandate was to conserve and exhibit 'national treasures'.

URBAN LAMPHUN COMMUNITY MUSEUM

Founded in 2007, the Urban Lamphun Community Museum (ULCM) focuses on the urban history of the town of Lamphun, with an emphasis on archival photographs of Lamphun's past. It is housed in a nearly 100-year-old wooden edifice, the *Khum Chao Rajabutra*, which was the former residence of a ruling lineage of Lamphun. A group of young volunteers, called the *Klum Kwong Wean Hlapoon*, initiated the museum project and have taken care of the museum since its foundation. The municipality of Lamphun has supported various activities and events organised by the museum's young cultural workers.

The museum exhibitions consist of four areas. First, on the ground floor, a series of photographs document the history of the *Chao Rajabutra* residency, while enlarged historical maps of Lamphun reflect changes and continuities of the urban townscape. Enlarged reproductions of old photographs from the National Archives invite visitors to learn about events, customs and rituals formerly practised by Lamphun residents. Another section of this floor focuses on Lamphun's urban history and culture from the 1950s onwards, including a photo exhibit of Lamphun's former beauty queens, a collection of antique toys and a display of matchboxes and lottery tickets. Most of the objects came from donations and acquisitions of Lamphun artefacts via online auctions.

Second, a small wooden building in the courtyard behind the main building has been reconstructed, modelled on an old cinema of Lamphun and a 1950s-era classroom. On several occasions the museum has cooperated with the Center for Film Conservation in Lampang to screen films and launch educational programmes for the general public.

Third, on the upper level of the main building, youth who are interested in traditional Lanna music such as the *Pin-paie* (idiophone) can learn to play the instrument with volunteer masters from local universities in the North. Photographs taken by an American ethnomusicologist who studied this instrument more than 30 years ago illustrate the history and significance of the tradition.

Lastly, the open-air space close to the main edifice hosts various activities for youth and the wider public, such as 'talkfests' about the past, ritual activities and performances. There is also a one-storey building divided into three adjoining exhibits: a collection of local firefighters' artefacts, a 1950s-era convenience store and a 1960s-era coffee shop.

Naren Punyapu, the museum's founder, emphasised that even though the museum received some support from the local municipality, the museum operators and youth groups still had to raise funds for their activities by soliciting public donations at weekend markets and organising fundraising events such as movie screenings.

On the first day of fieldwork, the working group focused on identifying the role of the museum in the community. According to a number of key informants, including the curator and several volunteers, the museum served as a centre to research, preserve, transmit and revitalise local knowledge, values and traditions. The museum was also a centre for youth volunteer groups' cultural activities, many of which focused on the transmission of elders' knowledge to young people. Operators and primary users included the volunteers and youth group networks and outside audiences include tourists and other interested persons. Additionally, a number of the museum operators have worked closely with local researchers associated with the Hariphunchai Institute, a local non-government research centre interested in Lamphun's local culture and history.

In terms of management approach, the ULCM is a good example of a community-based museum which relies fully on the participation of community members in all aspects of its work, from fundraising to curation and research. The museum's core challenges were a shortage of funding for activities and uncertainty about the exhibition space. The museum was also facing challenges in terms of a shortage of skills and appropriate methods for conserving, archiving and exhibiting collections.

Turning to the identification and selection of intangible heritage, in the inventory process the working group initially identified a number of elements of intangible heritage associated with the museum and museum community, including traditional music, the production of traditional handmade toys and the production of floating candles for the November floating candle festival (*Yi Peng*). Through observation and interviews, the working group discovered that at the heart of all the museum's activities was a spirit of volunteerism which the youth referred to as *jit asa*, and the working group translated as 'volunteer spirit'. As the group learned, this 'volunteer spirit' among youth actually had a long history in Lamphun province. As evidenced by archival photographs, *Num-Saw* youth groups have been involved in a range of social welfare, public service and community development projects for many decades. Past activities of these groups included building irrigation systems and rural schools, as well as organising events such as plays and performances to raise funds for local charities. The current youth volunteer groups involved with the ULCM see themselves as the inheritors of the *Num-Saw* volunteer spirit and, based on this model, they have spearheaded a range of activities, such as organising cultural events festivals (eg a revival of the *Yi Peng* floating candle festival) and teaching traditional folk music. The youth volunteers also undertake field research about Lamphun's past cultural practices and life

histories of local figures. Often beginning with archival photographs, youths seek out senior key informants who can tell them about practices and events featured in the photograph. Findings from interviews with elders are then used to document and sometimes to revitalise threatened or dying cultural practices, like the *Yi Peng* floating candle festival mentioned above. In this way, the research, sponsorship and organisation of these cultural activities supports intergenerational transmission of intangible cultural heritage. In summary, the working group found that the *Num-Saw* 'volunteer spirit' was the most significant element of ICH for the Urban Lamphun Community Museum, inasmuch as it reflects the distinctive historical and cultural identity of urban Lamphun and underlies all of the museum's educational and outreach activities.

Regarding documentation and research, the Urban Lamphun Community Museum already has a fair amount of existing documentation, such as old photos, newsletters, books, a museum website and a museum brochure. With respect to promoting, transmitting, revitalising and enhancing intangible cultural heritage, the working group found that the museum was already engaged in both inreach and outreach through a range of educational activities, cooperation and interpretation, and networking and partnership. For instance, the museum already served as a cultural learning centre transmitting knowledge about traditional practices and cultural activities. As for outreach, there was a monthly newsletter featuring articles about local history and cultural events, as well as a museum brochure and coverage about the museum's activities in local and national newspaper media. The museum had also featured in a TV documentary and on billboards, as well as on T-shirts promoting museum activities. In terms of recommendations, the working group suggested that the Urban Lamphun Community Museum develop a digital database featuring photo archives as well as documentation (interviews, etc). It was also suggested that the museum continue to expand fundraising efforts, in part through developing a statistical record of visitors to show the importance of the museum both locally as well as regionally and internationally. English language materials (brochure, labels) would make the museum collection and activities more accessible to the international community. Moreover, the museum needed to focus on improving its collection management, such as cataloguing and inventory methods. It was also suggested that the museum develop 'appropriate' conservation methods for the museum's photographs, media and artefacts. One specific suggestion made by the working group was the introduction of a simple form that could be used to develop a database of photographs.

The working group's proposed plan focused on strategies for transmitting the *Num-Saw* volunteer spirit model to other communities in the region, as well as nationwide. Based on their research and consultation, the group suggested that the museum produce a multimedia CD about the history of Lamphun's *Num-Saw* volunteer network and the museum activities focused on revitalising and transmitting this historically rooted practice of youth community service. The CD could be used to teach other districts as well as visitors about the *Num-Saw* youth volunteers' history, mission and methodology so that they could develop similar volunteer networks in their own communities. All in all, the museum volunteers responded positively to the working group's recommendations.

CONCLUSIONS: LESSONS LEARNED AND IMPLICATIONS FOR IMPLEMENTATION OF THE ICH CONVENTION

As posited at the outset of this chapter, the Field School offered some valuable lessons about the practical realities of implementing the 2003 ICH Convention. The first of these lessons is

that there is a vital need for training that combines both critical, conceptual frameworks and hands-on tools from the discipline of cultural anthropology – a discipline which teaches us that researching intangible cultural heritage requires patience, reflexivity, respect and a willingness to take the time to learn about living practices from the culture bearers themselves. Given its sceptical stance towards the Convention and similar international efforts to 'bureaucratise culture', cultural anthropology offers necessary critiques of the politicisation and commodification of cultural heritage, particularly at the national level.

Cultural anthropology also offers important practical and conceptual tools for heritage practitioners. Working with communities to inventory, research and safeguard cultural practices, heritage practitioners will invariably grapple with the complexity of cultural expressions in their local contexts. Therefore, heritage professionals must have tools to help them understand not only the meanings and historical contexts of cultural expressions, but also how these practices constitute gender identities, shape and reflect power relations and intersect with local, regional and national identity politics.

This brings me to the second lesson learned from the Field School; namely, that conceptions of what constitutes 'cultural heritage' are fundamentally shaped by the 'authorizing heritage discourses' (Smith 2006) in each national context. In Thailand, 'cultural heritage' is largely circumscribed by official definitions of heritage given by the state bodies within the Ministry of Culture. For instance, the Fine Arts Department classifies heritage into four domains, namely: historical parks, literary arts, performing arts and visual arts, while the Office of National Culture Commission (ONCC) focuses on 'folk' dimensions of heritage, such as 'local wisdom', ways of life and handicrafts. Generally excluded from this definition are beliefs and practices which are considered 'superstitious', unorthodox or non-traditional. No matter how central these living practices may be in constituting a sense of local identity and intergenerational continuity, as in the case of the Phra Rod amulets and the *Num-Saw* volunteer spirit, they are not officially acknowledged as heritage.

How can these tensions between how the state and local communities determine what should be valued as 'cultural heritage' be resolved? In fact, the answer to this dilemma is already stipulated in Article 15 of the ICH Convention, which explicitly calls for states to ensure 'the widest possible participation of communities, groups and, where appropriate, individuals that create, maintain and transmit such heritage, and to involve them actively in its management'. Instead of imposing preconceived notions of heritage, government agencies and heritage professionals must engage in dialogue with local communities in order to determine what aspects of intangible culture are significant and worthy of research, documentation and transmission. In countries such as Thailand, where heritage management has for so long been a top-down enterprise undertaken by experts, it will undoubtedly take time for the participatory approach to heritage management to take hold, but training programmes offering anthropological approaches can play an important part in accelerating this paradigm shift.

Finally, the last lesson from the Field School is that every national context is unique and presents a distinctive set of opportunities and challenges when it comes to safeguarding intangible heritage. Thailand is unique in the Greater Mekong Sub-region in that it is home to a network of over 1000 local museums which operate as repositories of local history and culture. Given that they are already engaged in the work of collecting, documenting and preserving cultural heritage, Thailand's local museums have an integral role to play as partners in the treaty implementation and should be actively included in this process.

POSTSCRIPT

In 2011, the management of the Urban Lamphun Community Museum (ULCM) was taken over by the Lamphun Municipality. Even though many of the youth activities are no longer based at the ULCM, the *Num-Saw* volunteer network continues to organise cultural events and activities focused on strengthening Lamphun's civil society.

BIBLIOGRAPHY AND REFERENCES

Brown, M, 2003 Safeguarding the Intangible [online], *Cultural Commons: The Meeting Place for Culture and Policy, Center for Arts and Culture*, available from: http://www.culturalpolicy.org/commons/comment-print.cfm?ID=12 [25 January 2010]

Davis, P, 2005 Places, cultural touchstones and the ecomuseum, in *Heritage, Museums and Galleries: An Introductory Reader* (ed G Corsane), Routledge, London, 365–76

Deacon, H, 2004 *The Subtle Power of Intangible Heritage: Legal and Financial Instruments for Safeguarding Intangible Heritage*, Human Sciences Research Council Publishers, Capetown

ICOM, n.d. *Code of Ethics for Museums*, available from: http://icom.museum/ethics.html#intro [25 January 2010]

—— n.d. *The Role of International Council of Museums for the Safeguarding of Intangible Heritage*, available from: www.unesco.org/culture/ich/doc/src/01367-EN.doc [25 January 2010]

Kreps, C, 2009 Indigenous curation, museums, and intangible cultural heritage, in *Intangible Heritage* (eds L Smith and N Akagawa), Routledge, London and New York

Kurin, R, 2004a *Museums and Intangible Heritage: Culture Dead or Alive?*, ICOM News No. 4, 7–9

—— 2004b Safeguarding Intangible Cultural Heritage in the 2003 UNESCO Convention: a critical appraisal, *Museum International* 56 (1–2), 66–77

—— 2007 Safeguarding Intangible Cultural Heritage: Key Factors in Implementing the 2003 Convention, *International Journal of Intangible Heritage* 2, 10–20

Nas, P, 2002 Masterpieces of Oral and Intangible Culture: Reflections on the UNESCO World Heritage List, *Current Anthropology* 43 (1), 139–48

Paritta, C K, 2006 Contextualising objects in Monastery Museums in Thailand, in *Buddhist legacies in Mainland Southeast Asia: Mentalities, interpretations and practices* (eds F Lagirarde and P C Koanantakool), Princess Maha Chakri Sirindhorn Anthropology Centre, Bangkok

Penth, H, 2001 *A Brief History of Lan Na: Civilizations of North Thailand*, University of Washington Press, Seattle

Smith, L, 2006 *The Uses of Heritage*, Routledge, London

Srisak, V, 2545 [2002] Thai Museums for a New Century, The Princess Maha Chakri Sirindhorn Anthropology Centre, Bangkok (In Thai)

UNESCO, 2003 *Convention for the Safeguarding of the Intangible Cultural Heritage* [online], available from: http://www.unesco.org/culture/ich/index.php?pg=00006 [25 January 2010]

Intangible Threads: Curating the Living Heritage of Dayak Ikat Weaving

Christina Kreps

A few decades ago, the *ikat* weaving tradition of the Dayaks, the indigenous people of Kalimantan (Indonesian Borneo), was considered a disappearing art (Gittinger 1979; Heppell 1994), but through the work of the Dayak Ikat Weaving Project based in Sintang, West Kalimantan, the tradition has been revived.

This chapter considers the role the Weaving Project plays in the revitalisation and preservation of intangible cultural heritage (ICH) associated with Dayak weaving. The Project is examined in the light of preservation strategies recommended under the 2003 UNESCO *Convention for the Safeguarding of the Intangible Cultural Heritage* as well as Indonesian laws recently enacted or drafted to protect intellectual and cultural property. I suggest that efforts such as the Dayak Ikat Weaving Project offer more culturally appropriate, holistic and integrative heritage interventions than those proposed by the Convention and Indonesian laws. Special attention is given to indigenous curatorial practices embedded in Dayak *ikat* weaving traditions, and how these exist as both forms of intangible cultural heritage as well as strategies for their preservation. My goal is to show how the intangible cannot be detached from the tangible, or the whole fabric of life, and preservation strategies need to be informed by more 'ecological thinking', as Michael Brown recommends in his article 'Heritage Trouble: Recent Work on the Protection of Intangible Cultural Property' (2005). For Brown, ecological thinking is 'characterized by holism and awareness of interconnections. It recognizes that the management of complex systems demands attention not to one variable but to many, and that there will always be uncertainty about how changes in one variable will affect the whole' (ibid, 42).

The UNESCO *Convention for the Safeguarding of the Intangible Cultural Heritage*

The UNESCO *Convention for the Safeguarding of the Intangible Cultural Heritage* was adopted by the United Nations General Conference in 2003 and entered into force in 2006. The Convention grew out of a concern within the international community over the rapid loss of the world's diversity of living cultural expressions. The Convention was also the culmination of years of debate over how to correct the imbalance in previous United Nations approaches that favoured the protection of tangible heritage in the form of monuments and sites over popular, folkloric and living traditions, especially those of historically marginalised communities such as indigenous people and ethnic minorities (Aikawa-Faure 2009, 14–15; Fairchild Ruggles and Silverman 2009; Kurin 2004a).

According to the Convention, intangible cultural heritage is:

The practices, representations, expressions, knowledge, skills – as well as instruments, objects, artifacts and cultural spaces associated therewith – that communities, groups and in some cases individuals recognize as part of their cultural heritage. This intangible cultural heritage, transmitted from generation to generation, is constantly recreated by communities and groups in response to their environment, their interaction with nature and their history, and provides them with a sense of identity and continuity thus promoting respect for cultural diversity and human creativity. (UNESCO 2003, Article 2.1, Definitions)

Intangible cultural heritage is manifested in oral traditions, including language; performing arts (traditional dance, music, and theatre); social practices, rituals, and festive events; knowledge and practices; and traditional craftsmanship. (UNESCO 2003, Article 2.2, Definitions)

One of the purposes of the Convention is to raise awareness and appreciation of ICH and maintain conditions under which it can be perpetuated, given the 'social good' it is purported to serve. Consequently, the aim is to sustain living cultural traditions, practices and processes in addition to collecting and preserving cultural products. The Convention also establishes a Fund for the Safeguarding of Intangible Cultural Heritage that can be drawn on to support safeguarding efforts. Furthermore, the Convention supports international cooperation and assistance, especially in the areas of research, documentation, education and training (Article 21). An important requirement of the Convention is that local communities and the 'culture bearers' themselves are involved in identifying their ICH and developing and implementing measures for its protection.

The articles of the Convention outline safeguarding measures in detail, as well as the role and responsibilities of state signatories to the Convention. The primary means for safeguarding ICH is the creation of national inventories, which, in turn, can be used to identify specific examples of ICH for nomination to the 'Representative List of the Intangible Cultural Heritage of Humanity and the List of Intangible Cultural Heritage in Need of Urgent Safeguarding'. Listing and lists are intended to ensure greater visibility of ICH, increase awareness of its significance and encourage dialogue on the need to respect cultural diversity. Under the Convention, 'safeguarding' means: 'measures aimed at ensuring the viability of the intangible cultural heritage, including the identification, documentation, research, preservation, protection, promotion, enhancement, transmission (particularly through formal and informal education) as well as revitalization of the various aspects of such heritage' (UNESCO 2003, Article 2.3, Definitions).

THE DAYAK IKAT WEAVING PROJECT

The Dayak Ikat Weaving Project was initiated in 1999 by the People, Resources and Conservation Foundation (PRCF), a community development non-governmental organisation, in collaboration with the Kobus Centre (Center for Cultural Communication and Art) in Sintang.[1] The

1 I first visited the Dayak Ikat Weaving Project in 2002 when I was sent to Sintang by the Ford Foundation in Jakarta to evaluate the Project's progress. I returned in 2003 with two of my students participating in the University of Denver/Indonesia Exchange Program in Museum Training funded by the Ford Foundation. Novia Sagita also participated in this training program and spent nine months at the University of Denver studying museology and anthropology. I made a subsequent research trip to Sintang in 2008. I want to thank Philip Yampolsky, who was the Cultural Program Officer at the Ford Foundation in Jakarta at that time for initially sending me to Sintang and for supporting the Exchange

project's goals are to enhance the artistic and managerial skills of weavers; contribute to women's empowerment through greater financial security and independence; and foster appreciation of weaving through research and education (Huda 2002). The Project's overarching goal is to revive and strengthen the *ikat* weaving tradition, which has become a hallmark of Dayak cultural heritage.

The decline in textile production among the Dayaks, as in the case of most traditional arts, was a consequence of general forces of culture change, modernisation and development. Religious conversion to either Christianity or Islam undermined traditional animistic religious beliefs and rituals inextricably tied to weaving while the introduction of commercial cloth and other goods some 200 years ago decreased the need for hand-woven cloth (Heppell 1994).

Ikat is a term derived from the Malay verb *mengikat*, meaning to tie, bind or knot. It is used to refer to a style of weaving in which designs on cloth are produced by a resist dye process.[2] Dayaks, especially the Iban, are famous for their *ikats*, which have been highly prized by collectors for centuries and can now be found in museum and private collections around the world.

One of the Project's main activities has been the development of a cooperative known as *Jasa Menenun Mandiri* (JMM), which translates as 'weavers stand alone or go independent'. The cooperative has a gallery and atelier at the Kobus Centre that serves as a collection and distribution point for the weavers' products, including articles such as *ikat* textiles, bags, picture frames, place mats, wall hangings, jackets and scarves, as well as other local crafts like basketry. The Kobus Centre and cooperative are housed in the residence of Father Jacques Maessen, a Dutch Catholic priest who has been working in the region since 1969. He is also founder of, and senior adviser to, the Project (see Fig 15.1).

When the cooperative was established in 2000 it had fewer than 50 members. It now has more than 1200 from 32 different villages in the Sintang district (Sagita 2009, 120). The cooperative buys and sells the weavers' products and provides them with loans to purchase materials such as thread and chemical dyes or for other needs. Through their participation in the cooperative, weavers have the opportunity to earn much-needed cash and acquire skills in financial and business management. Thus, it exists to generate income for the weavers and their communities as well as to validate their art. The cooperative also sponsors training workshops on the use of natural dyeing techniques and traditional designs, motifs and colours.

According to Father Maessen, the cooperative has been concerned with promoting the use of traditional designs and natural dyes since this makes the *ikats* more 'authentic' and increases their market value. This policy also fosters the preservation of the traditional art form. Younger, less experienced and knowledgeable weavers are sometimes provided with photographs of old textiles with traditional designs to replicate (Kreps 2002). Although Father Maessen knows that traditional style textiles sell better, he also does not want to stifle creativity. To this end, he encourages

Program. I am also grateful to Father Maessen and Novia Sagita for giving me the opportunity to work with them, and to the weavers and their families who generously opened their homes to us. Many thanks to Helaine Silverman for her thoughtful comments on the chapter, and to Randy Brown for photographs from the 2008 fieldwork.

2 The *ikat* process entails tying off portions of warp or weft yarns so that they will resist dyes and then untying and retying other sections before immersing the yarns in successive dye baths. After dyeing, the knots are untied or cut away leaving patterned yarns ready for weaving. The Iban weave on back-strap looms (Gittinger 1979, 233).

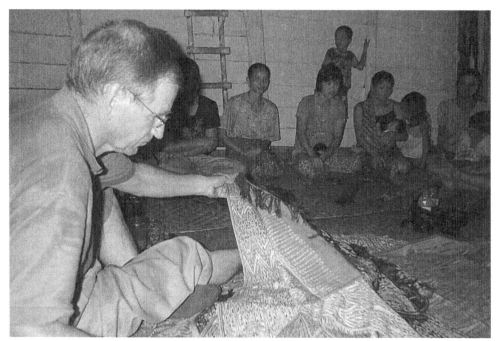

Fig 15.1. Father Jacques Maessen in the village of Ensaid Panjang, West Kalimantan, Indonesia, 2003.

weavers to be innovative, often buying non-traditional pieces, such as those that depict modern life and technologies such as mobile phones, aeroplanes and televisions, for his private collection.

Because *ikats* coloured with naturally-dyed threads fetch higher prices than those made from chemical, analine dyes, the Project has been promoting the collection of plants used to produce dyes.[3] However, deforestation, a serious environmental problem in Kalimantan, has led to a scarcity of natural dye raw materials. To address this problem, the Project, in cooperation with regional government and conservation agencies, has initiated a forest rehabilitation programme by cultivating dye-producing plants. This conservation work complements one of the key objectives of the Project: to create sustainable livelihoods for the Dayaks (Huda 2008).

The cooperative also promotes Dayak *ikats* nationally and internationally through exhibitions, seminars, publications and via their website. Additionally, it sponsors an annual exhibition and competition in Sintang to inspire quality work. The competition is also meant to increase community awareness and appreciation of local cultural heritage and the importance of its preservation.

Father Maessen has been credited for being the principal force behind the revitalisation and promotion of West Kalimantan *ikat* weaving. In fact, he received an award from the Ministry of Culture for his cultural heritage preservation efforts. He began collecting textiles in the 1970s when he noticed how fewer women were weaving, and how older pieces were being sold or

3 In 2006, the cooperative received a grant from the Ford Foundation to make an inventory of natural dye plants traditionally used by the weavers.

traded in response to demand from the international tribal arts market (Low 2009). Ironically, Father Maessen's initial attempts to rescue and preserve the textile tradition were met with resentment. He recounts how in 1974 a group of young women staged a protest in front of his house and burned heirloom *ikats* known as *pua kumbu*, a ceremonial cloth now highly valued. The women accused Father Maessen of trying to 'keep them primitive' and 'frozen in time' (Maessen as cited in Low 2009, 198–9).

This anecdote takes its significance from the historical context. At the time, the Indonesian state ideology mandated that citizens, especially those living in more remote regions, embrace modernisation and development. Not surprisingly, Dayaks began to reject traditional dress because they believed it marked them as 'backward' and 'primitive'. The use of *pua kumbu* was particularly shunned because it was historically associated with headhunting rituals and inter-tribal warfare and thus linked to a past identity Dayaks were trying to shed. Today, the situation is dramatically different. Young weavers have come to claim weaving and *ikats* as a symbol of their cultural heritage and identity. They also recognise that weaving is a significant economic resource and means of raising their standard of living. Weaving is also, for some, entry into a cosmopolitan world of international conferences, trade fairs, exhibitions and an elite national design and fashion industry. *Ikats*, as a result of these developments, have been transformed from being signifiers of 'primitiveness' to an internationally acclaimed traditional art form.

The Project is also illustrative of how globalisation intersects traditional art forms and the assertion of ethnic identities. While globalisation, on the one hand, tends to generate cultural homogenisation, on the other hand it also encourages the competitive marketing of difference. Through their participation in the Project, weavers receive international recognition and validation (via museums, collectors, publications, festivals, competitions, etc) not only of their art but also of their culture and identity as Dayaks, giving them added leverage when negotiating their identity and status on provincial and national levels.[4] This is particularly important in light of the Dayak peoples' continual struggles to secure land rights and access to other resources like jobs vis-à-vis other more economically and politically powerful ethnic groups. In the late 1990s, such struggles led to violent inter-ethnic and inter-religious conflicts (namely between Dayak Christians/Animists and Madurese Muslims) in Central and West Kalimantan, and the labelling of Dayaks as savage headhunters in the national press (see Schiller and Garang 2002, 250; Silver 2007).[5]

Commercial success is one way of validating and perpetuating Dayak *ikat* weaving. Conducting ethnographic research and producing knowledge about it is another. Hence, research is an essential component of the Project's work. It is considered 'urgent research' since knowledge of weaving techniques and associated customs is disappearing with the passing of older weavers. The information collected on oral traditions and *ikat* symbolism enriches younger weavers' understanding of the art and their own collection of symbols.

4 I am grateful to Helaine Silverman for this observation.
5 In October 2008 a new museum opened in Sintang, the Museum Kapuas Raya. One of its main attractions is a collection and display of Dayak *ikat* weavings, donated by Father Maessen. The Museum is the product of a collaboration between the Kobus Centre, the district government and the Tropenmuseum in Amsterdam. It is dedicated to educating the public on the rich history, art and culture of the Sintang district, and promoting peace and reconciliation among the various ethnic groups living in the region.

Research and documentation is also important for marketing purposes, as a cloth is considered more valuable to buyers if information on the meaning of specific motifs and the story behind them, as well as the weaver's name and village, is available. For this reason, the cooperative tags each piece with a label of 'authenticity' bearing the name of the weaver (artist) and her village (provenance), and whether chemical or natural dyes were used (materials). They also produce pamphlets that interpret the meaning of the cloth's motifs. Thus, the cooperative is savvy to the tastes and predilections of non-local consumers.

Novia Sagita, a Dayak woman from Pontianak, the capital of West Kalimantan, was a researcher for the Project and began field studies in the Sintang and the Upper Kapuas districts of West Kalimantan in 2002, focusing on Dayak Desa, Iban and Kantuk.[6] Sagita's research pertained primarily to documenting through photographs, notes and video the intangible aspects of Dayak *ikat* weaving, such as the symbols and motifs used in the textiles as well as their stories and meanings. She also recorded local customs, beliefs and rituals that accompany weaving along with oral histories of individual weavers. As such, her research was consistent with the safeguarding measures recommended in the Convention and by others involved in preservation efforts. Graham, for one, points out how 'ethnographic work is necessary to understand local ideologies of intangible culture in relation to safeguarding, documentation and representational practices. It is also essential to comprehending the precise nature of indigenous conceptions of and participation in such activities' (2009, 186).

In addition to the subjects above, Sagita was also interested in investigating indigenous curatorial practices associated with weaving, as this is part of the tradition that has been integral to its transmission and preservation, yet has been historically overlooked and undocumented. This is despite the fact that scholars have been studying and publishing on Iban textiles for decades.

INDIGENOUS CURATION OF DAYAK IKAT AND INTANGIBLE CULTURAL HERITAGE

Previously, I have asserted that indigenous curation is both a form of intangible culture as well as a means of safeguarding it (Kreps 2009). Indigenous curation is a phrase that has entered museological discourse in recent years which I use to refer to a constellation of museological forms and behaviour, including structures and spaces (indigenous models of museums) for the collection, storage and display of objects as well as knowledge, methods and technologies related to their care, treatment, interpretation and conservation (curation). Indigenous curation also encompasses concepts of cultural heritage preservation or conceptual frameworks that support the transmission of culture through time.

Indigenous models of museums and curatorial methods may be found in vernacular architectural forms; religious beliefs and practices; systems of social organisation and structure (especially

6 The name 'Dayak' is a generic term used to refer to the indigenous, culturally non-Malay and non-Chinese inhabitants of Kalimantan (Indonesian Borneo). However, a number of different Dayak groups inhabit the island and possess their own names, languages and cultural traditions. The ethnic groups named live in the middle Kapuas River basin and have therefore been referred to as 'Kapuas Ibanic' ethnic groups in the ethnographic literature. These groups include the Kantu', Seberuang, Bugau, Mualang, and Desa (King 1993, 49). The 'Iban proper' are sometimes called the Sea Dayak (Drake 1988, 29) and have historically inhabited areas that now comprise the border of the Malaysian state of Sarawak and Indonesian province of West Kalimantan.

kinship systems and ancestor worship); artistic traditions; and aesthetic systems, in addition to knowledge connected to people's relationships and adaptations to their natural environment (Kreps 2003a; 2009).

Many of the customs, beliefs and ritual practices linked to Dayak textiles can be seen as curatorial traditions if curation is viewed in terms of how people use, give meaning to and interpret, classify, take care of and preserve things of value to them according to prescribed cultural protocol. The term curator is derived from the Latin word *curare*: to take care of. Returning to this original definition of curator as custodian, guardian or keeper, we can see how individuals or certain classes of people such as priests, shamans, ritual specialists – and in the Dayak case, weavers – are curators. As caretakers of a family, group or society's cultural knowledge, practices and creations they are responsible for transmitting culture from one generation to the next, or, in other words, for cultural heritage preservation (Kreps 2003b).

To be a curator one must possess specialised knowledge on the technical and formal properties of an art or craft, be educated in particular styles and traditions, and possess an understanding and appreciation of particular aesthetic systems. Dayak weavers certainly meet these criteria and can be seen not only as curators but also connoisseurs of *ikat* textiles, being able to judge the quality and efficacy of a piece (as a ritual object and spiritual medium) based on local aesthetic canons and cultural conventions.

IBAN IKAT

The Iban are famous for their *pua kumbu*, as seen in Fig 15.2. *Pua kumbu* (*pua*, for short) are large, blanket-size warp *ikat* textiles with intricate patterns. They are one of the most ritually and symbolically significant forms of Dayak art and have been used in a variety of ritual contexts, such as birth and naming ceremonies, weddings, funerals, agricultural festivities, gift exchange and payment of fines, and, in former times, ceremonies involving headhunting. *Pua* are used to form a sacred enclosure around the space in which ceremonies are performed. They also have the power to protect wearers from malevolent spirits and facilitate their communication with the spirit world (Drake 1988; Freeman 1970; Gavin 2003; Haddon 1936; Heppell 1994; Mashman 1991). *Pua* are the embodiment of traditional Iban cosmological ideas, religious knowledge and beliefs. According to one author, '*Pua kumbu* … represent the quintessence of Iban culture. It is, depending on the design, historical archive, a mythological or religious story or a personal tale. It is a statement about the soul of the weaver and her relationship to spirits' (Jabu 1991, 76).

Weaving *pua* traditionally has been a spiritually charged and sometimes a perilous venture. Iban traditional religious knowledge is attributed to communication with the spirits and acting in response to divine guidance. Weaving certain designs, for instance, can be dangerous because it brings weavers into communion with the spirit world or because certain designs hold mystical properties and possess special powers (*guna* or *bisa*) (Gavin 2003, 26). 'The more powerful the design, the closer it brings an Iban to the spirit world – and the greater the danger there is for the weaver as she seeks to capture the essence of the spirit and render it in cloth' (Heppell 1994, 129). To protect themselves during the various stages weaving women use charms, in the form of small stones or other objects, and make offerings to the spirits. The display of *pua* with well-executed and innovative designs pleases the deities and elicits their blessings during rituals.

Weaving is distinctively a women's art and symbolises women's creative essence associated with fertility, childbearing and well-being. Weaving is a means of gaining status and prestige, and 'a

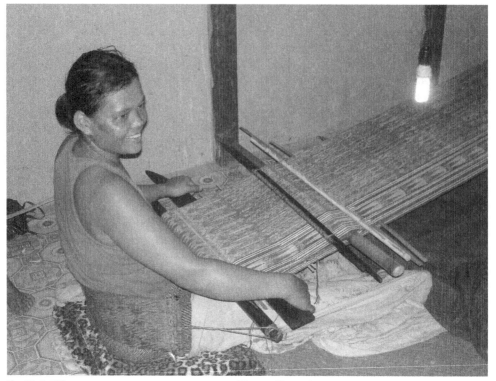

Fig 15.2. Weaving a pua ikat in the village of Kumin, West Kalimantan, Indonesia, 2008.

woman, depending on her use of dye, design, and skill, will fit into a certain rank within the community' (Jabu 1991, 80).

Nearly all the motifs on *pua* and other textiles are inspired by elements of the natural environment, religious beliefs and spirituality, or daily pursuits. Most Iban designs are so stylised that the only way to be certain of their exact meaning is to ask the woman who made the pattern (Gavin 2003, 235, after Haddon 1936). The weavers, when designing their cloth, traditionally relied solely on memory, so more intricate and complex designs are generally attributed to older weavers.

Many customs, taboos and restrictions surround designs, which are generally the property of a particular family or weaver. Design secrets are kept within a family and each woman has her own repertoire of designs. Among the Iban, the weaver owned the designs she wove and could pass them on to her daughter. She could also sell her designs, but if she did so, she forfeited her copyright to them (Mashman 1991, 245). New *pua* designs are first revealed to weavers through dreams. Designs that are copied are considered less potent because they do not come from dreams.

Dayak weavers have their own aesthetic canons and criteria by which the quality, value and potency of a piece may be judged. Iban value originality in design and expertise in executing difficult patterns. In dyeing, dark, rich, red colours are especially revered because they are the most difficult to achieve. They reflect a weaver's expertise in dyeing besides the degree to which

she is in touch with the spirit world. Because results can be unpredictable, weavers rely on divine intercession (Heppell 1994). Hence, there are a number of taboos and rituals attached to the multiple stages of dyeing. Each dyer has her own special recipes, which were often guarded secrets, and expert dyers can be well paid for their work (Jabu 1991).

Although various aspects of *ikat* weaving, such as ceremonial use, have changed considerably over time, Sagita found that many weavers, especially elderly women, still adhere to some of the traditional beliefs connected to weaving. For instance, she observed that older weavers continue to make offerings to the spirits or honour taboos throughout the weaving and dyeing process. In the following passage she describes her experience with an older weaver in a village.

> I was extremely fortunate to have been visiting her when she was about to finish the last part of the dyeing and tying process of one piece and was starting to weave it. I was there when she unfolded the warp and put it on the loom. I could already see a beautiful motif in the warp. It took one week for her to finish the *bidang*, or a cloth for a skirt while continuing her work as a farmer. The day she finished the *bidang* she took it off the loom and folded it without finishing the fringes. She put a plate and a lamp next to the textile and filled the plate with rice, betel leaves and lime, a piece of cake made from sticky rice, and a cigarette. Two of her daughters who were learning to weave helped her gather these offerings. I followed her to a small river next to her house where she threw the offerings [*pagelak*] into the water. She then placed the lamp on the plate and let it float on the water. She explained that she was making this *pagelak* because her work was finished. She asked for blessings and health for herself and her whole family. After that, she started to do the fringes, while telling me the names of the motifs. She said it was *pamali* [taboo] to mention the name of any motif before the weaving is finished. This is because they believe the motif may harm her and then she may not be able to weave a beautiful *ikat* anymore.
>
> The next day she asked me to come with her to visit her sister who was also a weaver. At her sister's house I was surprised when she pulled from her bag a piece of old *ikat bidang* (skirt also known as *kebat*) with a motif similar to her new textile. She gave the old textile back to her sister with a plate full of rice, a couple of betel leaves and cigarettes. She said it was to thank her sister since she had copied and borrowed her sister's old textile. They had inherited this textile from their parents. (Sagita 2009, 122–3)

Just as Ibu Rinai was required to 'pay' her sister for copying her ikat, Sagita was also required to pay the weavers for information about their motifs and in order to photograph them. She compensated them in cigarettes, rice, chickens or with money. These payments were not for the weavers themselves, but were used as offerings to the spirits.

Sagita suggests that the beliefs, customs and stories related to *ikat* weaving have worked to preserve the art form through the generations such as the 'indigenous copyright' system noted in the above narrative. She describes how she learned about the system in the course of her field research.

> When I visited the weavers in different villages, I sometimes showed them my photo collection of *ikats*. This was one method I used for gathering information on motifs. The weavers were very intrigued by these photos and asked a lot of questions about which Dayaks made which *ikats*, and how the textile were [sic] collected. It was interesting to listen to their discussions

about the photographs and the comparisons they made between their motifs and those on the textiles in the photographs. A middle-aged weaver said that it was unusual for them to see photographs of *ikat*. She was also a little worried about how the photographs made it easy for other people to copy motifs. For them, when they want to copy someone else's designs (even those of relatives), they have to make payments in the traditional way. I believe this indicated how weavers are concerned about respecting and protecting traditional rights to cultural property. Traditional rules and customs regarding the use of motifs is a kind of indigenous copyright. (Sagita 2009, 125)

Sagita documented other examples of indigenous curatorial practices, such as how weavers fold cloths to protect their motifs as well as how they store them in baskets with sayang leaves that work as an insecticide. Some women also store heirloom textiles in ceramic jars to guard them from excessive humidity, light, dust and rodents (ibid, 124–5). In these customs we can see indigenous forms of pest management and preventive conservation.[7]

Sagita also recorded the practice of giving long names or titles to cloths, which is a practice that is well documented in the literature on Iban textiles (see Gavin 2003). According to Sagita, titles are based on the story of a particular cloth. In one case, an old *pua kumbu* she was shown had the title 'there is a big bad spirit that sits and stays still at a banyan tree near the waterfall by the river'. Weavers, in addition to naming cloths, may also classify textiles based on type of design and motif, use, an individual weaver or ethnic group's style, or a cloth's supernatural qualities.

The above examples of traditional knowledge, skills, social practices and rituals corresponding to Dayak *ikat* weaving well fit the Convention's definition of intangible cultural heritage. Some also constitute safeguarding measures in the sense that they have worked to transmit weaving traditions from generation to generation. Furthermore, the aims and strategies of the Dayak Ikat Weaving Project converge with the Convention's 'rescuing mission' and efforts to revive and promote a disappearing art form of a historically marginalised indigenous people. The weaving Project's research, documentation and education activities are also consistent with the Convention's safeguarding measures. Finally, the Project is a community-based initiative that requires the participation of the culture bearers – that is, the weavers and local community members – to protect valued local cultural traditions.

The UNESCO Convention could hypothetically be used to increase awareness and appreciation of Dayak *ikat* weaving traditions and aspects of its intangible cultural heritage, such as stories and oral histories that accompany weaving as well as indigenous curatorial practices. This is a realistic possibility since Indonesia is a signatory to the Convention, signing on in 2007, and has to date listed three examples of traditional arts: batik cloth production, the performance of *wayang* shadow puppetry, and the ceremonial use of and knowledge surrounding *keris* (a sacred dagger). However, the Convention's suitability for preserving *ikat* weaving traditions is problematic on a number of levels.

To begin with, numerous authors have criticised the way in which cultural traditions are conceptualised under the Convention, seeing them as bounded, stable and autonomous entities

7 See Salomon and Peters (2009) for an example of indigenous approaches to conservation and heritage preservation in Peru.

originating in an identifiable past. Such views deny the fluid and performative nature of cultural traditions, and how they evolve over time within and outside communities through actual social practice (Brown 2005a; 2005b; Byrne 2009; Eriksen 2001; Handler 2002; Kirshenblatt-Gimblett 2006; Kurin 2004a; 2004b; 2007). 'Change is intrinsic to culture, and measures intended to preserve, conserve, safeguard and sustain particular cultural practices are caught between freezing the practice and addressing the inherently processual nature of culture' (Kirshenblatt-Gimblett 2006, 16). The conceptual isolation of cultural traditions into distinct, manageable units ignores the holistic nature of cultural expressions, or how they are inextricably tied to other aspects of life and culture. Such ways of thinking about cultural traditions, translated into policy and interventions, may inadvertently undermine the integrity of ICH by detaching knowledge and practices from their cultural whole. Byrne argues that heritage agencies and practitioners have a tendency to think of tangible and intangible heritage as two separate things, and heritage, in general, comes into being only via the discourse of heritage (Byrne 2009, 230).

But it is the safeguarding measures recommended – ie inventorying and listing – that many critics find the most inappropriate and ill-conceived. Many do not just question the logistics of creating inventories and lists but are also apprehensive about the unintended consequences of this documenting and archiving enterprise. Some fear it will lead to the objectification, reification and 'thingification' of intangible cultural expressions as they are translated into tangible forms such as inventories, lists, films, recordings, texts and so on. Brown sees inventorying and listing as nothing more than a 'vast exercise in information management' (2003).

Kirshenblatt-Gimblett asserts that 'the process of safeguarding, which includes defining, identifying, documenting and presenting cultural traditions and their practitioners, produces something metacultural. What is produced includes not only an altered relationship of practitioners to their art but also distinctive artifacts such as the list ...' (2006, 171). To Kirshenblatt-Gimblett, conventions, lists and the heritage enterprise as a whole are 'metacultural artifacts' that ultimately create a paradoxical situation in which the intangible is made tangible and thus subject to the same management regimes as material culture.

The inventorying and listing of ICH for the good of all humanity is also questionable because it makes public and accessible that which is restricted or private. Public ownership and unrestricted access is unacceptable to many indigenous communities who believe that certain bodies of knowledge and cultural property should remain secret or belong only to those who have the right to possess them (Byrne 2009; Kreps 2009). As illustrated above, Dayak weavers follow their own rules and customs that dictate who can copy motifs and what kinds of payments need to be made for this privilege.

The Dayak Ikat Weaving Project, with its emphasis on community participation, ethnographic field research and preservation through practice, offers an alternative approach to not only the safeguarding measures promoted through the Convention but also those being promoted by the Indonesian national government.

THE PARADOX OF LEGAL PROTECTION AS PRESERVATION

Since the early 1990s, the Indonesian government has drafted and enacted numerous laws to protect and regulate the use of the nation's intellectual and cultural property. These actions signal Indonesia's participation in international debates on how to protect national cultural 'assets' from external exploitation and privatisation. They also reflect adoption of a discourse on culture

promulgated by such bodies as UNESCO and the World Intellectual Property Organization (WIPO) which deploys particular ways of conceptualising culture and managing it, as discussed previously. Of special concern here are Indonesia's 2002 Copyright Law and the 2006 draft law known as the *Law on Intellectual Property Protection and Use of Traditional Knowledge and Traditional Cultural Expressions*. The laws overlap with the Convention and WIPO's discourse on culture and what they purport to protect.

Indonesia's 2002 Copyright Law was enacted to protect national cultural and intellectual property against foreign appropriation and commercial use. Following standard Euro-American copyright protection, the law grants Indonesian artists who practice 'Western style individualistic arts', such as painters, authors, choreographers and music composers, protection of their work for a period of 50 years after the work is produced or 50 years after the death of the creator, depending on the type of the work created (Aragon and Leach 2008, 613). However, the Copyright Law not only pertains to individual creators and rights to the ownership of their cultural property but also claims state ownership of the copyright of all communal 'folklore' and 'works whose creators are not known' (ibid, 608). Articles 10, 11, and 31 of the Law awards the state in perpetuity copyright jurisdiction for 'folklore and people's cultural products' as well as copyright in anonymous 'works whose creators are not known'. This protection is held by the state 'on behalf of the interests of the creator' for 50 years after the work is made known to the public (ibid, 613). According to Aragon and Leach, this section of the law is based on the concept that Indonesian 'common people's cultural products' [*hasil kebudayaan rakyat*] are 'valuable national goods' that are vulnerable to 'erosion and distortion', especially by foreigners, and thus need state protection (ibid, 613).

The *Law on Intellectual Property Protection and Use of Traditional Knowledge and Traditional Cultural Expressions* was introduced in 2006 and is still in draft form. It is designed to regulate any 'expression of traditional culture' that is preserved or practised by a 'community or traditional society' (ibid, 613). The Law employs the term 'Traditional Cultural Expression' (TCE), borrowed from UNESCO and WIPO, which refers to both tangible and intangible cultural property. If passed, it would regulate reproduction or adaptations of Indonesian regional material arts, music, theatre and dance, as well as stories and ritual ceremonies, regardless of their date of origin (ibid, 613).

While the copyright law and TCE law are purported to preserve and protect the rights of individual artists and 'traditional cultural communities', they are primarily motivated by economic development interests. In the words of Aragon and Leach, who carried out an ethnographic study of Indonesian intellectual property law from 2005 to 2007:

> Indonesia's 2002 Copyright Law and the draft law propose to regulate TCEs as if they were all tangible objects, like natural resources, from which the state should profit. TCEs are viewed as commodifiable 'cultural products' and national patrimony. Their use is properly supervised by the state and also, by moral right, subject to contracts with designated subsidiary 'owners and/or customary custodians' from 'traditional societies' (whose members or boundaries are unspecified). (2008, 614)

For Aragon and Leach these conceptualisations of culture as bounded entities subject to exclusive ownership runs counter to local understandings of regional/local arts as knowledge and practices, and a means of cultural reproduction that binds generations, as well as humans, spirits and ances-

tors, together. They also discovered that traditional Indonesian artists are not proprietary about their ideas and creative works, and nor do they see themselves as sole creators. In fact, many attribute the origin of their genius or creativity to an ancestral, communal tradition of which they are merely conduits. 'Much local rhetoric maintains that it is the ancestors who really "own" the land and knowledge traditions and who provide all descendants rights of access, subject to permission from elder custodians, ritual fulfillment, or oral contractual precedents' (ibid, 613). This holds true for Iban weavers, at least historically, who received their inspiration and ideas for new designs and motifs from deities and spirits through dreams. The supernatural realm, rather than individual weavers, was the source of creativity and innovation.

The Indonesian laws also make claims to ownership and impose protection where it is not needed. Aragon and Leach learned that many artists consider it their moral responsibility to share and promote the replication of their work and actively seek to spread it, seeing no need to restrict or have exclusive rights to ownership (ibid, 623). On the contrary, some feel honoured and proud when their art is duplicated. For many, the value of their art rests in acts of circulation, the exchange of ideas and ongoing social processes of production and reproduction within a universe of human and supernatural relationships.

Some Indonesian artists also fear that the new national laws will block customary access to their groups' heritage, and do not see a need for these laws because local customs already dictate codes of stylistic sharing, limitation, acknowledgement and reciprocity (Aragon and Leach 2008, 608). As Aragon and Leach report, 'most resisted the idea of their local social activities being managed by the government as a form of commercial property' (ibid, 624).

The new laws, furthermore, run counter to processes of democratisation and decentralisation that have been taking hold in Indonesia since the collapse of the Suharto government in 1998. These movements have 'transformed the role of local government from that of implementing national development objectives defined largely through the central government agencies in Jakarta to one of serving local community needs as identified by local stakeholders' (Silver 2007, 88). Silver contends that a powerful 'new localism' has emerged in Indonesia that has the potential to generate a heritage movement that is more respectful of local traditions than those of the past (ibid, 89). But the new laws, bearing the stamps of nationalism and globalism, may end up trumping localism.

Legal protection does not equal preservation (Aragon and Leach 2008, 611) and in fact may have the opposite effect. Placing the management, control and ownership of traditional arts in the hands of the state is dispossession rather than either protection or preservation. Legal protection also shifts the regimes of value in which artistic traditions have historically circulated. Traditional arts move from being valued for how they construct and maintain relationships and identities and what they do for people, for example in ritual contexts, to deriving value from their status as property, assets and national wealth.

CONCLUSION

In this chapter, I have attempted to show how the Dayak Ikat Weaving Project provides a more culturally appropriate, holistic and integrated approach to heritage preservation than those set forth by the 2003 UNESCO Convention, Indonesian 2002 Copyright Law and the *Law on Intellectual Property Protection and Use of Traditional Knowledge and Traditional Cultural Expressions.*

Fig 15.3. View of the longhouse in Ensaid, Panjang, West Kalimantan, Indonesia, 2008.

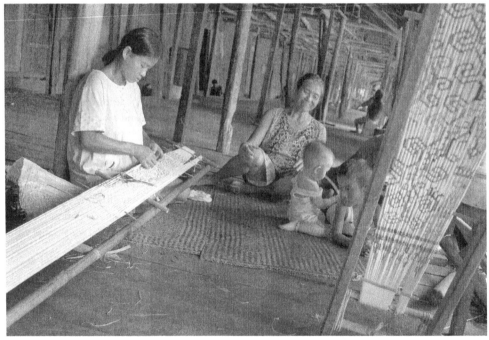

Fig 15.4. Preparing an ikat warp on the veranda of the longhouse. Ibu Limah with her daughter Rita and grandson Febri, 2008.

This is because it integrates Project activities into the daily lives, needs and interests of the weavers and their village communities.

Sagita contends that the Project has been successful because its organisers involved the weavers (culture bearers) in all phases of planning and developing the project. Organisers also respected local, indigenous knowledge as well as social organisation related to gender and work roles. Thus, while the Project was largely initiated by 'outsiders', community participation has been its cornerstone. The cooperative has also been very active in building the capacity of weavers to share their knowledge, skills and experiences with one another and with weavers from other areas of Indonesia (2009, 126–7).[8]

While many aspects of weaving have undergone change it is an activity that still carries much social significance. It continues to be integrated into the daily course of life, something women do in their spare time when they are not tending the rice fields, collecting firewood, preparing meals and looking after children and livestock. Weaving brings women together and gives them an opportunity to share the events of the day, tell stories and relax. It is in the comfort of home, or longhouse[9] (see Fig 15.3), where most young weavers still learn how to weave from their grandmothers and mothers or from other weavers (see Fig 15.4). And although most women now weave to earn an income, and textiles have become commodities, weavers control the means of production through their participation in the cooperative.

Father Maessen does not want the Project to evolve into a large-scale commercial enterprise in which women are engaged in factory-like production. He fears that this may not only lead to a decline in the quality and uniqueness of the weavings but also distract women from their other work. Even though he encourages competition as a means of inspiring the weavers to produce high-quality pieces, through, for example, annual competitions, he is also aware of how competition can engender jealousies and strife. In short, Father Maessen is mindful of the ways the Project can disrupt the integrity of village life and adversely influence the social dimensions of weaving (Kreps 2002, 5).[10]

The Dayak Ikat Weaving Project has been successful as both an economic development project for women and a cultural heritage preservation strategy because it is tailored to fit into the lives of weavers and the local sociocultural context or 'ecology', meeting specific needs and interests. It has not just been devoted to marketing and preserving a traditional art form. It has also been dedicated to preserving a way of life. Respectively, the Project is largely about curating

[8] It is important to note that the Project has also been successful owing to its organisers' ability to gain support from international foundations and non-governmental organisations like the Ford Foundation, provincial and district level government departments, and private donors.

[9] A longhouse is a multi-family dwelling comprised of attached apartments forming a long rectangle. Each apartment is inhabited by an individual family. A veranda, running the length of the longhouse, is a public, communal area. Longhouses have been described as a 'village under one roof'. Winzeler states that, for those who live in them, the longhouse is the core of traditional culture and way of life, and 'longhouse people are regarded as the keepers of tradition and *adat* (customary law and ceremonies)' (2004, 50).

[10] When I visited one village in August 2008, I was shown a building that had been built by a government agency as a place for women to weave. However, the building had never been used because the women preferred to weave in the longhouse where they could be with their family members and friends and watch over children.

(safeguarding) living culture – culture as process and culture as performed – and showing how it is the intangible threads of the *ikat* tradition that give it life and a future.

BIBLIOGRAPHY AND REFERENCES

Aikawa-Faure, N, 2009 From the Proclamation of Masterpieces to the Convention for the Safeguarding of Intangible Cultural Heritage, in *Intangible Heritage* (eds L Smith and N Aikawa), Routledge, London, 13–44

Aragon, L, and Leach, J, 2008 Arts and Owners: Intellectual Property Law and the Politics of Scale in Indonesian Arts, *American Ethnologist* 35 (4), 607–31

Brown, M, 2003 Safeguarding the Intangible, previously available [online] at: http://www.culturalpolicy.org/commons/comment [20 May 2010]

—— 2005 Heritage Trouble: Recent Work on the Protection of Intangible Cultural Property, *International Journal of Cultural Property* 12, 40–61

Byrne, D, 2009 A Critique of Unfeeling Heritage, in *Intangible Heritage* (eds L Smith and N Aikawa), Routledge, London, 229–52

Drake, R, 1988 Ibanic Textile Weaving, Its Enchantment in Social and Religious Practices, *Expedition* 30 (1), University of Pennsylvania, Philadelphia, 29–37

Eriksen, T H, 2001 Between Universalism and Relativism: A Critique of the UNESCO Concept of Culture, in *Culture and Rights: Anthropological Perspectives* (ed J Cowan, M Dembour and R Wilson), Cambridge University Press, Cambridge, 127–48

Fairchild Ruggles, D, and Silverman, H, 2009 From Tangible to Intangible Heritage, in *Intangible Heritage Embodied* (eds D Fairchild Ruggles and H Silverman), Springer, 1–14

Freeman, D, 1970 *Report on the Iban*, Athlone Press, London

Gavin, T, 2003 *Iban Ritual Textiles*, KITLV Press, Leiden

Gittinger, M, 1979 *Splendid Symbols. Textile Tradition in Indonesia*, The Textile Museum, Washington, DC

Graham, L, 2009 Problematicizing of Technologies for Documenting Intangible Culture: Some Positive and Negative Consequences, in *Intangible Heritage Embodied* (eds D Fairchild Ruggles and H Silverman), Springer, 185–200

Haddon, A, and Start, L, 1936 *Iban or Sea Dayak Fabrics and Their Patterns*, Cambridge University Press, Cambridge

Handler, R, 2002 Comments on Masterpieces of Oral and Intangible Heritage, *Current Anthropology* 43 (1), 144

Heppell, M, 1994 Whither Dayak Art?, in *Fragile Traditions: Indonesian Art in Jeopardy* (ed P M Taylor), University of Hawaii Press, Honolulu, 123–38

Huda, I, 2002 *Membangun Program Restorasi Tenun Ikat Dayak di Sintang*, Kalimantan Barat, Pontianak, PRCF Indonesia

—— 2008 Collaborative management: linking cultural weaving arts with conservation through sustainable use of non-timber forest products, case study Dayak Ikat Weaving Revitalization Program in West Kalimantan, Indonesia, paper presented at *Co-Management Training Workshop organised by Regional Network for Indigenous Peoples and Karen Environmental and Social Action Network*, 3–7 June, Chang Mai, Thailand

Jabu, D P E, 1991 Pua Kumbu the Pride of the Iban Cultural Heritage, in *Sarawak Cultural Legacy, A Living Heritage* (eds L Chin and V Mashman), Society Atelier, Sarawak, Kuching, 75–90

King, V, 1993 *Peoples of Borneo*, Blackwell, Oxford

Kirshenblatt-Gimblett, B, 2006 World Heritage and Cultural Economics, in *Museum Frictions: Public Cultures/Global Transformation* (eds I Karp, C Kratz, L Szwaja, T Ybarra-Frausto, G Bunttinx and B Kirshenblatt-Gimblett), Duke University Press, Durham, 161–202

Kreps, C, 2002 Report to the Ford Foundation on Visits to the Museum Pusaka Nias and Dayak Ikat Weaving Project

—— 2003a *Liberating Culture: Cross-Cultural Perspectives on Museums, Curation, and Heritage Preservation*, Routledge, London

—— 2003b Curatorship as Social Practice, *Curator* 46 (3), 311–23

—— 2009 Indigenous Curation, Museums and Intangible Cultural Heritage, in *Intangible Heritage* (eds L Smith and N Aikawa), Routledge, London, 193–208

Kurin, R, 2004a Safeguarding Intangible Cultural Heritage in the 2003 UNESCO Convention: A Critical Appraisal, *Museum International* 56 (1–2), 66–77

—— 2004b Museums and Intangible Heritage Dead or Alive? *ICOM News* 4, 7–9

—— 2007 Safeguarding Intangible Cultural Heritage: Key Factors in Implementing the 2003 Convention, *International Journal of Intangible Heritage* 2, 10–20

Low, A, 2009 Tension on a Backstrap Loom, in *Asian Material Culture* (eds M Hulsbosch, E Bedford and M Chaiklin), Amsterdam University Press, Amsterdam, 193–227

Mashman, V, 1991 Warriors and Weavers: A Study of Gender Relations among the Iban of Sarawak, in *Female and Male in Borneo: Contributions and Challenges in Gender Studies* (ed V Sutlive), Borneo Research Council Monograph Series 1, Williamsburg, 231–70

Sagita, N, 2009 Community-based Museum: Traditional Curation in Women's Weaving Culture, in *Can We Make a Difference? Museums, Society and Development in North and South* (ed P Vogt), Bulletin 387, The Tropenmuseum, Amsterdam, 119–28

Salomon, F, and Peters, R, 2009 Governance and Conservation of the Rapaz Khipu Patrimony, in *Intangible Heritage Embodied* (eds H Silverman and D Fairchild Ruggles), Springer, 101–26

Schiller, A, and Garang, B, 2002 Religion and Inter-ethnic Violence in Indonesia, *Journal of Contemporary Asia* 32 (2), 244–54

Silver, C, 2007 Tourism, Cultural Heritage, and Human Rights in Indonesia: The Challenges of An Emerging Democratic Society, in *Cultural Heritage and Human Rights* (eds H Silverman and D F Ruggles), Springer, 78–91

UNESCO, 2003 *Convention for the Safeguarding of the Intangible Cultural Heritage*, available from: http://portal.unesco.org/en/ev.php-URL_ID=17716&URL_DO=DO_TOPIC&URL_SECTION=201.html [28 March 2011]

Winzeler, R, 2004 *The Architecture of Life and Death in Borneo*, University of Hawaii Press, Honolulu

Conversation Piece: Intangible Cultural Heritage in South Africa

Harriet Deacon

Can you say something about yourself and your personal interest in ICH?

I'm a historian with an interest in heritage policy, heritage management and the relationship between heritage and health issues. I got interested in intangible heritage through my work at Robben Island Museum since it is a World Heritage Site with associated intangible values. Then I became interested in the opportunities the 2003 Convention provides to take another look at methods of identification, community engagement, significance assessment and conservation/ safeguarding of both tangible and intangible heritage.

In your country, were there policies already in place that have dealt with intangibles before UNESCO's 2003 Convention?

The Arts and Culture White Paper of 1996 defined heritage as including 'oral traditions'. It states (art 5.2) that:

> Attention to living heritage is of paramount importance for the reconstruction and development process in South Africa. Means must be found to enable song, dance, story-telling and oral history to be permanently recorded and conserved in the formal heritage structure.
>
> The Ministry and the National Heritage Council will establish a national initiative to facilitate and empower the development of living heritage projects in provinces and local communities. The recognition and promotion of living heritage is one of the most vital aspects of the Ministry's arts, culture and heritage policy. The aim is to suffuse institutions responsible for the promotion and conservation of our cultural heritage with the full range and wealth of South African customs. (5.28)

The 1996 White Paper also states:

> The strategy will be to facilitate the development of a structure and environment in which projects can be initiated by communities themselves. Resources will be sought to:
> • record living heritage practices
> • develop an inventory of living heritage resources
> • encourage awareness programmes amongst communities whose heritage has been neglected and marginalised
> • encourage museums to conserve living heritage through audio-visual media. (5.29)

Living heritage was to be integrated into education (5.29), informing strategies for developing cultural tourism (5.30) and cultural products (5.31). All of these ideas prefigured the approach of the 2003 Convention, and South Africans were in fact involved in its development. The South African delegation favoured the inclusion of endangered languages within the framework of the 2003 Convention, but this did not become part of the final draft.

The *National Heritage Resources Act* of 1999 accommodated intangible values associated with objects and places, but not intangible heritage elements as more broadly defined under the 2003 Convention.

If so, how has ICH been conceptualised within your country before the 2003 Convention?

Although 'living heritage' in the sense of the 2003 Convention was referred to in the 1996 White Paper, in heritage legislation only intangible values associated with places and objects were accommodated within the national estate. Traditional practice, especially African traditional practice, was and remains a highly contested and politicised terrain.

What initiatives/projects have already been underway in order to safeguard cultural practices?

The Department of Arts and Culture (DAC) established a Living Heritage Directorate which has been involved in a few projects nationally including the promotion of traditional foods but to date there has not been a coordinated national effort at ICH identification or safeguarding. In fact, there is no national consensus on what might constitute our ICH – this is probably a good thing. DAC funds research on indigenous music and other forms of ICH at the universities of Venda, Fort Hare and Zululand. DAC and the African Cultural Heritage Fund host regional, provincial and national competitions on indigenous dance and music (Arts and Culture Department, n.d.). It provides quite a bit of funding for oral history projects, but some of these projects are focused more on historical narrative rather than what would be seen as ICH in terms of the 2003 Convention.

In September 2010, DAC announced a theme for Heritage Month in 2010 and 2011 that would focus on supporting the bearers of intangible heritage: 'Celebrating South Africa's Living Human Treasures, the custodians of our Intangible Cultural Heritage' (Xingwana 2010). This may herald a new focus on intangible heritage within the Department.

When the National Heritage Council (NHC) was finally established in 2004, with the mandate to develop living heritage projects under its 1999 Act, it began a number of projects including a short-lived National Living Treasures project (mainly, as I remember, to recognise 'organic intellectuals' or struggle heroes). The NHC was also involved in the South African Traditional Music Achievers Awards and other ICH-related projects. The South African Heritage Resources Agency (SAHRA) established a Living Heritage Unit for a few years in the mid-2000s. This unit did some work on a draft ICH policy for SAHRA and supported some ICH projects such as the promotion of the Nama language and traditional 'Stap' dance (Manetsi 2007).

In March 2007 SAHRA's living heritage unit was appointed by ICOMOS SA to serve as a secretariat for its ICICH (International Committee on Intangible Cultural Heritage). The ICICH still has its Secretariat in South Africa but this has moved to the NHC's heritage section with Thabo Manetsi. The ICICH 'wished to formulate a doctrinal text for the development of a charter for intangible heritage in order to create a framework for best practice by site conser-

vationists and to entrench the area of intangible heritage as a legitimate specialisation in the conservation of heritage sites' (Sofeleng 2008, 2). However, this text, based on the ICOMOS Kimberley Declaration prepared in 2003,[1] is not yet publicly available.

Not all cultural practices are seen by the state as worthy of safeguarding because the Constitution protects human rights and the government encourages social cohesion. Indeed, recent legislation banned virginity testing for girls in South Africa. Traditional leaders are given state funding and have been made responsible for heritage and culture within their communities, but there has been some tension about their role within the democratic state. They have been pushing for greater responsibility within local government, a strategy which seems to be having some success in recent years, especially given the administrative failures of local government.

Most of the initiatives to record (and in some cases safeguard) ICH to date have happened at the level of projects, often run by small NGOs and museums. The Afrikaans Language Museum in Paarl, for example, ran a project to document and popularise traditional Afrikaans children's games (Snel 2009). A small group called the Bow Heritage Agents run by Thokozani Mhlambi and others promotes traditional African bow music. Researchers based at museums and universities have generated a huge quantity of research on ICH, including traditional craft such as basket-weaving, traditional healing, music, dance, food and many other domains. Sometimes these projects have promoted practice of the ICH by the communities or groups concerned. Noel Lobley (doing a PhD in Ethnomusicology at the University of Oxford), for example, helped to circulate recordings of Xhosa music collected by Hugh Tracey in the 1950s to elicit responses from Xhosa communities in South Africa today – taking the music back to the people. Many safeguarding projects focus on economic benefits for poor communities through, for example, spin-offs in craft production or tourism. The !Khwa ttu project in the Western Cape safeguards San ICH practices by revitalising community knowledge on indigenous food and medicine, as well as providing jobs and development opportunities.

How is the current term, 'intangible cultural heritage', conceptualised in your country?

We tend to use the term 'living heritage' instead of ICH. In the DAC draft policy on living heritage it is defined in the same way as ICH in the 2003 Convention, but in practice South Africans have been also inclined to include endangered languages, oral history and memory under their working definition of living heritage.

What is currently happening in your country/area with respect to the 2003 Convention?

We have not yet ratified the Convention, as of September 2010, but a draft Living Heritage Policy has been developed by the Department of Arts and Culture and is currently going through a process of community consultation.[2]

1 In the Kimberley Declaration, ICOMOS 'committed itself to taking into account the intangible values (memory, beliefs, traditional knowledge, attachment to place) and the local communities that are the custodians of these values in the management and preservation of monuments and sites under the World Heritage Convention of 1972'. See the ICOMOS Quebec Declaration: http://www.international.icomos.org/quebec2008/quebec_declaration/pdf/GA16_Quebec_Declaration_Final_EN.pdf.
2 See the draft Living Heritage Policy, November 1999, available from: http://www.dac.gov.za/policies/Draft%20National%20Policy%20on%20South%20African%20Living%20Heritage%20_ICH_.pdf.

What plans are being made with respect to safeguarding ICH at the national/regional/local levels?

In September 2010, DAC announced a theme for Heritage Month in 2010 and 2011 that would focus on supporting the bearers of intangible heritage: 'Celebrating South Africa's Living Human Treasures, the custodians of our Intangible Cultural Heritage' (Xingwana 2010). Provincial and local governments have not to my knowledge focused on this area yet.

What problems do you foresee as emerging from UNESCO's guidelines for safeguarding ICH within your country?

The 2003 Convention gives very few strict guidelines on the desirable methods of intangible heritage management, or safeguarding. The safeguarding methods used are supposed to be adapted to the requirements of the element and the local context. This means discussions need to happen at a national and local level about best practices and possible strategies, as well as possible problems. One of the issues that might arise is who defines what constitutes living heritage, and how this is affected by existing power relationships between men and women, old and young for example, within communities. Also, disputes will arise about whether certain ICH elements identified and valued by some communities in South Africa as part of their cultural heritage are worthy of safeguarding. For example, there are disputes over the value of virginity testing, polygamy, male circumcision, traditional medicine and other traditional practices, both within and outside of communities of practice. Some ICH practices may not conform to the requirement in the Convention (and in fact in our own Constitution) that they be compatible with international human rights instruments.

What are the strengths of the 2003 Convention with respect to implementing it within your country?

The Convention places a strong emphasis on community participation and consent in heritage identification and safeguarding. Implementing the Convention in South Africa thus has the potential to improve the relationship between heritage managers, researchers, government agencies and the communities involved in the enactment and transmission of living heritage.

Bibliography and References

Arts and Culture Department (Republic of South Africa), n.d. *Projects and Programmes* [online], available from: http://www.dac.gov.za/projects.htm#music [9 May 2011]

Manetsi, T, 2007 *Annual report: SAHRA Living Heritage Unit*, cited in Asia/Pacific Cultural Centre for UNESCO (ACCU), Country Report: South Africa, Safeguarding of Intangible Cultural Heritage in South Africa [online], available from: http://www.accu.or.jp/ich/en/training/country_report_pdf/country_report_southafrica.pdf [9 May 2011]

Snel, C, 2009 The role of traditional children games within the context of intangible heritage, paper presented at *GCAM 4: The Creative Museum: African Museums Using Culture for the Development of Children and Youth*, 24–29 October 2009, Chief Albert Luthuli Museum, Stanger, South Africa [online], available from: http://www.maltwood.uvic.ca/cam/publications/conference_publications/Snel.Catherine.GCAM4.pdf [9 May 2011]

Sofeleng, K, 2008 *Safeguarding of Intangible Cultural Heritage in South Africa*, Report to ACCU 'Training Course for Safeguarding of Intangible Cultural Heritage', 21–26 January 2008, Tokyo, Osaka and Kyoto (Japan) [online], available from: http://www.accu.or.jp/ich/en/training/country_report_pdf/country_report_southafrica.pdf [9 May 2011]

Xingwana, L, 2010 Address by the Minister of Arts and Culture, at the launch of *Heritage Month*, Pretoria, 6 September [online], available from: http://www.polity.org.za/article/sa-xingwana-address-by-the-department-of-arts-and-culture-at-the-launch-of-heritage-month-pretoria-06092010–2010–09–06 [9 May 2011]

Revitalising Amerindian Intangible Cultural Heritage in Guyana and its Value for Sustainable Tourism

D Jared Bowers and Gerard Corsane

Introduction

Within heritage management and museum work, there has traditionally been an emphasis on material culture and the immovable and movable tangible heritage resources. These resources include, for example, landscapes, the built environment, artefacts and a range of physical objects and material that people have produced. When intangible heritage resources have been consulted by heritage and museum practitioners, they were often used simply as a way of understanding and interpreting material culture and tangible heritage (Galla 2008). However, intangible cultural heritage (ICH) sources of evidence, as defined in the Introduction of this volume, are increasingly being viewed as significant and valuable in their own right (Deacon 2004; Kurin 2004).

The history of this increase in recognition can be traced in the work of anthropologists, ethnographers and those involved in folk-life studies (Kurin 2004). The roots of the current international interest in ICH can be traced back through several key UNESCO initiatives. These are the 1989 *Recommendations for the Safeguarding of Traditional Culture and Folklore*; 1993 *Living Human Treasures* project; and the 1998 *Proclamation of Masterpieces of the Oral and Intangible Heritage of Humanity* (Aikawa-Faure 2009, 13). The aims of these initiatives centre around encouraging governments, NGOs and local communities to identify key intangibles in culture and then to identify people as bearers of the knowledge, skills and techniques of these intangibles, who are able to pass them on to others (UNESCO 2011a; 2011b). In addition to these earlier initiatives, UNESCO facilitated the drafting of what has now become the cornerstone for the intangible cultural heritage movement, the 2003 *Convention for the Safeguarding of the Intangible Cultural Heritage*. The Convention sought to act as an alternative and effective method for safeguarding ICH in the absence of any 'international agreements' or 'binding multilateral instruments' (Marrie 2009, 173).

These UNESCO initiatives have been important in placing intangibles on the heritage map. They have raised an awareness and understanding of the value of ICH at an international level (Aikawa-Faure 2009). This will hopefully help to foreground intangible heritage resources even further, especially as these initiatives draw on what has already been done at regional, national and local levels in many parts of the world. Within these levels, ICH is increasingly being recognised for its value in interpreting cultures of Indigenous peoples in various contexts. However, despite efforts from organisations from international to local levels, most Indigenous communities continue to be overlooked in the safeguarding of their ICH (Marrie 2009).

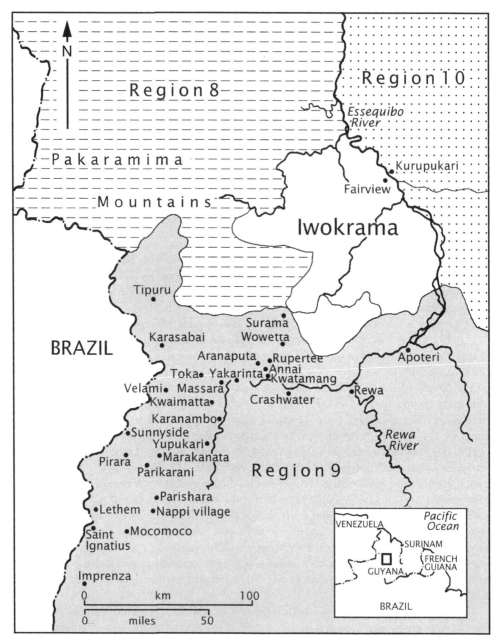

FIG 17.1. IWOKRAMA FOREST AND RUPUNUNI COMMUNITIES

Indigenous communities represent the foundation for much of the world's cultural diversity, but also are amongst its most 'culturally disempowered group of peoples' (Marrie 2009, 174). Current heritage management organisations and processes involving Indigenous people tend to follow 'Western' strategies and focus on tangible material culture, whilst intangible heritage resources have often been overshadowed (Kreps 2009, 194–9). Inclusive in intangible heritage are the 'practices, knowledge systems, skills and instruments' used by Indigenous people to portray their culture (Kreps 2009, 199). It is important for individuals and organisations involved in heritage management to concentrate on the empowerment of Indigenous people in safeguarding ICH, which will also assist in breaking those dominant Western notions of heritage management (Marrie 2009). Increased awareness about ICH in Indigenous communities often contributes to its value being translated into an economically viable tourism product (Kenny 2009).

Heritage tourism plays an important role in 'performing identity' through the presentation of both tangible and intangible heritage (Kenny 2009, 161). Products of intangible heritage such as songs, dance, traditional knowledge and practices have become a valued asset in cultural and Indigenous tourism (McKercher *et al* 2005). This display of ICH in tourism also contributes to a renewed sense of identity and place amongst individuals and communities (Gonzalez 2008; see also Corsane and Bowers forthcoming).

The increased prominence being accorded to intangible cultural heritage will soon place it on a far more equal footing with tangible cultural heritage. This will have important implications for heritage management. As such, the inclusion of Indigenous knowledge and ICH should be a primary concern owing to its importance and value. Amerindian Indigenous cultural heritage is being revitalised in the Rupununi region of Guyana and has subsequent value for tourism. As such, this chapter will examine how two organisations, the Iwokrama International Centre for Rainforest Conservation and Development (IIC) and the North Rupununi District Development Board (NRDDB), have been facilitating this revitalisation. Although the mandates of these organisations are not specifically associated with the development and interpretation of ICH, the activities they are involved in lend themselves to its revitalisation. They do this by promoting an atmosphere where the different ICH expressions from various communities are identified and used in conjunction with various types of development, including sustainable tourism. The overall aim of this chapter, therefore, is to examine how these two organisations, both directly and indirectly, are working to understand and revitalise ICH through responsible conservation and heritage tourism. This aim will be achieved by considering a number of central themes, including the historical background of Amerindian ICH, early research conducted on the subject in the Rupununi, specific projects aimed at tangible and intangible heritage management and the value of ICH for sustainable tourism.

Background to Amerindian ICH

The Rupununi is a vast tract of land in central Guyana composed of naturally occurring savannah wetlands and tropical rainforests. The region (Fig 17.1) has a population of 16,000 people, most of whom are Indigenous and are made up of three main groups: the Makushi in the North and the Wapishana and Wai Wai in the South (Conservation International 2010, 13). Various archaeological studies have proven that Amerindians have been living in the region for over 7000 years, initially as hunter-gathers with land cultivation occurring around 2000 BC (Williams 2003, 3–11).

ICH found in original Amerindian communities was composed of, for example, performing arts and traditional practices, each of which often related to their natural surroundings (MRU 1996). These cultural resources reflect a 'time depth' that establishes links between ancestors and contemporary descendants and are fundamental to cultural identity (Kearney 2009, 210). Much of the Amerindian ICH in the region was associated almost exclusively to the physical environment, with all of its geological, flora and fauna components (MRU 1996). As Indigenous community groups engaged with their physical environments – and with each other – spiritual and cultural landscapes were developed. Part of their ICH was associated with particular sites and spaces and occurred through the forms of animism beliefs of the Indigenous peoples, or beliefs that were rooted in the existence of spiritual presences in natural objects and phenomena. For example, a book written by an Indigenous group called the Makushi Research Unit (discussed further below) explains that in traditional Makushi beliefs 'human beings possess a spirit as do other animals and some powerful plants' which is evident in the ritualistic use of certain plants in healing through their beneficial spirits (MRU 1996, 206). In addition, the Makushi people and their environmental knowledge became well known in the late 18th century owing to their use of curare, a lethal arrow poison for which no antidote exists, in hunting (MRU 1996, 15). The poison is no longer in use today on arrows, but curare was later used in medicine as an anaesthetic and a muscle relaxant (ibid).

Today, the ICH found in Amerindian communities exists for different reasons. Traditional Indigenous knowledge about the physical environment is often a significant advantage for external researchers, scientists and surveyors of the land. Thus, a good portion of ICH in Amerindian communities continues to be useful for visitors looking to discover new and useful aspects concerning the native flora and fauna, such as new species or potential medicines. ICH is also used for tourism for visitors seeking to experience a unique culture and its practices and values, and is discussed further below.

Much of the traditional intangible and tangible cultural heritage described by early ethnographic reports has gradually disappeared, including the use of curare and blowpipes and the parishara dances and songs (MRU 1996, 14). Traditional belief systems such as animism were regarded as 'pagan customs and habits' and disintegrated with the arrival of European explorers and Christianity (ibid). However, not all ICH has been completely lost. The anthropologist Peter Riviere (1984, 8, from MRU 1996, 14), who studied the Amerindian communities, noted that while material cultural elements are 'most prone to change, abandonment, and substitution … this is in marked contrast with the ability of these groups to retain their social structures through the most adverse conditions'. The continued, albeit minimal, use of the Makushi language in conjunction with a deep understanding of traditional knowledge on the local physical environment and performing arts is a testament of continued Makushi social structure and identity (MRU 1996, 14). The next subsection focuses on the efforts made by individuals, from initial colonial explorers to recent anthropologists, in researching and collecting information on Amerindian ICH in the Rupununi.

Early research on Amerindian ICH

Documented evidence of Amerindian cultural heritage in the Rupununi can be traced back to the original European visitors to the area. The first written discovery of Amerindian heritage (rock art) was recorded by an explorer named Nicolas Horstman in 1740 (Williams 2003). Early

colonial explorers who ventured to the Rupununi found the Indigenous people's knowledge of their physical environment to be useful and often employed them as guides (Burnett 2002). Amerindians were 'culturally adapted at surviving in a difficult but extremely fertile environment' and were vital in making all colonial exploration into the region possible (Burnett 2002, 25). Consequently, a relationship developed between the colonial explorers and the Amerindians with the knowledge systems of the physical environment a constant reminder of their value. Reports by early explorers on the profound beneficial impact of Amerindian knowledge on the surrounding physical environment were as commonplace as messages of the negative impacts of colonial exploration on their cultural practices and beliefs (MRU 1996, 13–14).

Robert and Richard Schomburgk, German brothers who were early (1835–1844) explorers in the region, wrote several ethnographic reports on the Makushi in the early 19th century. Richard describes: 'Their speech is something unusually euphonious and has much resemblance to French … noted for their peace-loving, complaisant, gentle and friendly character … they also colour their face and body thickly with Bignonia Chica and Genipa Americana paint …' (Richard Schomburgk, 1840–44, quoted in Menezes 2002, 42).

Accompanying the Schomburgks on one of their journeys was the artist Edward A Goodall, whose sketches and notes contributed greatly to the increased recognition of both tangible and intangible cultural heritage of Amerindians. The images drawn by Goodall depict Amerindians in a variety of situations, such as the playing of musical instruments, hunting, dancing and common everyday practices (Menezes 2002). A long list of explorers followed their work, including C Barrington Brown (geologist), Everard Im Thurn (British Guiana Museum curator), Anglican reverends James Williams (1908–1913) and Walter White (1913–79), and also the anthropologists Curtis Farabee and Walter E Roth (MRU 1996, 9–10).

The information collected by the various visitors to the area included a number of ICH resources. Thomas Youd, a missionary who settled in the Rupununi in 1838, supposedly documented four local languages into dictionaries, but these were lost during a Brazilian raid (MRU 1996, 11). Another German explorer, Theodor Koch-Grunberg, contributed one of the better-known reports on the dances and songs of the Makushi during his travels between 1911 and 1913 (MRU 1996, 15). He wrote (1923, 154–5 from MRU 1996, 15):

> Like everywhere, so also in the life of these Indians, the dancing festivals play an important role … In addition to the pleasures of the dances themselves, the festivals served the purpose of fostering neighbourly relations with tribal relatives or with members of other tribes … The time-honoured song texts are carried on further by them from generation to generation.

During the early 20th century, there was a shift from European to North American studies on Amerindian cultural heritage, led by Walter Roth (Williams 2003). Roth was instrumental in documenting the intangible cultural heritage of Amerindian communities, which is evident in his many publications for the Bureau of American Ethnology such as *Animism and Folklore of the Guiana Indians* (1915), *An Introductory Study of the Arts, Crafts and Customs of the Guiana Indians* (1924) and *Additional Studies of the Arts, Crafts and Customs of the Guiana Indians* (1929) (Williams 2003, 22). Roth was eventually appointed curator of the British Guiana Museum, which today carries his name (ibid).

Members of the Walter Roth Museum, in collaboration with other North American anthropologists, continued to study the Amerindian communities of the Rupununi (Williams 2003,

32). Evidence of their findings, which include both tangible and intangible cultural heritage, can be found at the museum in Georgetown, Guyana (Williams 2003, 136). Efforts currently being conducted on researching Amerindian ICH are presented in the next section, and are followed by a consideration of their value for sustainable tourism.

RECENT FINDINGS OF ORGANISATIONS INVOLVED IN REVITALISING ICH IN THE NORTH RUPUNUNI

Current research and work on ICH in the Rupununi has largely been centred on the work of two key organisations, the Iwokrama International Centre for Rainforest Conservation and Development and the North Rupununi District Development Board. One of the key aspects of the 2003 Convention was the central role it gives to communities in the safeguarding and revitalisation of intangible cultural heritage (Blake 2009). As Blake (2009, 46) contends, 'inclusion of the idea of ICH within the broader rubric of cultural heritage provides opportunities to democratise the process by which we give value to heritage, giving a larger role to local people especially in the developing world'. This section demonstrates how the IIC and NRDDB have worked to empower local Indigenous communities and subsequently assisted with the revitalisation of Amerindian intangible cultural heritage.

Known as the 'green heart' of Guyana, Iwokrama is named for the sacred mountains of the Makushi people. This international not-for-profit organisation seeks to sustainably develop (through tourism, research, sustainable timber harvesting and education) a designated rainforest reserve. The protected natural area that the IIC manages consists of nearly one million acres of rainforest in the Rupununi region (See Fig 17.1). Also inclusive in its mandate is the unique collaboration it shares with local indigenous communities. Iwokrama has its main administration offices located in Guyana's capital city, Georgetown, but the heart of their conservation and community efforts lies at the Iwokrama River Lodge and Research Centre, located on the Essequibo River in Region 8 in central Guyana.

The idea behind the Iwokrama project was initiated in 1989 when Desmond Hoyt, president of Guyana at the time, made an offer of conservable rainforest to the international community during the Commonwealth Heads of Government Meeting. The organisation was formalised further when the National Assembly of Guyana passed the *Iwokrama International Centre for Rain Forest Conservation and Development Act*, which was signed in May 1996 by then-President Cheddi Jagan. Today, the IIC is governed by a carefully selected Board of Trustees with international, national and local representation, which meets regularly, whilst its day-to-day activities are administered by an employed management team and staff body.

Iwokrama can attribute much of its success to its engagement with all the key stakeholders in the region, most especially the local Amerindian communities. From the inception of the Iwokrama initiative, local people have played a pivotal role in the decision-making processes and in helping to steer the project. As mentioned before, there are three main Indigenous groups represented in the communities but the majority consists of Makushi people (MRU 1996). However, all of the Amerindian people have brought traditional Indigenous knowledge systems, cultural traditions and skills to bear on the integrated management of the natural and cultural heritage resources, both in the Iwokrama protected forest area and in the North Rupununi savannah landscape. Iwokrama's functioning relationship with Amerindian communities has principally been conducted through the North Rupununi District Development Board.

Established with support from Iwokrama in 1996, the democratic NRDDB has representation through the *Tuschao* (elected village leader) and village council systems of 16 local villages. Amongst them, Fair View village is the one community living in the forest conservation area, with the other villages located in the North Rupununi wetlands and savannah. The working partnership between the IIC and NRDDB was formalised with the signing of a *Memorandum of Understanding* (MoU) in 2003 and a *Collaborative Management Agreement* in 2005. The MoU contains some key codes of practice that have remained core to the partnership, including its first key phrase:

> Respect community protocols, customs and traditions; work with the NRDDB to minimise potential negative social or and cultural impacts from Iwokrama activities; and, guarantee positive benefits and outcomes from business enterprises and other activities. (Iwokrama 2007)

The development of the IIC and NRDDB generated two significant projects involving community representatives. These are the Makushi Research Unit (MRU) and the Community Tourism Board. The former is discussed further in the next section and has completed some excellent work in documenting and researching Makushi language, culture, traditional skills and the relationship between people and the natural environment. The latter has become increasingly important as the NRDDB further identifies the potential of heritage and ecotourism. Tourism in the region exists for both the affirmation and validation of the cultural identities of people living in the North Rupununi communities, as well as the possibility of generating income for sustainable livelihoods. Iwokrama has developed a set of guiding principles for stakeholder collaboration that recognise the adoption of a participatory approach. In this approach, Iwokrama encourages active engagement with local communities and the value of Indigenous knowledge and practices through capacity building, education and training (Iwokrama 2007). As a result, the working partnership between them is more holistic in character and attempts to reduce Western methods. Iwokrama has taken on a role in place management in the Rupununi, but also in what Marrie (2009, 191) considers important in safeguarding ICH for Indigenous peoples: community participation and involvement, capacity building, research and documentation. They engage in the rare practice of not overlooking Indigenous knowledge systems through the 'full recognition of cross-cultural values' (Kearney 2009, 210). However, the IIC and NRDDB have not acted alone in their efforts in revitalising ICH, and their partnerships with other organisations such as the Amerindian Research Unit (ARU), University of Guyana and Walter Roth Museum in Georgetown have all assisted with increasing recognition of Amerindian ICH. The next section will discuss one of these partnerships established between the ARU and Iwokrama. This partnership was created in the early development stages of the IIC and NRDDB, and is based on the documentation of Makushi Indigenous knowledge and traditions.

Makushi Research Unit

Officially launched in March of 1995, the MRU was created by the joint efforts of the ARU and the United Nations Development Programme (UNDP) (MRU 1996). The two organisations signed a formal agreement for the purpose of conducting research on two sub-projects: Amerindian Lifestyles and Biodiversity Use in the Iwokrama Area, and Study of Makushi Women's Ethnobotany/Ethnomedicine. Janette Forte, a member of the ARU, served as the principal

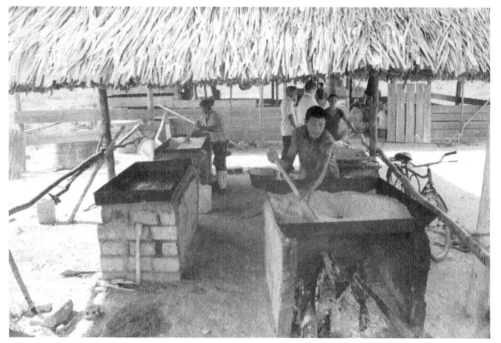

Fig 17.2. Cassava preparation

researcher, trainer and editor for the project (ibid). Funded by the World Bank and United Nations Global Environmental Facility, the research was to be conducted for the Iwokrama International Rainforest Programme, with the overall aim of investigating the 'characteristics and resources' of the project area to provide baseline data (MRU 1996, 29).

The ten researchers were all female, each representative of different North Savannah communities. All were trained in two separate workshops over a two-week period (MRU 1996). These workshops covered the techniques and methods and provided them with the skills required for collecting information from their communities and also in the recording and transcription of the Makushi language (ibid). Although there is a mixture of Indigenous groups within the communities, the Makushi were the sole focus of this research as they represent the majority in the region (Conservation International 2010). After the workshops, data collection was initiated through visits to interview and gather information from 'knowledgeable community members' (MRU 1996, 29).

The output of their research was collated in a book entitled *Makusipe Komanto Iseru: Sustaining Makushi Way of Life*. Published in 1996, the book contains information on topics such as the standardisation of Makushi orthography, descriptions of flora and fauna including ones used for medicinal and edible purposes (cassava preparation: Fig 17.2); religious beliefs including animism; traditional practices and knowledge (housing construction (Fig 17.3), family celebrations, customs); and fishing and hunting strategies (MRU 1996). This work is regarded as the first of its kind in Guyana and on the Amerindian peoples in general and has 'inspired' community members around the region in revitalising their heritage (MRU 1996, vii).

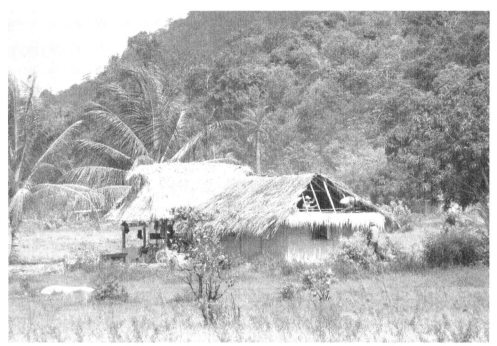

Fig 17.3. Traditional roof construction

Responsible tourism and the potential for safeguarding ICH in the Rupununi

Responsible cultural heritage tourism in the communities was largely initiated by the MRU's book. Heritage and ecotourism is seen by the IIC, NRDDB and other shareholders and stakeholders – from the international level through to the local level – as a potential central source of income generation. The presence of a unique history and cultural heritage, paired with an abundance of natural 'treasures', has resulted in an attractive tourism destination (Conservation International 2010, 3). As such, all of this has been adopted by several communities in the Rupununi with more communities seeking to follow in their footsteps. The emergence of tourism in the communities has coincided with an increase in the promotion of intangible heritage as new products are sought to attract tourists.

The cultural systems of Amerindian groups which are articulated with traditional livelihood practices have provided an experiential tourism product. These practices include traditional knowledge of hunting, fishing, gathering and harvesting from the forest and savannah resources, and, for at least 3000 years, the cultivation of cassava (Conservation International 2010). These activities are conducted by many communities as part of a 'cultural' experience that tourists so often seek (ibid). More recently, following the legacies of colonisation, modernity and globalisation, these traditional economic livelihoods have been threatened. It is through turning to tourism that there are possibilities of promoting and safeguarding aspects of these cultural systems, which remains plausible as several Amerindian communities still follow traditional lifestyles which bear 'strong allegiance to ancestral traditions' (Sinclair 2003, 143).

For instance, the flagship of community-based cultural tourism in the Rupununi continues to be the Surama Village. Surama is a small Amerindian community of around 300 residents, mainly Makushi, which has sustained a tourism business for over eight years. This has been possible through its managerial approach, partnerships with a range of stakeholders, including the IIC and NRDDB, and opportunities for tourists. Regional marketing magazines (Caribbean Beat) describe the Surama experience, detailing the 'knowledge' and 'stories' told by local guides during a tourist's stay (Laughlin 2006, 42–54). Tourism opportunities include a range of wildlife viewing opportunities and a rich cultural heritage that is displayed through the staging of cultural presentations and village tours describing traditional knowledge and practices (Conservation International 2010).

Amerindian culture is often used as the basis for what Smith (1996, 287–300) refers to as Indigenous tourism, formed by the four Hs: heritage, history, habitat and handicraft. A recent blueprint created by Conservation International (2010) has outlined tourism in the Rupununi and detailed all of the Indigenous communities looking to foster tourism in their village based partly on these four products. This blueprint states that 'Community tourism can play the dual role of promoting conservation of nature and culture and also simultaneously providing for community development … [Rupununi] has the potential for growth in many areas, especially nature and culture-based tourism' (Conservation International 2010, 1–3). Tourism experiences in these communities have endemic characteristics and are predominantly the product of Indigenous knowledge. The intangible cultural heritage found in Amerindian lifestyles has been revitalised through tourism and assisting with these developments and at the heart of all progressive tourism movement is the IIC and NRDDB.

The IIC and NRDDB's managerial approach toward tourism emphasises the cultural and natural heritage of the region, which in turn can lead to greater concern on sustainability through shared ideologies between communities (Farnum *et al* 2005). This sustainability is mainly possible through the formal and working relationships between stakeholders, particularly Indigenous communities (McKercher *et al* 2005). These two organisations empower communities by letting them decide on the composition and method in sharing their culture with the outside world. For example, Stanley (1998, 86) discusses the conflict in regions where organisations want communities to continue the display of 'pre-colonial heritage' and restoring 'non-western traditions' but the residents desire to express their modernity. Recognition and mediation of this conflict of interests by the IIC and NRDDB has empowered the Amerindian communities. As a result, the communities are also receiving the benefits of tourism. Although tourism is still in its infancy in the region, the model set forth thus far is likely to contribute extensively to a sustainable industry in the Rupununi.

CONCLUSION

This chapter set out to gain an understanding of the revitalisation of ICH in the Rupununi region of Guyana. It investigated the historical background of Amerindian ICH and research in the region, and examined current approaches towards revitalising ICH. The efforts put forth by the IIC and NRDDB have generated tourism products for the communities which are based on the historical and current aspects of Amerindian ICH. Much Amerindian traditional (intangible) cultural practices and expressions have been under threat in Guyana. However, with the need for finding alternative livelihoods, many Amerindian communities have already started, or are

considering the potential of, a combined ecotourism and cultural heritage tourism approach. This is important, as not only will it bring in economic capital, but it should also promote the exchange of cultural capital. As part of the latter, the development and consumption of these tourism experiences – when done responsibly – should encourage the promotion and safeguarding of ICH. The real key to success in bringing the safeguarding of ICH and its promotion through tourism is that it all needs to be done responsibly. With ongoing facilitation and support from the IIC, NRDDB and the other stakeholders this seems possible. It is hoped that through carefully negotiated and well thought through decisions and actions, Amerindian people will not be objectified and their cultural heritage will not be appropriated for the sole benefit of others and will not be translated into meaningless commodities where its true values and meanings are lost. This will, however, require a vigilant balancing act.

Bibliography and References

Aikawa-Faure, N, 2009 From the Proclamation of Masterpieces to the Convention for the Safeguarding of Intangible Cultural Heritage, in *Intangible Heritage* (eds L Smith and N Akagawa), Routledge, London, 13–44

Blake, J, 2009 UNESCO's 2003 Convention on Intangible Cultural Heritage: the Implications of Community Involvement in 'Safeguarding', in *Intangible Heritage* (eds L Smith and N Akagawa), Routledge, London, 45–73

Burnett, D G, 2002 'It Is Impossible to Make a Step Without the Indians': Nineteenth-Century Geographical Exploration and the Amerindians of British Guiana, *American Society for Ethnohistory* 49 (1), 1–40

Conservation International, 2010 *Community Tourism Enterprise Development in the Rupununi: A Blueprint* (eds E Nycander, C Hutchinson, J Karwacki, V Welch, C Bernard and G Albert), Conservation International Foundation Guyana, Inc, Guyana

Corsane, G E, and Bowers, D J, forthcoming Sense of Place in Sustainable Tourism: A Case Study in the Rainforest and Savannahs of Guyana, in *Making Sense of Place: Multidisciplinary Perspectives* (eds I Convery, G Corsane and P Davis), The Boydell Press, Woodbridge

Deacon, H, 2004 Intangible Heritage in Conservation Management Planning: The Case of Robben Island, *International Journal of Heritage Studies* (10), 309–19

Farnum, J, Hall, T, and Kruger, L, 2005 A Sense of Place in Natural Resource Recreation and Tourism: An Evaluation and Assessment of Research Findings, *Gen. Tech. Rep. PNW-GTR-660*, US Department of Agriculture, Forest Service, Pacific Northwest Research Station, Portland, OR, USA

Galla, A, 2008 The First Voice in Heritage Conservation, *International Journal of Intangible Heritage* (3), 10–25

Gonzalez, M, 2008 Intangible Heritage Tourism and Identity, *Tourism Management* (29), 807–10

Iwokrama, 2007 *Iwokrama: the Green Heart of Guyana* [online], available from: http://www.iwokrama.org/home.htm [31 March 2011]

Kearney, A, 2009 Intangible Cultural Heritage: Global Awareness and Local Interest, in *Intangible Heritage* (eds L Smith and N Akagawa), Routledge, London, 209–26

Kenny, M L, 2009 Deeply Rooted in the Present: Making Heritage in Brazilian Quilombos, in *Intangible Heritage* (eds L Smith and N Akagawa), Routledge, London, 151–68

Koch-Grunberg, T, 1923 *From Roraima to the Orinoco: Results of a Journey in North Brazil and Venezuela in the Years 1911–1913*, Vol 3 (trans Walter E Roth), Caribbean Research Library, University of Guyana, Georgetown, Guyana

Kreps, C, 2009 Indigenous Curation, Museums, and Intangible Cultural Heritage, in *Intangible Heritage* (eds L Smith and N Akagawa), Routledge, London, 193–208

Kurin, R, 2004 Safeguarding Intangible Cultural Heritage in the 2003 UNESCO Convention: A Critical Appraisal, *Museum International* (56) 1–2, 66–77

Laughlin, N, 2006 Great Beyond, *Caribbean Beat*, September/October, 42–54

Makushi Research Unit (MRU), 1996 *Makusipe Komanto Iseru: Sustaining Makushi Way of Life* (ed J Forte), North Rupununi District Development Board, Guyana

Marrie, H, 2009 The UNESCO Convention for the Safeguarding of the Intangible Cultural Heritage and the Protection and Maintenance of the Intangible Cultural Heritage of Indigenous Peoples, in *Intangible Heritage* (eds L Smith and N Akagawa), Routledge, London, 169–92

McKercher, B, Ho, P, and Cros, H, 2005 Relationship Between Tourism and Cultural Heritage Management: Evidence from Hong Kong, *Tourism Management* (26), 539–48

Menezes, M (ed), 2002 *Edward A Goodall, Sketches of Amerindian Tribes 1841–1843*, Macmillan Education, Oxford

Riviere, P, 1984 Individual and Society in Guiana: A Comparative Study of Amerindian Social Organisation, in *Cambridge Studies in Social Anthropology* 51, Cambridge University Press, Cambridge

Sinclair, D, 2003 Developing Indigenous Tourism: Challenges for the Guianas, *Contemporary Hospitality Management* 15 (3), 140–6

Smith, V, 1996 Indigenous Tourism: the Four Hs, in *Tourism and Indigenous Peoples* (eds R Butler and T Hinch), International Thomson Business Press, London, 287–300

Stanley, N, 1998 *Being Ourselves for You: The Global Display of Cultures*, Middlesex University Press, London UK

UNESCO, 2011a *Encouraging Transmission of ICH: Living Human Treasures*, UNESCO, Paris, available from: http://www.unesco.org/culture/ich/index.php?pg=00061 [31 March 2011]

—— 2011b *Implementation Guide to the Masterpieces of Oral and Intangible Heritage of Humanity*, UNESCO, Paris, available from: http://www.unesco.org/culture/heritage/intangible/masterp/html_eng/guide1.shtml [31 March 2011]

Williams, D, 2003 *Prehistoric Guiana*, Ian Randle Publishers Inc, Kingston, Jamaica

When ICH Takes Hold
of the Local Reality in Brazil:
Notes from the Brazilian State of Pernambuco

Paula Assunção dos Santos and Elaine Müller

Introduction

In Brazil, the field of heritage has undergone major transformations in the last decade. Important aspects of this change concern the increasing democratisation of heritage tools, as well as the rise of new stakeholders and their relationship with heritage policies. While these changes have occurred in other parts of the world, they have particular connotations in Brazil as social grass-root movements gain a more active role in the country's cultural governance.

The dramatic changes in the work with ICH also reflect the relevance of grass-root participation, as well as the impact of social demands on the development and execution of protective legal instruments and other policy tools. The consequences at the local level are immense; they have created a new field of action and raised great expectations. It is interesting to note that this is not simply a top-down phenomenon. The possibilities introduced by these safeguarding instruments, and by the construction of a professional discourse and practice concerning ICH, are also being appropriated by a range of stakeholders and cultural communities, transforming it into a crucial local issue.

Therefore, it is important to explore the new dynamics in the work with ICH in Brazil, especially in reference to the (often tense) relationships between the state and local-level communities and representatives. In order to discuss some aspects of these complex dynamics, this chapter will make use of examples from the north-eastern Brazilian state of Pernambuco.

The constitution of apparatuses, actors, goals and other elements turn engagement with ICH into a comprehensive enterprise in Brazil and worldwide. It is important to stress that the acronym 'ICH' represents much more than an abbreviation. This chapter will argue that ICH is not the same as the notion of 'intangible cultural heritage'. It will argue that ICH could be seen as the title of this new enterprise and will focus on the capacity of ICH to act and influence long-existing local heritage practices. Relevant aspects of how ICH is taking shape in Brazil will be discussed in the following section.

The agency of ICH and relevant developments in Brazil

Currently, the field of intangible heritage within the Brazilian context is connected to the global rise of ICH as a new heritage discourse, area of professional action and industry. A number of

publications[1] stress UNESCO's protagonism in the establishment of ICH policies and practices worldwide. The 2003 Convention[2] represents a political milestone regarding the central role of heritage bearers in safeguarding intangible heritage. At the same time, it has created conditions for new operational realities at the local level by means of state policies and the strengthening of all sorts of regulating apparatuses. As Kirshenblatt-Gimblett states:

> These measures reveal how different the professional heritage enterprise is from what the heritage that is to be safeguarded ... their most dramatic effect is to build the capacity for something new, including an internationally agreed-upon concept of heritage, cultural inventories, cultural policy, documentation, archives, research institutes, and the like.
>
> (Kirshenblatt-Gimblett 2004, 55)

Indeed, the impact of traditional preservationist perspectives on the participation of practising communities in the transmission of ICH is a point of contention within international discussions (see Kurin 2007). The reflection on ICH as a process of constant transformation and its appropriation by progressive professional practices reinforce the claims for the democratisation of heritage tools as well as for new roles for heritage institutions (Alivizatou 2009). Discussions regarding the engagement of ICH in heritage institutions include approaches focused on the immaterial dimension of existing collections or the appropriateness of traditional conservation strategies, as well as those concerning the terms and implications of engaging people in the making of meaning and processing of ICH (Alivizatou 2008; Boylan 2006; Kreps 2009; van Dartel 2009).

A crucial aspect surrounding ICH concerns the role of culture and heritage in global development strategies. One of the facets of the sustainable development paradigm in which ICH is embedded is the relation between intangible heritage and economics. 'The emergence of intangible cultural heritage is predetermined by the context of the substantiation of its economic value' (Matsevich 2009, 225). Such value is translated into the notion of cultural capital and gains space in the tourism industry worldwide (also fuelled by heritage lists and other creations). Appraising ICH under the framework of development also calls for the acknowledgement of a socio-political perspective connecting participation in heritage negotiations to ideas of citizenship, empowerment and emancipation. This is highly relevant in the case of Brazil, where we find a strong social discourse tradition in the heritage field, which has become even more evident with this new chapter on ICH.

Depending on the degrees of implementation in specific contexts, the local effects of these and other facets of ICH can convert into a number of elements. On the one hand, we have an imposition of new regulations; on the other hand, legitimising instruments are made accessible to different actors, including those at the local level. Additionally, there are the direct investments in local initiatives, renewed modes of interaction with professionals and institutions, impacts of tourism and other changes triggered by the needs and urgencies of ICH. For all it is, ICH is significantly more than a heritage qualification. It could be seen as an agent that, active at the local level, calls for the recognition of new heritage actors and users (as well as of heritage rights),

[1] For example, UNESCO 2004; Smith 2009; International Journal of Intangible Heritage 2008, vol 3, etc.

[2] Brazil signed the Convention in 2006.

provides a toolkit, imposes a language and, thereby, broadens the avenues of exchange with national and global stakes. Besides the appreciation of effects and counter-effects, the important question remains as to how much the bearers of intangible heritage and other relevant stakeholders in the society have been able to (in)form such agency.

How does the agency of ICH[3] take shape in Brazil? One very important factor lies with the promises of an inclusive project of society present in the country's recent history and made more tangible since President Lula took office in January 2003. Historically, the links between the notion of intangible heritage and social issues have been made explicit in the official heritage discourse since the 1970s, when the state was regarded 'as an important partner for supporting groups and communities in order to enable them their right to the production and preservation of culture' (Londres 2004, 170). The 1988 Constitution (adopted after 20 years of military dictatorship) recognises Brazilian heritage to be the carrier of references to the identities, actions and memories of different groups in society. In addition to acknowledging the importance of diverse social actors and their cultural activism, the Constitution establishes that 'the responsibility to protect heritage should be shared between the public sector and society' (Londres 2004, 169).

In relation to ICH, concrete initiatives were launched at the end of the 1990s, leading to the creation of the Registry of Immaterial Heritage and the National Programme for Immaterial Cultural Heritage in the year 2000. At the core of this 'institutionalisation' of ICH in Brazil one finds the notion of 'cultural references'. In the processes of construction of senses of identity, culture appropriates objects, practices and places. A differentiated meaning and value is attributed to these objects, practices and places, and they become cultural references – that is, references to a sense of belonging, a sense of participating, a sense of place (IPHAN 2006, 20). 'They are what is popularly called "roots" of a culture' (ibid). The concept of cultural references informs the ICH discourse and operates in ICH policies to advocate, first, for the active participation of producers and holders of living cultural assets in the processes of identification, recognition and support (in order to guarantee their reproduction and continuity); and, second, for projects aiming to improve social and environmental conditions necessary to the production, reproduction and transmission of these assets (ibid).

In the context of development strategies in Brazil, the notion of ICH works as an instrument for the recognition of cultural diversity and social inclusion (Castro 2008) and 'precedence is now inevitably given to the protection of popular cultures' (Arantes 2008, 31). Since 2003, the Ministry of Culture (MinC) has been working with three key concepts: first, the anthropological notion of culture, which created new opportunities for those forms of expression, until then invisible in public policies. In the words of Beth de Oxum, *yalorixá* of a candomblé temple (*terreiro*) and cultural centre (o Coco de Umbigada) in Olinda, 'it was under President Lula's government that our *batucadas* moved from being a police issue to becoming a political issue'.[4] The second key concept concerns culture as citizenship, which justifies the priority given to minority affirmative policies. Despite criticisms aimed at this strategy, the fact is that both the

3 The term ICH is used here in connection with the argument of ICH constituting an agent active at the local level and less to refer to the nature of intangible cultural heritage. The term ICH itself (PCI in Portuguese), although mentioned in the UNESCO-commissioned report (Castro 2008), is not commonly used in Brazil.

4 It is interesting to note that in Portuguese, *política* means 'politics' as well as 'policy'.

notion of ICH and the cultural policies have contributed to a 'sense of citizenship' in Brazil, a country with one of worst records of social injustice in the world.

The last concept refers to the idea of the economy of culture, which promotes an emergent field related not only to the affirmation of cultural identities but also to the possibility of generating income. Cultural policies themselves can contribute to the 'tagging' of financial values in many cultural manifestations. For example, the Registry of Immaterial Heritage can be argued to be used as a 'seal of authenticity' with regard to those cultural practices and entities that are selected. In the case of the craft-making of the *Paneleiras de Goiabeiras* in the state of Espírito Santo, a literal seal is attached to their clay pans stating that the product is a national heritage.

The strengthening of the interface between policy, local actors and societal stakeholders represents an important aspect of the current activities of MinC. Moreover, there are various modes through which this interface takes shape. Operating under MinC, the National Institute of Historic and Artistic Heritage (IPHAN) runs the main instruments for the safeguarding and promotion of intangible cultural heritage and is considered the main standard-setting body in the country, conceptually and methodologically[5] (Castro 2008). The National Registry of Immaterial Heritage is *the* authorising instrument and, by law, can only be deployed after a collective request, either by a group or a public authority. Before any heritage is added to the Registry, it is necessary to carry out inventory research. Such activities follow a specific research methodology developed by IPHAN, called National Inventory of Cultural References. This inventory methodology is promoted to other public, private and non-governmental organisations. Additionally, the research that goes into this is also carried out in order to generate information and knowledge about various cultural manifestations, even if compiling a Registry is not the goal.

In the current approaches to safeguarding ICH, the act of generating knowledge about cultural manifestations is far from being an end in itself. The inventorying process seeks to stimulate the participation of heritage practitioners. Aside from supplying information, the process also creates new demands for subsequent safeguarding actions. Accordingly, safeguarding actions are formalised into what is referred to as 'Safeguarding Plans', which aim to improve the conditions of ICH transmission through an integrated effort of government agencies, local forces, the private sector and other parties. In particular, these actions promote access to raw materials, community organisation, capacity building, insertion in the market and intellectual copyrights. Such an approach validates and supports ICH, relying on the articulation and inter-dependence of different interlocutors from the government, the public, the academy and local grass-roots-level actors, as well as the market. Furthermore, it also reinforces the role of various stakeholders in local heritage affairs. In this light, an important aspect of this approach concerns the introduction of the ICH technical staff, who sometimes operate as the relevant authority, or as advocates and mediators in a highly politicised web of relations.

Within this framework, there is a belief that investments should be devoted to the initiatives of cultural asset holders, in order to value their practices in society. In this regard, the institutionalisation of ICH has yet another fascinating face: the *Pontos de Cultura* ('Culture Hotspots'), which is the flagship activity of the Ministry's Living Culture Programme (*Programa Cultura Viva*), a programme of integrated actions aimed at promoting grass-root initiatives and citizen-

5 Brazil is also considered a world reference in terms of ICH policies (Castro 2008). The country plays an active role in UNESCO's debates. Also, one finds articles about Brazil in publications about ICH (see for example UNESCO 2004 and Smith 2009).

ship. Initiatives from civil society in different areas of culture can apply for the programme in yearly tenders. In addition to gaining the 'Hotspot' title, they receive funding from the government, which is deliberately limited in order to encourage self-management. As a result, initiatives will join the network of *Pontos de Cultura* as a means towards sustainability.

As a result of the fact that people do relate to the preservation and communication of ICH, such as in relation to the Candomblé temples, hip-hop groups, *Griôs* (storytellers), indigenous territories and community archives, the *Pontos de Cultura* are changing the dynamics of participation in culture. At the moment, there are about 2500 *Pontos* throughout the country. In general, they promote the democratisation of information and cultural expression, giving voice to communities and local groups. Most significantly, they can contribute to strengthening a sense of solidarity and citizenship among cultural and heritage actors, for they are called upon to act in networks and become new forces in the game of cultural governance. In turn, this dictates that the experiences carried out locally introduce new parameters for working with ICH that remain in dialogue with associated policies.

Besides the actuation of IPHAN and MinC, other societal bodies are gradually informing the agency of ICH in Brazil. Universities are starting to incorporate the subject into relevant course programmes where intellectuals have an important role in consolidating the ICH discourse. Additionally, the museum and library sectors have been subject to comprehensive policies that connect them to the broader cultural initiatives and, thus, to issues related to ICH, such as memory and the active appropriation of heritage processes (Dos Santos 2009). Once government actions rely greatly on the interplay of stakeholders and local actors, sectors such as tourism and industry also influence practice. Moreover, the channels of communication with grass-root and social movements are also highly important even though participation could become more equalised. On this note, it can be argued that participation also becomes more institutional as one moves from the dialogues between ICH staff and heritage bearers towards higher levels of decision-making.

Although the agency of ICH is still in expansion, its impact on its relationship with people can be qualitatively assessed. As explained earlier, social demands directly reinforce ICH practices and, at the same time, social demands benefit from ICH practices. The *Pontos de Cultura* are, perhaps, the most striking example. On a less institutionalised basis, one can appreciate how communities and social movements are making use of ICH opportunities: 'Most of the times, the recognition of immaterial cultural heritage are bounded with claims for social rights stated in the 1988 Constitution and, therefore, with territorial claims from social groups such as *quilombola*, indigenous and campesine communities' (Toji 2009, 12).

The following anecdote illustrates how ICH policies also relate to a growing sense of citizenship in Brazil. Candomblé is an Afro-Brazilian religion. Whilst in the past the cult was disregarded by the government, and even veiled in taboo, today it is seen as an important cultural reference in the country. More specifically, it involves a number of cultural elements and traits, such as mythology, dance, music, community organisation and food. Some of Candomblé elements are part of the daily lives of many Brazilians, as well as of those who do not practise the religion. One of these concerns the traditional dish, acarajé, which is a deep-fried ball made from peeled black-eyed peas and served with spicy pastes that are prepared with shrimps, ground cashew nuts, palm oil and other ingredients. Aside from being a ritual food, acarajé is also sold at street stalls, traditionally by women called Baianas dressed in white cotton dresses. Baianas are a cultural reference in the North East and specifically in the city of Salvador da Bahia. However, it

has also become common to find Baianas and their acarajé in other cities, such as Rio de Janeiro and Sao Paulo. While working at a food market in Sao Paulo, a municipal guard read in a newspaper that groups of Candomblé practitioners in the state of Bahia requested the registry of the craft of the Baianas of the acarajé. The guard took this news to a Baiana who had an acarajé stand at the market and began explaining to customers that she was now national heritage. A small crowd formed around the woman and a lively discussion followed. The next day, she walked into the closest IPHAN office to demand her new rights and asked for a national heritage card.

This section has provided an overview of the structures and agency of ICH in Brazil through discussions of the relations with societal stakeholders. The next section examines the dynamics of engaging with ICH policies in the state of Pernambuco and the changes, problems and expectations that have emerged at the local level.

Notes from Pernambuco

It is often said that the state of Pernambuco has one of the richest and most active popular culture 'scenes' in the country. At present, Pernambuco is the Brazilian state with the largest number of cultural assets on the National Registry of Immaterial Heritage (2 out of 16), including those that are in the process of registration (5 out of 12). The registered practices refer to the *Feira de Caruaru*, one of the largest popular markets in Brazil, and to the *Frevo*, a musical rhythm strongly associated with the carnival of the cities of Recife and Olinda. The Capoeira from Pernambuco, a form of dance and martial arts, also makes up the national registry of Capoeira. All three are the focus of associated safeguarding plans, which differ according to the specificities of each living tradition. These plans are sensitive to local circumstances, placing attention on technical, social and political variables.

At the request of the Recife authorities, the *Frevo* was added to the registry in 2007, coinciding with its centennial. After a year of marketing the centennial, it can be argued that both the tourism industry and the city's image benefited the most, rather than the lives of those who create the *Frevo*. Out of 'political will', the registration process progressed at a pace as fast as the musical rhythm itself, taking six months instead of the usual 18 months. As the inventory process started, an intense dialogue between heritage professionals and musicians, dancers, maestros and people connected with the different *agremiações* (clubs) was established. From this dialogue, it became clear that the *Frevo* itself was very much alive and far from being at risk of extinction. It was seen as necessary to invest in the *agremiações*, the orchestras and musicians, as well as in the preservation of documents related to the history of this tradition. The priority for the safeguarding projects was set as the regulation (institutionalisation) of the *agremiações* in order to qualify them for fundraising. However, the rush to complete the registry was not reflected in the development of the associated safeguarding initiatives. Consequently, a series of delays increased the frustrations of the *Frevo* practitioners. A key obstacle in this process was the registry law itself, which does not foresee the proper transfer of public money to the ICH practitioners and, therefore, hinders simple actions such as the assignment of book-keepers (a requirement for the regulation of *agremiações*). According to a specialised attorney who was asked to review the case, the problem lies in the fact that the law does not foresee that IPHAN will work with people when a cultural asset is registered.

This is just one of the challenges of implementing a public regulation/instrument founded on the input of heritage bearers. In addition to being very recent, the practice was never a priority

in the traditional approaches of IPHAN to the safeguarding of material heritage. The training of staff, which includes anthropologists, specialists in specific cultural manifestations and heritage bearers themselves, remains a problem, as does the perception of their professional relevance amongst older IPHAN staff.

It is clear from the contacts between ICH staff and communities that it is still very difficult for people to understand this new ICH concept, the registry and ICH safeguarding, as well as the implications of these new possibilities. Often, there is suspicion from groups about the type of impact – if any – such initiatives will have on their lives. For instance, immediate improvement of living conditions is a recurrent subject voiced by participants at the local level. Moreover, reactions to the registration of Capoeira illustrate this well: one master celebrated the 'immaterialisation' of Capoeira, whilst another phoned IPHAN's office the next week asking when he would be able to take his retirement pension. Subsequent disputes and accusations had aimed to define who was more or less worthy to be recognised as a Capoeira master.

The different criteria and interests of stakeholders come into play in the intricate construction of local ICH affairs. An example is Pernambuco's regional Registry of Living Heritage, intended to promote the techniques, skills and knowledge of popular cultures. Interested individuals or groups can submit their candidacy. They must fulfil certain criteria – subjective (cultural value), as well as objective (income and age) – in order to qualify for a small lifelong salary. A Special Commission of 'cultural personalities' shortlists three names for the State's Culture Council, which makes the final decision. The Council is under no obligation to respect the Commission's advice, including the possibility of not even naming any person or group. In 2008 and 2009, none of the names shortlisted were accepted into the registry. A series of distortions allow the policy instrument to obey more political criteria than technical criteria. In addition to the already difficult interplay with the technical criteria, candidates must submit themselves to the scrutiny of political interests which, in the Pernambuco case, could consist of small, immediate and sometimes obscure politics.

Although we still lack a comprehensive evaluation of the effects of ICH policies (especially the registry and its safeguarding plans), it is possible to suggest, from experiences in the field, that the processes at work have raised a great deal of expectation on behalf of practising communities. Most significantly, it can also be argued that these expectations have not yet been fully met. In terms of possible outcomes, gains are more subjective and can be related to self-esteem, for example, or to the increased value of local products in the market. It is also interesting to note that, except for one case, all requests for the registration of ICH in Pernambuco have come from regional or local authorities, rather than the wider public. Obstacles hindering the implementation of ICH 'promises' could possibly lead to the registry being used to serve the needs of the tourism industry, rather than the practising communities.

These examples highlight one of the core subjects in the debate surrounding ICH: the dialectics between the logic of the product and the logic of the process. Understood as a seal of recognition and authentication (Hafstein 2009), the registry serves to create a 'product' that can be used in different forms and by different stakeholders. Of course, the registry is not an end in itself in the current ICH policies (at least, in theory). It represents a stepping-stone in a more complex approach, which departs from the demand based on the value of cultural processes (see the notion of *cultural references*) and aims at reinforcing process-based actions. At the heart of these actions, one finds the inventories, based on the participation of heritage bearers, and the

safeguarding plans, which are based on the improvement of the social and environmental conditions for the continuity of these cultural processes.

In 2008, IPHAN and MinC asked for the inclusion of Capoeira in the National Registry of Immaterial Heritage. The authentication of Capoeira is a large-scale national project which appraises the relevance of this cultural manifestation based on its representativeness for the country and abroad (as an expression of the Brazilian identity). The discourse behind the project points to the necessity of valuing the craft of the Capoeira masters and negotiating with other ways of providing them with social benefits, such as those supporting retirement, from the government. The registry was based on Capoeira practices of three states: Rio de Janeiro, Bahia and Pernambuco.

At the same time, it created a new value: the registry imposed new demands for this cultural asset. There are two main types of Capoeira in Brazil: Capoeira Angola (more 'African') and Capoeira Regional (more 'martial'). The Capoeira practised in Pernambuco does not fit into either of these two modalities since it is frequently a mix of the two, or does not even fall under such distinctions. Therefore, it can be asked: which Capoeira is being recognised as national heritage? The registry tends to look for elements that are found repeatedly over time and that represent the different facets of the same cultural asset. Therefore, at the heart of the creation of a 'product' one finds the unavoidable degree of artificiality.

Considering that the cultural communities do not passively absorb the values and legitimacy attributed to external preservation institutions, signs of cultural diversity are often transformed into manifestations of cultural difference in the political sphere (Arantes 2008, 32). In this regard, the response of practitioners in Pernambuco was to demand active participation in the execution of an exhaustive inventory in order to identify the differences of the local Capoeira from those of the rest of the country. Aside from the promotion of an 'authentic' expression, the process also reinforced some disputes (rivalries) among groups, which is, in a certain way, part of the very culture of Capoeira.

However, one of the most exciting developments involved practitioners overcoming rivalries and coming together to fight for their common interests and priorities. In a scenario where urgent matters of local interest depend directly on broader negotiations (between 'product' and 'process', between local and national and so forth), heritage bearers find themselves in the position of acting as political groups and also making use of their 'cultural differences' for that purpose. Fortunately, there seem to be possibilities for negotiating grass-roots governance on more substantial and permanent levels in the future. The Capoeira groups, the 48 *Pontos de Cultura* currently working in Pernambuco, the networks and the advocacy of ICH professionals can contribute to the establishment of a more democratic agency of ICH in Brazil.

Conclusion: the promises of a new reality

The handling of immaterial heritage in Brazil has always been heterogeneous. The new agency of ICH has been responsible for introducing qualitative changes at the local level, creating demands and establishing a new type of work based on the interplay between societal stakeholders. The net of modes of intervention and interaction creates a complex game of power and negotiation. It also has direct effects on the constitution of ICH and on the dynamics of cultural processes.

Some of the changes introduced into the processes of working with ICH that have been discussed in this chapter refer to the introduction of new legitimising tools and the authentica-

tion of new ICH 'products' within the reach of different societal stakeholders. The initiatives aimed at guaranteeing the vitality of cultural processes also create a demand for very practical improvements in the lives of heritage bearers, the introduction of the ICH professional as a (political) mediator and advocate, the growing institutionalisation and professionalisation of grass-root participation and the possibilities for heritage bearers to influence the ICH agency at higher levels, going beyond consultation and in regard to broader national interests.

These new ways of working with ICH are still expanding. Moreover, there are certain obstacles challenging the successful realisation of such ambitions, such as the limitations imposed by bureaucracy and the difficulties of understanding policy instruments. Furthermore, while it is clear that the impact of safeguarding actions and other promises might emerge in the long term, expectations, especially those at the local level, are focused on short-term benefits.

The current approach to ICH is a construction that attends to a broader societal project. It calls for the opening of channels of communication and influence of various stakeholders with differing interests and degrees of power. The examples mentioned demonstrate how the sometimes difficult negotiations, particularly between the state and heritage bearers, constitute the complex game of governance at play in the cultural field. In this sense, frustrations are also symptomatic of social dynamics in Brazil. One could sum up the approach to participation in the field of ICH as representing a concrete possibility for the democratisation of tools and decision-making, while being framed by a political legitimising project that carries with it institutionalising tendencies. At the heart of the problem lies the question: if the solutions at work are the best way forward, then what are their consequences in terms of the lives of those who produce and live their heritage? At present, we still lack sufficient means to evaluate and hold dialogue with heritage bearers (especially with those not organised in more institutional ways).

One of the principles informing ICH policies is that investments work only as an initial push towards a more sustainable reality in which an engaged society takes responsibility for the value and use of cultural assets. This inevitably calls for the empowerment of groups traditionally ignored by the state and their capacity to play a meaningful role in the country's cultural governance. In effect, hopes for democratisation could lie in the revolutionary role of the networks forming in the field of ICH, in the cooperation of the professional field with grass-root and social movements and in the possibility of recognising that the growing sense of citizenship is an important force for change.

Bibliography and References

Alivizatou, M, 2008 Contextualizing Intangible Cultural Heritage in Heritage Studies and Museology, *International Journal of Intangible Heritage* 3, National Folk Museum of Korea, Korea, 44–45

—— 2009 Rethinking 'Intangible Heritage' through preservation and erasure: perspectives from comparative museum ethnography, in *Sharing Cultures 2009* (eds R Amoêda, S Lira, C Pinheiro, J Pinheiro and F Oliveira), Green Lines Institute, Porto, 643–54

Arantes, A A, 2008 Africa-Brazilian Cultural References in National Heritage, *Vibrant* 5 (1), Associação Brasileira de Antropologia, 20–33, available from: www.vibrant.org.br [9 January 2009]

Boylan, P, 2006 The Intangible Heritage: A Challenge for Museums and Museum Professional Training, *International Journal of Intangible Heritage* 1, National Folk Museum of Korea, Korea, 54–65

Castro, M L V de and Londres, M C, 2008 *Patrimônio Imaterial no Brasil: Legislação e Políticas Estaduais*, UNESCO, Educarte, Brasília

van Dartel, D, 2009 There's a Story behind Everything – Moving Towards the Intangible at the Tropenmuseum, in *Sharing Cultures 2009* (eds R Amoêda, S Lira, C Pinheiro, J Pinheiro and F Oliveira), Green Lines Institute, Porto, 341–51

Dos Santos, P A, 2009 *Mapping of the Heritage Field in Brazil*, SICA, Amsterdam, available from: www.sica.nl [1 January 2009]

Hafstein, V, 2009 Intangible Heritage as a List, in *Intangible Heritage* (eds L Smith and N Akagawa), Routledge, London and New York, 93–111

IPHAN, 2005 *Patrimônio Imaterial e Biodiversidade, Revista do Patrimônio* 32, IPHAN, Brasília

—— 2006 *O registro do Patrimônio Imaterial: Dossiê final das atividades da Comissão do Grupo de Trabalho Patrimônio Imaterial*, (org Márcia G De SANT'ANNA), 4 edn, IPHAN, Brasília

Kirshenblatt-Gimblett, B, 2004 Intangible Heritage as a Metacultural Production, *Museum International* 56 (1–2), UNESCO, 52–65

Kreps, C, 2009 Indigenous Curation, Museums and Intangible Cultural Heritage, in *Intangible Heritage* (eds L Smith and N Akagawa), Routledge, London, 193–208

Kurin, R, 2007 Safeguarding Intangible Cultural Heritage: Key Factors in Implementing the 2003 Convention, *International Journal of Intangible Heritage* 2, National Folk Museum of Korea, Korea, 10–20

Londres, C, 2004 The Registry of Intangible Heritage: the Brazilian experience, *Museum International* 56 (1–2), UNESCO, 166–73

Matsevich, I J, 2009 The Conceptual Basis of the Re-evaluation of European Intangible Cultural Capital, in *Sharing Cultures 2009* (eds R Amoêda, S Lira, C Pinheiro, J Pinheiro and F Oliveira), Green Lines Institute, Porto, 225–30

Muller, E, and Franca, J P, 2007 A 'patrimonialização' dos bens culturais de natureza imaterial: notas a partir das experiências de Registro em Pernambuco, paper presented at the *VII Reunião de Antropologia do Mercosul*, 23–26 July, Porto Alegre

Smith, L (ed), 2009 *Intangible Heritage*, Routledge, London

Toji, S, 2009 Patrimônio Imaterial: marcos, referências, políticas públicas e alguns dilemas, *Patrimônio e Memoria* 5 (2), UNESP, São Paulo, 1–16

UNESCO, 2004 Views and Visions of the Intangible, *Museum International* 56 (1–2), 221–2

Reconfiguring the Framework: Adopting an Ecomuseological Approach for Safeguarding Intangible Cultural Heritage

Michelle L Stefano

Introduction

As also noted by Alivizatou in this volume (Chapter 1), the 2003 Convention provides the structure of the current framework within which ICH is both conceptualised and managed at the international and national levels due to the fact that 142 States Parties have agreed to promote and safeguard it within their respective territories (UNESCO 2012). In this light, the methods, as well as suggestions, for safeguarding ICH that are put forward in this document are becoming increasingly dominant through their global acceptance and, thus, geographic expansion. However, as one of the core arguments of this chapter, safeguarding approaches need to be just as diverse and nuanced as the heritage expressions they intend to sustain.

It is clear that at the heart of ICH are the individuals, groups and communities that embody, practise and transmit it. Thus, elements such as emotions, values and memories should also be placed within the concept of the intangible (Kirshenblatt-Gimblett 1998, 30; Smith 2006, 56). In this regard, ICH stands for more than dance steps, plot twists in storytelling, or any other examples of obvious events and actions; it is composed of deeper, underlying values such as teamwork and generosity, as well as significance that stems from senses of belonging and pride, as examples discussed later. Moreover, 'place' also plays a role in the relationship between intangible cultural expression and community. Senses of belonging and pride can be linked to the places within which certain expressions have evolved and/or are expressed today. As Smith (2006, 56) argues, these sentiments, values and meanings render all representations of heritage as intangible, whether a site, building, object or performance.

Nonetheless, one of the main limitations of UNESCO's approach, as structured by the 2003 Convention, concerns the potential neglect of these inextricable links to people, places and larger contexts that, all together, constitute the true diversity of ICH. This is predominantly due to the fact that the current framework promotes its safeguarding in a top-down manner: from the international and national levels to, presumably, the local level. Within this discussion, these two top levels are referred to as the 'non-local level' since ICH, as a term, operates both internationally and nationally as a direct result of its conceptualisation and categorisation by UNESCO and its 2003 Convention. Combining these two levels is based on the idea that while UNESCO seeks to promote ICH on a global stage, it is 'organized entirely along national lines' (Ruggles and Silverman 2009, 11). Even though the 2003 Convention established an international governing body (the General Assembly), States Parties have retained ultimate control over how the ICH of their national territories will be safeguarded (Blake 2006, 45). Therefore, a key question is posed:

will practitioners who express ICH at the local level – and are its true 'arbiters of value' (Kurin 2007, 13) – be involved in this non-local safeguarding scheme?

In response to potential limitations of the current framework, this chapter suggests that the more holistic, as well as locally based, safeguarding approach of ecomuseology can provide an effective way forward for ensuring that ICH can continue to evolve. Through an examination of the significance and values of three intangible cultural expressions – a sword dance, bagpipe playing, and more general folk music practices – that have developed over the course of several centuries in North East England, it is shown that ICH derives its vitality from highly nuanced and interconnected relationships between people, heritage and place. It is argued that the current framework, as based on the 2003 Convention, may serve to sever these relationships through its highly promoted system of making lists, as well as through vague assurances that local communities, groups and individuals will be involved in safeguarding efforts. In the final section, it is demonstrated that there exists a strong resonance between the three ICH examples and key components of ecomuseological philosophy, as formulated by academic researchers in the International Centre for Cultural and Heritage Studies (ICCHS) at Newcastle University (see Corsane *et al* 2004; Corsane 2006a; 2006b; Corsane *et al* 2007).

ICH IN NORTH EAST ENGLAND

The North East of England is a region with a rich cultural past and present. It is home to a multitude of intangible cultural expressions that range from the performing arts and occupational skills to the distinctive Geordie dialect of the city of Newcastle (Beal 2000). The following discussions concern three particular intangible cultural expressions that have existed for centuries and are still practised today, both in the region and beyond. The first is a sword dance, the Rapper Dance, which originated in the 18th-century coal-mining villages of the North East (Lawrenson 2007). While the dance is rather difficult to explain, the following description and figure are helpful:

> [The dance] involves five people connected by short, two-handled, flexible swords (called rappers) forming a chain. Without breaking this chain the dancers weave in and out of one another twisting the swords to form locks and breastplates, sometimes jumping or even somersaulting over the swords. (Rapper Online 2010; see also Fig 19.1)

The second example of ICH is the music played on the Northumbrian Smallpipes, a bagpipe unique to the region. This also includes the tradition of composing for the instrument, as well as its handmade construction. The earliest known set of Northumbrian-style pipes dates to the late 17th century (Say and Say 2003). The third intangible cultural expression consists of the general folk music traditions of both the countryside and the city of Newcastle using a range of instruments from the fiddle to the flute. These musical traditions developed over centuries with their largest divergence occurring in the late 19th century. During this period, Newcastle was becoming more cosmopolitan and, in turn, music halls were opening at a rapid pace. Thus, musicians moved to the city and developed new styles that blended with the popular music of the time, styles that were not as prevalent in the countryside (although this division has blurred with time) (Harker in Allan 1972, iii; Murphy 2007, 256).

All three of these traditions remain in the care of their practitioners. Folk musicians are still

FIG 19.1. A RAPPER DANCING TEAM AT A COMPETITION IN 2008

out in pubs and other cultural venues playing tunes, whether centuries old or recently written in a style particular to the region. Indeed, it is not uncommon to come across a pub in the many towns and cities of the region where folk musicians are gathered together, playing in informal musical sessions, on any night of the week. At events like this, the musicians are playing for each other, utilising the opportunity to share tunes, practise and converse. Similarly, the Rapper Dance is no longer performed in the coal-mining villages of the North East; pubs and festivals are used as the main venues due to the decline of the coal-mining industry. During the 20th century, the dance shifted hands from the coal-miners to a more general community of devotees with differing occupations and interests.

A large number of the dancers and musicians also partake in more than one of these expressions. For instance, many Rapper dancers are also folk musicians since they play a variety of instruments, including the Northumbrian Smallpipes. In order to demonstrate that ICH cannot be itemised and, thereby, separated from those who embody it, the following examination is based on an analysis of data collected from roughly three years of participant observation and interviewing. Categorised under two themes, *significance* and *values*, this investigation not only provides insight into the vitality of such expressions but can lead to a new understanding of how these traditions survive, thrive and can continue to evolve. Why do they do it? What values, feelings and messages are represented through their commitment? These areas of interest developed from the desire to understand ICH from local-level perspectives, as well as to understand what constitutes its true 'intangibility' in a more holistic light.

SIGNIFICANCE

Practising, transmitting and celebrating their respective living traditions have become influential factors in how the dancers and musicians define themselves. One piper joked: 'I got the pipes when I was fifteen and since then I'd definitely say that's the only way for me … the whole folk ethos has kind of taken over my life' (Interview Ac1 2007). Another piper recalled a time during his doctoral research in Chemistry when, instead of applying for his passport as a student, he decided to 'call meself [sic] a piper' (Interview Ac2 2007). Although a humorous anecdote, it provides a strong example of how they see themselves through their devotion to these cultural practices. As one musician commented, 'Making music is part of who I am' (Interview Ac6 2007); therefore, it is difficult to neglect the strong relationship between sense of self and cultural expression.

With respect to shared motivations, the notion of 'sense of belonging' has emerged as a key factor in why these living traditions are significant. The idea of belonging can also be understood as multilayered since there are a variety of entities to which the dancers and musicians feel connected. Accordingly, 'sense of belonging' has been broken into three components: belonging to the community of fellow dancers and musicians; belonging to the North East and the places in which these living traditions have evolved and are transmitted today; and belonging to the shared heritage that is expressed through these practices. With regard to the first sense of belonging, being a part of a group of 'diverse' people with 'one common goal' is an influential factor in their continued participation, as well as in overall importance attributed to these expressions. They mentioned that they would not meet their fellow musicians and dancers otherwise and, through their participation, have found a 'team' of people who have enriched their lives and can be considered friends, as well as an 'extended family'.

As noted earlier, a large number of the dancers and musicians come from different back-grounds and occupations – from teaching and social work to working for large pharmaceutical companies. Additionally, not all were born in the North East; some settled in the region at various points in their lives as a result of educational opportunities or work. In any case, a sense of belonging to a community of people with shared interests has emerged. On this note, a piper commented:

> When I talk to people out there, I know them all … we play together and interact together … and also from the point of view of teaching, I enjoy teaching the actual pipes themselves … and it's mainly the interaction between people, which is a main important point … also, obviously, the playing … we have sessions regularly and we meet in each other's homes, as well, which is very important. (Interview Ac3 2007)

Moreover, belonging to 'place', as expressed through these forms of ICH, was another significant influence for ongoing participation. Folk musicians and dancers alike noted the apparent links between the music, the dance and the historical events, lifestyles and landscapes of the region. For example, a dancer stated:

> I do get a definite feeling of belonging because I do this dance, but it's actually most enhanced when you're not in the North East … so it's when you are somewhere else, you can talk about coming from the North East … and talk about being a part of this tradition.
>
> (Interview Aa1 2007)

Speaking about belonging to this community and to the North East, a piper highlighted the relationships between the music, learning from well-known players and the regional landscapes. He commented:

> I was born in Newcastle, but when I moved out to the country and started playing with the guys up there, which I did in the countryside, it was almost as though [the music] was just expressing the whole location … you could picture scenes … matching every note to a blade of grass, almost … it was so close to that part of the country and that's where I was living … and I just loved it; it all just hung together … then we had great social nights … you felt that they, as a Geordie lad [of Newcastle city], they took me in and let me feel very welcome and part of this whole scene … so, it's really a sense of belonging … a sense of expressing the land through the music; it's really amazing. (Interview Ac2 2007)

Here, the distinctive characteristics of the North East constitute both the original and contem-porary settings of these living traditions and, thus, a strong connection to the region is felt. These connections represent a certain 'sense of place' that is expressed through the three living traditions, as well as through the bonding that occurs during the conversations, and ale-drinking in between.

It is worth noting that a feeling of nostalgia was mentioned in connection to the broader feeling of belonging. This sentiment is bonded to certain towns, landscapes, parts of the city of Newcastle, tunes and events that compose childhood memories. For instance, one respondent, a Northumbrian Smallpiper and folk musician, noted:

> It was something that started when I was three or four … I heard Jack Armstrong and Patricia Jennings playing on the last run of the [train line] and I could remember them getting off at Scots' Gap and I remember my father holding me out the window so that I said, 'Why are they getting off?' And I always liked to listen … and it was a surprise by my mum when I was about eighteen that she'd seen a set of Northumbrian Pipes made by somebody called Archie Dagg and she bought them out of the journal … for about twenty-three pounds.
>
> (Interview Ac4 2007)

Another piper commented that the folk songs of Newcastle, 'Tyneside tunes', that are still heard today, remind him of walking down to the Tyne river as a child, more than half a century ago, when musicians were playing those same melodies on street corners.

In addition to the senses of belonging, a feeling of pride was also discussed. The pride felt on the part of the dancers and musicians has been broken down into the most commonly stated themes of pride in locality, pride in the distinctiveness of these living traditions and pride in their personal involvement in them. Specifically, they referred not only to a feeling of belonging to the region, but also a feeling of pride in representing it through their ongoing participation. Closely tied to this response is also a pride in the living traditions themselves since they are distinctive, separate from mainstream popular culture, and have strong historical roots. An older folk musician noted:

> Originally, I just liked American music; [it] was a way of getting out of the rather banal pop music of the day … so, it was an excitement that sound, but gradually, as I began to sing in the folk song club in 1958, I realised that there was this strong tradition of local songs and, as I was working in the coal mines at the time, I got interested in miners' songs … and gradually, [I] started rediscovering the history of the North East through the collections [of music] […] So, really it's a pride in the area and an interest in particularly how the history and the songs are linked. (Interview Ab4 2008)

Another dancer stated:

> I'm proud of the origins of [the Rapper Dance] and proud of the fact that it is something specific to the North East of England … yes, I know they dance it all over the country now, but when it first started off, back two hundred years ago during the mining industries, it was only in the North East of England that you would ever see this dancing … and it was never anywhere else. (Interview Aa4 2007)

They also expressed a pride in their own personal participation. This last sense of pride stems from a common opinion that their involvement is helping to safeguard these living traditions for the future. It was stated that just through attendance, or the basic efforts of 'showing up' to rehearsals and performances, they are ensuring the vitality of the community and their practices for, at least, the next couple of decades.

On the same note, a pride in 'bringing it to the public' was also discussed since the dancers and musicians help raise awareness on the part of the general public of these living traditions. The previously quoted dancer continued:

Fig 19.2. Northumbrian Smallpipes competition at the Morpeth Chantry Bagpipe Museum, Morpeth

> Quite proud, actually … when we're out there dancing, especially dancing in the streets and people are, like, joining in and getting excited themselves about the whole thing … I like that … when people see the dance and they've never heard of it before and you're, like, explaining it all to them and how it's so old as well … and they're like, 'Really?' […] They just love it and I love explaining it to them! (Interview Aa4 2007)

The process of 'passing the knowledge on' to younger generations is also currently underway through workshops, formal teaching and judging at competitions (see Fig 19.2). It was mentioned that this is an important community activity for guaranteeing that their respective living traditions continue.

Values: Teamwork, Respect and Altruism

In addition to senses of self, belonging, place and pride, there are also broad values that are represented by these relationships and expressed collectively. One main value that is represented by involvement in these three living traditions is that of 'working together' as a team. In reference to one of the Rapper dancing teams, the Newcastle Kingsmen, a member noted: 'The Kingsmen are very much team-spirited wherever they are; whether they are performing or whether they are drinking or whether they are travelling between pubs or whatever it is' (Interview Aa5 2007).

Examining teamwork further, the opinion was expressed that 'loyalty' and 'solidarity' greatly contribute to this overall value. The dancers and musicians expressed an 'obligation', which is in no sense dreadful, to their 'teammates' by 'doing their best', attending rehearsals and performances and, generally, being accountable to their community.

Respect, as a value, was also associated with teamwork through the aforementioned feelings of loyalty, solidarity and obligation. In general, they commented on their respect for each other as both friends and fellow performers. Additionally, there is respect for not only fellow community members, but for the living traditions themselves. One respondent, a Northumbrian Smallpiper, believes she is 'defending' the tradition through her participation and subsequent promotion of its uniqueness and connection to the region (Interview Ac6 2007). She elaborated that her commitment to the folk music community stems from a respect for others: the audience, the music and the pipers who had come before her.

As conveyed through their ongoing participation and, particularly, performances, altruism, which was discussed in terms of generosity, open-mindedness, sharing, 'decent behaviour' and community spirit, can also be considered a strong value. In particular, a fiddle-player commented:

> I think the easiest way to say it is to say what [folk music] doesn't represent. I don't think a folk musician is necessarily associated with hoodies and knives … so, maybe the opposite of that is, kind of, more decent behaviour, you know? [...] Not even clean living … just a generous spirit. You want to share things; you want to meet people … I always get so joyful, you know, if I find something [related to music] or somebody gives me something. I get really excited and want to pass it along to the next person. (Interview Ab2 2007)

Another musician recounted the times he spent learning the pipes from the well-known Northumberland piper, Billy Pigg:

> I used to go up [to Northern Northumberland County] a lot, but sadly he only lived another two or three years more … and at that time I didn't have a set of pipes, I just had my concertina, but later on took up the pipes … it was something about the generosity of spirit, happily sharing tunes with me … you know, whenever you visited that generation of people in the country, you always had, at least, tea and scones and, you know, homemade jam and the whole bit … you can't just pop in for ten minutes … so this was a whole new set of relationships.
> (Interview Ab3 2008)

Furthermore, the musical circuits of which they are a part welcome musicians of all ability levels. Indeed, feeling welcomed into these communities and groups has been mentioned by both beginner dancers and musicians, and can also be felt by observers as well.

These examples have provided insight into the nature of ICH and the interconnected relationships between the dancers and musicians, their heritage expressions and places. Notions of identity, belonging, pride and teamwork, to name a few, have emerged as strong components of the lifeblood that is given to these forms of ICH. Sustaining such expressions should call for a set of guidelines that not only seek to safeguard the dance steps and tunes but also take these relationships and sentiments into account. However, as argued in the following section, the increasingly promoted UNESCO framework may serve to separate ICH practitioners – and the significance and values they embody – from their cultural expressions due to particular limitations that stem from its non-local and non-holistic approach.

The Limitations of the Current Framework

As noted in the Introduction, one main limitation of the current framework is its top-down approach to conceptualising, spotlighting and safeguarding ICH. In this regard, the very concept of 'intangible cultural heritage' is dichotomous in nature. At the non-local level, ICH serves to represent all cultural diversity in intangible form and, thus, is conceptualised as universal in nature (see UNESCO 2003, Preamble; Kirshenblatt-Gimblett 2006, 161). Nevertheless, ICH is also specific and nuanced when thought of in terms of the multitude of languages, dialects, cultural knowledge, craft skills and musical expressions, for example, that live at the local level in connection to those who practise and transmit them. After all, these cultural expressions have existed long before the categorical label 'intangible cultural heritage' was developed (and new cultural practices and beliefs develop contemporaneously regardless of this term). With reference to the three intangible cultural expressions examined in the previous section, it is true that they are components of cultural diversity in the larger sense; however, they cannot represent any other expression of ICH other than themselves. In other words, the Rapper Dance cannot represent any other dance, no matter how similar they may appear. This is due to the interconnected relationships its practitioners have with it, as well the places in which it is expressed. Moreover, these expressions interact with broader economic, social, cultural, political and environmental contexts. This 'constellation' of contextual 'interactions' (Kurin 2007, 12) gives ICH its vitality as well as its specificity.

Most importantly, how is this specificity to be safeguarded within the current framework? As the 2003 Convention provides the structure of this framework, it is the activity of listing that can be argued to be the key mechanism that propels the promotion and safeguarding of ICH at the non-local level forward (Kirshenblatt-Gimblett 2004; Blake 2006, 78; Hafstein 2009, 105). In particular, this listing mechanism consists of the three main instruments of the 2003 Convention: the *Representative List of the Intangible Cultural Heritage of Humanity*, the *List of Intangible Cultural Heritage in Need of Urgent Safeguarding* and the obligatory inventories of ICH that are to be compiled at the national levels.

In addition to the problematic issue of selecting cultural practices, Hafstein (2009, 105) highlights that at the core of any listing activity is the inherent process of 'itemisation', or 'artifactualisation'. Specifically, the intangible cultural expressions that are, for whatever reasons, chosen for inclusion within the international lists and/or national inventories are subject to decontextualisation (Hafstein 2009, 105; see also Kirshenblatt-Gimblett 2004). The inextricable connections that ICH has with source contexts, including the interconnected relationships to those who embody it, are threatened with new values that are derived from the non-local level. In essence, these cultural practices are recontextualised as 'intangible cultural heritage' through newly formed relationships to other listed items and, thereby, shift from being understood as local and specific to being viewed as 'representative' and universal (Hafstein 2009; Kirshenblatt-Gimblett 2004; 2006). Moreover, it can also be argued that this itemisation tends to favour the aesthetic attributes of ICH, or its 'externally experienced' qualities. Indeed, the Representative List has been described as a 'beauty contest' for cultural practices and beliefs (in Hafstein 2009, 102).

With this in mind, it is important to examine where ICH practitioners are situated within this safeguarding framework since they, in large part, provide the nuanced and specific characteristics of their expressions. The information offered on UNESCO's website in reference to

the 'elements' inscribed on the Representative List illustrates a lack of detail about those who embody the knowledge, significance, values and potential for change that gives the selected ICH its vitality and uniqueness (UNESCO 2011). While it can be intrusive and laborious to list the names of those associated with these practices, it is evident that the 'specificity' of ICH rests solely with what it looks like and how it is practised; these are the markers of cultural diversity used at the non-local level.

Similarly, Kirshenblatt-Gimblett (2004, 55–6) remarks that after decades of UNESCO meetings, reports and recommendations, the outcome is – ironically – a series of lists, as opposed to 'actions that would directly support local cultural reproduction'. Here, it is asserted that the roles people play in transmitting and effecting change in their cultural practices are not directly addressed within the current framework. According to Article 15, States Parties are asked to 'endeavour to ensure the widest possible participation' of local communities, groups and individuals in safeguarding efforts (UNESCO 2003). Nonetheless, it is argued that this 'vague' wording allows governments to exert control over potential initiatives, where the extent to which ICH practitioners participate is decided at the national level (Blake 2006, 76). Furthermore, monitoring these efforts becomes difficult since little direction is given as to how involved local people must be.

Based on the listing mechanism and unclear community participation features of the current framework, it can be considered that a non-holistic view of ICH is in the process of being promoted. Indeed, Brown (2005, 48) likens the UNESCO approach to 'mistaking a map for the territory it represents'. In other words, ICH is conceptualised and managed in a manner that tends to isolate, or treat separately, its life-giving elements, such as the relationships between its practitioners and ever-changing contexts. Recalling that ICH is embodied by people, as the earlier examination from North East England has shown, a safeguarding framework that does not automatically include their involvement and, thus, fails to uphold their expertise, can prove to be ineffective. In recent years, Kurin (2004a, 75), Brown (2005, 42), and Kirshenblatt-Gimblett (2006, 164) have called for a more holistic approach where ICH is considered as one component of a larger ecology of human experiences.

A TRADITIONAL MUSEOLOGICAL BASIS

Before examining the ecomuseological approach, it is worth highlighting that the current framework relies heavily on traditional museum practices. More precisely, traditional museological methods such as inventorying and documenting are extended to 'living persons, their knowledge, practices, artefacts, social worlds and life spaces' (Kirshenblatt-Gimblett 2006, 161). Indeed, the 2003 Convention encourages States Parties to 'establish documentation institutions' for ICH, in addition to the mandatory exercises of defining, identifying and inventorying it (UNESCO 2003, Article 13). While Kirshenblatt-Gimblett (2004; 2006) contends that officially selected expressions are automatically given new universalising and 'metacultural' values, it is important to stress that these traditional museological activities constitute the very mechanisms for propelling the current UNESCO framework forward. Even though it appears as though this movement to safeguard ICH is recent, the ways in which it proposes to do so are not. In essence, can traditional museum practices be used to effectively safeguard ICH?

A significant limitation of the traditional museum is that it tends to treat source communities, groups and individuals, and the contexts in which they live and operate, separately from one

another. In general, a more conventional museum is 'cut off' from the communities of its area, including their associated places and the abovementioned plethora of 'interactions'. It focuses on collecting from the community and bringing representations of cultural heritage into the museum building to be preserved, interpreted and displayed for those who visit (Davis 1999, 32). With respect to ICH, this can heighten the potential for 'fossilising' it and, thereby, rendering it meaningless (Davis 1999; Boylan 2006). Indeed, at the 2004 General Conference of the International Council of Museums (ICOM), which was dedicated to the theme of 'Museums and ICH', this notion of potential fossilisation was cited as a major obstacle museums need to overcome if they are to become involved in safeguarding intangibles (Kurin 2004b, 8; Lee 2004, 6; Matsuzono 2004, 13; Yim 2004, 12; see also Pinna 2003). Interestingly, 20 years earlier, Loomis (1992 [1985], 193) argued that living heritage expressions are inevitably changed within the more artificial museum context. He stated:

> A farmer making brooms in a shed behind his house may use the same kind of straw and winder that an interpreter in a museum uses, but one craftsperson possesses vitality derived from his interaction with a natural context whereas the other one has had the vitality wrung out by the conditioning effect of his refined setting.

A Northumbrian Smallpiper also explained that his tradition can only remain alive when in the hands of its practitioners. He added:

> I think if it doesn't change, it's not living ... it's got to be a living thing, otherwise ... I mean, if it's dead, it's dead ... it is a museum piece [...] It's lovely to have old instruments and appreciate the workmanship and a lot of them probably wouldn't play well now, but you can't do that with the actual music ... it won't work and, if you're trying to do that, it will die and it deserves to die ... if people aren't reinvigorating it and bringing different ideas within that framework, it's no good. (Interview Ac2 2007)

Therefore, ICH needs to be safeguarded from a standpoint that upholds the links between people, their heritage and places as part of an ever-changing living system: the fundamental approach of ecomuseology (Corsane and Holleman 1993; Davis 1999; Corsane 2006b). As argued in the following section, ecomuseology can provide an effective way forward as a result of the importance it places on the interconnectedness of people, their heritage and the places in which it is expressed. In a holistic heritage management approach, intangible cultural expressions remain in continued social practice – that is, in the hands of their communities, or their true *agents of change*.

Furthermore, they must remain in their source – as opposed to artificial – contexts or surroundings, the ever-changing places and regions within which they are transmitted, recreated and reflected upon. Kurin (2007, 12) succinctly phrases this by stating that '[ICH] is not something that can easily be isolated from a larger constellation of lifestyles, nor de-articulated from a broader world of ecological, economic, political, and geographic interactions.' Through people, cultural practices and beliefs are modified and changed in response to these broader interactions. This 'permeability', or the porous relationship between ICH and the 'outside world', is integral to its vitality and must be given a high priority during safeguarding efforts.

A Way Forward: Using the Ecomuseological Approach to Safeguard ICH

The distinctions between traditional museology and that of ecomuseology have been developed since the late 1960s, beginning with the work of Hugues de Varine and George Henri Rivière in France (Davis 1999, 62). These differences have been concisely compared in two formulae first set forth by Rivard (1984, 92; 1988) and used by others (see Davis 1999, 69, 74; Corsane 2006a; 2006b; Boylan 1992, 29; 2006, 56). These formulae are as follows:

> Traditional Museum = building + collections + expert staff + public visitors
> Ecomuseum = territory + heritage + memory + population

In general, ecomuseology, as a philosophy, lays a foundation for a 'holistic museology' approach that emphasises the life of people in terms of their full physical, economic, social, cultural, political and environmental interactions and contexts (Corsane and Holleman 1993, 121–2; Davis 2011, 17–20). This viewpoint highlights the notion that a heritage management scheme that addresses the relationships between people, heritage and place holistically can also safeguard the intangible cultural expressions that are connected to each. As Davis (1999, 68) states: 'Intangible local skills, behaviour patterns, social structure and traditions are as much part of the ecomuseum as the tangible evidence of landscapes, underlying geology, wildlife, buildings and objects, people and their domestic animals.'

Nonetheless, as a departure from the earlier ecomuseum notion, the ecomuseological approach, as argued here, does not necessarily have to be 'tied' to a specific territory (see also Corsane and Holleman 1993, 116). While the idea of an ecomuseum may bring to mind images of a demarcated area, where the 'beginning' and 'end' of the ecomuseum are geographically defined, the ecomuseological philosophy should be viewed as a set of guidelines that recognise that ICH is embodied by people and, thus, is ever-changing and, in some cases, migratory (for specific principles see Corsane *et al* 2004; Corsane 2006a; 2006b; Corsane *et al* 2007).

For instance, threaded through the philosophy is the notion of adaptability and responsiveness to local needs (Corsane 2006b, 404). In this regard, ecomuseological practice aims to respond to ever-changing environmental, economic, social, political and cultural conditions at a local level. More specifically, it 'looks at continuity and change over time, rather than simply trying to freeze things in time' (Corsane 2006a). An example of how ICH changes can be found in the fact that the Rapper Dance had been practised only by men until recent decades. Today, a large number of Rapper dancers are female. This change, which is reflective of the larger societal movement for gender equality, may not have occurred if safeguarding efforts focused only on representing the dance as it was using strict historical standards.

In terms of the current framework, Nas (2002, 139) wonders if UNESCO's efforts, such as the use of lists, may alienate ICH from its 'living sociocultural source' and subsequently lead to its fossilisation, as noted earlier. Similarly, Smith (2006, 56) believes that such 'registers of heritage' risk stifling 'mutable cultural practices' through 'management practices laden with the burden of preservation'. However, the ecomuseological approach operates within 'living sociocultural sources' of heritage expressions and derives its strength from being initiated and steered by local communities. This basic idea highlights efforts that are, as Hugues de Varine puts it, 'grown from below' and not 'imposed from the top' (de Varine 1993). Similarly, Kurin (2007, 13) notes:

[It] is the dynamic social processes of creativity, of identity-making, of taking and respecting the historically received and making it as one's own that is to be safeguarded. And the arbiters of value – those who might be mindful of variants and yet decide on their relative significance and correctness – are not governments or scholars, but rather members of the concerned communities themselves.

With respect to the Rapper dancers and folk musicians, it is impossible to effectively safeguard their expressions without their motivation and steering. Most significantly, they know and value the most intricate details of their expressions' histories, techniques and standards of authenticity. Without them, the dances cannot be performed and the music cannot be played. Not involving local communities could sever the significance and values from the heritage being safeguarded and, thus, render it meaningless – a potential problem that can be mitigated through their full involvement in safeguarding efforts.

Conclusions

From the discussion on the current framework, it has been shown that there exist key limitations that can sever the ties between people and their heritage practices and places. The dependence on lists has been argued to threaten intangible cultural expressions with the prospect of recon-textualisation through non-local valorisation. As a result, original values and meanings that are attributed at the local level in connection with source communities, groups and individuals can be diminished. Moreover, the vagueness of the 2003 Convention text in guiding States Parties to involve local communities in safeguarding their heritage has also been viewed as a potential hindrance to effective initiatives. In contrast, within the ecomuseological approach, the practitioners of ICH remain in control of how it is to be safeguarded, as well as by whom. Ever-changing circumstances are dealt with and decided upon by the owners of ICH and their safeguarding approach can, therefore, remain flexible.

It can be considered that ecomuseology, based on its guiding principles, promotes bottom-up heritage management initiatives, as well as a holistic view of how and why ICH is expressed. Based on research within the North East of England, this chapter has highlighted that ICH is specific, nuanced and local due to the particular relationships people have with it and the places in which it evolves and is expressed today. In essence, any safeguarding approach should be customised to these specifications. The growing acceptance of the 2003 Convention can be viewed as a movement towards treating ICH as universal, where a sword-dancing tradition from the North East of England is deemed representative of performing arts practices from around the world. Moreover, the safeguarding methods that are prescribed through the current framework may also become standardised. In this light, it can be argued that the specificity inherent to ICH may be neglected. Therefore, an effective safeguarding approach must embrace the diversity of ICH through initiatives that operate at the level where people value, transmit and change their heritage resources.

Acknowledgments

I would like to thank Gerard Corsane for our discussions on the applicability of the ecomuseological approach in safeguarding intangibles. Analysis of the links between ecomuseological practice and the nature of ICH has been guided by his expertise.

Bibliography and References

Beal, J, 2000 From Geordie Ridley to Viz: Popular Literature in Tyneside English, *Language and Literature* 9 (4), 343–59

Blake, J, 2006 *Commentary on the UNESCO 2003 Convention on the Safeguarding of the Intangible Cultural Heritage*, Institute of Art and Law, Leicester

Boylan, P, 1992 Is Yours a 'Classic' Museum or an Ecomuseum/'New' Museum? *Museums Journal* 92 (4), 30

—— 2006 The Intangible Heritage: a Challenge and Opportunity for Museums and Museums Professional Training, *International Journal of Intangible Heritage* 1, 53–64

Brown, M, 2005 Heritage Trouble: Recent Work on the Protection of Intangible Cultural Property, *International Journal of Cultural Property* 12 (1), 40–61

Corsane, G, 2006a From 'outreach' to 'inreach': how ecomuseums principles encourage community participation in museum processes, in *Communication and Exploration: Papers of International Ecomuseum Forum* (eds S Donghai, Z Jinping, P Davis, H de Varine and M Maggi), Chinese Society of Museums, Beijing, 157–71

—— 2006b Using Ecomuseum Indicators to Evaluate the Robben Island Museum and World Heritage Site, *Landscape Research* 31 (4), 399–418

Corsane, G, Elliot, S, and Davis, P, 2004 Matrix of enabling features and ecomuseum indicators and characteristics, unpublished document

Corsane, G, and Holleman, W, 1993 Ecomuseums: A Brief Evaluation, in *Museums and the Environment* (ed R De Jong), South African Museums Association, Pretoria, 111–25

Corsane, G, Davis, P, Elliot, S, Maggi, M, Murtas, D, and Rogers, S, 2007 Ecomuseum Evaluation: Experiences in Piemonte and Liguria, Italy, *International Journal of Heritage Studies* 13 (2), 101–16

Crawhall, J, 1883 *Crawhall's Chap-book Chaplets*, Field & Tuer, London

Davis, P, 1999 *Ecomuseums: A Sense of Place*, Leicester University Press, London and New York

—— 2011 *Ecomuseums: A Sense of Place*, 2 edn, Continuum, London and New York

De Varine, H, 1993 *Tomorrow's Community Museums* [online], available from: http://assembly.coe.int/Museum/ForumEuroMusee/Conferences/tomorrow.htm [10 June 2010]

Hafstein, V, 2009 Intangible Heritage as a List: From Masterpieces to Representation, in *Intangible Heritage* (eds L Smith and N Akagawa), Routledge, London and New York, 93–111

Harker, D, 1972 Introduction, in *Allan's Illustrated Edition of Tyneside Songs* (by T Allan), 7 edn, Frank Graham, Newcastle-upon-Tyne, i–vii

Interview Aa1, 2007 Anonymous interview with Rapper dancer, Cumberland Arms, Newcastle-upon-Tyne, 5 September

Interview Aa4, 2007 Anonymous interview with Rapper dancer, Cumberland Arms, Newcastle-upon-Tyne, 12 September

Interview Aa5, 2007 Anonymous interview with Rapper dancer, Cumberland Arms, Newcastle-upon-Tyne, 17 September

Interview Ab2, 2007 Anonymous interview with folk musician, The Sage Gateshead, Gateshead, 1 November

Interview Ab3, 2008 Anonymous interview with folk musician, The Sage Gateshead, Gateshead, March 2008

Interview Ab4, 2008 Anonymous interview with folk musician, Bridge Folk Club, Newcastle-upon-Tyne, August 2008

Interview Ac1, 2007 Anonymous interview with bagpiper, Cumberland Arms, Newcastle-upon-Tyne, 3 October

Interview Ac2, 2007 Anonymous interview with bagpiper, The Sage Gateshead, Gateshead, 1 November

Interview Ac3, 2007 Anonymous interview with bagpiper, The Alnwick Gathering, Alnwick, 10 November

Interview Ac4, 2007 Anonymous interview with bagpiper, The Alnwick Gathering, Alnwick, 10 November

Interview Ac6, 2007 Anonymous interview with bagpiper, Morpeth Chantry Bagpipe Museum, Morpeth, 18 November

Kirshenblatt-Gimblett, B, 1998 *Destination Culture*, University of California Press, Berkeley, Los Angeles and London

—— 2004 Intangible Heritage as Metacultural Production, *Museum International* 56 (1–2), 52–65

—— 2006 World Heritage and Cultural Economics, in *Museum Frictions: Public Cultures/Global Transformations* (eds I Karp, C A Kratz, L Szwaja and T Ybarra-Frausto), Duke University Press, 161–202

Kurin, R, 2004a Safeguarding Intangible Cultural Heritage in the 2003 UNESCO Convention: a critical appraisal, *Museum International* 56 (1–2), 66–77

—— 2004b Museums and Intangible Heritage: Culture Dead or Alive?, *ICOM News* 57 (4), 7–9

—— 2007 Safeguarding Intangible Cultural Heritage: Key Factors in Implementing the 2003 Convention, *International Journal of Intangible Heritage* 1, 10–20

Lawrenson, T, 2007 Lecture on the Rapper Dance, Cumberland Arms, Newcastle-upon-Tyne, 17 September

Lee, O Y, 2004 Preparing a Vessel to Contain Lost Life: Preservation and Successful Inheritance of Intangible Cultural Heritage, *ICOM News* 57 (4), 5–6

Loomis, O, 1992 Folk Artisans Under Glass: Practical and Ethical Considerations for the Museum, in *American Material Culture and Folk Life: A Prologue and Dialogue* (ed S Bronner), Utah State University Press, 193–200

Matsuzono, M, 2004 Museums, Intangible Cultural Heritage and the Spirit of Humanity, *ICOM News* 57 (4), 13–14

Murphy, J, 2007 Pipedreaming: Northumbrian Music from the Smallpipes to Alex Glasgow, in *Northumbria: History and Identity 547–2000* (ed R Colls), Phillimore, Chichester, 256–76

Nas, P J M, 2002 Masterpieces of Oral and Intangible Culture: Reflections on the UNESCO World Heritage List, *Current Anthropology* 43 (1), 139–48

Pinna, G, 2003 Intangible Heritage and Museums, *ICOM News* 56 (4), 1

Rapper Online, 2010 Introduction to the Rapper Sword Dance [online], available from: http://www.rapper.org.uk/intro/rapper.php [13 July 2011]

Rivard, R, 1984 *Opening up the Museum or Toward a New Museology: Ecomuseums and 'Open' Museums*, Québec (Copy held at the Documentation Centre, Direction des Musées, Paris)

—— 1988 Museums and ecomuseums: questions and answers, in *Økomuseumsboka-Identitet, Økologi, Deltakelse* (eds J Gjestrum and R Maure), Norsk ICOM, Tromsø, 123–8

Ruggles, D F, and Silverman, H, 2009 From Tangible to Intangible Heritage, in *Intangible Heritage Embodied* (eds D F Ruggles and H Silverman), Springer, London and New York, 1–14

Say, B, and Say, J, 2003 *A Brief History of the Northumbrian Smallpipes* [online], available from: http://www.nspipes.co.uk/nsp/ww3hist.htm [9 June 2010]

Smith, L, 2006 *The Uses of Heritage*, Routledge, London and New York

UNESCO, 2003 *Convention for the Safeguarding of the Intangible Cultural Heritage*, UNESCO, Paris, available from: http://unesdoc.unesco.org/images/0013/001325/132540e.pdf [18 July 2011]

—— 2011 *Intangible Heritage Lists* [online], available from: http://www.unesco.org/culture/ich/index.php?pg=00011 [13 July 2011]

—— 2012 *The States Parties to the Convention for the Safeguarding of the Intangible Cultural Heritage (2003)* [online], available from: http://www.unesco.org/culture/ich/index.php?pg=00024 [29 January 2012]

Yim, D, 2004 Living Human Treasures and the Protection of Intangible Cultural Heritage: Experiences and Challenges, *ICOM News* 57 (4), 10–12

Conversation Piece:
Intangible Cultural Heritage in Italy

Maurizio Maggi

Can you say something about yourself and your personal interest in ICH?

Since 1982 I have been a researcher within a government organisation, the *Istituto Ricerche Economico Sociali del Piemonte*, based in Turin, Northern Italy. Within this organisation, which is a section of the Piedmont regional government, I have focused to a large extent on local development and its relationship with the natural environment and heritage resources. Exploration of these kinds of relationships necessarily involves consideration of the concept of intangible heritages, including how they relate to economics. Intangible heritages are very important to the economy because of their connections to, for example, environmental quality and a sense of community; people need to feel secure, have a sense of well-being, develop their creativity and a sense of trust. All of these factors are related to social capital and I feel that these 'invisible' aspects of community life affect visible economic phenomena. Like distant planets on a cloudy night, we are not always able to observe them directly, but we cannot ignore their impact on the heavens.

In Italy, the state bureaucracy 'owns' – or at least has responsibility for – almost the entire natural and cultural heritage. At the national level then, heritage is regarded as a concept mainly connected with material things. However, the regional governments and associated institutions, who own very little, are more open-minded on the matter of ICH. Hence, the cultural background of the regional research institute in which I work is a favourable environment for due consideration of the documentation, safeguarding and transmission of intangible heritage.

In Italy, were there policies already in place that have dealt with intangibles before UNESCO's 2003 Convention?

Intangible heritage is a flexible concept in Italy. Accustomed to managing material culture, the state bureaucracy reluctantly deals with this new concept and, when necessary, handles it as a new kind of material heritage, as entities that, as Byrne (2009, 229) suggests, are 'fixed and immutable rather than fluid and socially determined'. The reason for this is deeply rooted in the historical shaping of the Italian unitary state. Italy, as a state, was created *manu militari* in 1861 by the action of Piedmont, a single militaristic mini-state. Since the foundation of Italy as a country the problems of coordinating and implementing policy with the regions have conditioned the authority and the leadership of central government. Cultural policies have been seriously affected by these constraints. Deposing the sovereigns of the many pre-existing Italian mini-states was accompanied by intentional fragmentation of their regional heritages, a literal transportation

of objects from their original sites to Rome: a true *diaspora* of local culture (Pinna 2001, 63).[1] This process of repressing regional identities was intended to be followed by the recomposition of a new national identity. However, this failed, although the dismembering of the heritages of pre-unification states was successful, with effects that are still visible in the public administration and organisation of culture today. In fact, the repression of the symbolic significance of historical objects, accompanied by the enormous importance attributed to their physical preservation, has meant that the government's approach is to prioritise safeguarding historical objects without considering their significance, meanings and values. Having trained its personnel accordingly, the national government is unprepared to deal with the emerging recognition of complexity in the heritage field: like a hammer, they see every problem as a nail.

The situation is quite different at the regional and local level; the majority of the 21 Italian regional governments have policies on the subject of ICH. Even though these policies are some-times confused, incoherent or aligned with state 'reification of culture' (Byrne 2009, 229), the interest in local arenas reveals a revitalised interest in intangible heritage. Furthermore, the poli-cies also reflect sympathy towards, and interest in, ICH on behalf of the politicians and heritage professionals working in Northern and Southern Italy.

The first initiatives specifically connected to ICH date to the late 1970s and consisted mainly of festival sponsorship and other performing arts events, organised on the township level. Many traditional local celebrations were rediscovered and revitalised. For decades, celebrations such as the Patron Saint Day, or Easter, have been carried out by local churches and the Pro Loco:[2] more than 6000 grass-roots volunteer groups with some 600,000 members nationwide. The heritage departments of regions and towns, especially in Northern and Central Italy, supported many traditional celebrations – dances, songs, parades – generally connected to the Easter day (but often with pre-Christian origins) or to the Carnival. For instance, in Piedmont, Northern Italy, 'Cante` j ov' is performed at Easter by young men begging for eggs and singing in front of farms; in Tuscany and other regions of central Italy, 'Cantamaggio', a procession of the 'maggiaioli', consists of people singing at each local house, generally on the last night of April, to celebrate the advent of Springtime and the awakening of Nature; in the Salento area, in southern Italy, 'Pizzica' is a dance that is supposed to derive from the rituals of Dionysius and, until the 1950s, was regarded as having exorcism properties.

However, some unsuccessful stories also demonstrate the limit of those policies. In Northern Piedmont, not far from the Swiss border, had lived the Walser, a Tittschu-speaking minority, since the 13th century. Their remarkable large wooden houses were the most outstanding tangible heritage element there and they contributed, together with some important intangible elements (the language above all), to a distinctive sense of place. However, the houses were the main focus for public heritage policies; even now the name 'Walser' is spontaneously associated mainly with a distinctive style of architecture. Although initiatives were also undertaken to preserve the language and other intangible elements, this was done in a piecemeal fashion. As a result, the value of their architectural heritage increased and many residents sold their houses to tourists from Turin, Milan or other urban areas. Aware of their value, but also of their price, they received

1 '[…] a cultural policy which was designed to destroy the symbols of the former Italian States dating back to the days before unification, while at the same time seeking to construct and disseminate new symbols of the new nation.'
2 Literally: 'for the place'.

considerable income from the sales which they spent on contemporary-style houses. These were generally built near the historical ones, altering the scenery and disturbing the distinctive sense of place. Nowadays, 3500 people living in the area still speak Tittschu but their numbers are declining severely.

If there were policies in place before the 2003 Convention, how has ICH been conceptualised within Italy before the Convention?

For years, regional and city policies focused mainly on funding initiatives, such as those mentioned above, as well as on raising awareness of them. These actions supported the livelihoods of volunteers already involved with traditional practices, which can be argued to be consistent with what the 2003 Convention states as 'measures to ensure the safeguarding of the intangible cultural heritage'.[3] However, these approaches tended to view ICH as a series of 'products', as opposed to the 'processes' within which it evolves and is given meaning. Failing to recognise this evolutionary perspective, the result of the local government policies during the 1970s and 1980s was twofold. On the one hand, they gave recognition to many expressions of intangible cultural heritage; on the other, they encouraged their absorption in the production chain of the heritage industry, hence facilitating a general process of trivialisation of ICH. More recently, local administrators have regarded ICH as important for preserving cultural diversity, seen as a strategic means of enhancing local competitiveness. Hence, ICH policies are more and more considered within the general framework of sustainable development and through the specific policies for landscape and spatial planning.

What initiatives/projects are already underway in order to safeguard cultural practices?

Cultural practices are mainly supported by funding the local groups who perform them, such as theatre companies or choral groups. The regional governments are the most important sponsors. The risk of trivialising those practices is still relevant, especially because of pressures from the tourism industry, interested in the short run exploitation of cultural landscapes.

How is the current term, 'intangible cultural heritage', conceptualised in Italy?

ICH is still interpreted as conservation of the past and not as conservation of the necessary conditions for self-preservation and evolution. This approach completely dominates at the state level and is very strong at the regional one, dependent on the region and the individual formulating policy. But, even when ICH is correctly interpreted as something different from a mere new kind of material heritage, a community-based approach to management is seldom adopted. The social actors (local cultural groups, small museums, minorities) involved in specific kinds of ICH activities are regarded as possible recipients of public funding, but within the strict borders of existing legal instruments and cultural policies: if they are eligible, they are funded; if they are

[3] As stated in article 11/a of the 2003 UNESCO Convention.

not, they are ignored. The idea of changing the instruments and creating new policies in order to take advantage of the potential represented by those actors is rarely considered.[4]

What is currently happening in Italy with respect to the 2003 Convention?

The UNESCO ICH list includes two Italian elements: the Sicilian puppet theatre known as the 'Opera dei Pupi' and the polyphonic singing 'Canto a tenores', peculiar to the pastoral Sardinian tradition. They were included in 2001 and 2005 respectively, but no initiatives were taken to support them. Sicily and Sardinia are autonomous regions, with more powers in many fields, heritage included, but the main initiatives until now consisted of regional funding to the munici-palities for the performing of 'Opera dei Pupi' and 'Canto a tenores'; in effect they are regarded as the same as other local cultural initiatives but without any specific relevance or status. The Sardinian regional government showed concern about the trivialisation of the 'Canto a tenores' operated by the tourism industry which pressed the choral groups to perform only specific songs, and songs not necessarily original to the place where they were being performed. No specific countermeasures were implemented or suggested.

In June 2008, the Italian Senate passed a motion supporting the inclusion of the Mediterra-nean diet in the ICH list. The initiative, a joint effort between Italy, Spain, Greece and Portugal, aims to preserve a common culinary identity including oral traditions and expressions, social practices, rituals and festive events and a wide range of aspects connected with the anthropology of alimentation.

What plans are being made with respect to safeguarding ICH at the national/regional/local levels?

The central state has provided very little support, even in terms of arranging meetings or promoting traditional information initiatives. At the regional level, the most interesting policy is the support for ecomuseums, now regulated by law in seven regions. Some interesting practices are also provided by local groups following more traditional approaches. The National Union of Pro Loco, for example, with the initiative 'Abbraccia l'Italia – Antichi saperi e nuovi linguaggi' ('Embrace Italy – traditional jobs and new languages'). The basic message is that culture can promote social inclusion and local identity, with two main effects. First of all, the sense of community can enhance local relationships; secondly, a more evident character of the place can mobilise resources for local sustainable development. But this vision is quite far from the approach taken by the Ministry for Heritage: as a matter of fact, the initiative is sponsored by the Employment and Social Policies Ministry.

What are the responses (public, scholarly, heritage sector professional) to the 2003 Convention/the ICH concept in Italy?

The public administrations, especially the local ones, deal with ICH by funding events, meetings or exhibitions. Scholars highlight the importance of ICH, but generally do not suggest policies;

4 The ecomuseum regional laws were a notable exception: they moved from the idea of creating a new policy, able to also mobilise actors normally considered irrelevant in cultural policies.

when they do, they are generally ignored. Professionals are more influential in the policymakers' domain, but they are deeply involved in the big events policies because they provide services for them; they have few motives to criticise present policies, as they are among their main beneficiaries.

How are museums and heritage organisations involved in safeguarding ICH in Italy?

The involvement of museums and heritage organisations in safeguarding ICH depends on their participation in the local governance process. But even in areas of the country where governance is more active, the role of museums is regarded simply as a repository of objects more than potential players in a complex social project.

What problems do you foresee as emerging from UNESCO's guidelines for safeguarding ICH in Italy?

The connection between intangible heritage and local social processes is clear: cultural diversity and therefore ICH barely survive in a declining social and economic context. Difficulties arise due to many reasons:

- Policymakers follow different tracks; at the state level and partly at the local level, they implement conservative policies targeting only the outstanding part of the ICH. Part of the local government believes in an evolutionary approach and treats ICH also as 'processes' and not only as 'things'.
- The instruments adopted at the local level have often provided encouraging results, but they are restricted by population size and geographical extent. Many local initiatives proved to be successful, but how can we best spread good practices?
- The effectiveness of the 'process-based' approach is generally recognised, but the managers in charge of cultural policies still control complex machines: offices, budgets, networks of consultants and professional business, personal expertise and authoritativeness, recognition. As a result, restructuring priorities or processes to encourage ICH activities is neither easy nor painless.
- Demographic decline is a serious problem for innovative policies, especially at the local level. Social processes need social actors. While turnover in rural areas is negative, urban areas are still growing because of inflows from abroad. But in the absence of any reliable integration and immigration policy, this negatively affects citizenship and the care for places. As a result, it is very difficult to promote social processes able to promote a new role for ICH in both theatres.

If there are foreseeable problems, what alternatives could be used in order to safeguard ICH effectively?

If what allows a traditional practice to endure for centuries stems from its social function, recognised within a certain community, then its potential to disappear lies with the disintegration of its community and the decline of its social vigour. According to this point of view, each example of cultural diversity should be regarded from an ecological point of view, as the epiphenomenon of a more complex system, where it is almost impossible to preserve a part if all the rest changes. Even the most enduring and ancient traditions, such as some pre-Christian and pre-

Roman rituals, survived because they preserved a part of themselves and modified another part, in accordance with the social changes of the surrounding environment. In a word, they evolved.

Are any alternative methods being used at this time? (please describe)

In the middle of the 1990s some innovative policies for ICH emerged at the local level. Here, many innovative local authority managers realised the complexity of the cultural domain, the significance of the relationship connecting tangible and intangible heritage and the relevance of the social and economic background. They also had valuable expertise in fields such as local development.

In 1995, the Piedmont regional congress passed three laws on heritage. Notably, they tried to preserve the local heritage and the sense of place of many rural small towns and villages. Two laws dealt respectively with vernacular architectures and historical craft workshops and laboratories. Cataloguing was their main instrument, a rather traditional approach. A relatively new model of museum inspired the third law: the ecomuseums law. The name sounded quite eccentric and the concept vague, at the beginning. The clearly-stated ambition was to preserve the local heritage, both tangible and intangible, in a lively way, leaning on participation and community involvement, taking into consideration the social and economic background of a local society and not only its culture. Although the first steps were uncertain, at the beginning of the new decade, in 2000, the first new cultural creatures began to colonise their niches. An emblematic case study will illustrate how.

This is the case of the 'Ecomuseo dei Terrazzamenti e della vite' (the Ecomuseum of Terraces and the Vine). It is located in the Langhe, a hilly district situated more or less between Turin and Genoa. Cortemilia is a little town with just over 2000 inhabitants; its area is intensely covered with terraces, which are now albeit abandoned. The whole Bormida Valley made news headlines in the 1980s due to pollution caused by just one factory, which had considerably damaged the entire natural environment of the valley floor and consequently the economic and social situation. Following fierce protests the factory was closed but the decline, especially in social and demographic terms, continued. The production of high-quality wines, for instance, affected by fogs full of phenols, was abandoned and the techniques and *savoir faire* deteriorated too, with entrepreneurial self-confidence vanishing altogether. In 1994 severe flooding caused a landslide which risked destroying part of the town. Restoration work was carried out and, taking advantage of the law on ecomuseums, the following year the decision was taken to recover the heritage made up of the terraces once used to grow vines. Terraces are not peculiar to this area only (they can be found all over the planet, where there are hills suitable for cultivation) but in this area they are particularly dense compared with the rest of Piedmont.

Initially the project did not mobilise the residents, who had long since been resigned to submitting to gradual decline, and the municipal council failed to understand the project's potential, seeing it as nothing more than a source of extra income. Therefore, the ecomuseum limited its activity to the recovery of part of a small terraced slope, with its paths, dry stone buildings, cultivations and the restoration of an historical building in the middle of the town to house the ecomuseo headquarters. The initial financing arrived in 1997 and the building was opened to residents in 2001. Here, an interpretive display highlights the relationships between the themes and elements of the terraced landscapes; the functions and values of the places are explained. The building also houses a themed section devoted to the landscapes and societies of the world

characterised by dry stone constructions, a reading room (also used for temporary exhibitions) and a projection and conference room. An alphabet poster on the local distinctive features of the place was produced with the young pupils of the local school. It involved, of course, their parents and grandparents and proved to be an effective way of also attracting the adults' interest and of sparking curiosity about the local heritage, both tangible and intangible. Little by little, interest was aroused in the terraced landscape, previously ignored or classed as a useless residue from the past. In the meanwhile, the ecomuseum launched a literary prize for children's books, 'Il Gigante delle Langhe' (The Giant of the Langhe). Its aim was to operate on a symbolic level too, creating imaginary meanings in relation to the terraced landscape. The award ceremony has now become a regional event and the jury comprises artists and writers of national renown. Stories inspired by the terraces are sent in by children from schools from all over the Piedmont.

A community exhibition on local recipes was a second occasion to highlight the local resources and provoked a lively debate among the families on the traditional ways of processing them. Together with the recipes, related gestures and jargon, dishes were collected, inventoried and published in a recipe handbook then gifted to the participating people. Another community exhibition 'objects seeking, but along with stories', asked people to lend simple everyday objects, relevant for personal reasons, but accompany them with their anecdotal stories. The result was a very vivid portrait of the local community over more than half a century that mixed tangibles and intangibles in a fascinating way.

The ecomuseum also committed to conserving and transmitting specialised knowledge related to the construction of 'small architectures' of a rural nature: a small dry stone construction known as a 'scau', a circular building used for drying chestnuts, was recovered and rebuilt, with the involvement of the elderly residents and using their knowledge, skills and memories. Now it is once again used to dry chestnuts. Small packages of dry chestnuts and chestnut flour are marketed and a once forsaken ceremony takes place, once a year, around it.

Dynamic in its research and in national and international collaborations, the ecomuseum then undertook to recover an abandoned farm (Monteoliveto) overlooking the town, transforming it into a living meeting place for the organisation of various activities linked with local culture but also with productive aspects such as that of high-quality wine. A series of well-integrated events took place here between 2001 and 2003. First of all, the site, which comprises a farming area on terraces and a farmhouse, was purchased by the ecomuseum for a modest sum. A project for its recovery and reuse was then elaborated and the sites began operating in spring 2003. In the summers of 2002 and 2003, two summer work camps mobilised young people from different European regions in the recovery of the terraces around the building. The activity was carried out with the aid of local experts, mainly older people still able to build using the dry stone technique.

The project produced very important developments for the recovery of local wine production. The ecomuseum produced a small quantity of very high-quality wine, making it clear that modern and competitive wine activity was both technically possible and economically profitable. In 2003 an organised group of local winegrowers united under the label 'Produttori Associati dei Terrazzamenti della Valle Bormida'. Promoting their wines jointly and using the 'Terrazzamenti' name was an expression of the importance acquired by this architectural element, which had vanished completely from the local area prior to the activity of the ecomuseum. It is also significant in this sense that several producers, with no connection to the project, chose a name ('il vino dei terrazzamenti' – the wine of the terraces), which refers to the same symbol.

About 10 years from the official start of the ecomuseum activity, we can observe some signifi-

cant results as far as ICH is concerned: people are more committed in preserving the general sense of place; some local culinary and ceremonial traditions flourished again; the terraces are used as a trademark and knowledge of dry stone building is now seen as something relevant and worthy. Above all, these intangible aspects are now connected to quality and sense of place, rather than to nostalgia.

Another interesting practice developed during the same time, originating in England: Parish Mapping. A Parish Map is a participative visual representation of the distinctiveness of a place. It is made by a group of volunteer residents, following questions such as: what is important to you about this place, what does it mean to you? What makes it different from other places? What do you value here? (Clifford 1996, 4). Originally introduced by the English charity Common Ground, Parish Mapping is now an important activity for many ecomuseums and is carried out by them. Following initial practice in Piedmont and other areas of Northern Italy, a significant evolution is now taking place in Puglia, in the South. There, many maps have been developed by volunteer groups and the regional department for spatial planning has decided to include them in the new regional landscape plan due to their ability to represent the values of places – aspects not usually detected by official planning procedures. Archives, catalogues, aerial pictures and planimetrical sketches: all of these tools quite exhaustively cover the tangible heritage, but almost ignore the intangible. Although planners perceive it, they are not able to distinguish between what is still living in contemporary practices and what is just a relic. Moreover, they do not consider the relationship between intangible heritage as experienced phenomena and the invisible social actors who keep them alive. They are unaware of their problems and weaknesses. Parish Maps alone cannot be the key, but they certainly add value to ordinary heritage instruments – not only for their sensitiveness to intangible values: the collective discovery that takes place in a mapping group requires negotiation among the participants about the importance of the values themselves. Hence they take a picture of the social feeling related to the ICH, precisely what other ordinary instruments have difficulty surveying.

What are the strengths of the 2003 Convention with respect to implementing it in Italy?

At the moment, the ICH Convention is just an opportunity to implement old policies in a new field. The main efforts of UNESCO in Italy should address making the policymakers aware that we need new policies that encourage community-based heritage management and mobilise new actors.

Bibliography and References

Byrne, D, 2009 A Critique of Unfeeling Heritage, in *Intangible Heritage* (eds L Smith and N Akagawa), Routledge, London and New York, 229–53

Clifford, S, and King, A (eds), 1996 *From place to PLACE, Maps and Parish maps*, Common Ground, Champaign, IL

Pinna, G, 2001 Heritage and 'Cultural assets', *Museum international* 2 (53), April–June, 62–4

Looking to the Future:
The *en-compass* Project as a Way Forward for Safeguarding Intangible Cultural Heritage

GERARD CORSANE AND ARON MAZEL

INTRODUCTION

The value of Intangible Cultural Heritage (ICH) resources, as defined in the Introduction to this volume, has been receiving increasing recognition internationally during the last few decades. This is in large part due to the recent work that has been undertaken by UNESCO before and after the adoption of the *Convention for the Safeguarding of Intangible Cultural Heritage* (UNESCO 2003) at the 32nd session of its General Conference in 2003. The Convention entered into force on 20 April 2006 after the terms of Article 34 within it had been met and 30 States had ratified it by 20 January of that year. Since then the recognition and interest of ICH has continued to escalate and, by January 2012, 142 States Parties have deposited their respective instruments of ratification, acceptance, approval or accession to UNESCO (UNESCO 2012a). Furthermore, within these countries, organisations and bodies at a number of levels have conducted work and developed programmes and projects to document, safeguard and promote ICH resources. These actions have become crucial, with so many ICH resources, traditional practices and cultural expressions being under threat from phenomena such as industrialisation, modernisation, urbanisation and globalisation. With the ongoing loss of these resources, practices and expressions, there is the need for practical and sustainable ways to safeguard these valuable aspects of heritage as forms of social, cultural and identity capital.

A later UNESCO convention that has further bolstered the interest and work around safeguarding ICH and cultural expressions around the world is the *Convention on the Protection and Promotion of the Diversity of Cultural Expressions* (UNESCO 2005), which was adopted by UNESCO during the 33rd session of its General Conference in Paris on 20 October 2005. It came into effect on 18 March 2007 under the terms of Article 29 of the Convention which had been met. By January 2012, 120 States Parties and one regional economic integration organisation, the European Commission, had deposited their State instruments of ratification, acceptance, approval, or accession of the Convention with UNESCO (UNESCO 2012b). This convention noted the 'importance of cultural diversity for the full realization of human rights and fundamental freedoms proclaimed in the *Universal Declaration of Human Rights* and other universally recognized instruments' (UNESCO 2005, 1; see also Article 2).

Cognisant of the substantial strides which have been taken during the last decade with the recognition and safeguarding of ICH resources, this chapter will outline a particular project that was developed in order to help further safeguard and promote cultural products and expres-

sions, including ICH, under threat in four different parts of the world. In 2008, the European Commission issued a call for funding bids entitled *Investing in People: Access to local culture, protection and promotion of cultural diversity* (European Commission 2008), hereafter referred to as the *Investing in People* scheme. In response to the call, the International Centre for Cultural and Heritage Studies (ICCHS) of Newcastle University (UK) developed a partnership with organisations in the People's Republic of China, Kenya, and Guyana to prepare a bid for this call. The successful bid was given the name of *en-compass – an international diamond of cultural dissemination, capacity building with countries from the North, East, South and West* (referred to hereafter as *en-compass*) (Corsane and Mazel 2009). This project provides a model and a way forward for the promotion and safeguarding of ICH using a multinational approach.

Through providing the outline of the project and sharing some of the completed and ongoing activities, the key aims of this chapter are to highlight the factors that informed the different aspects of the project, to describe its development so far, and to consider some of the lessons that have been learnt. The chapter is divided into sections that deal with: project partners; the call for *Investing in People* proposals; the bid proposal (from proposal submission to launching the project); developments to date; and brief conclusions.

Project partners

A key element of the project was to ensure that there were partner organisations in the arts, cultural and heritage sectors that shared and subscribed to similar values, with remits that matched the aims and objectives of the bid. In particular, the partners needed to have an interest in indigenous and ethnic minority communities, as well as in safeguarding tangible cultural products and intangible cultural expressions. This was ensured, as the authors already had established contacts with three appropriate potential partners in China, Kenya and Guyana and knew the missions of the three organisations approached.

The Chinese partner is the Hainan Provincial International Cultural Exchange Centre (HPICEC), which is an affiliated institution of the Department of Culture, Radio, Television, Publication and Sports of Hainan Province (Hainan Government 2011). The partner in Kenya, Africa, is the Centre for Heritage Development in Africa (CHDA), which is an international non-governmental organisation (NGO) 'dedicated to the preservation, management and promotion of cultural heritage in Africa through a programme of training and development support services. Its core value is in the preservation of immovable, movable and intangible Cultural Heritage in Africa' (CHDA 2011). This organisation is an important point of contact in Africa for Anglophone countries and engages with a wide range of stakeholders. The third partner is the Iwokrama International Centre for Rainforest Conservation and Development (IIC) in Guyana, South America (Iwokrama 2009). This organisation has responsibility for one million acres of protected rainforest in central Guyana that the Guyanese Government gifted to the international community in 1989. Central to the IIC is the concept of a truly sustainable forest, which involves the mutual reinforcement of conservation, environmental balance and economic use of forest resources. This is achieved by working closely with a range of shareholders, most especially the local communities through the umbrella body of the North Rupununi District Development Board (NRDDB), which is an autonomous body that represents the inhabitants of the local Amerindian villages (Forest Connect Guyana – Iwokrama 2008; see also Bowers and Corsane, Chapter 17, this volume).

The 2008 European Commission's *Investing in People* scheme's call for bids was informed by the May 2007 *Communication on a European Agenda for Culture in a Globalising World*. This document states that:

> Culture lies at the heart of human development and civilisation. Culture is what makes people hope and dream, by stimulating our senses and offering new ways of looking at reality. It is what brings people together, by stirring dialogue and arousing passions, in a way that unites rather than divides ... World-wide, cultural diversity and intercultural dialogue have become major challenges for a global order based on peace, mutual understanding and respect for shared values, such as the protection and promotion of human rights and the protection of languages.
>
> (Commission of the European Communities 2007, 2)

On referring back to the above-cited document and the *Convention on the Protection and Promotion of the Diversity of Cultural Expressions* when reading the guidelines for the *Investing in People* bid, the authors noted how much the call was based on, and influenced by, these two documents. The sentiments expressed in these two documents resonated strongly with the authors, especially where statements brought together the links between development and culture.

Moving to the *Investing in People* guidelines for bid documents, the authors related particularly strongly to the following passage:

> the programme promotes access to local culture along with protection and promotion of cultural diversity, in order to contribute to mutual understanding and dialogue between peoples and cultures, to encourage cultural diversity, to serve as a reminder that all cultures deserve the same dignity and to strengthen cooperation and experience-sharing in the various fields of culture, education and research. This holding true in general, special attention needs to be paid to the protection of the social, cultural and spiritual values of indigenous peoples and minorities to fight social inequalities and injustices in multi-ethnic societies.
>
> (European Commission 2008, 4)

In addition, the authors believed that they could develop a proposal with the partners identified which would meet the two general aims of the call, which were to facilitate:

1. strengthening local culture, access to culture and dissemination of culture and, in exceptional cases, supporting protection of cultural heritage in imminent danger;
2. promoting all forms of cultural expression which contribute to the fight against discrimination, be it gender-based, ethnic, religious, as well as discrimination recognised in traditional and customary practices (ibid).

Moreover, although the call suggested that any proposal should help to achieve one, or several, of the eight identified specific objectives (European Commission 2008, 5), the authors felt that, with the partners, their proposal could meet all eight, as will be shown in the next section of this chapter. All eight were taken verbatim as the specific objectives (SO) for *en-compass*. In addition, the guidelines for the call also listed ten general expected results that any project could aim to achieve (European Commission 2008, 5–6). Again, the authors felt that *en-compass* could prob-

ably achieve all ten. In the next section it is noted that the ten general expected results (GER) were also expressed word-for-word in the proposal.

Finally, the authors also considered a set of examples provided in the guidelines as a scope of 'indicative types of eligible activities' (ibid) and felt that *en-compass* would include many of these, such as awareness campaigns and activities, cultural exchanges, networking, training, capacity building, and identification and planning activities.

Response included in the bid proposal

With all that was contained in the call for bids, as outlined in the previous section, the authors believed that they could develop a proposal that would start a process of activities and actions that would meet the requirements of this *Investing in People* scheme. In terms of process, they had to first submit a Concept Note in the first round of the call. Once this was selected, they were given the opportunity to enter the second round of the call for proposals. This involved the completion of *Grant Application Form (Part B), Annex A*. In writing this section of the chapter, the authors have decided to include the original wording of parts of *Annex A* of the full bid to guarantee that the essence and the sentiments contained in the bid are clearly reflected and the relevance to the scheme's specific priorities and objectives are clearly articulated.

In the introduction to the proposal, the authors noted that:

> The increased pace and scale of globalisation has resulted in people and communities from disparate parts of the world coming into contact with each other in a way that has not happened previously. These processes have enabled people in the developed world to gain some access to cultural expressions and products from the lesser developed parts of the world. However, this has not always resulted in a mutually beneficial situation, because people and communities in the developing world have fewer opportunities to engage with the 'free exchange and circulation of ideas, cultural expressions and cultural activities, goods and services, and to stimulate both the creative and entrepreneurial spirit in their activities'.
>
> (UNESCO 2005, 6; Corsane and Mazel 2009, 5)

In order to meet the above challenge, *en-compass* aimed to:

> develop a series of internationally vibrant and meaningful 'building-block' exchange and training opportunities … It is likely that the benefits will move beyond provincial and country borders, as participants in the exchange and training programmes cascade their experiences and learning nationally and internationally. The promotion of a 'cascading' approach will be built into the programme. (ibid)

Through these exchange and training opportunities, the project set out to follow:

> the tenets outlined in the introductory comments, objectives and guiding principles of the *Convention on the Protection and Promotion of the Diversity of Cultural Expression* (2005, UNESCO). In particular, it will meet the aim articulated in Article 14(b) of this convention by providing for 'capacity-building through the exchange of information, experience and expertise, as well as the training of human resources in developing countries, in the public and

private sector relating to, *inter alia*, strategic and management capacities, policy development and implementation, promotion and distribution of cultural expressions, small-, medium- and micro-enterprise development, the use of technology, and skills development and transfer'.

(UNESCO 2005, 9)

Apart from developing opportunities for exchange and training, the authors also believed that *en-compass* had potential for incorporating two further 'added values'. The project should help with (i) the development of sustainable heritage tourism and (ii) raising awareness of the fight against climate change, especially in relation to the partner organisations, where there are substantial tracts of rainforests in their countries. The authors were particularly keen to emphasise that:

the division between cultural and natural environments is artificial ... [and] ... that the development of cultural environments and processes are interwoven with how people interact with their natural environments ...This is important as the action will be able to engage with cultural diversity and show how it can impact on significant perspectives about issues like climate change and global warming. (Corsane and Mazel 2009, 7)

When turning to the overall objectives (OO) of the project, the authors divided these into three. These three were based on the aims 1 and 2 of the call as stated in the previous section of this chapter. The overall objectives of *en-compass* were expressed as:

OO1. to strengthen local cultural expressions, production and services;
OO2. to improve access to culture, dissemination of culture; and,
OO3. to support protection of cultural heritage in imminent danger. (ibid)

It was also noted that in working towards achieving these overall objectives:

special attention will be paid to the cross-cutting second core aim as expressed in the *Investing in People – Culture* 'Call' which emphasises 'promoting all forms of cultural expression which contribute to the fight against discrimination, be it gender-based, ethnic, religious, as well as discrimination recognised in traditional and customary practices'. (ibid)

When considering forms of discrimination, the authors felt that in the three countries of the non-Newcastle University partners there were bodies, policies and programmes that were aimed at promoting the cultural expressions and products of indigenous and ethnic minority groups. The authors believed that any forms of discrimination that impacted on communities in these countries are more often linked to:

globalisation where dominant western cultural expressions, products and services have become internationalised to the detriment of local cultural diversity, particularly with small scale cultural entities. Concerns about these predicaments are clearly expressed in the *Convention for the Safeguarding of Intangible Cultural Heritage*, where it is stated that 'recognizing that the processes of globalization and social transformation, alongside the conditions they create for renewed dialogue among communities, also give rise, as does the phenomenon of intolerance, to grave threats of deterioration, disappearance and destruction of the intangible cultural

heritage, in particular owing to a lack of resources for safeguarding such heritage ...' (UNESCO 2003, 1). These issues have jeopardised culture in smaller communities and territories and in some instances have actually led to the extinction of cultural resources. The *en-compass* action is proposed in direct response to these urgent needs for action to mitigate against imbalances, threats and global discrimination. It will 'provide opportunities for domestic cultural activities, goods and services among all those available within the national territory for the creation, production, dissemination, distribution and enjoyment of such domestic cultural activities, goods and services' (UNESCO 2005, 6; Corsane and Mazel 2009, 7–8).

With these overall objectives identified, the authors developed the logical framework in which the purpose of *en-compass* was noted 'to increase capacity, through planned exchange and training programmes, of cultural and heritage practitioners from China, Anglophone Africa and Guyana to identify, promote and safeguard cultural expressions and products' (Corsane and Mazel 2009, 8).

The authors then went on to develop specific objectives (SO) of *en-compass* which can be seen to map directly onto the wording of the specific objectives contained within the call:

SO1.　to contribute to the development and production of cultural events promoting local culture in developing countries;

SO2.　to improve access of people in developing countries to local and foreign culture;

SO3.　to promote dissemination of cultural production from developing countries towards the EU and other developing countries and regions;

SO4.　to promote intercultural dialogue and all forms of cultural expression in respect of cultural diversity and gender equality, as well as religious and ethnic diversity;

SO5.　to raise awareness of the role of culture in social cohesion and in fighting all forms of discrimination, including those accepted by customary law;

SO6.　to promote the exchange of expertise and best practices between cultural actors and promoters;

SO7.　to support capacity-building in the cultural sector at locally and regionally; and,

SO8.　to preserve cultural heritage at risk in the short term.

(Corsane and Mazel 2009, 8)

The authors continued by including the general expected results (GER) taken from the guidelines for the call. These were:

GER 1.　Improved access to culture for people in developing countries, including both local and foreign culture;

GER 2.　Improved ownership of populations in developing countries of their own culture, whilst fighting discrimination;

GER 3.　Increased flows of cultural production from developing countries towards EU and into other developing countries;

GER 4.　Improved capacity for training and professionalization in the cultural sector;

GER 5.　Improved capacity of private and public culture promoters to preserve, make accessible and use cultural heritage and creation;

GER 6. Channels for cultural exchanges developed, especially for remote and isolated countries and regions;

GER 7. Reinforced networking and partnerships, good practices exchanged;

GER 8. Improved conditions of creation and production;

GER 9. Improved conditions for preservation and ownership of cultural heritage;

GER 10. Cultural heritage at risk safeguarded.

(Corsane and Mazel 2009, 8–9)

From this platform, the authors then developed the six specific expected results (SERs) of *en-compass*. These were then mapped onto the three years of the project, along with the corresponding SOs and GERs listed above (Table 21.1).

Table 21.1. Overview of the Specific Expected Results and how they map on to the 'Call for Proposals' objectives and the 'Call' examples of General Expected Results

Specific Expected Results	Mapped SOs and GERs from *Investing in People – Guidelines for Grant Applications*	
Year 1		
SER1	International team following a coherent programme of action to mobilise people in their countries by conducting awareness and dissemination campaigns.	SO4, SO5, SO6, SO7, SO8 GER1, GER2, GER6, GER7, GER9
SER2	Initial inventory of cultural heritage resources in each partner's country, including those at risk in the short-term, and database of heritage practitioners.	SO3, SO8 GER1, GER2, GER5, GER9, GER10
SER3	Travelling exhibition that will be hosted in Newcastle upon Tyne (UK), Hainan Province (China), Kenya and Guyana. Material supporting this exhibition will also be made available online so that other countries, especially those in the EU and Anglophone Africa, will have access to information about cultural expressions and products from developing countries.	SO1, SO2, SO3, SO4, SO5, SO6 GER1, GER2, GER3, GER6, GER7
Year 2		
SER4	Development of a cadre of heritage practitioners with a sound knowledge and appreciation of the protection, management and interpretation of cultural heritage resources and expressions. The training to take place in Hainan Province, Kenya and Guyana.	SO4, SO5, SO6, SO7, SO8 GER2, GER4, GER5, GER7, GER8, GER9, GER10
SER5	Production of research outputs and teaching material to disseminate and raise the profile of local tangible and intangible heritage practices and knowledge systems.	SO4, SO6 GER7
Year 3		
SER6	Develop a group of well-trained and motivated students with the skills and knowledge to return to their own territories to provide capacity-building training programmes at different levels to support the preservation of culture at risk.	SO4, SO5, SO6, SO7, SO8 GER4, GER5, GER7, GER10

In order to deliver the SERs, the authors designed three years of activities. In the first year it was planned that ICCHS and the other partners would each select three participants who would come together as a team for dialogue and cultural exchange. This team of 12 people would first be brought together in Newcastle for discussions and training in an initial week-long workshop.

During this workshop they would consider cultural expressions and products under threat in their own countries. They would then think about how these cultural heritage resources could be documented and records created for a database. At the workshop consideration was also to be given to how the general public could be made more aware of the value of these resources and how to reduce the threats they faced. It was intended that these participants would be able to help develop a programme where processes and tools to scope, identify and document cultural heritage resources could be developed. Following the initial workshop in Newcastle it was planned that the team of 12 participants would travel to each of the other three partner areas in turn to participate in two-week in-country scoping workshops to observe cultural expressions and products *in situ* and to further develop the scoping and documentation processes and tools, leading to the recording of at least 15 cultural expressions and products in each country. The 15 examples from each country would provide the initial entries for an online database. In addition, it was planned that these examples would provide the 'collection' which could be used to design and curate a travelling exhibition that would be mounted in each country for a short period. It was the intention that these activities in the first year would help to raise people's awareness in the partner countries of the need to scope and document cultural heritage resources under threat. It was also anticipated that these first-year activities would provide the initial framework for 'cascading' and 'snowballing' the processes and tools to others so that the activities of scoping and documenting of cultural heritage resources under threat would be further promoted.

As a means to stimulate this 'cascading' and 'snowballing', the authors planned that the second year of *en-compass* should focus on the design and running of two-week in-country training workshops. At these in-country workshops there would be a facilitator from ICCHS and input from the partner organisations and participants. Each of these workshops would be aimed at training a further 15 people in the scoping and documentation processes and tools developed by the original team of 12 participants, partner organisations and project leaders. The workshops would also be used to introduce international and national policy and legislation frameworks, issues related to heritage management, and the role of heritage interpretation in education and sustainable heritage tourism.

Finally, in the hope of embedding the long-term sustainability of the project and continuing the promotion of the 'cascading' and 'snowballing' effect of *en-compass*, it was felt that it would be useful to have three people from each of the non-UK partner countries trained to a postgraduate level. Consequently, it was proposed that in the third and final year the partners from the three other countries would each select three people to apply to register for one of ICCHS's taught MA postgraduate programmes, which provide training in heritage education and interpretation and heritage management. It was felt by the authors and project leaders that, along with the three participants from the first year, the 15 from the second year and the three from the third year, the project would have a cadre of people who could take forward the programme in each country and its surrounding regions. It was believed that these cadres would strengthen structures and mechanisms facilitating the continuation and growth of the project's aspirations through the principles of 'cascading' and 'snowballing'. It was further believed that if this was successful, the model could be rolled out to other countries and regions.

With the ideals contained in the response to the *Investing in People* bid outlined above, and the proposed activities described, the following sections will focus on the implementation of the project and the first-year activities.

Table 21.2. Key dates in the process up to the final launch of the *en-compass* project

Date	Event
03 March 2009	Newcastle University internal notification of the call for proposals
09 April 2009	Submission of Part A Concept Note for the first round
28 May 2009	Concept Note 'pre-selected' for the next round of the restricted call for proposals
06 July 2009	Submission of Part B – Full Application Form in the restricted call for proposals
23 September 2009	Letter informing of success of bid
18 December 2009	Received Grant Contract
21 December 2009	Newcastle University signed and returned Grant Contract
17–20 May 2010	Steering Committee Meeting to plan and launch the project
4–8 October 2010	Newcastle Workshop for the 12 first-year project participants (three from each country)
28 October 2010	Collaboration Agreement relating to *en-compass* project signed by all four partner parties

As is often the case with complex multinational programmes, the first phase of *en-compass* has not always been straightforward and there have been times in the timetable (Table 21.2) when things went more slowly than first planned or expected. At the beginning, events moved very quickly. Within four months, between early March and the end of May 2009, the process was complete from when the call for proposals was first advertised at Newcastle University through to hearing that the submitted Concept Note had been pre-selected for the second round of the *Investing in People* scheme. The next phase of the process also went relatively quickly. The full proposal bid application was drafted, circulated to the project partners for comments and then submitted early in July of that year. Within three months the final selection process was completed and towards the end of September a letter was received from the European Commission saying that the bid had been successful. However, some further work on the finer details of the project was required, with the final grant contract between the European Commission and Newcastle University being signed in December 2009. Although partners had been given a chance to review the project before the bid was submitted, the start of the project was slowed when Newcastle University prepared and sent out the detailed collaborative agreement for Newcastle University and the other partners to sign. With their relative autonomy, the partner organisations in Kenya and Guyana found the substantive collaborative agreement easier to sign. In contrast, the partner organisation in Hainan had to obtain approval from the provincial and state government structures. This was complicated by the fact that this Western approach to agreements is culturally foreign in China and that this was probably the first of this type of international project to be undertaken by a province in the country. In addition, there was the issue of language and terminology differences which impacted on the translation of the document. Consequently, the resulting negotiations became rather protracted, with the collaboration agreement only finally being signed in October 2010. Although there was this delay in signing the paperwork, all the partners showed sensitivity to each others' interests and a strong willingness to start the project. With trust and understanding, it was agreed that the Steering Committee of the project with representatives from the four in-country partner organisations would have its first meeting

without the collaborative agreement being finalised and signed. This meeting was arranged to take place in mid-May 2010. The meeting was organised, but even this was not straightforward. The main reason for this was the volcanic eruptions in Iceland which disrupted air travel and made representatives concerned about travelling to the UK. Although the Newcastle hosts and the representative from the partner organisations of two of the other countries made the meeting in person, the representative from the remaining country's partner organisation could only join the meeting via Skype. This proved to be a viable solution and the meeting went ahead. In fact, the excitement caused by trying to solve these logistical problems provided a good 'team-building' experience, with the partner organisation representatives providing very enthusiastic input. Although there may have seemed to have been obstacles in the way, the project ended up getting off to a very positive start. Following the meeting, partner representatives went away and started the processes to select the three participants from their home countries to participate in the first-year project activities. As a guideline, it was suggested that the each partner should select a visual artist, a performing artist and a heritage or museum practitioner. A balance in gender, age and ethnic background were also seen to be important in the selection.

EN-COMPASS ACTIVITIES: THE STORY SO FAR

Following the Steering Committee meeting in May 2010, all four partners started the processes of selecting the three participants from their area. They also started to confirm dates for the three in-country scoping workshops that were to take place in China, Kenya and Guyana. Although the full details of the collaboration agreement had still not been finalised four months after the initial May meeting, it was decided to continue with the delivery of the activities of the first year of the project. It was felt by the partners that en-compass should not be delayed any longer as this may have already compromised the project. In good faith the partner organisations agreed to proceed and, without the collaboration agreement fully signed, the 12 participants came together in Newcastle for their initial training workshop early in October 2010. At this workshop the opportunities for dialogue and cultural exchange were facilitated and much group work and comparative analysis was done. The participants came up with frameworks for what expressions and products needed to be identified and documented in their countries. A process was started to develop a documentation template that was later discussed with the partner organisations via e-mail and then finally consolidated by the two authors. Each country's group of three participants also started to think about what needed to take place during the in-country scoping workshops.

IN-COUNTRY SCOPING WORKSHOPS

Following on from the Newcastle workshop in early October 2010, participants took part in a series of two-week-long in-country workshops in Kenya, Guyana and China between October 2010 and January 2011. The Kenya workshop was based in and around Mombasa, which is situated on the east coast of the country along the Indian Ocean, while the Guyana workshop was initiated in Georgetown, the capital of the country, which is on the coast, and then relocated to the Iwokrama protected rainforest area and North Rupununi, which is in the hinterland of the country. In China, the workshop took place in Haikou, the capital city of Hainan province, and in small towns and villages on the island. As already mentioned, these workshops were primarily

intended to identify and audit a minimum of 15 key tangible and intangible heritage resources, including cultural expressions, products and services in each partners' country, and to commence the cascading process. It was also deemed beneficial that the participants from all the partner countries were involved in each of the in-country scoping workshops to ensure continuation of the intercultural dialogue and discussion initiated during the initial Newcastle workshop and that participants could have access to the cultures of other target groups.

The four workshops provided the participants with a unique opportunity to, on the one hand, share their concerns and experiences regarding the safeguarding of tangible and intangible resources in their home countries with colleagues from other parts of the world and, on the other hand, to initiate a dialogue regarding the mechanism through which some of the problems could be tackled. It should be noted that for many of the participants it was their first opportunity to view and experience tangible and intangible cultural heritage resources outside of their home countries. Of particular importance was the realisation for some of them that many of the challenges which they faced regarding the safeguarding of heritage resources mirrored those in other parts of the world. It is fair to comment that this was a salutary experience for the participants. Given the shortened lead-in time for the in-country scoping workshops due to the delays in the signing of the collaborative agreement, it was not possible to fully realise the aim of using these workshops to conduct joint *in situ* detailed recording of the heritage processes and products. In particular, the Kenyan workshop was disadvantaged by the fact that it ended up being back-to-back with the initial Newcastle workshop. The Newcastle workshop was instrumental in identifying which categories of items and processes should be recorded, and the different information sets which needed to be recorded for each of the countries. There was, however, insufficient time to translate the participants' Newcastle workshop input regarding what needed to be recorded into a suitable format for consideration (and modification) by the partner organisations before the Kenyan workshop. While this was initially considered to be setback for *en-compass*, on reflection it has proved beneficial for two reasons: (i) it has allowed more time to reflect on the nature of the documentation (or auditing) that is required for the *en-compass* database, and (ii) it has become evident that the documentation of items and processes is a time-consuming process and if this had been undertaken during the in-country scoping workshops it would have impacted significantly on the opportunities that the participants had to travel around each other's territories and to observe and participate in different cultural practices. Furthermore, the subsequent modification to the documentation strategy has given the participants greater opportunity to mobilise their in-country cultural networks to contribute to the auditing process and also to lay the foundation for the proposed awareness campaigns. It is our hope that this will engender greater momentum for the ongoing scoping and auditing activities.

DEVELOPMENT OF THE DATABASE

As will have become evident, there is a close working relationship between the Newcastle and in-country scoping workshops and the creation of the database of intangible and tangible heritage resources for the participating countries. It was evident from the conceptualisation of *en-compass* that it was necessary to develop a systematic database that would provide consistency in documenting cultural heritage resources, including those at risk in the short-term, in the *en-compass* countries (and beyond). This was particularly important as the four participating countries have different recording traditions. It was for this reason that the Newcastle workshop was in part

dedicated to discussions among the participants about (i) which process and products needed to be recorded and (ii) the nature of the information to be documented. The resultant database will be made available on the *en-compass* website, thereby giving it exposure not only to participants and people in their home countries, but also to a much wider international audience.

The documentation processes and associated database are critical for the effectiveness of *en-compass*. This is for many reasons, the key of which can be summarised as follows:

- The creation of the database will enable the representatives from each country to enhance their access to the cultures of their countries and to draw on their experiences and knowledge to provide recommendations about how these may be safeguarded. The practitioners will also develop a better understanding of the condition and value of the different resources;
- the documentation processes and the database will provide the platform for the creation of ongoing scoping projects with resultant online resources being developed in the home countries;
- the documentation work will complement existing work being done in the participants' countries and in other parts of the world and it will serve to promote (and encourage) this work;
- it is intended that the information and knowledge available in the database from the initial and proposed ongoing scoping and auditing activities which will benefit the arts, music, heritage and museum sectors. Furthermore, we believe that encouraging information gathering and exchange regarding heritage resources will make these resources more useful in terms of developing sustainable tourism initiatives;
- the online database catalogues will also give people in each country access to cultural and heritage resources from the other partners' countries. Most importantly, it may also stimulate the 'flows of cultural production' to EC countries, as people from these countries access the online information;
- it will make available to an international audience the range of information which we believe needs to be included in a database dealing with intangible and tangible heritage resources; and
- finally, the database will become the prime foundation for understanding what is available for inclusion in the *en-compass* travelling exhibition. Already the scoping and auditing activities undertaken in the partner countries have served to identify and highlight the wealth and value of tangible and intangible cultural heritage resources of indigenous peoples and ethnic minority groups in the partners' countries. Furthermore, it has helped with the identification of heritage and cultural expressions, products and services which may be under threat, or perhaps even close to extinction.

The underlying basis of the database was established in the Newcastle workshop of October 2010. As mentioned above, it was, however, not possible to complete the exercise at the workshop, and this was done by the two authors in early 2011. Draft framework documents were circulated to the project partners and participants for comment. Furthermore, on the advice of the database specialist contracted to develop the electronic version of the database for use on the *en-compass* website, it was decided to limit the number of characters for each of the completed categories. This was to ensure some level of consistency between, on the one hand, the information in different categories of items and, on the other, the extent of the information contained

in the databases. It is appreciated that these characters' lengths may be increased in associated or complementary databases.

The database was divided into six categories: 1. Art, Craft and Traditional Skills; 2. Language; 3. Poems and Stories; 4. Traditions, Ceremonies and Rituals; 5. Music and Songs; and 6. Dance. We appreciate that there are different ways to categorise products and expressions; however, listing each item individually will enable future community members and researchers the opportunity to reconfigure the categories should they wish to do so. Furthermore, a wide range of documentary fields have been identified for completion, such the general origin and history of the different practices, the gender of art or craft practitioners, the age range of practitioners (if appropriate), and descriptions of raw material(s), manufacturing techniques and tools used. It should be noted that, alongside the process and products database, *en-compass* will facilitate the development of a database of heritage practitioners in each partner's country, or region, as in the case of Kenya. Finally, it is worth noting that both the heritage practitioner and product/processes databases will be published in both English and Mandarin text.

Website development

A dedicated *en-compass* website (http://www.en-compass.ac.uk) has been developed to fulfil a series of purposes. Of particular importance is that it will be the primary mechanism through which the work of the project is conveyed to the public in the participants' countries and to the broader international community. This will be achieved through not only introducing the different components of *en-compass* but also giving exposure to the partner organisations and project participants. It is also important to highlight the significant work done by the partner organisations in the safeguarding of cultural heritage. Recognising the partner organisations and participants will not only be valuable for those organisations and people involved but it will also provide *en-compass* (and indeed the website) with a sense of legitimacy (and accountability) which stems from the organisations and people associated with it. These are important factors in the development of partnerships, especially of an international nature, when organisations that have never before collaborated together join forces under the umbrella of a multinational project.

While the website will be an important vehicle for promoting different aspects of *en-compass* we would like to draw attention to two of these: the travelling exhibition and the databases. In terms of the travelling exhibition, the website will (i) provide publicity for the travelling exhibition, and (ii) it will enable people who will not be able to physically visit the exhibition to experience it virtually. The publication of the cultural products and processes database on the website will not only enhance their global exposure and hopefully encourage sustainable tourism and local entrepreneurship but will also provide a template for other organisations with an interest in similar work and issues to consider for use in their documentation programmes. In addition, the publication of the practitioner database has been designed to help facilitate networking among heritage practitioners in the different countries and regions.

Travelling exhibition

Alongside the documentation processes, arrangements are underway to develop the travelling exhibition which will be shown for a minimum of two months in each of the participating countries. The exhibition will include both panels and cases; some of the infrastructure will be built

in-country to set specifications so that parts of it will embody the 'look and feel' of exhibition traditions in the host countries. Although still at the initial stages, a series of display themes has already been identified and is being negotiated with the partner organisations.

Conclusion

Although *en-compass* is still in its infancy, it is already possible to draw some lessons from the process to date. Two key lessons relate to the organic nature of the project. First, the project has only been able to progress as it has when there has been buy-in, time and resources dedicated by the project leaders, partners and participants. It has been seen that this engagement needs to be continuous and not simply revolve around an initial agreement and commitment. The project has gained a rhythm of life dependent on input. As with a living organism, the project has had times of increased activity and times when things have moved more slowly, as those involved have had to turn their attention to other projects for periods and then come back to the *en-compass* activities. A second important lesson relates directly to cultural diversity. People from different cultural backgrounds do have different ways of seeing and doing things. This has meant that all have had to be sensitive and considerate to each other at times and this has inevitably increased the learning experience of all involved in terms of cultural awareness. Furthermore, the intercultural dialogue that has been generated through the project has already exceeded the expectations which we had when we established *en-compass*.

We appreciate that *en-compass* is still ongoing; however, it is already shaping up to provide a model for the safeguarding of ICH which could be considered by other parties interested in this increasingly important issue. The strength of the project lies not only in the meaningful collaboration between different parties in disparate parts of the world but also in the wide range of interconnected (and articulated) activities which underpin the project. Ultimately, the safeguarding of ICH will not be achieved through focusing on any one activity or approach. Rather, this will be realised by deploying multifaceted strategies which appeal to a wide range of people and organisations. This is the framework which *en-compass* has embraced with its wide range of activities, such as scoping and training workshops, databases, exhibition and website. As alluded to above, this has not been a straightforward exercise but it has already made significant gains and these will be built on as *en-compass* progresses.

Acknowledgments

The *en-compass* project would not have been able to happen without the support and funding from the European Commission through the *Investing in People: Access to local culture, protection and promotion of cultural diversity* scheme. The authors are indebted to the European Commission for this opportunity. The *en-compass* project has also benefited from the input and support of a wide range of people. It is not possible to identify all of them but our heartfelt thanks to all of those who have contributed to the project, both within Newcastle University itself and elsewhere. We would like to acknowledge the input from our partners in the project, in particular Shaoling Tan (Hainan Provincial International Cultural Exchange Centre), Deirdre Prins and Peter Okwaro (Centre for Heritage Development in Africa), and Dr Raquel Thomas (Iwokrama International Centre for Rainforest Conservation and Development). At Newcastle University, we have received sterling support from Dan Chen, Chris Hoy and Thereza Webster. Finally, our

thanks are due to the *en-compass* participants for their concerted efforts and enthusiastic support of the project: Pei Chen, Kaiyao Lin and Yiping Zhang (Hainan); Glendon Allicock, Ossie Hussein and Benita Roberts (Guyana); Jack Obonyo, Juliette Omolo and Jabbal Otuga (Kenya); and Niki Black, Sam Taylor and Kate Young (UK).

This document has been produced with the financial assistance of the European Union. The contents of this document are the sole responsibility of University of Newcastle upon Tyne and can under no circumstances be regarded as reflecting the position of the European Union.

Bibliography and References

CHDA, 2011 *Centre for Heritage Development in Africa*, available from: http://www.heritageinafrica.org/ [6 May 2011]

Commission of the European Communities, 2007 *Communication from the Commission to the European Parliament, the Council, the European Economic and Social Committee and the Committee of the Regions on a European agenda for culture in a globalizing world, {SEC(2007) 570}, (COM(2007) 242 final)*, available from: http://eurlex.europa.eu/smartapi/cgi/sga_doc?smartapi!celexapi!prod!DocNumber&lg=en&type_doc =COMfinal&an_doc=2007&nu_doc=0242&model=guicheti [6 May 2011]

Corsane, G, and Mazel, A, 2009 European Commission: Investing in People: Access to local culture, protection and promotion of cultural diversity, Restricted Call for Proposals 2008, Annex A, Grant Application Form (Part B), Reference: EuropeAid/127875/C/ACT/Multi, unpublished grant application form

European Commission, 2008 Investing in People: Access to local culture, protection and promotion of cultural diversity, Restricted Call for Proposals 2008, Guidelines for grant applicants, Budget line 21.05.01.03, Reference: EuropeAid/127875/C/ACT/Multi

Forest Connect Guyana – Iwokrama, 2008 *North Rupununi District Development Board*, available from: http://iwokrama.org/forestconnect/membership/profile/rd_nrddb.htm [6 May 2011]

Hainan Government, 2011 *Department of Culture, Radio, Television, Publication and Sports of Hainan Province: Brief Introduction*, available from: http://wtt.hainan.gov.cn/swtt/ywb/ [6 May 2011]

Iwokrama, 2009 *Iwokrama – the Green Heart of Guyana*, available from: http://www.iwokrama.org/wp/ [6 May 2011]

UNESCO, 2003 *Convention for the Safeguarding of Intangible Cultural Heritage*, UNESCO, Paris, available from: http://unesdoc.unesco.org/images/0013/001325/132540e.pdf [6 February 2012]

—— 2005 *Convention on the Protection and Promotion of the Diversity of Cultural Expression*, UNESCO, Paris, available from: http://unesdoc.unesco.org/images/0014/001429/142919e.pdf [7 February 2012]

—— 2012a *The States Parties to the Convention for the Safeguarding of the Intangible Cultural Heritage (2003)* [online], available from: http://portal.unesco.org/la/convention.asp?KO=17116&language=E [7 February 2012]

—— 2012b *The States Parties to the Convention on the Protection and Promotion of the Diversity of Cultural Expression*, UNESCO, Paris, available from: http://portal.unesco.org/la/convention.asp?KO=31038&language=E [7 February 2012]

Contributors

Shatha Abu-Khafajah is Assistant Professor in the Architectural Department and the Cultural Heritage Management Department at Hashemite University. She gained her bachelor degree in 1997 from Jordan University's Architectural Department. She studied for her Masters degree in Archaeology at Jordan University, with special interest in the documentation and conservation of archaeological sites, and graduated in 1999. Shatha's PhD research was conducted at the International Centre for Cultural and Heritage Studies, Newcastle University, prior to graduating in 2007. Her PhD thesis is concerned with cultural heritage management in Jordan and the meaning-making process of places with historic significance.

George Abungu is a Cambridge-trained archaeologist who is currently an independent international heritage consultant. He is the Founding CEO of Okello Abungu Heritage Consultants and former Director General of the National Museums of Kenya. He has many years' experience in the Museum and Heritage field and is a founding chairman of Africa 2009, Centre for Heritage Development in Africa, and was Kenya's Representative to the UNESCO World Heritage Committee from 2005 to 2009. He sits on a number of Boards and serves as a visiting lecturer in a number of universities internationally. He has published widely on subjects ranging from archaeology and heritage management to museology.

Marilena Alivizatou is a Teaching Fellow in Museum Studies at the Institute of Archaeology, University College London. She lectures on museum history and theory and coordinates courses on collections curatorship, care and management. In 2009 she completed her doctoral thesis on the critical examination of intangible heritage from the global level of international politics to the local realities of heritage and museum work in Oceania, America and Europe. She has worked for museums and heritage organisations in Greece, the UK and France, including the Intangible Heritage Sector of UNESCO in Paris.

Paula Assunção dos Santos, Master of Museology and PhD candidate in Sociomuseology, is a lecturer in cultural heritage and Managing Director of the International Masters Degree Programme in Museology at the Reinwardt Academie, faculty of the Amsterdam School of the Arts. Originally from Brazil, she has lived in the Netherlands for eight years, where she has also co-founded the Culturalia Foundation, which aims at developing network projects in the areas of mutual cultural heritage, community museology and participation in heritage processes. The projects focus on Portuguese-speaking countries and on the connections between Brazil and other countries such as the Netherlands and South Africa.

Vasant Hari Bedekar holds two Masters degrees, a postgraduate Diploma in Museology with Distinction and a Doctorate. Prior to his retirement in 1989, he worked as Lecturer, Reader, Professor then Head of the Department of Museology (Faculty of Science) at the MS University of Baroda. He is a member of ICOM, the Museum Association of India and Museum Association of Gujarat and was awarded a Lifetime Achievement Award by the Museum Association of

India in the field of Museology. As a museums adviser, he has worked on several national museum committees and delivered lectures on the subject of Museums, Museology and Art History, and has participated in ICOM conferences and international seminars in Australia, Argentina, Brazil, Mexico, Japan, South Korea and the Netherlands. Professor Bedekar has published around 50 articles in museum journals and books including: 'So you want good museum exhibition' (1978); 'Stylistic Approach to Indian Miniatures' (1979); 'How to write Assignments, Research Papers, Dissertations and Thesis' (1982); 'New Museology for India' (1995); 'Laur-Chanda – A study in styles', Chandigarh Museum (2006).

Ewa Bergdahl is an archaeologist with a BA in Arts. For the last 20 years she has worked within the field of museums, regional development and culture heritage, in both a strategic and opera-tional capacity. Between 1996 and 1999 she was director of Ecomuseum Bergslagen and then director of the City Museum in Norrköping, where she worked with the reusing and transition of the former textile industrial city landscape into a modern commercial and educational centre. From January 2004 to June 2009 Ewa was appointed as head of the Cultural Tourism division on the National Heritage Board. Today she works as director of the Public Division at the Swedish Museum of Natural History in Stockholm.

Jared Bowers is a PhD Researcher at Newcastle University who has worked and researched in tourism development in several countries around the world. Specific roles have ranged from ecotourism consultant and manager to adventure tour guide. His research interests are in the processes of sustainable tourism development and the management of natural and cultural heritage resources. He received an MSc in Ecotourism from Edinburgh Napier University (UK) and a BA in Communications from Elon University (NC, USA). He is currently working towards his PhD on using ecomuseology principles as a management tool in developing sustainable tourism in the Rupununi region of Guyana.

Gerard Corsane is Dean for International Business Development & Student Recruitment in the Faculty of Humanities and Social Sciences at Newcastle University. He is also a Senior Lecturer in Heritage, Museum & Gallery Studies in the International Centre for Cultural and Heritage Studies (ICCHS), School of Arts and Cultures. He teaches across the museum studies, heritage management, interpretation and education modules of the postgraduate programmes in ICCHS. His research interests are in community participation in sustainable heritage tourism, integrated heritage management, ecomuseology and the safeguarding of intangible and tangible cultural heritage expressions and products.

Alissandra Cummins is the Director of the Barbados Museum and Historical Society and Chair of the National Art Gallery Committee of Barbados. She is a lecturer in Heritage Studies with the University of the West Indies and in 1999 was appointed as Special Envoy for Cultural Heritage. She was elected founding President of the Museums Association of the Caribbean (1988–1992), and served as President of the International Council of Museums (2004–2010). She was elected as Chairperson of UNESCO's Intergovernmental Committee for Promoting the Return of Cultural Property to its Country of Origin or its Restitution in Case of Illicit Appropriation (2003–2005), and was appointed as Chairperson of UNESCO's Memory of the World Programme (2007–2009). Alissandra was awarded Barbados' Gold Crown of Merit in 2005, and is a Fellow of the Museums Association (UK). She was recently elected Chairperson

of the Executive Board of UNESCO, and was also appointed as Editor in Chief of the Interna-tion Journal of Intangible Heritage.

Peter Davis is Professor of Museology at Newcastle University. His research interests include the history of museums; the history of natural history and environmentalism; the interaction between heritage and concepts of place; and ecomuseums. He is the author of several books, including *Museums and the Natural Environment* (1996), *Ecomuseums: a sense of place* (1999; 2nd edition 2011) and (with Christine Jackson) *Sir William Jardine: a life in natural history* (2001).

Harriet Deacon is a heritage consultant based in London and a correspondent for the Archival Platform, a research, advocacy and networking organisation in the archive, museum and heritage sector in South Africa. She has worked in the heritage sector in South Africa for over a decade (specialising in intangible heritage and health issues) and remains an Honorary Research Fellow of the Archive and Public Culture Research Initiative at the University of Cape Town. In 2010–11 she worked with Dr Rieks Smeets developing training materials for UNESCO on implementing the Intangible Heritage Convention.

Alexandra Denes is an Associate Researcher at the Sirindhorn Anthropology Centre in Bangkok, Thailand, where she directs the Intangible Cultural Heritage and Museums Programme and the Culture and Rights in Thailand Research Project. A cultural anthropologist specialising in Southeast Asian Studies, Alexandra has spent over 14 years living, working and researching in the region. In 2002, Alexandra received a Fulbright scholarship to conduct field research on Khmer heritage and Khmer ethnic identity in Thailand. The research culminated in her doctoral disserta-tion, entitled 'Recovering Khmer Ethnic Identity from the Thai National Past: An Ethnography of the Localism Movement in Thailand' (Cornell 2006). She is broadly interested in issues of ethnic identity, ritual, memory and the politics of cultural heritage revitalisation within the context of nationalism.

Andrew Dixey (BSc Biological Sciences, Lancaster 1978; MA Heritage Management, Newcastle 2008) has had a varied career in wildlife and countryside management, including teaching walling and hedge-laying. In 1992 he became a Research Assistant in Farming and Crafts at the then Welsh Folk Museum, Cardiff, Wales. Since 1996 he has been Estate Manager at the now-named St Fagans: National History Museum. He is particularly interested in the question of how ICH is and might be sustained, with particular reference to crafts and craft skills in 'first world' societies. Andrew's spare time interests include the continued restoration of a traditional farmhouse in the Tatra mountains of Slovakia.

Sylvie Grenet graduated from the *École du Louvre* (archaeology and anthropology) and has a PhD in English studies dedicated to the notion of *genius loci*. She was head of the information department of the Ile-de-France regional branch of the Ministry of Culture before joining the *Mission Ethnologie* of the French Ministry of Culture in 2002. She has been involved in the implementation of the ICH Convention since its ratification by France in 2003.

Kate Hennessy is an Assistant Professor specialising in Media at Simon Fraser University's School of Interactive Arts and Technology. Her research explores the role of digital technology and participatory media production in the documentation and safeguarding of cultural heritage, and the mediation of culture, history, objects and subjects in new forms. As a founding member

of the Ethnographic Terminalia curatorial collective, her video and multimedia works investigate documentary methodologies to address Indigenous and settler histories of place.

Christian Hottin studied History and the History of Art at the *École nationale des chartes*, the *École pratique des hautes études* and the *Institut national du patrimoine*. From 2001 to 2005 he was curator at the National Archive in Roubaix. Since 2006 he has been in charge of the Department of Ethnology (department for research since 2010) at the Ministry of Culture and Communication and is involved in the implementation of the 2003 Convention in France. He is a member of the French delegation of the Intergovernmental Committee for ICH.

Susan Keitumetse has a background in Archaeology and Environmental Sciences. Her PhD, from Cambridge University's Department of Archaeology, dealt with the interface between Sustainable Development and Cultural Heritage Resources Management in developing countries of Sub-Saharan Africa, with a strong focus on community participation in cultural resources conservation and management for both identity and economic development. She is a research scholar in Cultural Heritage Tourism at the University of Botswana's Okavango Research Institute, focusing on wetland heritage in protected areas of the inland Okavango Delta, Northern Botswana. She was previously a research fellow at the Smithsonian Center for Folklife and Cultural Heritage. She advises various Botswana governmental departments on how to safely incorporate cultural heritage resources in their portfolio and she has also worked as a UNESCO consultant on a pilot project inventorying intangible cultural heritage in Sub-Saharan Africa.

Christina Kreps is Associate Professor of Anthropology and Director of Museum Studies at the University of Denver Museum of Anthropology. Her research focuses on cross-cultural and international approaches to museums and heritage management. She has conducted research and museum training programmes in The Netherlands, Indonesia, Italy, Thailand, Vietnam and the United States. Dr Kreps served as former editor of *Museum Anthropology*, the journal of the Council on Museum Anthropology of the American Anthropological Association. Her publications include *Liberating Culture: Cross-Cultural Perspectives on Museums, Curation, and Heritage Preservation* (2003).

Lyn Leader-Elliott is Adjunct Senior Lecturer in Cultural Heritage and Tourism, Department of Archaeology, Flinders University. Her interest in heritage values stems from cultural heritage policy development she undertook for the Australian Heritage Commission in Canberra in the mid-1970s. Since then she has worked in many areas related to the nature of cultural heritage, its place in community life and its consumption, especially through the tourism industry. She is particularly interested in the relationship between tangible and intangible heritage in both Indigenous and non-Indigenous communities in post-colonial societies. She is a member of the ICOMOS International Scientific Committee on Cultural Tourism and a research associate of the Canada-based Intellectual Property Issues in Cultural Heritage project. She was Senior Lecturer Cultural Tourism at Flinders University, South Australia, from 2000 to 2009.

Richard MacKinnon is a Tier One Canada Research Chair in Intangible Cultural Heritage at Cape Breton University. His research interests include all aspects of Atlantic Canada's culture, including oral traditions, music, language, material culture and vernacular architecture. His publications include: *Vernacular Architecture in the Codroy, Newfoundland* (Ottawa, National Museum of Civilization, 2002) and *Discovering Cape Breton Folklore* (Sydney, Cape Breton

University Press, 2009), and he has worked in the multimedia field developing CDROMs and websites, including a website for secondary teachers focusing on various aspects of Atlantic Canada's cultural diversity. He is the editor of the journal *Material Culture Review/Review de la culture matérielle* and has also produced audio CDs of CBU students and faculty, including *Prefer Performance* (2009) and *Cape Breton University Soundtracks* (2010).

He is the founding Director of the Centre for Cape Breton Studies, a research centre at Cape Breton University that includes a state-of-the-art digitisation lab and facilities used by faculty, visiting scholars and undergraduate, graduate and post-doctoral students.

Maurizio Maggi (Turin, Italy; 1956) is Senior Researcher at the Institute for Social and Economic Research in Piedmont. From 1992 to 2007 he was in charge of local heritage research and was chief of the Local Heritage Research Unit of Ires. Local heritage, cultural diversity and new museology are his main areas of interest. Maurizio has taught on postgraduate courses in Turin, Milan, Valencia and Goteborg and was a member of the board of directors of the Ethnographic Museum of San Michele all'Adige (Trento). His publications include: 'Ecomuseums: what they are and what they can be' (Allemandi, 2001); 'Ecomuseums. A European Guide' (Allemandi, 2002); 'Museums at the edge' (Jacabook, 2009).

Aron Mazel joined Newcastle University in 2002 after a 25-year career in archaeological research and heritage and museum management in South Africa. Between 2002 and 2004 he managed the Beckensall Northumberland Rock Art Website Project, which won the Channel 4 ICT British Archaeological Award in 2006. He is also a Research Associate in the School of Geography, Archaeology and Environmental Studies at the University of the Witwatersrand (South Africa). His research interests include the management and interpretation of heritage; museum history; the construction of the hunter-gatherer past; the dating of rock art; and Northumberland rock art. Recent publications include *Tracks in a Mountain Range: exploring of the history of the uKhahlamba-Drakensberg* (2007, with John Wright) and *Art as Metaphor: The Prehistoric Rock-Art of Britain* (2007, co-edited with George Nash and Clive Waddington).

Léontine Meijer-van Mensch is lecturer in heritage theory and ethics at the Reinwardt Academie, Amsterdam, and chair of the ICOM International Committee for Collecting. Her PhD research focuses on the museology discourse in the German Democratic Republic and its international resonance. Her main interest is remembrance culture and contemporary collecting.

Peter van Mensch was, until his retirement in 2011, professor of cultural heritage at the Reinwardt Academie, Amsterdam. He earned his PhD degree at the University of Zagreb on the basis of a thesis on the theory of museology. As a researcher he is interested in developing an integral and integrated approach to heritage.

Elaine Müller has a PhD in Anthropology and is lecturer of museology at the Federal University of Pernambuco. She worked for three years at the National Institute of Historic and Artistic Heritage (IPHAN) as an ICH technician. She was involved in the inventories in Frevo and Capoeira in Pernambuco, which involved long-term contact with practising communities.

Shaher Rababeh, author of *How Petra was Built*, is an assistant professor of architecture, head of the Department of Architecture, and Director of the Department of Engineering Projects at the Hashemite University, Jordan, where he is also a member of the department of Conservation Sciences. He received his BSc in Architectural Engineering from Yarmouk University, Jordan,

in 1987, MSt in Classical Architecture and DPhil in Architectural Techniques and Methods of Design from the University of Oxford in 2005. His research interests include architectural history, construction methods and techniques, architectural design and heritage conservation.

Michelle L Stefano is an emerging scholar within the field of heritage studies. Her research focuses on the impacts of transnational and national cultural policies at the local level, as well as on the utilisation of holistic and integrated approaches in safeguarding living cultural expressions. Michelle was awarded her PhD in Cultural and Heritage Studies from the International Centre for Cultural and Heritage Studies at Newcastle University in 2010. She received her MA in International Museum Studies from Gothenburg University, Sweden, in 2004, and a BA in Art History, as well as another in the Visual Arts, from Brown University, USA, in 2000. She is currently the Program Coordinator of Maryland Traditions at the Maryland State Arts Council, as well as the Folklorist-in-Residence in the Department of American Studies at the University of Maryland Baltimore County (UMBC), USA.

Daniella Trimboli is a jointly-awarded PhD candidate in the School of Culture and Communication, University of Melbourne, and the Department of English, University of British Columbia. Her dissertation investigates the ways in which concepts of ethnicity and race are engaged through multicultural arts practice in Australia and Canada. She has worked as a lecturer and research assistant in Tourism, Australian Studies, and for the Yunggorendi First Nations Centre at Flinders University. Prior to this, she worked for the Queensland Folk Federation (QFF), organiser of the Woodford Folk Festival and the international Indigenous festival, The Dreaming. Her work with the QFF heightened her interest in the concepts of cultural heritage and ethnic diversity.

Index

Heritage Matters

Lightning Source UK Ltd.
Milton Keynes UK
UKOW07f0448020615

252728UK00009B/189/P

9 781843 839743